generations & geographies in the Visual Arts

FEMINIST READINGS

In *generations and geographies*, the challenge of contemporary feminist theory encounters the provocation of the visual arts made by women in the twentieth century. The major issue is difference: sexual, cultural and social. *generations* points to the singularity of each artist's creative negotiation of time and historical and political circumstance; *geographies* calls attention to the significance of place, location and cultural diversity, connecting issues of sexuality to those of nationality, imperialism, migration, diaspora and genocide.

generations and geographies is framed by theoretical debates in cultural analysis by Griselda Pollock, Mieke Bal, Elisabeth Bronfen and Irit Rogoff, and two historical analyses of representations of the female nude by Rosemary Betterton and Nanette Salomon. Essays on international contemporary art discuss artistic practice by women working in both western and non-western contexts, focusing on themes of the mother, the body, the land and history/memory. The artists discussed include the French performance artist Orlan, the Cuban American artist Ana Mendieta and Jenny Saville from Britain, the Chilean artist Cecilia Vicuña, Shimada Yoshiko from Japan, the Korean artist Re-Hyun Park and the Korean/Canadian artist Jin-me Yoon, Bracha Lichtenberg Ettinger from Israel and the American artist Cindy Sherman. British/Zanzibari artist Lubaina Himid provides specially commissioned artists' pages on the theme of history, location and displacement.

Contributors: Mieke Bal, Elisabeth Bronfen, Irit Rogoff, Nanette Salomon, Alison Rowley, Michelle Hirschhorn, Judith Mastai, Lubaina Himid, Rosemary Betterton, Young-Paik Chun, Catherine de Zegher, Brenda Lafleur, Anne Raine, Hagiwara Hiroko, Griselda Pollock.

Editor: Griselda Pollock is Professor of Social and Critical Histories of Art and Director of the Centre for Cultural Studies at the University of Leeds. She is author of *Mary Cassatt; Old Mistresss; Framing Feminism; Vision and Difference; Avant-Garde Gambits;* and editor of *Dealing with Degas* and *Avant-gardes and Partisans Reviewed.*

generations & geographies in the Visual Arts

FEMINIST READINGS

Edited by Griselda Pollock

London and New York

First published 1996
by Routledge
11 New Fetter Lane, London EC4P 4EE

Simultaneously published in the USA and Canada
by Routledge
29 West 35th Street, New York, NY 10001

Designed and typeset by
🔨 Tek-Art, Croydon, Surrey

Printed and bound in Great Britain by
Redwood Books, Trowbridge, Wilts

British Library Cataloguing in Publication Data

A catalogue record for this book is available from the British Library

Library of Congress Cataloguing in Publication Data

A catalogue record for this book has been requested

ISBN 0–415–14127–3 (hbk)
ISBN 0–415–14128–1 (pbk)

Contents

Illustrations

Contributors

Mieke Bal is Professor of Theory of Literature and Director of the Amsterdam School for Critical Analysis at the University of Amsterdam. She is the author of major books on narratology and feminist biblical studies, including *Lethal Love: Feminist Literary Readings of Biblical Love Stories* (Indiana University Press 1987) and *Death and Dissymmetry: The Politics of Coherence in the Book of Judges* (University of Chicago Press 1988). Her work on semiotics and the visual produced *Reading Rembrandt Beyond the Word Image Opposition* (Cambridge University Press 1991). This has been followed by a new work on museums, *Double Exposures: The Subject of Cultural Analysis* (Routledge 1996).

Rosemary Betterton teaches art history and critical studies at Sheffield Hallam University. She is the author of *Looking On: Images of Femininity in the Visual Arts and Media* and *An Intimate Distance: Women, Artists and the Body*, and has written widely on the areas of feminist art history and theory.

Elisabeth Bronfen is Professor of English and American Studies at the University of Zurich. A specialist in nineteenth- and twentieth-century literature, she has also written articles in the areas of gender studies, psychoanalysis, film, cultural theory and art. Her recent books include *Over Her Dead Body, Death, Femininity and the Aesthetic* (Manchester University Press) and a collection of essays, *Death and Representation*, co-edited with Sarah W. Goodwin (Johns Hopkins University Press). She is currently editing the German edition of Anne Sexton poetry and letters and writing a short monograph on Sylvia Plath for the Writers and their Work series. Her forthcoming book (1997) is entitled *The Knotted Subject. Hysteria and its Discontents*.

Young-Paik Chun is a Ph.D. research student in the Department of Fine Art at the University of Leeds. Her chapter in this volume formed part of the postgraduate thesis for the programme of the Feminist Theory, History and Criticism in the Visual Arts in 1994. She completed an MA thesis in Korea, *Reading of 'A Bar at the Folies-Bergere' by Edouard Manet* in 1991. She has published articles in *Space*, a Korean arts and architecture magazine.

Lubaina Himid was born in Zanzibar in 1964. She studied at the Wimbledon School of Art and the Royal College and is currently studying for a Ph.D. at the University of East Anglia. She has had many major solo exhibitions including *A Fashionable Marriage* (1986); *Revenge* (1992); and *Beach House* (1995), and curated as well as exhibited in group shows such as *Thin Black Line* (1985) and *The Other Story* (1989). She teaches Fine Art at the University of Central Lancashire and prepares work for international exhibitions in New York and Chicago.

Hiroko Hagiwara was born in 1951. She was a founding member of the Asian Women and Art Collective (AWAC) in Tokyo, which organizes a series of seminars seeking alternative perspectives beyond and against cultural colonialism, Confucian patriarchy and first-class consumerism. She has written several books in Japanese, on gender, race and art and she translated Griselda Pollock's *Old Mistresses* and *Vision and Difference* into Japanese. She lectures on women's studies and Western ideologies at Osaka Women's University.

Michelle Hirschhorn was educated at the University of Leeds, the San Francisco Art Institute and the Otis Art Institute in Los Angeles. She is currently Curator at the Zone Photographic Gallery

in Newcastle upon Tyne. She has written articles for *New Observations, Versus Contemporary Arts Magazine* and *Oversight*. She has taken part on the panel of 'Women and Art 4', a workshop series sponsored by *Feminist Art News*, Leeds and was a Guest Speaker at the Orlan Conference, City Art Gallery, Leeds.

Brenda Lafleur received her MA in Feminist Theory, History and Criticism in the Visual Arts from the University of Leeds in 1993. She continues to work on the subject of how landscape images and spatial practices determine and are determined by issues of gender, race and class. She lives in Ottawa, Canada.

Judith Mastai is Director of the Vancouver Art Forum Society in Canada, publishers of the journal *Collapse: the view from here*. Formerly Head of Public Programmes at the Vancouver Art Gallery from 1987–94 and, before that, Program Director, Fine Arts and Design in Continuing Studies, Simon Fraser University for seven years, she is currently involved in a number of contemporary visual arts projects as a critic and curator.

Griselda Pollock is Professor of the Critical and Social Histories of Art and Director of the Centre for Cultural Studies at the University of Leeds. She is the author of *Old Mistresses: Women, Art and Ideology* (co-author Roszika Parker) and *Vision and Difference, Dealing with Degas* (edited with Richard Kendall). Forthcoming titles include *Differencing the Canon: Feminist Desire and the Writing of Art's Histories, The Case Against Van Gogh,* and *Avant-Gardes and Partisans Reviewed* (co-author Fred Orton). She lives in Leeds with another professor and two children.

Anne Raine earned an MA in Feminist Theory, History and Criticism in the Visual Arts from the University of Leeds, and is now a doctoral candidate in English at the University of Washington. Her current research explores the intersections of cultural production, aesthetics and geography, focusing on landscape, subjectivity and space in early twentieth-century American literature.

Irit Rogoff teaches Critical Theory and Visual Culture at the University of California at Davis. She is editor of *The Divided Heritage – Themes and Problems in German Modernism* (Cambridge University Press 1991) and *Terra Infirma – Geography and Spectatorship* (Routledge 1996). She writes extensively on the intersections between contemporary visual culture and issues of sexual, cultural and racial difference.

Alison Rowley is an artist. She currently teaches on the Visual Art Theory programme at Edith Cowan University, Perth, Western Australia. Her recent projects include images for *Night and Day*, a collection of short stories by Terri-Ann White (Fremantle Arts Centre Press 1994), and paintings for an exhibition at the New Collectables Gallery, Fremantle (1995). She was the 1995 winner of the *Women's Art Magazine* New Writers' Award.

Nanette Salomon is Associate Professor of Art History at the College of Staten Island of the City University of New York. She has published on seventeenth-century Dutch genre painting and feminism, as well as on the history of art history. She is currently working on a feminist analysis of the paintings of Johannes Vermeer and Jan Steen.

Catherine de Zegher was born in 1955 in Groningen, The Netherlands. She studied History of Art and Archaeology at the State University of Ghent, Belgium. In 1985 she became a co-founder of the Kanaal Art Foundation, a centre of contemporary art. In 1992 she was co-curator with Paul Vandenbroeck of the exhibition, 'America. Bridge of the Sun: 500 Years of Latin America and the Low Countries'. In 1995 she was appointed visiting curator at the ICA, Boston and organized the exhibition 'Inside the Visible' for its sixtieth anniversary. She lives and works in Belgium and the United States.

Preface

Griselda Pollock

The purpose of this book is to explore the complex field of interpretation in the visual arts in a way that privileges neither the historical nor the contemporary, neither theory nor practice, by putting them all into a constructed correspondence. The conversation is represented in the book by its double focus. Generation refers us to history and questions of difference posed by historical specificity around femininity, feminism, sexuality and representation. Geographies is a spatial image that implies the issues of cultural difference and the specificity of location which is cultural and social as well as political. Along these two axes we align a series of theoretically informed and historically researched case studies presented by artists, art historians, theorists, curators, writers. Feminist analysis of the practices of the arts varies culturally, historically, geographically, generationally. This volume does not wish to erase differences between women. Its ambition is to offer insight into historical and cultural specificity while also finding a space to acknowledge the more durable temporalities of sexual difference, the epoch of reproduction as Julia Kristeva might call it, which forms one of the key axes for the 'condition of women'.

This collection brings together writers and artists from Australia, Belgium, Britain, Canada, Chile, Cuba, France, Germany, Holland, Israel, Japan, Korea, Switzerland and the United States. In their diversity, they find common cause in thinking through the problems posed by artistic practices by means of the resources provided by feminist interventions in philosophy, narratology, semiotics, psychoanalysis, geography, history and politics. Part of the purpose is to confront the false dichotomy that still stalks many a fine-art studio programme or an art history department, namely that theory is opposed to practice and vice versa. In this volume there are artists who are also theorists, theorists who make art, there is art deeply informed by theory, theory that was generated by art practice, there is art that reveals its aesthetic density and cognitive complexity only after a detour through the terrains of specifically feminist theorizations of sexual difference, semiotics, subjectivity or painting.

Why this book, now?

We are twenty-five years into a renewed engagement with the politics of feminism. In a world fashioned on the commodity and the market that makes us very out of date. Feminism is *passé*; we're into something new – post-whatever. This books contests that fashion-oriented view of the project to change the condition of women and suggests that the politics of feminism remain a vital element of both artistic practice and intellectual work.

But feminism is a historical project and thus is itself constantly shaped and remodelled in relation to the living process of women's struggles. In twenty-five years feminism has changed from its opening salvos as a predominantly western, educated and middle-class revolt which belongs with a series of new social movements that found self-celebration an organizing principle. Affirmative actions and positive endorsements of sisterhood sound hollow in the realization of how much racism and class discrimination, how much homophobia and first worldism could be veiled by such slogans. Difference and with it, the painful realization of conflict and even antagonism, structure a much more careful, self-conscious and chastened feminist discourse.

Also the marches and the big national conferences, the public campaigns seem part of a disappeared political culture. These have been replaced by journal publication, what we might call a politics of the text and a presence of feminism in the spaces of representation that are broader than those of the legislature: cinema, art, media, cyberspace.

This book is about one such space of representation: the visual arts. It reflects the interests and concerns of those who make art, care about it, study and curate it. But we are not some remnants of an archaic breed who would be better off studying computer games and girls' bands. In the current climate, technologies and information systems are all too much part of the multinational conglomerated cultures that threaten to erase ideas of singular responsibility and relational identities. As the languages of collective politics leave the stage of history for a while, the questions of ethics and aesthetics join forces to create a significant role for artistic practices.

Julia Kristeva has written about current forms of dissidence and about revolutionary poetics. Dissidence in the late twentieth century is represented by several figures: the political rebel who takes on the state; the psychoanalyst, struggling against religion, explores relations between law and desire; the writer battles with the orders of language. But then, Kristeva adds a fourth arena, sexual difference and a final – but ambiguous – figure of dissidence: Woman. What is dissidence for Kristeva, the materialist student of psychoanalysis, literature and art? It is *thought*:

> For true dissidence today is perhaps simply what it has always been: *thought*. Now that Reason has become absorbed by technology, thought is only tenable as an 'analytic position' that affirms dissolution and works through differences. It is an analytic position in the face of conceptual, subjective, sexual and linguistic identities.[1]

This does not imply a retreat from politics into the academy as some compensatory substitute. Kristeva is arguing for the politics of analysis where being an intellectual can mean serving the powers that be in their bureaucratic adminstration of power, or it can mean being a dissident where challenging the very orders of sense and meaning themselves contain a radical relation to systems of power. As the balance of forces sways in the continual struggle that is social and historical practice, there is a moment for critical analysis that keeps alive thought as a practice of dissidence. In artistic practices and those practices engaged in its social representation we find a particular instance of such *thought*.

FEMINISM AND THE POLITICS OF IGNORANCE; THE DISSIDENCE OF THOUGHT (OR DO I MEAN THEORY?)

Since my earliest involvement with the renewed women's movement, when I was a fledgling art historian, I have been troubled by the ways in which ignorance can be created and systematically passed on. I was not taught about artists who were women when I was trained in a prestigious institute for the history of art. Despite over a quarter of a century of active advocacy and theoretical analysis, it is still possible to see the ignorance about women artists being perpetuated. How much has the mainstream allowed itself to be radically transformed by the implications of both its exposed ignorance and the substantive alterations to theories of art and artist predicated on a serious grasp of issues of sexual difference? As so much more than a matter of quotas, tokens, or the assimilation of a few fashionable names, have things really altered?

Ignorance does not just mean not knowing women's names or being able to identify pictures, sculptures, photographs, films or videos by women. It is much more complex. It is about an invisibility of meaning that arises from the indifference and indeed hostility of the culture to where these works come from, what they address and why they might have something to offer that realigns our understanding of the world in general. If I call the work of women 'different' I immediately fall prey to the deadly paradox: to name what makes it interesting to study art by artists who are

women is to condemn the artists to being less than artists: women. It is to find oneself in special-pleading, partisan advocacy of a special-interest group that is seen to be at odds with the assumed universality of art – art speaks to us all across the barriers of all our differences, art is meant to be simply truth and beauty.

But if the history of art is of any value as something more than a preparation for a day's spending at Sotheby's, it must have taught us that cultural practices are integral elements of the social formation as whole. Cultural practices shape not only meanings for, and thus understanding of, the world but help to form the very subjectivities and identities which, consuming these meanings, are then made in their image. This process of semiotic production and subject formation is not indifferent or neutral. It is deeply embedded in the mess and matter of social life, class, gender and cultural antagonism, the legitimation of power, the repression of resistance, the struggle for change. We call this ideology, and thus art – what it is about – matters. Whether it is used to cast the enchantment of beauty over the ugliness of social exploitation or to represent the ambitious imagination against the deadening utility of exploitative societies, whether it calls to great collective experience or with integrity dares to name a singular sensation, artistic practice is to be acknowledged as a particular but contributing facet of what we call society. Feminism has consistently addressed, therefore, both the impact of cultural forms on the creation of particular regimes of gender power and sexuality, and the possibility of cultural practices as part of the process of their contestation and the invention of other alignments.

We do not live merely in a culture that has forgotten women. As I have argued before, we must come to terms with the official and modern erasure of women from the records of culture. Moreover, I would suggest that, in some profound way, at least western culture hates women – often murderously. I am not being overdramatic or hyperbolic. Think of how many of our cultural myths climax with our dying – most beautifully, as Cathérine Clément has shown in her book on European opera – or how often female death is the key narrative moment of painting and literature, as Elisabeth Bronfen has shown in her study of the persistent western cultural tropes that unite the aesthetic, femininity and death.[2]

Feminism has been more than a prompt or a device for correcting an oversight of women artists. By asking the question about why we do not know about artists because they are/were women for instance, we quickly found ourselves questioning the fundamental assumptions of the whole enterprise of officially sanctioned knowledge. Once realizing that we could not begin to speak of the women artists we would re-excavate from dusty basements and forgotten encyclopaedias using the existing languages of art history or criticism, feminists have had to move both against ignorance and towards new formulations that would allow us to see and understand what we had recovered in ways that do not merely reconfirm the other status, the negative value, the secondary character of a group that by being named is disqualified from being representatives of humanity as whole. Art is merely art, women's art is only that.

But there is another level of difficulty. We are the products of this culture. Our intellects as much as our emotions have been trained within its imaginative and cognitive limits. Would we as women be able to see or understand any more readily? What we are is fashioned within existing ideologies of femininity and our imaginations thrill to implanted plots. To claim that we could will ourselves to be different would be to assume that the term 'women' has a given, substantive meaning or that by virtue of anatomy or psychology we are automatically outside our culture in full self-possession and self-consciousness. That is impossible to conceive in the current theoretical climate of recognition of both the human subject as formed in language and divided from knowledge of itself through the unconscious.

Feminist theory has worried any such claim to self-evidence for the word 'women', challenging us to deal with the contradiction that is at the heart of feminism. We organize, campaign and the-

orize in the name of a collectivity, women, that must by those activities dissolve before our intellectually and politically acute analysis: every woman is the complex product of her specific historical and cultural framing: generations and geographies. There is neither Woman nor women. Everyone has a specific story, a particular experience of the configurations of class, race, gender, sexuality, family, country, displacement, alliance . . . the list is not limitless but it reflects the serious business of our social and imaginative realities. Those stories are mediated by the forms of representation available in the culture. So instead of a metaphor of women being outside patriarchal culture, we contend with a problem of being formed within it as an kind of internal exile: we live in a culture whose languages do not imagine a specificity for that which is not the One. That is what is meant when we talk of patriarchal or rather phallocentric culture. 'Woman' is a term in a system of meanings that denies the possibility of its signifying anything about those who are designated by it as women, other than their not-being.

I would argue that art made by women is different – but not in ways which we can easily recognize or understand. But difference does not just mean being 'different from. . .' – whatever we put in that space would thus be the norm. Its difference is not singular enough to allow the constitution of a new curatorial category. Its differences are as vivid between women of diverse historical moments and cultural locations: the difference is part of the calculation of how sexual difference – differentiation on the axis of sex – articulates with other imperatives and burdens. The artistic practices of women require deciphering, like monuments from lost or unfamiliar cultures. There is some system to the patterning of signs into meanings. We need, however, to find the codes that lend the symbols generated there resonance and meaning, both within the context of their production and across time and space to other contexts. These codes, as I name them, are not merely semiotic signs, but those shaped in concrete social and historical conditions, which in turn shape and are shaped by the psychic life of individuals framed and formed in specific trajectories of socially constituted but psychically lived subjectivity.

This collection of essays represents an enterprise undertaken from diverse cultural and social experiences. They address a range of artistic practices equally incommensurate. They do not add up to a view on feminist art or even art by feminists. They offer *feminist readings* of the complexities which are women's social situations, and imaginative and intellectual aesthetic interrogations of them. These differ one from the other. It is clear, in the mid-1990s, that the organizing unities of feminism, women, theory and so forth, which helped us to locate a point of dissidence and critical difference from official knowledge and established social forms, have themselves to be politically fractured. Feminism stands here for a political commitment to women and to changes that women desire for themselves and for the world. Feminism stands for a commitment to the full appreciation of what women inscribe, articulate, voice and image in cultural forms: interventions in the fields of meaning and identity from the place called 'woman' or the 'feminine'. Feminism also refers to a theoretical revolution in the ways in which terms such as art, culture, woman, subjectivity, politics and so forth are understood. But feminism does not imply a united field of theory, political position, or perspective. Feminism has been identified with a women's movement and it is important historically that it should be so; but at this moment, its autonomy as the place in which the question of gender is posed acquires a particular political and theoretical significance.

Feminist readings are made from the spaces of politicized and theorized feminist subjectivities and social positions. These are necessarily plural. For while the renewed feminist impulse began with a desire for affirmation and solidarity signified by the notion of sisterhood, contemporary feminism is acutely aware of conflicts, diversity and resulting tensions between the political alliances signified by feminism and the real divergences and distances between the socially constituted women who make up the movement. The stage of having to declare that 'I read as a . . . (name one's class, nationality, religion, culture, sexual orientation in any combination)' has consolidated into an

awareness that these positionings, far from being superficial bureaucratic self-labelling, are both the conditions and the restraints under which any one of us makes art or writes. Thus this collection is a collection not an anthology. There are many positions, interests, desires at work: they are acknowledged in the title. *Generations and Geographies in the Visual Arts: Feminist Readings* alerts us to cultural and historical specificities across the axes of location and time.

The project stems from my own concern to find other ways to write histories and study the historical trajectories of women's practices than those offered by art history's teleological narratives or art criticism's musealized categories. Both converge on a series of '-isms', defined by style, tendency, moment and crowned by a representative, if possible genius, figure. Feminist interventions in the field quartered by art history, art criticism, the museum and the publishing house require us to erase many of the boundaries between these domains while establishing other paradigms for analysis of the practices that these four discourses curate and categorize.

There are collections of essays in feminist art history and anthologies of feminist criticism. This collection includes a historical range, although there is certainly an underlying unity in the concern with art practices of the twentieth century and those of this very moment. But these are not framed as early modernism, mid-century conceptualism, contemporary body art, figurative painting or abstract sculpture, or postmodern land art. The only larger framework I might propose would be something like femininity, modernity and representation. The essays are grouped around issues, themes, debates. The topics derive first from the actual study of those things about which women have made their art and second from the way in which feminist theory and feminist history have attuned us to notice what is important to women and for them: motherhood, sexuality, location, memory and trauma, hysteria and death, and critical and theoretical ways of understanding the process of subjectivity, ideology and the production of meaning. If the project of analysis is reframed as *feminist readings*, I would define that which we are trying to read as *inscriptions in the feminine*. I use the term that might seem to privilege writing over the visuality of visual arts advisedly. It invokes the idea of mark-making as well as making your mark, of registration (*einschreiben* in German is what is done to alien immigrants, and registration in French is also a form of bureaucratic recording) and monumentalization (in the sense of graven tablets and other memorials). I use it to avoid all the fallacies of expressionism and intentionalism associated with notions of self-conscious authorship. Of course, I believe that there are producers of art works, highly intelligent and self-critical practitioners who devise their strategies and respond to their own personal, political and aesthetic promptings. But according to one major twentieth-century theory, that of psychoanalysis, we are not fully known or even knowable to ourselves. Split between conscious and unconscious levels, structured by histories and the desire they foster that culture and language repress, what we make, paint, write or film is only partially framed by our own purposes and known tactics. 'Inscriptions' brings us closer to a kind of analytical reading of symptoms – pressures and signs from the other scene, the other registers of meaning, the scripts of desire.

In the feminine, not *of* the feminine, denies both an expressive and a purely possessive relationship between producer and product. I use the phrase to suggest that we are positioned by language, by culture, by the process of becoming a sexed subject. The feminine does not refer to the essence of Woman of which the perfume advertising industry dreams. In current feminist theory – so different from the the early 1970s when 'the feminine', as in Betty Friedan's phrase, 'the feminine mystique', was precisely what feminism opposed – 'the feminine' is a linguistic or a psychic position; it might signify a philosophical possibility: alterity, difference, excess. From structuralist linguistics the feminine comes to stand as a relative term whose meanings relate and defer to others in the chain of signifiers that mark the world in order that it be intelligible to us. The feminine means nothing in and of itself, but marks the place of difference in a hierarchy whose dominant term is still currently the masculine. In Lacanian psychoanalytical terms, these linguistic positions

acquire yet other dimensions through the intimacies with the constitution of sexed, as well as speaking, subjectivity. In this case, the feminine is other (not the big Other through which all subjectivity is constituted), at once a negative term to the Phallus around which phallocentric meaning and subjectivity is organized, and a 'beyond' within that system that cannot be defined. It can only be gestured at through oddities such as Woman, Other, Thing, Jouissance and so forth. Then there are feminist theories, moving through such negative theorizations to dare to propose the feminine as a sphere, a domain, a possibility of meaning, which while being as yet unavailable to women for lack of a means of signifying it, none the less is necessary for our survival and redemption from the madness, the hysteria, the muteness, the abuse, the violence, to which phallocentricism condemns those it names woman.

Part of the feminist project of reading inscriptions in the feminine is to suggest that artistic practices can be a kind of semiotic interruption, a renovation, a revolution even, that draws upon the negativity[3] of the feminine – its alterity and place as the repressed of phallocentricism – in order to create new possibilities for meaning and the alignments of subjectivity and sexual difference.

Does this move into an arcane theoretical language about subjectivity, semiotics and *jouissance* signify a retreat from politics, from the more obvious kinds of social commitments that seem so much more evident in notions of expressive art-making, communication, consciousness-raising and so forth? I don't think so. We have always had to walk the tightrope between the women's movement as social revolution and the necessary conditions of revolutionary thinking and analysis which sustain and challenge the former. And further, there has been another thin line between functionalizing art and aestheticizing politics.

This project remains within a frame of feminist commitment to radical social and intellectual change. But that commitment is to be regularly re-examined through the prism of history – *generation* – and location – *geography*. In July 1995, the Feminist Arts and Histories Network organized its second biennial anti-conference using the title of this book as its theme. Its rationale was related to this project. There seemed a need to create a space in which the practices of art and the discourses of response and analysis which art invites can be addressed in clear contradiction to the increasingly administered forms of art production and art consumption that have turned the art world into just another a commodity market. There are clear axes between metropolitan centres, institutions, curators, critics, journals, dealers and the condition of contemporary culture as high art fashion-mongering. There are many women being incorporated into this world, many careers being made and much interesting debate. But there are other worlds, other pathways, and other models which achieve no comparable visibility and are simply marginalized because they are not rich enough to belong to the business and because the lines of connection that would lend disparate practices a kind of genealogical relation to each other have yet to be forged by analytic thought and committed response to these generationally and geographically dispersed artistic practices.

The Feminist Arts and Histories Network is about inventing a critical space and mirror for another kind of discourse and another set of social and symbolic relations between artistic practices and their analysis. Forming a connection between sites of art training, historical study, critical theory and artistic practice as an exchange between equals, the project is to generate ways of addressing art practices that are both attentive as art history has tried but often failed to be to the work and animated by theoretical and cultural understanding that has often become too remote from the particularity of practices.

The theme of generations and geographies invites a way of addressing art that explodes the large collectivities of feminism: art, theory, practice, history, and the heavily overcoded and inadequately specified unities of class, race, gender, sexuality. These are too broad, too inelastic to deal with the specificity of actual practices even though our approach to them must be informed by the con-

cerns to which such terms alerts us. Gone are the days of 'gender and . . .'; issues of 'race and . . .'. Instead the practices of specific women are the starting point for a polyvocal debate that reveals the significance attached to each person's specific history and relation to histories, each person's location and relation to cultural and social geographies through diaspora, displacement, revolution, war, migration and so forth.

This collection is not the product of evenly constituted academic discourses. Length varies, as do form, intent and the nature of the project. The aim is to mark a kind of space in the writing about the visual arts that is not art history, not art criticism, not curated meaning and not theoretical appropriation. The writers are artists, historians, curators, self-employed, graduate students, teachers, theorists, workers – in varying proportions. The unity lies only at the level of the project to elaborate critically the specific import of particular practices. The groupings formed out of the selection; the themes did not shape the choice in advance. In the centre is a specially commissioned work of art by Lubaina Himid, which, addressing the thematic of the collection, marks the place of art itself as the site for the production of its particular forms of understanding and critical reflection.

At the end of this century, we have lived through a quarter of it actively re-engaging with the unfinished business of the 'woman question' which was posed so vividly by the generation of 1928 (a European model is being used here and may be adjusted to deal with the different moments for different cultures which I suspect all have a symbolic date around which issues of modernity and femininity congealed as a political and an aesthetic conjunction) and resumed by the generation of 1968. Between lay the horrors of fascism, imperial wars and the rise of totalitarianism in its many guises. These disrupted the specific moves towards a radical modernization of sexual difference just as the re-emergence of such dangers at the end of our century jeopardizes the revitalization of feminism that began after 1968. Our moment requires vigilance and resistance. Feminism is not remote from this serious political and symbolic stage; nor is feminist theory. Certainly art – aesthetic practices as Julia Kristeva calls them – is vital to whatever we are witnessing and whatever we might allow ourselves to imagine in contrast to the packaging of meaning and fabricating of subjectivities that form billion-dollar industries from cinemas to computer games. Art acquires a particular significance in this new historical configuration. Artistic practices are a form of witness, a testimony of survival, a promise of imaginative projection as well as the commitment to honest appraisal, to stories that must be told.

The art discussed in this collection deals with serious matters based on the histories of women in the twentieth century and the diverse spaces and places of those lived histories. It marks the beginning of an attempt to ensure that such artistic practices are written about through the prism of a fissured and self-critical feminism that insists that the 'feminine' – the alterity and dissidence of what has been denied, negated, erased and refused – is a political issue of our times. The artistic practices which give it form through the specific articulations of particular practices produced in time and place are an important site for a critical self-knowledge about our late twentieth-century world.

The collection opens with a series of chapters about writing about art. Functioning as reviews of debates within the feminist community about the interpretation of the visual arts as well as specific contributions to theoretical elaboration of such practices, these essays break the mould of theory versus art, but equally they question the usual stand-off between word and image, commentary and object. What is the object of analysis? A thing, and if it is a text, does the text have to be self-advertising as art? What is it to read art or to see imaginatively into theory? What kinds of discourses and practices constitute the domain of the effect we call art – what of gossip?

The following four chapters are grouped around an overpopular and undertheorized trope: the body. Three of the chapters are written by artists. They range between an art-historical study of

the key image of female corporeality in art, the so-called Pudica pose initiated by the *Knidian Venus*, and a study of the issues of class, representation and painting which links the photographic work of Jo Spence to the paintings of Jenny Saville and Dorothea Tanning, and the work of a French performance artist, Orlan, who uses surgical intervention to question the integrity of the body and the image for women, and finally to a study of 'anorexic' installations by women in Canada in relation to the structures of funding. Intending no continuity, but finding an insistence around the space of the body which is then explored through the specificities of each practice, the term becomes an incitement to analysis, not a holdall for postmodern fashion.

The central section of the book is given over to Lubaina Himid, an artist born in Zanzibar, now living in Britain. A composition in words and images, stories and memories, it is entitled *The Beach House*, and it produces a kind of traveller's tale that crosses generations and geographies with an autobiographical discovery of history.

The next section takes on the maternal in work that is located historically at the beginning of the century in Europe and in the mid-century in Korea. A section on Land explores questions of identity and displacement in ways which challenge the political and ideological freight of landscape art and the ways in which women artists using myths associated with landed peoples have been misappropriated. The artists in this section, who each belong to their own individual political diaspora and thus to modernity itself, form a bridge to the final section, History *(memory, pain)*, in which the implications of the horrors of the Second World War are explored from different perspectives. A Japanese artist responds to the role of women from Japan in the exploitation and abuse of women from Korea by the Japanese military and an Israeli artist works through the burden of the Holocaust to provide a new theoretical future in which the question of strangers, femininity and difference may be otherwise configured.

The final ambition of this collection is to bring a wider readership to a new kind of critical writing on artistic work that may allow us to recognize a new way of relating to artistic practices. The artists we discuss can also find their places within existing art institutions, narratives of art history, curators' catalogues and cabinets. But beyond what those systems allow us to see, beyond what mainstream discourses make visible, is what feminists are reading for: inscriptions in the feminine, from the feminine, in which the feminine signifies neither an already known essence, nor merely an enigma, mystery, otherness. The feminine comes to stand for an ethical, political, aesthetic dissidence that we want to allow to emerge into the social and cultural systems of meanings so that it can really make a difference through what it reveals of other possibilities, other affects, other aspirations, other understandings, other desires, other forms of ambivalence and conflict.

Feminism is no longer, if it ever was, a campaign for mere equality. The very phrase means that we would only be endorsing what already is, what is the norm, white, masculinist, colonial, capitalist Feminism in the 1990s, because of both the work of artists and the work of theorists, is now in a transformed relationship to what we call femininity: to the very possibilities of different relations to the world, alignments between subjects. These may come to be made because of the specificities of the historical formations of the subjects formed 'in the feminine'. We are differentially placed by generation and geography, by history and location, in our encounters with the body, the mother, the land, and history, as well as with our means of thought: theories. Neither art history nor criticism, this book invites a different approach to reading for inscriptions in the feminine in the spaces of the body, the land, the psyche, the archive. All that remains is to thank all the contributors for agreeing to be part of the project.

Notes

1 Julia Kristeva, 'A New Type of Intellectual: The Dissident' (*Tel Quel* 1977, pp. 3–8), reprinted trans. Sean Hand, in *The Kristeva Reader*, ed. Toril Moi, Oxford, Basil Blackwell, 1987, 299–300.

2 Cathérine Clément, *Opera, or the Undoing of Women*, trans. Betsy Wing, London, Virago Press, 1989; Elizabeth Bronfen, *Over Her Dead Body: Death, Femininity and the Aesthetic*, Manchester, University Press, 1992.

3 Used here in a Hegelian sense to mean that which is the antithesis to a given situation out of whose difference new things can be produced. It does not mean negative as a pejorative or absent quality.

PART I

Stagesetting

Chapter One

The politics of theory:

generations and geographies in feminist theory and the histories of art histories[1]

Griselda Pollock

I am the Director of a graduate programme I devised in 1991. Titled 'Master of Arts (MA) in Feminist Historical, Theoretical and Critical Studies in the Visual Arts', its name registers the complex and expanded character of feminist interventions in the study of the visual arts, past and present, including changes in art history, art theory, art criticism and art practice wrought by a range of theoretical and political initiatives. For brevity, it is known as Feminism and the Visual Arts, a phrasing which sets in direct confrontation a tradition of theoretical reflection and social activism by women – feminism, with the theory, history and practices of visual culture. This already breaks the traditional boundaries of art history which segregate that art history from criticism, distancing art history from the production of living culture and thus disavows its own investments in the writing of history. The speciality of the course is the attempt to bring together, in one space, feminist cultural and historiographical theory, studies in the histories of women's work in the visual arts, analyses and practices of contemporary art by women. Thus the course attracts students who are or are aiming to be artists, curators, critics, art historians, as well as women from related disciplines interested in a dedicated study of feminism and cultural theory. It refuses to observe the frontiers between art history and contemporary art practice, between academic theory and the visual arts.

Devising this 'dedicated' feminist course seemed a logical extension of my own work 'as a feminist' and I was convinced that I could no longer offer feminist theory or studies in art and art history as an optional extra on courses framed by other theoretical projects. Feminism's own history and internal complexity as theory and practice demanded its own conceptual and academic space. Until 1991, my work had been housed within the broader project of The Social History of Art, within which feminist concerns were a permitted but theoretically underdeveloped subset, often swamped by both the dominance of a materialist paradigm whose main axis of power is class, and by the indifference of the social historian of art to questions of gender and of sexuality. I did not wish to forgo the relevance of a materialist critique for feminist work in art history.[1, 2] But few social historians of art allow feminist analysis to sully the purity of a class-based analysis, which thereby reveals its repressive masculinism.

In the practice of feminist studies, I have been as eclectic as necessary, feminist theory being of necessity a form of bricolage which does not, therefore, show feminism to lack a centre, a core, but rather demonstrates how comprehensive is its theoretical and political vision. It is a common misunderstanding that feminism is a perspective or approach which prioritizes gender over all other structures of oppression. Feminism is not for gender what Marxism is for class, and postcolonial theory for race. First, there is a range of feminisms, in varying alliances with all the analyses of what

oppresses women. Socialist feminism has always concerned itself with matters of class, and black feminism details the configurations of imperialism, sexuality, femininity and racism. In their breadth, as the plural, feminisms deal with the complex and textured configurations of power around race, class, sexuality, age, physical ability and so forth, but they have of necessity also to be the particular political and theoretical space that names and anatomizes sexual difference as an axis of power operating with a specificity that neither gives it priority, exclusivity or predominance over any other nor allows it to be conceptually isolated from the textures of social power and resistance that constitute the social. Feminism has had to fight long and hard to win acknowledgement of the organizing centrality of sexual difference with its effects of gender and sexuality as one of planes of social and subjective constitution.

For many years I have taught from an avowedly feminist position. I have written and researched in ways that reveal my commitment to a feminist politics of knowledge. But now, on this course, I was no longer merely teaching 'as a feminist'. I had to make feminism itself a teaching object. Thus I had to map the various traditions and debates which constitute feminist theories of culture, history and art to produce a pedagogically and intellectually coherent scheme of study. There is a politics in this theoretical project. I had to produce a feminist approach to feminism itself.[3]

I started my first class by asking a simple question: Why are you here? What has brought you to this course/classroom? I collected a range of responses which proved very revealing. One student, auditing the seminar, stated that she had not signed up for the course because she feared the stigma attached to doing an MA in feminist studies. It is a real question given the institutional categories and disciplinary forms by which prospective employment will be achieved. Another said she wasn't a feminist but felt that there was a lot in feminist theory which was relevant to social studies in the history of art. Between these two positions were those of the fully engaged, often older women, whose experience as mothers or in employment had brought them often painfully face to face with the concrete effects of contradictions which shape women's lives in the classed, raced and gendered structures of western society. For these women, feminism is a practice, the means to make sense of and survive life; it is not theoretical icing on an academic cake. For many of the younger women, it seemed that it was not overwhelming politics which brought them to the seminar room, but a sense that something interesting and important was taking place in something called feminist theory.

The term 'feminist theory' has a wide currency now. But what is it? Does it mean that there is a coherent perspective on all areas unified under the rubric feminism? We cannot really say that we now have feminist art history, feminist sociology, feminist legal studies, feminist cultural studies, as cohabitants of the main disciplinary formations. Isn't feminism more a matter of interventions which change each discipline and theoretical terrain because feminism introduces the repressed question of sex/gender?[4] Raising that question catapults us from the neatly ordered universe/university of intellectual knowledge with these clear disciplinary divisions into a field of practice. The feminist question – the question of feminism – brings down the dividing and loadbearing walls which compartmentalize academic knowledge to reveal the structure of sexual difference by which society and culture is riven, showing that all disciplines are impregnated with the ideological premises of a sex/gender system.[5]

Feminism as we know it today is, in part, the product of the historical moment in the 1950s/1960s which saw new political, social and cultural theories developed to deal better with the problems posed by late capitalism. The legacy of New Leftism and other political critiques deriving from civil rights movements, black power, anti-racist, anti-colonial struggles and student revolts gave new impetus to the study of ideological practices and cultural forms as being both privileged sites of *ideological* oppression and the place from which to mount *cultural* resistance.[6] At the theoretical level, New Leftism challenged the idea of culture as Culture – truth and beauty, the best ideas

and values of civilization – by proposing that culture is ordinary, a 'way of life', a 'way of struggle', the territory of social meanings and identities.[7] Such displacements of traditional categories of the political to include aspects of cultural practice, identity and custom were deeply sympathetic to a new feminist politics based on the slogan 'The personal is political'. But this culturalist approach was challenged by French structuralist and post-structuralist theorizations. These proposed a linguistic-philosophical paradigm, derived from Saussure's initial theory of semiotics. As a result, not only was theorization as an activity raised to new prominence but a creatively theoretical enterprise took off which has reshaped the humanities and the study of cultural practices. In its engagements with and mutual influence on this 'cultural revolution', the women's movement produced an ever growing theoretical wing : an instance of the women's movement which is known as feminist theory.[8] But that phrase defines practices and positions which are extremely heterogeneous precisely because feminism has unevenly registered the shifts within, and the changing theoretical paradigms of, culture, society, language and subjectivity, while functioning as an external, hence political critique of all of them.

Furthermore, the term 'feminist' functions as a perpetual provocation to women engaged in feminist scholarship, as much as to other scholars and theorists. Feminism demands that certain issues remain in view, and it functions as a resistance to any tendency to stabilize knowledge or theory around fictions of the generically human or the monolithically universal or any other androcentric, racist, sexist, or ageist myth of imperial western culture and its (often not so) radical discourses.

Thus I would assert that feminism signifies a set of positions, not an essence; a critical practice not a doxa; a dynamic and self-critical response and intervention not a platform. It is the precarious product of a paradox. Seeming to speak in the name of women, feminist analysis perpetually deconstructs the very term around which it is politically organized.[9] This paradox has shaped the history of the last twenty years of feminist practice, which can perhaps be characterized by the passage from essence (a strong sense of the identity of woman and the collectivity of women) to difference (a more anguished recognition not only of that which divides and undoes the collectivity women, but also of the structural condition of the term 'Woman' as an effect of psycho-symbolic systems which produce and differentiate subjectivities across the formations of class, race and sexuality). Yet there has been no linear progress from early thoughts to mature theories. Rather we have a synchronic configuration of debates within feminism, all of which have something valuable to contribute to the enlarging feminist enterprise. Yet they are all, none the less, caught up in the very systems of sexual difference they critique. The issue becomes one of how to make that paradox the condition of a radical practice.[10]

It does not surprise me, therefore, that after more than twenty years' involvement in the women's movement, I should find myself confronting, as a problem of theoretical definition, the question 'What is feminism?' This is very different from the more easily answered challenge, 'Are you a feminist?' The latter is a matter of personal affiliation; the former an issue of both historical knowledge and critical distance on my own as well as on a collective predicament. I was glad to turn to a collection of essays edited by eminent British feminists such as Juliet Mitchell and Ann Oakley also asking 'What Is Feminism?', a book which included a major article with this title by Rosalind Delmar.[11]

Delmar begins by pointing out how fractured and heterogeneous feminism – or what now coexists under that umbrella – has become. The representation of this variety of women's social and political initiatives as 'feminism' is itself a recent development, she argues. For the wave of activism which broke out in the late 1960s was intially known as the Women's [Liberation] Movement. In the gap between the two terms, Delmar questions any automatic identity between them although their interrelationship is a feature of contemporary feminism which has at times named itself the

'second wave', after the activism of nineteenth-century women's campaigns for the vote. That feminism can be separate from a women's movement is both a theoretical matter, which I shall discuss further below, and a matter of history. If the decade of the seventies produced feminism most commonly as campaigns and conferences, in the eighties feminism was housed more often in journals and academic courses.[12] The emergence of the seemingly free-floating term 'feminist theory' indicates this shift of emphasis. Delmar, however, counters the popular identification of feminism exclusively with social activism by arguing that feminism, historically, is a tradition of ideas about 'the woman question' which did not always coincide with politically organized struggles to change the social position of women. Feminism is an address to the philosophical question of sex/gender but it has a discontinuous history because the ways in which the question of sex/gender has been posed were shaped by the prevailing political/philosophical discourses available to women at different historical moments. Thus, in the eighteenth-century moment of revolution, the feminist question was articulated in an Enlightenment discourse on natural rights.[13] The ideological framework for mid-nineteenth-century suffrage campaigns, however much they claimed descent from eighteenth-century foremothers, in fact derived from then current bourgeois notions of property rights which inscribed hierarchies of class into arguments about women's right to the vote. Thus white bourgeois feminists did not necessarily concur with universal suffrage, but claimed, like their bourgeois brothers and fathers, the right to *represent* their working-class or black sisters.[14]

This argument requires us now to confront the ideological frameworks within which our own moment of an enlarged and internally challenged feminism has been formulated. Late twentieth-century feminism looks back for reinforcement to a historical tradition of women's campaigns and political struggles, while organizing itself quite differently. For instance, the language has changed. Liberation replaces emancipation, collectivism displaces individualism, radical political theories and sociologies lead to alliances with the left and anti-racist struggles and, far from focusing on traditionally defined political objectives, our feminisms have coined the new term, 'sexual politics' and the new slogan 'the personal is political'.

The renewed wave of feminisms at the end of this century is a response to the fact that such economic and political reforms as were achieved by the nineteneth-century campaigners did not really alter the deep structures of sexual divisions in society or shift the ideological and psychological structures that they sustained. A cultural revolution was called for which both derived from, and contributed to, the interest in the fields of the cultural, the ideological and the subjective which has characterized radical critical theory and cultural practice in the last thirty years. The key term that grasps the specifically feminist version of this larger discourse is 'the body'. Rosalind Delmar states: 'The pursuit of questions about the female body and its sexual needs has become distinctive of contemporary feminism.'[15] The new feminisms are, in significant ways, a politics of the body – in campaigns around health and the claims for female sexualities, the struggle against violence and assault as well as pornography, the issues of motherhood and of ageing. The new politics articulates the specificity of femininity in special relation to the problematic of the body, not as a biological entity, but as the psychically constructed image that provides a location for and imageries of the processes of the unconscious, for desire and fantasy. The body is a construction, a representation, a place where the marking of sexual difference is written, and it is because the body is a sign that it has been so invested in feminist politics as a site of our resistance. For this kind of feminist theory, the body is precisely a point of transaction between the social system and the subject, between what is classically presented as an intimate or private inside and a public or social outside. The semioticized body, as a figure of political speech and organization, erodes the distinction between that opposition, which has, up to this point, shaped the conception of the politics of liberation.

In the nineteenth century, bourgeois society made gender one of its major social divisions, and represented this as an absolute split between the public and the private, which was figured by rigidly

differentiated bodies, Man and Woman. This polarization incited bourgeois women, ideologically and practically confined to the 'inside', private, domestic sphere, to campaign to enter the public sphere (working-class women were already there and paying the price for their apparent transgression of the public/private gender division through both economic and sexual exploitation). Women demanded the right to be represented as part of the outside, the public sphere — as citizens, as consumers, as users of the public domain. Quite at odds with this position is the twentieth-century feminist slogan 'the personal is political', which insists that the so-called private is in fact already a public space. That is, it is not immune from the play of power. It is not a place of personal refuge but it can be a site of violence and exploitation that penetrate the most intimate pores of the body of the female subject. By that assertion, however, that the public and private spheres are mutually contaminated, feminism has effectively deconstructed the opposition to create the specific territory of its own political and theoretical project.

Let me come at this point from a different angle. The priority of the sexual body and the language of liberation are not unique to feminism. They are shared with a wide range of radical revolts which took place in the 1960s, amongst students as much as among those fighting against racism and colonialism. Generating the 1960s cultural revolutions of the West were important revisions to notions of the self, which fostered a politics of identity, and produced major shifts around notions of consumption and pleasure. The discourse of liberation was, however, posed in the terms of classic bourgeois political theory, namely the conflict between a self seeking liberation from *outside* social constraints, and an *inside*, a self suppressed and oppressed by the social outside. Post-structuralist and critical theory rejected such formulations in favour of arguments in which language, discourse and subjectivity become the key terms for recognizing the imbrication of the self and the social; the idea of the decentred, speaking subject puts the subject as the central effect of social systems identified with language itself. This subject is in fact both spoken and *subjectified* in social and symbolic systems. Language is then the territory in which both the social and the subject are fabricated. Against the power of the linguistic metaphor, however, and its tendency to collaborate with the social order, the insights of psychoanalysis have been used to undermine the status quo precisely by insisting that the decentred subject is in fact a divided or split subject, formed as both conscious and unconscious by the traumas of becoming a human subject in accession to language under a phallocentric law. Psychoanalysis as theory and institution, however, is troubled by femininity, which seems to destabilize the system created by a phallic law. For that very reason, psychoanalysis has been seized upon by feminists because, despite itself, it has offered a theorization of femininity as both always-already part of the social and symbolic systems, yet their perpetual transgressor.[16] Thus semiotics, post-structuralism and psychoanalysis can be shown to have a historic as well as a theoretical connection to feminism because they all involve a challenge to the hegemony of bourgeois politics (i.e. ideas of the autonomous self, a self defined by the public/private split, who is a presumed bourgeois and masculine self), within whose frameworks current feminist questions can no longer be posed. Feminist theory, which often refers to the formulation of questions of sex/gender in the light of these three analytical paradigms, is then to be understood as politically incompatible with those contemporary forms of feminist thought and practice which still inhabit the nineteenth-century, bourgeois problematic of equal rights, which in fact not only suppresses questions of class and race power, but in crucial ways, through the repression of any notion of subjectivity, defaults on the fundamental question for feminism, that of sexual difference.

The combination of semiotics and psychoanalysis, which Julia Kristeva formulated as *semanalyse* is based on a rejection of both the Cartesian legacy of a self who is outside language/society by virtue of a sovereign consciousness and the Marxist tradition of a subject so indelibly social as to be completely determined in its [false] consciousness by structural forces such as social relations

and economic conditions. For Kristeva, the heterogeneous formation of the split human subject in language fissured by the unconscious, a historical and speaking subject with a body, creates the conditions of both the forces of constraint in the social order and those which destabilize the symbolic order by transgressing it in order to renew or to change it. In the essay which most cryptically states this case, Kristeva, however, remains indifferent to the issue of gender and subjectivity. [17] A highly disembodied notion of masculinity and femininity as defining modes of language, rather than as descriptions of men or women, informs much of her writing until her essay of 1979, 'Women's Time', in which she too ponders the history of feminism and its varied enunciations of and on femininity. The historical difference Delmar identified between feminist intellectual history and that of women's movements Kristeva recasts through the allegory of generations. [18] Her use of the idea of time has important repercussions for us all, but notably those involved in that peculiar practice of producing historical studies of culture, art history.

Kristeva begins her essay with an analysis of the modes of time which feminists both inherit and modify. There is linear, cursive, historical time, the time of nations and their histories, the time of politics and rights. Kristeva names a first generation of feminists originating in the nineteenth century but still active in contemporary equal-rights feminism whose object is to join in with this time of the nation. Their ambition to enter the public (*outside*) domain as political subjects and to improve the social and economic lot of women, Kristeva defines as a desire to enter *linear* time, the time of history. It is part of a logic of identification, a desire to be, if not the same as empowered men, then, at least, treated as equal within the hegemonic definitions of power currently enjoyed by privileged men.

On the other hand, there is what Kristeva calls *monumental* time, a temporality more closely associated with what might be deemed specific to women: the time of the body, of cycles, recurrences and the very long *durée* of women's relation to reproduction and its representations. In our period, we can identify a post-1968 generation of feminists who rejected the politics of political ambition, identification with and entry into the public realm and its historico-national time and who turned instead to the specificity of female psychology and the imaginary and symbolic representations of the corporality and sexuality of women, seeking 'to give a language to the intersubjective and corporeal experiences left mute by culture in the past'. [19] Kristeva is no doubt thinking of authors and writers such as Monique Wittig, Annie Leclerc, Hélène Cixous. What is defined as specifically new to this form of feminism are hitherto neglected sites for radical – or reformulated – ideas of 'political' practice, namely culture, writing as the point of creation of a representation for the feminine psyche and the female, the lesbian and the maternal body.

Going beyond the general histories of feminism, can we not also read the dilemmas of feminist art history in this model of generational conflict and temporal difference in feminism? Feminist art historians desire to reintroduce forgotten women artists into an art historical record which is linear and nationalistic in its formations (French School, American Art, German culture, etc.) and discursive modes (development of western civilization, style, periodization etc.). We try to endow women artists with the canonized artistic subjecthood enjoyed by some men, using a logic of identification to try and render women artists, if not the same as men, at least equal in terms of recognition and respect. Yet the meanings of works produced by women will only become vivid to us when we can articulate what is particular to them, what makes them different from the existing norms, and when we define signifying temporalities quite other than those of styles, movements, avant-garde innovations and so forth. We are searching for ways to acknowledge the 'spaces of femininity' and its subjective temporalities in the rhythms of women's lived experience within and against the hierarchies of sexual difference as that is configured in complex social formations of class, race and sexuality. Can we adequately enunciate the specificity of varied feminine inscriptions in all cultures in terms of art history's prevailing linear discourse on history? I don't think so.

Yet to stress women's specificities outside the terms of some form of historical time and its current discursive enunciations is to risk our continued fixation on the margins as mere ciphers of an ahistorical, or essential, 'difference'. Thus we must follow Kristeva through to her dialectical resolution in order to discover the basis of a *feminist* practice of feminist art history.

Despite being entitled 'Women's Time', and using the generational metaphor, Kristeva's concluding section shifts from the temporalities of femininity and feminism to reconceptualize both in terms of *space*.

> My usage of the word 'generation' implies less a chronology than a *signifying space*, a both corporeal and desiring mental space. So it can be argued that as of now a third attitude is possible, thus a third generation, which does not exclude – quite to the contrary – the parallel existence of all three in the same historical time, or even that they be interwoven one with the other. [20]

Leaving aside for the moment Kristeva's third space at its own theoretical level, I would like to play for a while with the metaphors of time and space as ways of understanding the feminisms of which we are a part and which we embody in our heterogeneous practices 'as feminists'. What is specific to Kristeva's formulation of space is that it is semiotic. It is inscribed with meanings and is also the site of the production of meanings that transgress existing social and symbolic orders. Feminism is not just a discontinuous history of ideas or cultural expressions on the one hand, or a history of movements and campaigns for social change on the other. Feminism can be reconceived as a signifying space, the space in which, through a feminist imperative, we both negate existing orders of phallocentric meaning, and in struggle with representation, generate critical, even new, meanings. Since the subject is in a sense the effect of the meanings a culture, its symbolic order, allows to be signified, the battle for meaning is also a struggle for kinds of subjectivity. As women, we are derelict, or in exile, in a symbolic order that does not signify us except as a sign of its own, phallocentric meanings. Thus to call feminism a signifying space is not to retreat from politics, but to lodge them at a different level that might be able to articulate the crucial relations between subjectivity and sociality which is a critical axis of contemporary power.

Feminism re-emerged as part of the signifying spaces created since 1968 which have shaped new notions of the self, gender, sexual difference, as well as creativity, art and representation. Kristeva introduces into political discourse the notion of modes of production as signifying the temporalities of productive relations, while there are also, discontinuous with them, temporalities of signification and of the subject, and hence of sexual difference. Thus sex/gender is not ahistorical, apolitical, or merely private. But it can only be historically and theoretically thought about by acknowledging its specific temporalities, and the terrain on which it most formatively functions – language and sexed subjectivity.

From this apparently disconnected discussion of Kristevan and related theories, I want to derive an important conclusion for preparing the course on Feminism and the Visual Arts. Such a course could not begin by uncritically narrating a history of ideas or of events and campaigns or artists and movements. It is necessary to start by mapping the historically specific and varying enunciations of feminism as elements of spaces and temporalities of sexual difference. Cartography is known, of course, as a major instrument for the production of interested knowledge through its relative projections of space and the inscription of perspective. The world is always mapped from a position of (attempted) mastery.[21] A mapping of feminist theory appears already to exist with its own concrete geography. There are traditions of American feminism quite distinct from those in France, Scandinavia, Germany, Italy, Japan, Chile and Britain. Political and theoretical conflicts are represented in feminist literature as national differences. There is, however, a North Atlantic hegemony – a question of influential European languages. French and Anglophone feminism have become more internationalized than Scandinavian or German tendencies. In her article, 'Feminism,

Postmodernism and Style: Recent Feminist Criticism in the US', Toril Moi responded to criticism of her book *Sexual/Textual Politics* (1985) for its apparent omission of a specifically transatlantic tendency in American feminist criticism which orients itself towards French post-structuralism. She coins the phrase 'Atlantic post-feminism' to define the in-between state of writers such as Alice Jardine, who, in her book *Gynesis: Configurations of Woman and Modernity* (1985), seems to hover above the Atlantic, looking towards France and speaking to America. The apparent ease with which we can map such a geography for contemporary feminist theories hides more fundamental conflicts than the appropriate national or intra-national location of theoretical tendencies. The danger, argues Moi, is that feminisms will reduce to a question of style – with feminist theory turning the political insights about language and subjectivity into a debate about styles of writing and self-presentation. Toril Moi wants, rightly, to insist that feminism poses instead the question of the *politics* of theory. Of her own position, as a Scandinavian feminist, with strong connections to a British socialist feminism, Toril Moi writes: 'In general I would characterise my project, both here and in *Sexual/Textual Politics,* as an effort to argue for a *politicised* understanding of feminism as opposed to a *depoliticised* one.'[22] In the conclusion to her article, writing about another mid-Atlantic post-feminist, Jane Gallop, who most vividly reduces the content of feminism to a matter of style, Toril Moi states:

> Jane Gallop is right to claim that to take up a style is to take up a position, but she is wrong to recommend a single stylistic move as uniquely feminist, just as she is wrong to assume that style can be analysed without regard to content and the specific historical space where it makes its intervention. I have already argued that to take up a political position is to risk being wrong. In the same way we may find ourselves lumbered with the wrong style in the wrong place. The risks of style are also the risks of political commitment.[23]

Theoretical developments within the contemporary moment of feminist intellectual history, therefore, have to be screened and examined for their political effects. The choice of argument or theory is not just a matter of varying styles of art history, for they will have political effects whether or not they are intended or recognized. Feminist art history is thus susceptible to a similar critique to that mounted by Toril Moi of literary criticism. I could put it thus: not everything that feminists undertake is automatically feminist – if we understand feminism as interventions in signifying practices which are politically effective in a situation in which feminism itself has altered the very definition of the political away from accession to public rights towards understanding of the conditions and effects of our formation as sexed, speaking subjects.

This general discussion leads back to my own dilemma in formulating an academic course on feminism and the visual arts. Not for the purpose of confession or egotistic self-advancement, I would like to introduce some biographical information as index of my own recognition of being the product of historical processes and conditions. As academic and feminist, I was formed by the late 1960s reconfiguration of feminism as the Women's Liberation Movement. I became involved in feminism slowly and interruptedly. At the age of fourteen, I read Betty Friedan's *Feminine Mystique* (1962) when my father brought it back from a business trip abroad, thinking it a suitable manual for a young girl about to enter the mysteries of femininity. I was enthralled by this early feminist text. Despite my having not yet been caught in the traps Friedan so movingly exposed, I could identify with the horrors of the feminine mystique through my recently deceased mother, who had been thus 'wasted', in contrast to some of her friends, who had fought to go to university in the 1930s and to have professional careers but had been obliged to forgo marriage and children because of the complete prohibition on married women working in their chosen careers, teaching. Their generation was a sort of link in a chain back to the nineteenth-century suffrage feminists. At university myself in the late 1960s, I was quickly and negatively identified as a feminist, because of my intellectual interests and my refusal to sabotage my intelligence in pursuit of a man of my own. Intellect and femininity were not compatible on the scale of social or sexual

success. I therefore tried hard for a while not to be a 'feminist'. But in 1970, the students at my university, inspired by the events of 1968, organized an occupation of the administration and this was the first major political action in which I became involved. It coincided with the first Women's Liberation conference in Britain, on the theme of history, significantly, held at Ruskin College, Oxford, in March 1970.[24] Women from the conference came to lend solidarity to our occupation. I remember how I looked out at these 'women's libbers' with mixed feelings, having buried my interests in Friedan and de Beauvoir and read sensational newspaper articles about Valerie Solanas and women burning their bras. When I left university that summer, however, I decided to seek out a women's group – itself a novel phenomenon, an informal network of local groups co-ordinated through one office and a London magazine. The women's movement offered an authenticity to my politics as a radical but middle-class woman. I could act and speak in my own voice, seeking alliances and links through varying yet also common experiences of oppression. This was clearly a movement of bourgeois, white, equal-rights feminism, disguised in the new languages of consciousness-raising and identity politics. The legacy of an earlier movement of suffrage politics remained strong in the group I joined, which decided to take on the state and campaign for equal rights legislation. Public meetings were organized, women's groups lobbied, and a women's newspaper founded and edited. All this took place while I went to study art history at the Courtauld Institute of Art, in protest against using a good education as a secretary in publishing or in market research – the career options I was advised to adopt.

I was in a group of highly motivated students and one week we had a slide test which we all passed with nine correct answers out of ten. One image defeated us. We could date it, define it as a post-Impressionist work produced in Paris, etc., etc. We were completely unable to name its author, Suzanne Valadon, because it never occurred to us to search our extensive art-historical databases for a woman's name. The shock, not only of my academically condoned ignorance of women as artists, but of the impossibility, within the existing framework of art history of imagining women as artists, led me to invite Linda Nochlin to speak at the Courtauld Institute in 1973. It was the first feminist lecture ever given there, the first time women artists were named and considered seriously. As a result I recognized there was a politics to be engaged with, in this my 'private' professional area as well as in the typically public spheres of Parliament and the media. Coincident with this event was the attempted prosecution in London for obscenity of the Swedish artist Monica Sjoo, for the exhibition of her painting, *God Giving Birth*.[25] A public meeting was organized and as a result a new group formed, the Women's Art History Collective. A typically feminist group of that date, an informal auto-didactic collective, we affiliated with the Women's Workshop of the Artists' Union, to locate ourselves not as a professional pressure group but as part of a political and social movement, in which women organizing for themselves, none the less, saw themselves in alliance with other radical movments in and beyond the arts. Significantly, artists were organizing politically and art was being recognized as politically involved institutionally, economically and ideologically.

Across these various spaces – the stronghold of academic art history, the informal meetings of the Collective in someone's front room, the visitors' balcony of the Houses of Parliament – I began to forge a practice, not *in* art history, but *on* art history from within the signifying space of the women's movement. Long before we systematically read the work of Michel Foucault, many women recognized that knowledge was an intimate associate of power. Art History as a form of knowledge is also an articulation of power. What it says and what it disallows affects many living artists who are negated simply because they are women, a term art history has made antagonistic to that of artist. My project on art history was then to write histories of and for the present; to write in the real as well as symbolic presence of female people, who, living under the sign Woman, in a phallocentric culture, suffer the real and material injuries of class and race through the configurations

of gender. The theoretical journeys that I have undertaken have a constant point of reference. They are tested against political questions and priorities: why is it important to undertake this research, this paper, this book, in terms of the present configurations of power? In this way I refuse one of Art History's key divisions by which it polices the boundaries between the past and present. Art History argues that the distance of time alone validates historical enquiry. 'The only good artist is a dead man.' The present, argues Art History, is too close and cannot be objectively assessed. I would argue that all history writing is formed in the present. The politics of historiographical practice belongs to the ideological moments of its own production. Furthermore, it is vital to show that the present is historically shaped. Sexual difference and sexual divisions in society are not natural but historical and that is why they can be challenged and changed. The past as Tradition – in Art History it becomes the Canon – is used to justify the present status quo. Validated by time, the canons of great art brook no discussion or serious reconsideration. Feminist interventions have to disrupt canonicity and tradition by representing the past not as a flow or development, but as conflict, politics, struggles on the battlefield of representation for power in the structural relations we call class, gender and race.[26]

Over the last few years there have been many review essays and analyses of feminist activities on art, art criticism and art history. Mostly in feminist journals, these provide a valuable documentation of what are often scattered and disparate activities. But these are not just a matter of information. As representations of feminist art historical practice, they are themselves historical texts, shaped both theoretically and politically by their ideological position. In 1987 the prestigious American art history journal, *The Art Bulletin*, finally admitted feminism into the canon of art history by publishing in its series of reviews of the state of the discipline a review article by Thalia Gouma Peterson and Patricia Matthews on 'The Feminist Critique of Art and Art History'.[27] Their compendious study is invaluable as a bibliographic reference text. As well as being a valuable archive, the text significantly undertook to map out the main tendencies and debates in feminist art history and criticism since 1971.

I have to say that I like the essay, because it has a lot of nice things to say about British feminist art history and about my work in particular. I want, however, to read the article symptomatically for the problematic – the framework – within which it is produced. This is not a covert criticism, a means of disagreeing with the authors' conclusions. We need to debate our field, and respond to all projects, especially when their value as historical record must be qualified by acute awareness of their status as representation. The article in the *Art Bulletin* exhibits some correspondences with the texts of Toril Moi and Julia Kristeva, notably using both the generational metaphor and the idea of a geography for feminism. Yet the text becomes most uncomfortable when it has to name the political nature of the differences between the generations and the geographies. These terms fail to enlighten and become a means of flattening out, depoliticizing the struggles between feminisms within (and against) art history.

According to Thalia Gouma Peterson and Patricia Matthews, the geography of feminist art history spans the Atlantic. America versus Britain is the main axis of difference. There are also two generations of feminists with different theoretical positions and projects which traverse a symbolic ocean. The geographical and the generational divisions overlie each other, however, to produce the authors' concluding arguments about American foremothers and British daughters – a curious reversal of the Old World/New World division in which some white American women once called themselves 'Daughters of the Revolution'. Despite the dynastic approach, there is no real genealogy in the Foucauldian sense of excavating the conditions of discursive formations and the systematic dispersion of the objects of new discourses.

The generation gap seems political. The first, American, generation is presented as ultimately conservative, revisionist, celebratory and empirical in its scholarship. The second, British, genera-

tion is 'radical' (a euphemistic term), interventionist, and above all theoretical in its scholarship. The division between feminism as ideas and feminism as movement we have already encountered is thus relocated in both time and space: the founding American feminist art historians represent 'movement', while the younger feminist Brits represent 'theory'.

This division occurs because, I suggest, there is a profound confusion created by the frequent use of one term, 'methodology'. This recurs repeatedly in the later sections of the essay. Second-generation feminist art criticism exhibits 'a more consistently radical critique of traditional methodologies' (346); 'a debate concerning methodology has recently erupted in art-critical circles between these two groups' (347); 'contemporary art critics among the second generation bring a feminist perspective to their use of new Postmodern methodologies of poststructuralism, semiotics and psychoanalytic criticism' (349), and finally, 'just as with art-critical methodologies, so feminist art-historical methodologies differ according to one's ideological position which is itself often conditioned by nationality' (350). Both politics and theories disappear into the umbrella term 'methodology', which defines a procedure for doing the job of criticism or art history. The important questions about what frames or motivates the 'doing' are not asked. This is not to propose an opposition between theory and practice. There is no practice without an informing theory, even if it is not fully recognized or acknowledged, and theories are only realized in practices. Methodology only becomes apparent, that is different from the normalized procedures of the discipline, when a different set of questions is posed and demands new ways of being answered. Thus, until feminism emerged, along with social and materialist histories of art, methodology was not really a major issue for Art History. Art History was practised in the masters' schools – Panofksy and iconography, Wolfflin and formalism, and so forth. If I ask a question about women's apparent absence from the art-historical record, however, a question which derives from interests at odds with the status quo in Art History, I need a different way of thinking and researching in order to answer it, since the present practices of Art History not only suppress knowledge of women artists but disallow the very idea of women being 'artists' in the canonical sense of the word. The ideological project of the discourse of art history is to render masculinity and creativity naturally synonymous.[28] Thus in *Old Mistresses*, Rozsika Parker and I had to make Art History itself the object of ideological critique – showing how it served the interests of an unacknowledged sexual hierarchy. Methodological novelty is only, therefore, a symptom. It is not the real force changing art criticism and art practice. Methodological issues are the symptom of a political conflict waged at the level of both cultural discourse and the representation of culture. The authors of the *Art Bulletin* review article actually quote Lisa Tickner: 'feminism is a politics, not a methodology' in the only sentence that admits of a feminist 'engagement with *theory*' (my italics).[29] Yet the authors are inhibited from examining the implications of the statement because feminism doesn't function as a politics in their text; it is unconsciously depoliticized by its history's being represented in terms of generational and geographical differences.

I want to explain how the engagement between feminism and semiotics, post-structuralism and psychoanalysis arose not as methodological icing on a disciplinary cake but as necessary ways of thinking about issues and problems which actually confront us in both social practice and the contemporary study of culture. Theorization is not a cerebral exercise, remote from political necessity, designed to terrorize the uninitiated. It is an inevitable component of a political practice. How do we understand the problems we have to experience as women in all the concrete diversity of that term, and how do we understand the oppression of 'women' historically? How do we understand the condition Woman, sexual difference, social injustice, in ways which render it possible to resist and change? How do these structures inform cultural representations? What part do cultural representations play in the enactment of these structures and the production and reproduction of relations of power and difference? To call such theoretical enterprises 'methodology' is to cut art

history off again from that larger framework of social practice and cultural history, from feminism as something larger than feminist art historians or art critics. It keeps us at the level of 'Are you a feminist [art historian]?' as opposed to 'What is feminism?' and what does feminism do to art history and all existing formations of knowledge?

The authors of the *Art Bulletin* article have, moreover, considerable problems with their framework. Lucy Lippard appears as both a first- and a second-generation writer. Lisa Tickner appears similarly in both contexts. The discussion of various readings of the work of Nancy Spero is indicative. Spero is presented as a first-generation artist, criticized by second-generation critic, Jane Weinstock. Spero then defends herself by reference to her interests in French feminist theory, and is indeed appraised in thoroughly second-generation terms by Lisa Tickner. Because the authors themselves have not engaged with post-structuralist theories of reading and authorship, they cannot resolve the apparent confusion here by recognizing that 'Spero' is a quite different entity according to the text/critic (herself included) by which she is represented. In typical Art History, which is often essentialist in terms of its notions of human and artistic nature, there is an elision between the person, the social producer and the author produced by the text, an elision which is signified by the artist's proper name. From a post-structuralist vantage point, there is no essential 'Spero-ness' conferred upon the works by virtue of their being proprietorially named 'Nancy Spero'; there are readings of the work, empowered by radically different interests and theoretical resources. Thus Tickner can 'read' Spero for her exhibition at the ICA in London in 1987 in the light of French feminist theory about 'écriture féminine', recalling Kristeva's second generation: 'these women seek to give a language to the intrasubjective and corporeal experiences left mute by culture in the past.'[30] In part this is a result of the historical development of the feminist theory precipitated by the historico-politico-cultural moment of 1968 which focused on issues of the body and subjectivity. We now have the terms to appraise women's inscriptions in culture in ways which acknowledge the specificity of the corporeal and psychic conditions of femininity without being trapped philosophically in an essentialism which is what Weinstock – an ardent user of psychoanalysis, a French-orientated American critic – reads into Spero's own statements about her practice. The difference, then, between Kristeva's use of the generational metaphor and that of Gouma Peterson and Matthews becomes pointed precisely in the latter's inability to see theory as materially altering what we can now do because of what we can now think. Instead, the American authors present the feminist critique of art and art history as a sequence of different ideas or traditions, some being seen as overtly theoretical and others less so. In their article, the term 'theoretical' operates as a euphemism for 'ideological' in the absence of adequate theorization of how, at the level of knowledge, we effect changes through being able to contest the significations of femininity. Thus the generational imagery of this text ultimately creates a linear history with hidden assumptions about progress, evolution and development in place of a grappling with theoretical difference as a conflict within feminist theory and its politics.

The metaphors of first and second, American and British, overlap with young and old to create false impressions. Although I would not dare to underestimate the immense courage and influence of Linda Nochlin in making possible the feminist interventions in art history, I think it is misleading to give the impression that Lisa Tickner and I were not as much involved in the beginning of the project in the early 1970s, even though I was then a young graduate student, and Linda Nochlin an established professor at Vassar. The break from art history into feminism for us all was independent of age or stage. It was the possibility created by the opening up of a space called the women's movement. Furthermore, I do not see the fracture between American-dominated positivist feminist art history in the 1970s and British-dominated theorized art history in the 1980s. My work of 1977 is quoted in discussion of first-generation art criticism, while as an art historian I am placed at the end of the second generation. In addition, I derive much inspiration from the

work of Carol Duncan, writing feminist-Marxist analyses as early as 1973. Her article on 'Virility and Male Domination in Early Twentieth Century Vanguard Art' in *Art Forum* (December 1973) was a complex analysis of representation and sexuality in terms which are as pertinent and power-ful today as when they first appeared. Why fetishize named theories, such as semiotics and psychoanalysis, privileging them over politically framed analytical thought derived from another theory, Marxism, unless the present respectability of theory in the American academy derives pre-cisely from its having become depoliticized in its translation from France and Britain? I sense that fashion is playing a distorting part, making deconstruction and psychoanalysis more acceptable as 'theory' than the traditions of materialist social histories of art deriving from the pre-Cold War 1930s and renovated in the 1970s. One remains politics and is not allowed a theoretical input while what is called theory is denied a political import.

When Rozsika Parker and I wrote *Old Mistresses* (planned in 1974, begun in 1976, completed in 1978, though only published in 1981 because of the bankruptcy of the commissioning pub-lishers), we had not yet become formally acquainted with deconstruction. Yet, the text exhibits tendencies that make it a deconstructive text, a reading of the discourses of Art History, exposing what they say beyond the surface of what is written. Equally, our text used an Althusserian model of symptomatic reading of Art History for its structuring absences and the informing ideological frameworks. The project was not driven by theories but by specific questions raised by feminism for the practice of research, teaching and writing about art. In retrospect, we can recognize more and more of its resources and recognize how ideas with which we were not directly familiar none the less percolated down to us as part of a conversational community of radical and feminist writ-ers. The book was an attempt to enunciate the social contradictions of gender in a specific site, Art History. It was a result of the signifying space of the women's movement, which was producing ways to articulate the issues of sexuality, subjectivity, gender power and pleasure. From within that framework, we could argue that women had never been outside the realm of art, i.e. our version of the public sphere. They were always-already within it, though 'woman' was structurally posi-tioned as a negative term in opposition to which 'masculinity' established its dominance and exclusive synonymity with creativity. The stereotypical construction of femininity is not *essential* in a biological sense, but, to use the word differently, it is essential, that is, necessary, to the dis-cursive production and perpetuation of the hierarchy we call sexual difference.

Old Mistresses: Women, Art and Ideology, with the word 'ideology' in its subtitle, was enabled by the currency of Althusser's formulations about ideology. These stressed that ideas neither float in the free space of idealism nor are a matter of consciousness, false or otherwise.[31] Althusser speci-fied ideology as a material practice in so far as the production of both meanings and subjects for meanings and social positions takes place in the social practices and institutions such as the fam-ily, the school, the church, the media, the university. This, combined with Foucault's definition of discourse and discursive formations, which equally have an institutional site through which objects and subjects of discourse are constituted, made possible the identification of art history as a dis-course, practised in specific institutions, from art history departments to publishing houses, from museums to gift shops. If discourse is the product of social practices, the burden of discourse is the shaping, the disciplining of subjects for the regimes of social power. In both Althusserian Marxism and Foucault's discourse theory the issues of social power pass through the field of the subject and the sign: these will be precisely the site of Julia Kristeva's feminist reorientation towards imagining revolutionary change through sexual difference.

It is highly significant that, in their listing of theories misrepresented as methodologies, Gouma Peterson and Matthews include neither Althusser on ideology nor Foucault on discourse. The only reference indeed to ideology is locked into a quote from *Old Mistresses*. This is a significant, indeed a symptomatic, repression in their text. It indicates the ideological limits of the argument by mark-

ing what cannot be said. Thus the text is, in Althusserian terms, structured by what it absents. In the absence of a sense of ideology, the article unconsciously reiterates the dominant discursive formations of an academic narrative of which the stories Art History tells are paradigmatic. This text thus construes the history of feminism and Art History through a typical art-historical narrative of development and progress. The authors tell a story that begins in 1971 and moves from simple beginnings to sophisticated developments, from emotional and personalized female-identified writings of sensibility and experience to intellectual, analytical and difference-orientated theoretical texts. One could further suggest that these transitions are read as moves from the maternal space of togetherness and solidarity to a more troubled, rigorous and even masculine space which risks exclusiveness and authoritarianism: 'Unfortunately, such feminist, Postmodern positioning can often take the form of authoritarianism itself.'[32] Here another ideological axis inserts itself, identifying theoretical difficulty with masculine culture and thus depriving feminism of precisely what is necessary, given the complexity of the predicaments in which we find ourselves: *feminist* theory.

Because of the perspective of the authors themselves, such oppositions are represented as a linear progress so that a cartography of American versus British styles of feminism becomes a temporal narrative utterly symptomatic of the way Art History writes its histories. In the developmental flow of *time,* there is no *space* for conflict, for ideology and for politics which fracture the evolving diachronic story to produce complex, politicized synchronies. Feminism cannot be understood or defined only diachronically, as the history of ideas or the succession of social movements, or an unfolding of generations. In our moment, there has emerged a dispersed and fractured feminist space in which conflicting ideologies and politics simultaneously coexist, between groups, tendencies, communities. These conflicts of loyalty and politics often coexist within individuals. I have always argued for an understanding of the differences between various feminist positions and practices, while indicating that none is correct. Yet against any suggestion that this allows a happy postmodern eclecticism, I would stress the need to take up a position and argue it.[33] There is as much danger in the word 'differences' becoming a polite fiction allowing us to disregard the real injuries of class and race that disfigure feminist aspirations. By joining the debate in this essay, I want to stress the need within feminism for analysis and debate, not for a process of pigeon-holing, labelling and neat classification, even though our curricula and course materials might often seem to require it for the sake of introducing students to an otherwise confusing field of historical diversity and political conflict. It is clearly easier to digest feminism as a matter of national schools of thought, and generations of methods, than it is to confront what is at stake, and to name the power and interests that certain ways of thinking about art and art history continue to serve and reinforce. To name the work of British feminist art historians advanced, sophisticated or theoretical is to deprive it of the politics which motivate it – the conflict from which feminism is generated and which it continuously challenges precisely through its alliances with anti-bourgeois positions of historical materialism, socialism, anti-racism and lesbian and gay politics.

The authors of the *Art Bulletin* article do, however, work against this tendency themselves. In their final section they give a political gloss to the debates and draw upon the work of Olive Banks to confirm their observations of a tradition of interest in British feminism with questions of class and with popular culture. They cite Lisa Tickner, who in fact shows that as far as art criticism goes, it has not been a matter of theory versus no theory, but rather a question of different choices of theories. Thus postmodernist questions have been posed in the States more through Baudrillard and Debord than through Brecht, Althusser, Barthes and Lacan. But the reasons for the lack of continued theorization in American feminist art history which Thalia Gouma Peterson and Patricia Matthews advance reveal a sudden loss of certainties.

First, American art historians are not given an academic foundation in radical theory and methodology as are the British, in Marxism for example, and are therefore not so quick to respond with feminist transformation of that theory. In fact American art historians are not encouraged to use any particular methodology, except a 'traditional', i.e. empirical one whatever that may encompass. [34]

The second reason they offer is that American feminist art historians first became involved with social history and since that was itself quite radical in the context of traditional art history, few have moved beyond social history. (But this is very contentious, since there is a clear difference within practices which claim to be social histories, and I think we are safe to assume that the authors are not thinking about Carol Duncan's Marxist social history here.) Third, the authors mention a distrust of European methodologies. Once again it important to note the substitution of methodology for the naming of specific theories and the slippage between the two. This salvages the professional identity of Art History. The political issue of what questions we should be asking of the histories of visual representations and their cultures, namely that which takes us beyond art history, is replaced by the safer debate about which methodology to use within it. But deconstruction, semiotics and psychoanalysis are not *methods*. They have methods, of course, but these follow on from their theoretical problematic, a framing of an exercise in the production of knowledge about that which is defined as each theory's object – respectively writing, sign systems, the unconscious. Method follows from theorization. That's what keeps disappearing from the *Art Bulletin* text along with the historical contexts in which the political battle of theorizations emerged in the late 1950s–1960s.

It is relevant to correct the assumptions made by Gouma Peterson and Matthews about Britain as a context for feminist activity. They confuse a non-establishment British political tradition of socialist thought and the emergence of New Leftism with which significant feminists were initially allied – Rosalind Delmar, Juliet Mitchell, Michelle Barrett, Sheila Rowbotham, Elizabeth Wilson, to name but a few – with what happens inside British universities and Art History departments. There almost no one would automatically get an academic foundation in theory and methodology and especially not in Marxism. (The programmes at the University of Leeds are the exception and our course in the Social History of Art, begun in 1978, fills a need felt by many artists and art historians to have a chance to study historical materialism.)[35] Such knowledge as British feminists acquired in the early 1970s was procured by our forming reading groups and collectives, established in the radical tradition of workers' self-help groups and feminist consciousness-raising. We formed reading groups to study Marx, Lacan and Foucault. We went to conferences organized by film societies in order to come to grips with psychoanalysis. We read magazines like *Screen, New Left Review* and *Red Rag*. A combination of collective self-help and intellectual bricolage re-educated a range of activists and intellectuals seeking the means to resolve the dislocation between what was officially on offer as knowledge – be it of art, history or society – and what we needed to be able to say and understand because of the crisis we were living through. There were enough books, few though there were, to begin to guide us to others and to the cultural intellectual revolution taking place, particularly in France, under the impact of structuralism and other changes in western Marxism that had discontinuously occurred during this century. This all brought me to the then emergent critical space of the social history of art, associated with the writings of T.J. Clark, Linda Nochlin, Klaus Herding and others. Thus the American excuse does not stand the test of evidence, but it does indicate a real difference at the level of experience of non-professional education.

We should never underestimate the impact of the Cold War and its cauterization of Marxist tradition in the American academy as much as in society. Moreover, Art History is a more profoundly professionalized and institutionalized discipline in the United States than in Britain. Art History was founded in the US with chairs in the subject by the mid-nineteenth century. British universities did not institute the teaching of the subject until well into this century, and this was limited to the Courtauld and the Warburg Institutes (the latter only coming as a refugee from Europe in

the 1930s). In Britain, in the 1960s, an expansion in art education led to an increased demand for
art historians to teach on Fine Art courses in the newly founded polytechnics which then, too,
began to expand, creating a wholly new sector in which initiatives in graphics, design history, cul-
tural studies, film and media studies could also develop in ways which cross-fertilized with the
kinds of art history that were being fashioned to accommodate the priorities of fine art students.
Far from being an elite member of the humanities in universities, Art History expanded in Britain
in a climate which momentarily fostered an alliance between that fledgling discipline and cultural
and critical theory which often cohabited within the same individual. Many of us began to teach
film, and look at a range of visual phenomena without the imprimatur of being Fine or Great Art,
i.e. part of the canon or tradition of Western Civilization. Photography, illustration, caricature and
a whole range of contemporary visual representations replaced the hierarchies of traditional Art
History and, of course, of modernist art and art history too. Since 1968, feminist theory and prac-
tice began to develop in marginal spaces and emergent sectors, where the lack of rigorously policed
disciplinary boundaries allowed a new kind of intellectual practice to develop, of which feminist
practice in knowledge and theory was both one instance and a major influence and resource.

While we have seen departments of media and communication studies, of cultural and film stud-
ies, find homes even in British universities and polytechnics, feminism, however, remains an outsider.
Of course, there are a few centres running Masters programmes in Women's Studies, but there are
no departments or programmes on the scale of those to be found in American universities and else-
where.[36] Feminism retains an outsider status in the academy.[37] Never integrated into disciplines, it
remains forever alien, while it is not even a unified other. It is heterogeneous and conflicted. At least
it offers an Archimedean point from which the array of contempoary debates in social and cultural
theory can be appraised, raided, reworked, from which interventions can be made which will change
the discrete disciplines, but also begin to formulate a non-disciplinary field of knowledge where the
divisions between social knowledge, historical knowledge, political knowledge and cultural knowl-
edge are eroded so that we can grasp their concrete interactions in the texts we study and those we
write. Institutionally as well as theoretically, then, feminism is what Teresa de Lauretis calls 'a space
off', and this is the value of treating feminism as a signifying space which retains some sense of being
both a movement, and *in movement* – something which is also projecting a future.[38]

Rosalind Delmar's definition of feminism as a history of ideas separate from women's social
activism can be rephrased via Julia Kristeva as a dialectic which is always historically grounded. I
want to retain my own personal history in the women's movement, for its politics and practices
still shape what I do now that I have won a place within the institution. I want also to keep alive
the specific interaction of theory and movement which characterizes contemporary feminism as
both a resurgence of activism for social change and a profound but deeply political philosophical
return to the question of sexual difference. Feminism alone provides the point outside both his-
torical materialism and Art History, from which I can fashion a feminist project for the study of
visual representations and its practices, discourses and institutions. This feminist project compre-
hends both materialist concerns and recognition of the role of the psycho-symbolic domain. In
that sense while I would answer in the affirmative to the question 'Are you a feminist?', I could not
do the same if asked 'Are you an art historian?' I am always tempted to ask, as I did at the Women's
Caucus in 1990, 'Can Art History Survive the Impact of Feminism?'

I share the terrain of enquiry with art historians. I study the same artefacts or images and read
the same documents. But the object of this discourse is not 'art', i.e. the aim is not to validate art
as a category and a value. The object of feminist analysis is the social-psychic production of sexual
difference and the relations of power as they fracture across the coterminous formations of race
and class which both form the conditions for visual representation and are performed and per-
petuated by the economies of visual representation. Neither fashion nor style, neither geography

nor generation, should determine our projects. I do not travel with a methodological suitcase into which I pack semiotics, psychoanalysis, etc. Using structuralism and post-structuralism means participating in a revision of the key categories by which the studies of the humanities, art history included, have been hitherto organized. If we abolish the idea of the individual and expressive author and undertake historically located and positioned readings of equally historically located and positioned texts and their producers, the traditions of monographic celebrations of 'fathers of modernism' and other great phallacies become impossible. These models themselves are tested against theories of subjectivity which, despite themselves, have made it possible to spell out the formations of femininity and masculinity as both social and psychically installed constructions. Each theoretical system provides the partial means to deal with the questions feminism has to pose. Each provides the means of critiquing the limitations of the others. As theory fights with theory, rather than nestling neatly into the shopping trolley at the intellectual supermarket, feminism's project provides the space for momentary conjunctions and creative conflict, what I call bricolage. Feminism is this complex harnessing and negotiated conflict, for we have still so far to go to enunciate our feminine predicaments and formulate effectively our expanded feminist challenges. Reviews such as that by Thalia Gouma Peterson and Patricia Matthews unintentionally flatten out this conflict and its histories to produce a two-dimensional map of individuals and their ideas, for which the authors can only provide a temporal itinerary. The terms 'generation' and 'geography' lose their historical and political specificity in such a narrative cartography.

In formulating a way into a Masters programme in Feminism and the Visual Arts, I found myself obliged to identify the problematics of the field and to suggest that to approach the topic we need at least five areas of theory: theories of the social, that is how we can think about the totality of social relations; theories of the historical, that is how social change occurs; theories of the ideological, that is how meaning is produced in formations of power; theories of the textual, that is how meaning is produced by sign systems and discursive formations; and theories of the subject. These provide access to the objects of analysis: power, domination, representation, desire and difference. The politics of theory is a political resistance to the repression of the fact of oppression, and to the suppression of the means of analysis of oppression and its transformation. If sex/gender as an axis of power is the repressed question of our culture, its theorization is continuously repressed consciously, by those who oppose the speaking of this knowledge, and unconsciously, by those who fail to theorize its repression. It is, therefore, of critical importance that we think about, i.e. theorize, how we study women, their condition and history, their place in representation and their representations, how we make women's studies *feminist*. That is, to refer one final time to Toril Moi, to politicize and to practise the politics of theory. Art History and the Histories of Art (including that of contemporary art) remain necessary sites for this contest, for in their seeming distance from the social or political sphere, as a privileged inside, in their privatization of culture immune to the dirty business of politics and power, the discourses of Art History and Art protect the dominant structure of power, with its Eurocentric, homophobic and patriarchal stories of art.

History or Art History as Narrative is being challenged by a more complex and conflicted sense of the social and historical process and it is here that I would like to reposition the terms 'generations' and 'geographies' as matters of the specificities of women in time and space, in history and social location. I can only agree with the socialist historian Elizabeth Fox-Genovese, who concludes her own study of 'Placing Women's History in History' with these thoughts:

> In this sense, women's history challenges mainstream history not to substitute the chronicle of the female subject for that of the male, but rather to restore conflict, ambiguity and tragedy to the centre of historical process: to explore the varied and unequal terms upon which genders, classes and races participate in forging a common destiny.[39]

Since we are part of the historical process, we must subject our own histories to such recognition.

Notes

1 This chapter was originally written for a seminar given at the Centre for Women's Studies at the University of Stockholm. A Swedish version appears in the women's studies journal, *Kvinnovetenskapligtidskrift* 44 (1992). It was published in English in *Genders*, no. 17, Fall 1993.

2 For a statement on this see 'Vision, Voice and Power . . .' in *Vision and Difference, Feminism, Femininities and the Histories of Art* (London: Routledge 1988).

3 Feminist tradition is now an object of study as well as a set of theories and methodologies for the study of other objects, the visual arts or film, for instance. The course is thus organized into three components: Feminism and Culture: Theoretical Perspectives; Feminism: Art: History; and Feminism and Practice in the Visual Arts: Configurations of the Feminine.

4 I realize there is a difficulty in translation here. Gender is used in English often as a sociological term for learnt behaviours which signify the socially conditioned difference between boys and girls. It is often thought of as a matter of roles and stereotypes which are socially constructed. Sex, on the other hand both refers to the biological fact of being male and female, and to the question of the divisions and differences between men and women, the sexual division of labour for instance. Poststructuralist use of psychoanalysis introduces the concept of sexual difference to indicate a psychic regime within which masculinity and femininity are produced as differential terms within a phallocentric symbolic system. Using the phrase 'sex/gender' I follow Gayle Rubin, who formulated the term in order to specify the social production of human subjects for social arrangements of sexual reproduction, kinship and exchange of women, systems seen to be mutually dependent so that the smallest social unit will contain at least one man and one woman, and they will, through processes of construction in sexuality, predominantly become heterosexual. Sex/gender thus refers to a complex of social, psychic and sexual formations. Feminism is that discourse which, by naming such systems and studying their structural operations, explodes all appearances of sex as nature while also suggesting that attention only to social roles without a theory of the sexed subject is inadequate. Gayle Rubin, 'The Traffic in Women' in Rayna Reiter (ed.) *Notes towards an Anthropology of Women* (Boston: Monthly Review Press 1975). See also Luce Irigaray, 'Women on the Market' in *This Sex Which Is Not One*, trans. Cathy Porter (Ithaca: Cornell University Press 1985).

5 This phrase is taken from Elizabeth Fox-Genovese, 'Placing Women's History in History', *New Left Review*, 133 (1982) 7.

6 See Juliet Mitchell, *Women's Estate* (London: Penguin Books 1971).

7 R. Williams, *Culture and Society* (London:Penguin Books 1958) and *The Long Revolution* (London: Penguin Books 1961); E.P. Thompson, *The Making of the English Working Class* (London: Penguin Books 1963).

8 Christine Delphy ('Pour un matérialisme féministe', *L'Arc* 61 (1975)) argues that feminism-as-a-movement aims at a revolution in social reality, and feminism-as-a-theory aims at a revolution in knowledge. Reprinted in Elaine Marks and Isabelle de Courtivron (eds) *New French Feminisms* (Brighton: Harvester Press 1980), 198.

9 For a useful discussion of this paradox see Denise Riley, 'Does Sex Have a History?' in her book *Am I That Name? Feminism and the Category of 'Women' in History* (London: Macmillan Press 1988), 1–17.

10 Teresa de Lauretis, 'Technologies of Gender' in *Technologies of Gender* (London: Macmillan Press 1987).

11 R. Delmar, 'What is Feminism?' in J. Mitchell and A. Oakley (eds) *What Is Feminism?* (Oxford: Basil Blackwell 1986), 8–33.

12 I am grateful to Mary Kelly for this insight, which she has incorporated in her project *Interim*, for a catalogue of which see *Mary Kelly Interim* (New York: New Museum of Contemporary Art 1990).

13 Delmar is considering Mary Wollstonecraft's *A Vindication of the Rights of Woman*, 1792. See also Jane Rendall, *The Origins of Modern Feminism: Women in Britain, France and the United States 1780–1860* (London Macmillan 1985).

14 Angela Davis, *Women, Race and Class* (New York: Random House 1981); Hazel V. Carby, *Reconstructing Womanhood* (New York: Oxford University Press 1987).

15 Delmar, 'What Is Feminism?', 27.

16 See Jacqueline Rose, 'Feminism and the Psychic', in *Sexuality in the Field of Vision* (London: Verso 1987), and the work of Julia Kristeva, for instance in Toril Moi, *The Kristeva Reader* (Oxford: Basil Blackwell 1986).

17 J. Kristeva,'The System and the Speaking Subject' [1973] in T. Moi (ed.) *The Kristeva Reader* (Oxford: Basil Blackwell 1986), 24–33.

18 J. Kristeva, 'Women's Time' [1979] in T. Moi, *Kristeva Reader*, 188–213.

19 Ibid., 194.

20 Ibid., 209.

21 B. Barnes, *Interests and the Growth of Knowledge* (London: Routledge & Kegan Paul 1977).

22 T. Moi, 'Feminism, Postmodernism, and Style: Recent Feminist Criticism in the United States', *Cultural Critique* 1 (Spring 1988), 4.

23 Ibid., 22.

24 Michelene Wandor, *Once a Feminist: Stories of a Generation* (London: Virago Press 1990), provides interviews with women who attended that historic event in British feminism.

25 For documents on this event see Rozsika Parker and Griselda Pollock, *Framing Feminism: Art and the Women's Movement 1970–85* (London: Pandora Books 1987).

26 I am writing a book which addresses this issue directly: *Differencing the Canon: Feminism and the Politics of Art's Histories* (London: Routledge 1996).

27 Thalia Gouma Peterson and Patricia Matthews, 'The Feminist Critique of Art and Art History', *Art Bulletin* 69: 3 (1987), 326–57.

28 Richard Easton has shown that this synonymity is further limited to a canonised heterosexuality, 'Canonical Criminalisations'. (Leeds University MA thesis 1990), in a special issue of *Differences*, 'Trouble in the Archives', vol. 4, no. 3, Fall 1992.

29 Gouma Peterson and Matthews, 'The Feminist Critique', 350.

30 Kristeva [1979] in Moi, op. cit., 194.

31 Louis Althusser, 'Ideology and Ideological State Apparatuses' [1969] in *Lenin and Philosophy and Other Essays*, translated by Ben Brewster (London: New Left Books 1971), 121–70.

32 Gouma Peterson and Matthews, 'The Feminist Critique', 350.

33 For a fuller statement of this see my review of Mary Garrard's 'Artemisia Gentileschi: The Image of the Female Hero in Baroque Art', *Art Bulletin* 72: 3 (1990), 499–503.

34 Gouma Peterson and Matthews, 'The Feminist Critique', 350.

35 There is now a growing number of Masters programmes which focus on critical and cultural theory in relation to art history, but such innovations are the product of real and continuing struggles which have found feminist academics in the foreground and there is no doubt that the energy in the discipline is coming from students studying on these programmes. But we should be wary of blithely seeing this as 'success' or 'acceptance into the mainstream'. To do so would be again to depoliticize the process, the cost, and the precariousness of such a challenge to hegemonic notions of Culture and the Humanities.

36 Jennifer Johnson of Robinson College, Cambridge, is currently researching this area. Paper given at the Association of Art Historians' Conference, London 1991.

37 This is not to romanticize the situation or pretend that there are not now feminist art historians in prominent positions and well-paid jobs. They may not be in these positions because of any institutional recognition of the legitimacy or necessity of a feminist intellectual presence. More often, it is despite their avowed politics and intellectual commitments, because of an indifferent assessment of such market values as productivity, student drawing power, tokenism, that make it possible for feminists to achieve positions that then permit the project of feminism to be consolidated as academic material available to further generations of women students to participate in study and art making, not as aberrant others or transvestites, but 'as women', speaking in their own varied, race-, class- and sexuality-specific voices. The status and professional recognition of feminists and their discourse does not stem from any profound acknowledgement of women; rather it bespeaks the precarious 'tolerance' of increasingly market-led liberal bourgeois states.

38 de Lauretis, 'Technologies of Gender', 25–6.

39 Fox-Genovese, op. cit., 29.

PART II

Thinking theory: reading critically

Chapter Two

Reading Art?

Mieke Bal

Fear not. This woman cannot kill. She is only an image. Caravaggio's *Medusa's Head* (Figure 2.1) shows us the essence of the *femme fatale*, the monster who is able to kill men, visually, just by looking, and being looked at. This myth alone raises a first important point about images and their cultural place; about visual culture. Jacques Lacan understood the creepy, spooky quality of this being-looked-at-ness, and made it the starting point for his reconsideration of the gaze. But no, she won't kill. Not because she is 'just' an image. Even within the game we play, the game of 'reading fiction', of 'willing suspension of disbelief', she won't kill. Like most Medusas in the history of art, this head, allegedly able to petrify the spectator, is without power – why? Because she is without a look. She averts her eyes. Art historians have a lot of relevant things to say about this work, concerning the suspicion that this is a self portrait – how interesting that a painter should depict

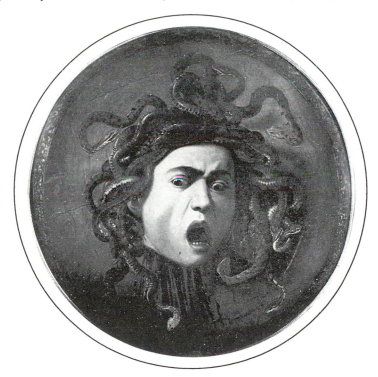

Figure 2.1 Michelangelo da Caravaggio, *Medusa's Head*, 1600–1.
Florence, Galleria Uffizi

himself as this blinded Medusa – the commission, the iconographic tradition, Caravaggio's other works, other Medusas, other disguised self portraits. What is there, in addition to all those questions, to *read*?

In the following pages, I will make a case for a concept of *reading* images that is neither predicated upon a linguistic invasion of visuality, nor exactly identical to what art history has construed as its proper domain. This concept of reading is both broader and narrower than that. The method, or, more modestly, procedure has in common with ordinary reading that the outcome is *meaning*; that it functions by way of discrete visible elements called *signs* to which meanings are attributed; that such attributions of meaning, or *interpretations*, are regulated by rules, named *codes*; and that the subject or agent of this attribution, the reader or viewer, is a decisive element in the process. Furthermore – and that is the focus of this chapter – each act of reading happens within a sociohistorical context or framework, called *frames*, which limit the possible meanings. Some aspects commonly discussed in art history remain outside this concept – all those visual aspects that do not contribute to the construction of meanings – whereas others exceed the confines of that discipline, like those predicated upon the notion of syntax, rhetoric and narrative.

APPROPRIATION

Caravaggio's *Medusa* can provide a first overview of the issues broached here. Medusa looks away, and she looks terrified herself. What could possibly frighten her who cannot even see the frightening snakes on her own head? There is a story attached to this vision, a story we can read. But that's only a pre-text. According to that pre-text, Perseus has petrified Medusa by means of the mirroring effect of his own shield, and is thus able to behead her. And who would not be terrified at being beheaded? This story is dissolved, however, by the confrontation with the image, because the self portrait presupposes a mirror, too, and makes the figure, the monster, change sex. Is Perseus merged into Medusa? Is the painter the model; the killer the addressee? The starting point for a reading of this image could be: the insistent look is not mirrored. Yet the portrait remains an event of *facing*, strangely reassuring, because Medusa loses her otherness in the partial exchange with him who sees her. As Louis Marin pointed out in an interpretation of this painting, 'The frontal portrait doubles and visually animates, figuratively, the correlation of subjectivity . . . the model is "I" and "you" and the spectator is "you" and "I".'[1]

The mythical pre-text is not irrelevant, but it becomes an intertext brought in for questioning; the viewer is implicated in the gendered myth of assigning lethal power and monstrosity by some sort of identification stimulated by the transsexual movement between model and figure. This confusion allows a sensibilization to the fright, not provoked but undergone by Medusa. The look that looks away installs narrativity by turning the figure into the character of a narrative, not the ancient one about Perseus, but the visual one in which things happen between an image and a viewer. Medusa looks away in order to get you to look away with her, to escape the myth that binds her into an evasion from that frightening role. Medusa 'speaks', visually, in an exhortative mode, enticing 'you' to look, with her, for the true source of the fright, in the ideology that turns women into monsters.[2]

I was just reading away. Reading an image, on its own terms, taking its elements – signs like 'words'? – at face value, the painting 'at its word' – see what it has to say. Putting myself in the place of the 'you' a text always addresses, but then, a looking 'you'. Reading a story that happens in the act of looking; yet, reading it. I would like to talk about reading, reading images, reading art. It is my contention that the use of the concept of 'reading' has a potentially important political relevance along with a semiotic power of specification.

When I gave my book on 'Rembrandt' the title *Reading 'Rembrandt'* I knew what I was doing. I thought, but erroneously as it turned out, that stating clearly in the introduction what I intended to do in the book would protect me from the charge of linguistic imperialism that the title suggests, admittedly, at first 'sight'.[3] Now, let me reread that phrase: at first sight? Does this way of phrasing the misunderstanding insinuate that visual people are superficial readers, and that those who misconstrued my argument about reading are not only inclined to privilege vision over reading, but to stick to a 'first sight' interpretation of the former? In other words, is reading more profound than 'sighting', which is superficial? Is seeing a form of sightseeing, of seeing sites, seeing aside; is it tourism, objectifying and appropriating, exploitative and consumerist; and on the side, lateral, misfiring, looking away? Of course, it is not all those things, not by definition, you all know that or you wouldn't be reading this book, but sometimes it is, and many art historians today are worried about that. But nor is *reading* by definition profound. So the opposition suggested by the phrase 'at first sight' is deceptive. Yet, language and images pertain to two different media, and if a binary opposition between the two is in no way arguable, not by standards of logic at any rate, a difference in modes of expression and communication between the realm of the visual and that of the linguistic is too obvious to try to challenge it. So, what I will say does not entail a suppression of the differences between texts and images.

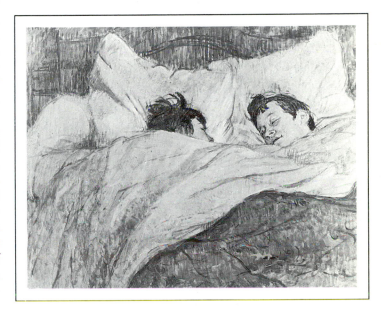

Linguistic imperialism has had its damaging effects even by the doing of the most keen and interesting critics, and I will cite an example in a moment. 'Applying' linguistic or language-based theories to visual art can be as blinding as it can also be revealing, as in fact any notion of 'application' is already blinding, because it consists of putting blinkers on, deliberately. Yet I have, I think, good reasons to maintain the notion of 'reading' art, maintaining it as adequate, illuminating, providing surplus heuristic value, and as a critical tool. This is a

Figure 2.2 Henri Toulouse-Lautrec, *The Sleepers*, 1892, drawing. Paris, Musée du Louvre

position paper, meant to engage you in a discussion of how the business of 'art', the routines, habits, traditions, of talking about, and dealing with, art can be made more complex and relevant through such a notion.

A first, and in fact central, issue is framing. Let me make an extreme case. At the time she was still married to him, this innocent, sweet 1892 drawing by Toulouse-Lautrec was sent to the husband of a friend of mine as a postcard by one of his students (Figure 2.2). The text on the back was a not very clear message to the effect that she liked his classes and wanted to get to know him better. Nothing particularly troubling about that, although the step was unusual. But, in connection with this innocent enough message, the almost arbitrary image on the postcard seemed so incongruously out of place, that instead of the childlike innocence the image had possessed for my friend so far, she – and her husband as well – immediately saw the postcard as an invitation and the image

as utterly suggestive of sexual initiative. Much more so than, say, Manet's *Olympia*, of which it is so often said that it is shockingly overt in its sexual overtones, so much so that the professions of the represented women as prostitute and house-servant, respectively, are never questioned.[4] *Olympia* has become too much of a classic for any serious person to take the painting, sexually, at face value. Lautrec's sleepers of indeterminate sex[5] don't do any of the things Olympia is charged with doing, yet in the situation there was no doubt as to what the image's message was meant to be. In blatant disregard for the artist's intentions, the historical context, the historical use the image might have been put to, my friend and her husband *read* the image.

I quote this example because, at a time when I was not at all working on images, in a domestic situation, I immediately saw her do something which I knew was in some way wrong, in another way very right – as subsequent events proved. The act of interpretation was reinserting the image within a larger whole that included my friend, and even, potentially, affected her life. Here is a clear case of appropriation of an image, insertion of it within another textual whole – the pass the student was trying to make at my friend's husband – which semioticians call *reframing*. It brings out possible meanings in an image that one did not think of before it was reframed in this way. This act is the opposite of historical interpretation. The new frame, of course, was much more complex and comprehensive than just the connection between back and front of the postcard, between text and image. It included many other frames, of which the association between bed and sex, but also, the clichés of cultural plots and the trespassing of assigned roles, are only fragments. The new frame also obscured aspects of the image. For example, the situation in which a woman student approached a man by way of this image made the obviously lesbian overtones of the representation irrelevant, or better: invisible.

The *reading* event was also double: the student had first read the drawing, realized its potential, connected it to her own intention, and, to use a pun, put her stamp on it. This was an act of appropriation. It was that stamped image that my friend and her husband read in a second round. Correctly, as far as the intention of the student was concerned; obviously erroneously in any art-historical sense. But the reading itself 'made sense', so what we have, as an object of reflection, is an act of reading, however idiosyncratic. The case may seem extreme, but it is not essentially different from any other processing of images. Similarly, what we study as 'art' consists primarily of such 'stamped' images. With my book I wanted to draw attention to the innumerable acts of reading that constitute 'art' in the ongoing history of its functioning. Obviously, then, this ongoing history cannot be identified with the discipline called 'art history', although in a way it *is* an art history, just as well.

The example is, of course, so idiosyncratic that it doesn't bear in-depth analysis; academically speaking it is futile. But not every act of reading is so contingent, hence, futile. The postcard was a bit like this reframing of Rembrandt's *Syndics* in an ad for underwear that I once found in a slide projector, and that changed my reading of the *Syndics* (Figure 2.3). I had never seen that painting in terms of voyeurism, in spite of the obvious staging of the gaze. In Rembrandt's work, the mobility of that man seems to insert another 'discourse', a narrative of some sort of interruption that serves to emphasize that the men are actually alive and kicking. The mobility of the one man on the left who is half standing up does seem to imply a statement on vision more than on capitalist assessment of the fabrics they are allegedly gauging; but in the reframed image, a woman in underwear is simply inserted. Through this reframing the same figure becomes a businessman using his gauging skills to evaluate women's bodies, whose clothing it becomes his business to see, and see through. This piece of pop art is a representation of an act of reading, a 'stamped' image that displays its stamp, just like the Toulouse-Lautrec postcard sent by the student. More than the name of the individual who did the stamping, it is relevant to realize who, which social constituency, is doing the reading.

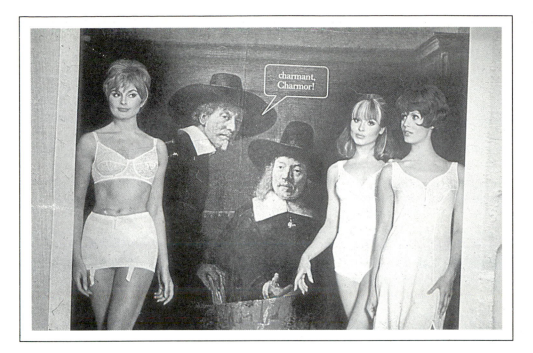

Figure 2.3 Advertisement for underwear

Reading an image, I would like to emphasize, is nothing like reducing images to linguistic discourse. Instead of remaining locked within the binary opposition that has, I think profoundly wrongly, been construed around the two media, or modes, I would like to go over those aspects of *reading* that articulate aspects of seeing whose taking into account I consider not only relevant and meaningful, but also *visually* indispensable. On certain conditions.

NEITHER SPEECH NOR ICON

One important issue, it seems to me, is the status of signs in communication, a process called semiosis, and the subjects involved in that process. Before going on to show how reading art can be an effective way of understanding an image and its cultural position in a critical manner, I would therefore like to clear two misunderstandings about the alleged connections between image and language: the analogy between speech and vision, which affects the status of the subjects and their acts, and the conflation of iconicity and visuality, which is a matter of the status and modes of operation of the sign.

To begin with the latter, the term 'icon' is semiotic, derived from the writings of Charles Sanders Peirce, and tremendously useful to help semiotics free itself from the linguistic stronghold that almost made it useless in the French tradition. But using the term as a synonym of 'visual' is throwing it away, and with it, the possibility of 'reading' (semiotically) the visual (as such). I may simply remind you of what Norman Bryson and I wrote in our state-of-the-art overview in *Art Bulletin*: 'As Peirce clearly states, the iconic is a quality of the sign in relation to its object; it is best seen as a sign capable of evoking non-existent objects because it proposes to imagine an object similar to the sign itself' (1991). Peirce's definition runs as follows: 'An *icon* is a sign which would possess the character which renders it significant, even though its object had no existence; such as a lead-

pencil streak as representing a geometric line' (Innis 1984: 9–10). Iconicity is in the first place a mode of reading, based on a hypothetical similarity between sign and object. This means that we assign to the sign a character which makes it significant.

Thus, when we see a portrait, we imagine a person looking like the image, and we don't doubt the existence, in the time of the painting's production, of such a person; we don't demand substantiation of that existence by other sources. Whether or not we know the name and status of Fredrick Chopin, we believe that Delacroix, in his portrait of Chopin, did depict an existing person who 'looked like' this canvas, and whose name was Chopin. Hence, the sign – the portrait – *is*, is taken to be, Chopin. Similarly, we think we know the face of a self portraitist, say, Rembrandt, even though other painters have presented a face of Rembrandt quite different from his self portrait, just because we adopt the iconic way of reading when we look at Rembrandt self portraits, to quote Svetlana Alpers' example.[6]

But the example of portraits might wrongly suggest that the icon is predicated upon the degree of 'realism' of the image. An abstract element like a triangular composition can become an iconic sign whenever we take it as a ground for interpreting the image in relation to it, dividing the represented space into three interrelated areas. Leo Steinberg (whose *Sexuality of Christ* constitutes the clearest example of reframing within art history), for example, makes this division in his paper on *Las Meninas* (1981). Instead of visuality in general, or realism for that matter, the decision to suppose that the image refers to something on the basis of likeness is the iconic act, and a sense of specularity is its result. A romantic sound of violins accompanying a romantic love-scene in a film is as iconic as the graphic representation of Apollinaire's poem about rain in the shape of rain.

Second, I want to raise the issue of communication between subjects, by taking my distance from the position made popular by the late Louis Marin. That position is most reputedly laid out in his famous articles on Italian and French painting, the often reprinted analysis of Poussin's *Arcadian Shepherds*.[7] The example of *Las Meninas* (Madrid, Museo del Prado) can clarify this point as well. Marin's model of analysis draws on speech act theory, a theory best known to art historians through John Searle's response to Foucault's interpretation of *Las Meninas*. Foucault argued that the painting inscribed the invisibility of the viewer, whose place is taken by the royal couple reflected in the mirror. Searle contests this interpretation by arguing that the viewer *cannot* be there where logically he must be. I won't go into the question of which logic Searle refers to, which is *not* really that of linear perspective although he refers to it, but instead consider his interpretation as a reading according to a specific theory. Speech act theory is based on the notion that speaking is an *act*, which has an *effect*, which can succeed or fail. In *Reading 'Rembrandt'* I have criticized this model as follows.

Foucault interpreted the painting as self-reflexive, and claimed that in that capacity it stages the absence of the viewer. Searle contradicts Foucault's view by arguing that the work is paradoxical, taking the visual existence of the painting as proof that the representation *on* it cannot be impossible. Here is a sample of his strikingly positive discourse: 'We know that the paradoxes *must* have a *simple* solution because we know that the scene depicted is a visually possible scene' (256; my emphasis). But thus he missed the point of Foucault's reading.[8] Foucault has been faulted for not doing his homework on perspective, but the point he made was an act of reading: interpreting the painting as a proposition, as a visual work that *has something to say*. Searle's submission to the work is indicated by his taking the painting, as it were, at its word: visual evidence is privileged positivistically. Taking the picture tautologically as proof of itself, rather than taking the work as questioning itself, he takes it to affirm itself, thus averting all possible questions it might challenge viewers to raise. Thus he silences the work, strikes it dumb; vision is, again, taken as blind surrender to a 'first sight', as the stupidest thing one can do.

This 'realism' in turn makes the solution to the paradoxes *simple* – unified, that is. The desirability and the possibility of the solution are implicit in the syntax of Searle's sentence, rather than explicitly stated. But paradoxically, Searle submits to 'what his eyes see', only to turn his back immediately on visuality. Although the self-evidential effect of the painting is attributed to its visuality, the solution to the paradox proposed by Searle is, not surprisingly, linguistic.

Drawing upon speech-act theory, Searle proposes the following simple solution:

> Just as every picture contains an implicit 'I see', so according to Kant every mental representation contains an implicit 'I think', and according to speech-act theory every speech act can be accompanied by an explicit performative, for example 'I say'. But just as in thought the 'I' of the 'I think' need not be that of the self (in fantasy, for example) and in speech acts the 'I' of the 'I say' need not be that of the speaker or writer (in ghostwriting, for example) so in the *Meninas* the 'I' of the 'I see' is not that of the painter but of the royal couple.
>
> (257)

Rather than cite the obvious and relevant – but problematic – cases of 'third-person' versus 'first-person' narrative, Searle uses the unlikely, irrelevant, and hardly illuminating case of ghostwriting to argue that the 'I' can be different from the declared speaker.[9] In ghostwriting the *speech act* performs the identification of one speaker, the subject of the utterance, with someone s/he is not but chooses to be for the time of the utterance. The word 'ghost' in that expression suggests the uncanniness of the doubling of the subject and proposes to see the subject of writing as an image, albeit an image of the invisible – which is what ghosts are. The reason why different narrative structures are more problematic as well as more relevant is precisely because in those structures sheer subject-identity is not assumed but challenged.

Here is the problem with this theory. The mode of reading images based on speech-act theory rests on the assumed analogy between seeing and speaking. In its simple form, this analogy is untenable for two reasons: it conflates different modes of perception without examining the implications of that conflation – thinking and seeing; speaking is hardly an act of perception – and it conflates different subject-positions in relation to acts – visually representing, not seeing, would be the act parallel to speaking.

To be sure, the insight that vision is as much subject to the social construction of the visual fields and the modes of semiosis we are trained to adopt as speech is subject to the social construction of discourse, has been an important impulse for a critical approach to visual art. But assuming an unargued analogy between 'I see', 'I think' and 'I say' is not the same thing as criticizing and undermining an unwarranted opposition between two media; rather, it obscures the issues involved in such a critique. That analogy also allows another conflation, that between acts of production and acts of reception, to pass unnoticed.

The latter conflation reduces the unstable I–you interaction of the personal language situation to one stable and unified. There is a world of difference between interaction, which leaves the subjects distinct but distributes their respective power, and conflation, which blurs and entangles the identities of the individuals concerned. Strictly speaking, the act analogous to speaking would be painting, not seeing the result, and the act analogous to representing something visually 'out there' would be 'third-person narration'. Thus, Marin's model as practised by Searle also represses the verbal aspects of his response by repressing his own position as a viewer. This theory, then, offers escape from the troubling involvement in the Caravaggio *Medusa* I have suggested earlier. Thus, it takes the critical sting out of the idea of reading; it appropriates the idea of reading in favour of an avoidance of a reading that could entail trouble.

The conflation of addresser and addressee, of representing visually with viewing, demonstrates again paradoxically the absorption of the critic into the work. In Searle's response to *Las Meninas*, for example, denying his own position, he increases his own importance. He conflates what *Las Meninas* distinguishes so exemplarily: the master and the servant, whose interdependence can only

be assessed so long as a minimum of autonomy is preserved for each. In the case of this painting, it is easy to see what readerly aspect gets erased.

Svetlana Alpers convincingly argues that Velázquez does not reject the humble work of craft. The attention to that aspect requires a reading that avoids the conflations Searle got entangled in. The portrait, the self portrait, is explicitly crafted, not simply assigned by the social hierarchy; it is made by the self, out of brush-strokes. However, such signs are necessarily ambivalent. They rest on a sense of humble, honest work whose humility they aim, at the same time, to subvert. It is a mistake to believe that craft and art are in opposition. Art subsumes craft as its necessary but insufficient condition. It is in this respect, as a *presupposition*, a discourse whose relevance makes the work possible, that both class and gender are inscribed by Velázquez. For Velázquez an ambivalence towards work as craft and service is not surprising, for *Las Meninas*'s focus on social roles makes it less than likely that the painter will manage to repress his own position as a servant entirely. The very effort to define royalty through those who make it, is a symptom of this awareness. The bodily contiguity between painter and attendant symptomatically signifies the return of the repressed. This reading is based on *interdiscursivity*: it takes the painting as an intervention in, and response to, social discourses that were relevant at his time, and are still, or again, or differently, relevant in our time.

Reading is an act of reception, of assigning meaning. The viewer reframes the work – which is, in this specific sense a 'text' – not simply as it suits him or her, according to contingent circumstances, as in the case of my friend's husband's student. She reads according to a 'vocabulary', a selection of elements taken to be signs, and connected in a structure that is a syntax in the semiotic sense: a connection between signs that yields a coherent meaning which is more than the sum of the meanings of the individual elements. Vocabulary and syntax can be learned, taught. They guarantee the right to reading, each person's access to culture. But, according to the 'I'–'you' interaction, each viewer can bring her own frame of reference.

THE NEED TO READ

The point I am trying to make is not that 'reading' is inherently richer, more pertinent, or more subtle than any other mode of looking. I am contending that every act of looking *is* – not only, not exclusively, but always also – a reading, simply because without the processing of signs into syntactic chains that resonate against the backdrop of a frame of reference an image cannot yield meaning. But endorsement of this basic semiotic principle, that is, awareness of the act of reading and the place of these factors in that act helps to come to terms with the difficulty of being confronted, as a woman, with the particular imagery that surrounds us and seems to impose its view – of us, on us. And, similarly, with the pressure that a simplistic view of 'history' puts on us to accept that 'that's the way things are' in our culture.

Instead of arguing, then, for an analogy between painting and language, I would like to discuss some of the tools that semiotics has developed, with or without help from linguistics; to examine how the idea of *reading* helps address questions of meaning and the power over meanings, without reducing the image to what it is not. Framing, and analysing the relevant frames, is one such tool. Anybody confronted with Rembrandt's *Blinding of Samson* (Figure 2.4) is shocked out of his wits, but nevertheless, it will be framed: seen as biblical image, the painting will emphasize the wickedness of the woman who, they say, enjoys her cruel victory, viciously obtained through lying, and for money. The cruel victory can be seen on her face, they say.

Refusing that framing forces the viewer to revert to the image and look again. Doing that, I happen to be unable to see such cruelty on the face; I rather see shock, the same shock as my own.

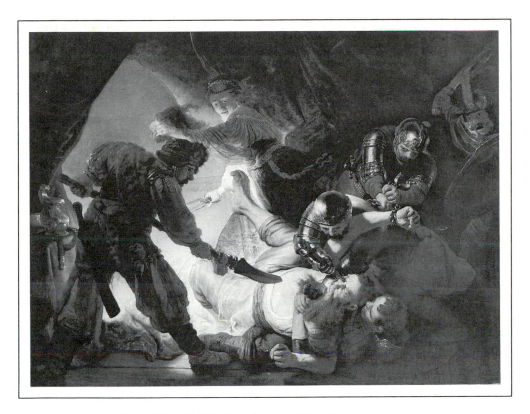

Figure 2.4 Rembrandt van Rijn, *The Blinding of Samson*, 1636, oil on canvas.
Frankfurt am Main, Städelsches Kunstinstitut

But the framing of the work by the doxic memory of an unread biblical story does the job for whoever is, by such a frame, *predisposed* to see it. One can also frame it totally differently, as a representation of pure pain. Unlike the doxic-biblical one, which is, in this case, misogynistic, such a frame is, say, humanistic, and as a result, the misogyny recedes a bit. Or one frames it as a statement on blindness, an obsession for visual artists, and emphatically so in Rembrandt.[10] Vision is at stake then, and the work's horror becomes self-reflexive. One can easily see how the intersection of these frames can help us in dealing with a work such as this without staying confined in the tautological exclamation 'the horror! the horror!' that was so confusing in one of English's literary masterpieces, Conrad's *Heart of Darkness.*[11]

Framing is a constant semiotic activity, without which no cultural life can function. Trying to eliminate the activity of framing is futile, but it does make sense to hold readers accountable for their choices of frame. Framing an image of body-building on the cover of a magazine devoted to that sport, for example, is unambiguous: the male body is exposed as a proud product of sport, and the magazine format of its presentation frames the image as 'popular culture'. To counter this, to elevate his sport to an art, Arnold Schwarzenegger had black-and-white photos made of his body, and exhibited these in an art gallery. You can easily see how the image now interacts with a discourse of high art. Such framing can go on within the representation itself; in one photograph (Figure 2.5), the figure of the body-builder has adopted a pose that is not only readable within the idiom of high art, but of a particular class of high art: mythological history painting. The Olympic

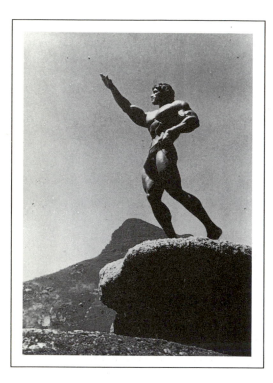

Figures 2.5 & 2.6 George Butler, *Arnold Schwarzenegger*, photographs

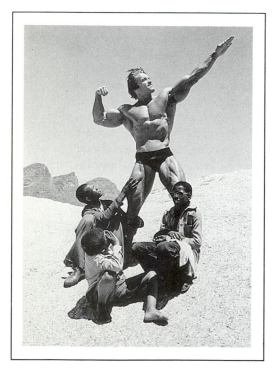

pose turns the athlete into a god, a god who, we read on, owns the land that surrounds him, to his glory. No other people populate that land.

Well, that's not quite true (Figure 2.6). Standing where he stands, with the Table Mountain as a background, the figure re-enacts the conquest of South Africa as if it were empty space instead of populated. Suddenly, the image becomes ironic; the dominating position of the athletic hero over the admiring black boys, highly embarrassing. An embarrassment, I am happy to say, that the hero is paid back for in another image where, beheaded, he becomes objectified by a slightly amused female look cast on him by two elderly ladies sitting on a bench when he jogs by (Figure 2.7).[12]

Analysing the way images are, and have been, framed helps to give them a history that is not terminated at a single point in time, but continues; a history that is linked by invisible threads to other images, the institutions that made their production possible, and the historical position of the viewers they address. The advertisement (Figure 2.8) for a sound system makes a good case. And since this is 'popular culture', not 'high art', one isn't interested in intention; moreover, since it is an advertisement, effect is more relevant.

The festive atmosphere speaks to the consumers' desire to enjoy themselves, and some of these viewers will be more sensitive to the suggestion of free time, others to sunshine, yet others to travel, things that, the image suggests, one can actually buy.

Although one could spend hours on the subtleties and complexities of this ad, I would like to draw your attention to the representation of framing itself. The three smaller images on the lower half all represent some form of 'exotic life': the very life whose attractiveness is supposed to appeal to the viewer. But this 'life' is represented *as* framed, imprisoned, captured and exported; these forms of life are snapshots. But thus they emphasize the other framing that goes on: the joys of simple fishermen, the beauty of an exotic girl, the honest craft of a society unspoiled by industrialization: all aspects of the confining, condescending clichés through which our culture constructs its 'others'. They are framed as well as fixed.

The main image, the upper one, takes up the central place and, within it, the white woman, who is as central as the reflected royal couple in *Las Meninas*. Welcomed in her white dress to sing and dance with black people whose garb is also as white as possible within the confines of the stereotypical colourfulness betokened by red ele-

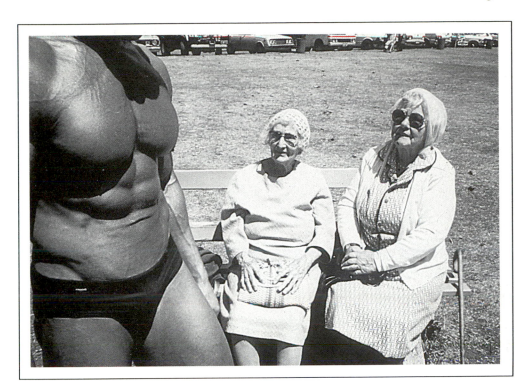

Figure 2.7 George Butler, *Arnold Schwarzenegger*

ments, the white woman clearly serves as the focus of the image, the point of entry, the Medusa head that draws us in and confounds us. Her place in the image is a matter of *syntax*, another useful tool that semiotics has to offer. Of course, art historians call that composition. The difference, however, is important.

Syntax refers to the structural relationship between elements, and so does 'composition'; but the elements connected by syntax are considered *signs*, and processed as such. Seen as a composition, the image shows pleasure in interracial intercourse; but semiotically speaking, as readable 'text', it is problematic in its syntax, which makes composition significant. The central position of the white woman is, then, a sign of her central position in the world. The fact that she is cheered by the black men recalls Roland Barthes' analysis of the black soldier saluting the French flag as a sign of his submission to colonialism (1957). With the image thus framed the verbal slogan that accompanies the image is so disturbing, it becomes highly ironic: 'Make them yours forever.' It refers interdiscursively to the two discourses of appropriation: colonialism and marriage. As it turns out, these discourses are the actual ground on which the image's effect is fixed.

Guess what, or who, the 'them' becomes through such interdiscursive feeding. Through it, the white woman becomes an ambiguous sign where these two discourses cross: subject of the colonial appropriation, she is also, syntactically, part of the image to be appropriated – by the viewer, enticed to buy this particular audio equipment, and, in fantasy, power over whatever it is that attracts him most in the image.

For the ad caters to a variety of tastes. And the syntactic principle alerts us to the presence of tiny visual elements that might be taken as random visual 'noise', quite normal in photography, but that, in an exercise of reading, become meaningful. What to think, for example, of the small element visible

between the legs of the second dancer on the right? The tiny sign I want to point out is syntactically positioned like an embedded subordinate clause within a sentence. In the distance, far from the represented carefree world of pleasure, we see the bent-over body of a gardener in tight blue jeans. Seen from behind, this black man is planting; the history of plantations creeps up. I will refrain from speculations about what fantasies this tiny figure can arouse: slavery, a man taken from behind suggesting a passive homosexual position emphasized by the tight jeans he is wearing, but I choose to read in it the inevitable presence of, and submission to, work in a world which offers pleasure for sale.

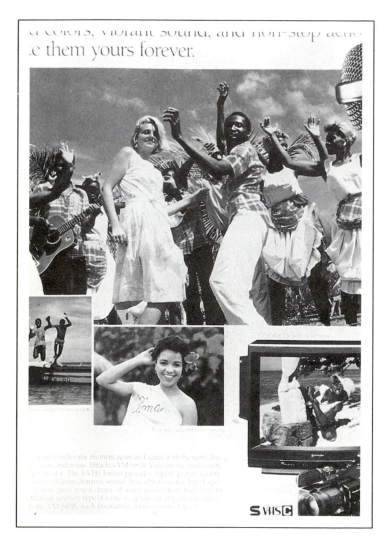

This reading was based on the visual elements of the ad, and in it I made use of semiotic tools for reading: frames and interdiscursivity; syntax and signs. The point is: no element can be dismissed as meaningless. The result, or product, of my reading is something like a statement: a propositional content I attributed to the ad, activating it, putting *it* to work. By making, perhaps making up, a propositional content for an image, I am opening up the possibility that images can produce meanings normally denied to the visual. They can signify contradictions; they can respond negatively. Negation is one of the elements of language that seem hard to visualize. Burke said that images could not negate; nor, said Freud, can dreams. Freud offered the proposition that the presence of contradictory elements together make up a denial. I think that is not even necessary; denial can be represented visually.

A drawing of Judith does precisely that (Figure 2.9). Negation becomes part of the message as soon as pretext and interdiscourses are taken into account, and, as I argued above, framing inevitably does that, so that these interdiscourses are inherently part of the processable image. The drawing allegedly represents Judith. As soon as we hear the name or see the scene,

Figure 2.8 *'Make them yours forever'*, advertisement

we are already, willy-nilly, involved in the frame of biblical heroism, cultural misogyny, the conflict of loyalties where this woman is heroic for killing the enemy and lewd for trapping a man through sex.

But one can hardly deny that another relevant frame is narrative; not a particular narrative, but the abstract, structural idea of narrative. This is an image which we process by imagining a story.

Things happen. One of the things that happens is that a woman is cutting a man's throat. One might speculate about the *care* her facial expression seems to convey. But I want to draw attention to the small signs the syntactic structure includes in the image: the two soldiers outside.

As narrative elements, the soldiers function on different levels. In the fabula, they fail their duty to stand guard. In the story, they represent focalization, the narrative equivalent of perspectival centring. The event happening in the foreground is not being *seen*. In the text, they serve as rhetorical figures, again in different ways. Synecdochically, that is, as part representing the whole, they signal the military frame in which the event happens, and from which it derives its meaning. Thus, the figures of the soldiers drive home the important point that Judith is being heroic, not lurid. Metonymically, that is, as signs of what comes next, they signify that she is in danger of being caught in the act. As metaphor, the soldiers represent distraction, a statement on vision and its difficulty; a narrative form of blindness. All these readings of the soldiers converge, perhaps. But they also demonstrate the readerly quality of images.

READING THROUGH, SKIN DEEP

Let me give one last example of the point of *reading* images; one that undermines the notion that images depend on their maker's intention. This here (Figure 2.9) is a crayon drawing by Dutch contemporary artist Treska van Aarde. It represents a young girl. Needless to point out the elements in the image that show that the girl is in a state of horror. The mouth seems to scream, the hair is raised, a hand holds her slim throat. Less conspicuous elements are the transparent representation of her face and body. So far, there is no particular need to 'read' the image. But why not give it a try?

If we assume syntax, the elements must be taken to have meanings that are related. The thin throat overlaps with the thin handle of what could be a mirror, the triangle covering

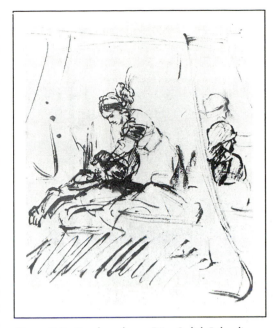

Figure 2.9 Rembrandt van Rijn, *Judith Beheading Holofernes.*

Figure 2.10 Treska van Aarde, *Me and My Father.* (property of the artist; handled by Stichting Beeldrecht, The Netherlands)

her breast being its base. The screaming mouth puns, then, with the mirror itself. Colour, the insistent brightness of the ground and the colourlessness of the figure, must then also be signs. Signs, not 'pure' visual elements but units that produce meaning. When we begin to interpret the meaning of these signs we are crossing the border that separates art history from semiotics.

The consequence of that border-crossing is that iconography yields to intertextual reading.[13] Various intertexts can be invoked as products of the discourses to which this image responds. Within the discourse of representations of children, for example, there are Ingres' chubby cupids, attractive, with appealingly soft skins, happily celebrating female beauty when they accompany Venus rising from the sea. Such beauty is often called 'female sexuality'; it is obviously thus misnamed, for such images are primarily invoking male sexuality – the sexuality to which they appeal. The cupids, here, are children as seen by adults. Over against such children, Van Aarde posits her girl. The girl Van Aarde represents is shown as seen, experienced, by herself. She it is who holds up the mirror the cupids hold up for Venus. Venus's discourse is thus evoked and responded to; the discourse where female narcissism thinly veils male desire is equally questioned. What this girl sees in her mirror is not available beauty, as, for example, in Velázquez' Venus, but horror; a horror that she cannot even see.

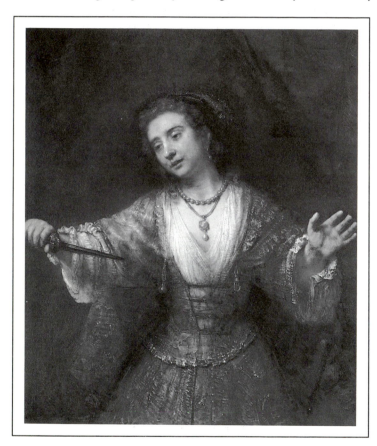

This is where we cannot miss the notion of reading. So far, one may want to call the procedure iconography. The black hole before the girl's mouth refers to the mirror that is Venus' traditional attribute, the sign of woman's vanity. But then it becomes necessary to read interdiscursively. For 'Venus before the mirror' is not just a tradition of images. That tradition derives its meaning from a discourse that backs it up. And the 'discourse' in which this traditional mirror functions – gets its meaning – is the one of male sexuality. Women's vanity is a desired feature of women, it takes good care of their beauty, and it shows that they care, which suggests they make that beauty available.

Figure 2.11 Rembrandt van Rijn, *The Suicide of Lucretia*, 1664, oil on canvas.
Washington, National Gallery of Art

But Van Aarde's girl doesn't see her face. The mirror loses its realistic illusionary reference and only keeps its ideological one. The interdiscourse is complex; two different intertexts play. Van Aarde's mirror speaks, not just to the presumably pleasurable gaze of a beautiful woman contemplating her trade, but also a woman who suffered lethal damage from it. The mirror responds to Rembrandt's Lucretia's false mirror. In the *The Suicide of Lucretia* in the National Gallery in Washington (Figure 2.11), the woman who is about to kill herself after, and because, she was raped,

holds the dagger as if it were a mirror. Thus, that image represents a perverted Venus tradition by showing the mirror not as an instrument of self-reflection but as one of self-immolation; the mirror not as supporting beauty but as an alien and hostile construction.

Van Aarde's mirror is more than iconography; it is not a stylistic bow to predecessors, but a meaning-producing engagement with the discourse that sustains that tradition. It is reframed as that which surrenders the girl: 'beauty' puts her at risk. At the same time, the mirror covers her mouth, preventing her screams from going out, from being heard. The mirror/sign of 'beauty' *is* her mouth. Indeed, if one combines these meanings, the only possible interpretation imposes itself: this work represents a girl whose substance as a subject has been destroyed – the transparency – by a horrible violence done to her, in the name of her 'beauty', and the locus of that violence was her mouth. Van Aarde made this image without thinking what she was doing; she didn't know what it meant. Indeed, as a reader of her own, intuitively produced image, the artist *discovered* something about her own history that she didn't know. She read in the image her hands had made that, in a long-buried past, she had been repeatedly orally raped by her father. That didn't leave her much room to gaze fondly at her beauty.

The work was made as part of a creative therapy; the woman suffered from serious incapacitation and had sought help without knowing what troubled her. She was put to work with paper, paint, crayon. When she saw what she had made, she was seized by the message: she read her own work as something outside her, as, precisely, such a mirror that turns her into a 'third person'. Its readability made it possible for her to re-emerge from the timeless mud of trauma. She thus read her own soul. The work was her memory; her forgetting had caused her incapacitation.

READING HISTORY

To put it strongly, if provocatively: 'reading' art is a subjective act, but it is not idiosyncratic. Instead, the image becomes a meeting ground where cultural processes can, precisely, become *inter*subjective. It is an act that requires the present tense to interact with the past tense. It is an act that declares the image and even its tiniest elements to be saturated with meaning, its semantic density constituting its social, cultural relevance. But, and this is perhaps the most important aspect of such a view, precisely because of this density, the image loses its apparent coherence. Small elements turned into signs can subvert the overt, overall meaning so as to inscribe something that didn't seem to be there, yet appropriates the image for a counter-message, a counter-coherence.[14] As we have learned from early semioticians, difference reigns amongst signs, constitutes them. If art history considers an element as not-fitting it tends to construct it as alien, a later addition, for example. Reading capitalizes on such elements, in contrast.

Where does that leave art history, or, in other words, how can art history relate to such a view? By the contingencies of history, the study of art got the name 'art history', unlike, for example, literary studies. As a consequence, the historical perspective is one out of several elements in the latter, the overwhelming one in the former. Although I am more at ease with a discipline where history is not an *a priori* but a framework that puts it up for constant evaluation and readjustment than with one where its place is dogmatically ascertained, I am myself keen enough on the historical accountability of what we do to be able to accept that 'history' is the rule of the game. But what 'history' means is another question.

My partiality to reading is an attempt to integrate the questions of the social history of art, lucidly phrased by Griselda Pollock as 'what made this possible', with an enquiry into what that deictic little word 'this' means.[15] Deictic elements refer to the situation of utterance; 'this' means nothing outside a context, a situation, in which a finger can be pointed. That situation is historically situated, inexorably, in the present. The present is historical, too. 'This', then, is not just the painting someone in the present points to, but the relationship between historically situated

viewers and this object that came to us from the past but is now here. It inevitably imposes the present tense on the verb: what *makes* this possible.

The concept of history has been thickened by philosophers and writers who questioned its simplicity. Walter Benjamin argued that history is inevitably altered by our memorization of it. Many of you know the famous story by Jorge Luis Borges, 'Pierre Menard, Author of the Quichote'. The story is a paradigmatic example of a postmodern literature that questions the foundations of its own art.

Pierre Menard is a deceased poet who had verbally transcribed portions of Cervantes' *Don Quichote*. The narrator states that, although verbally identical to Cervantes' text, the transcription by Menard is 'almost infinitely richer'. He then goes on to demonstrate how that is possible by comparing a half-sentence. I will quote a rather long stretch of Borges' text:

> [Cervantes] wrote (part one, chapter nine):
>
> . . . truth, whose mother is history, rival of time, depository of deeds, witness of the past, exemplar and adviser to the present, and the future's counsellor.
>
> Written in the seventeenth century, written by the 'lay genius' Cervantes, this enumeration is a mere rhetorical praise of history. Menard, on the other [hand], writes:
>
> . . . truth, whose mother is history, rival of time, depository of deeds, witness of the past, exemplar and adviser to the present, and the future's counsellor.
>
> History, the *mother* of truth: the idea is astounding. Menard, a contemporary of William James, does not define history as an inquiry into reality but as its origin. Historical truth, for him, is not what has happened; it is what we judge to have happened. The final phrases – *exemplar and adviser to the present, and the future's counsellor* – are brazenly pragmatic.
>
> The contrast in style is also vivid. The archaic style of Menard – quite foreign, after all – suffers from a certain affectation. Not so that of his forerunner, who handles with ease the current Spanish of his time.
>
> (Borges 1962: 69)

Borges' Menard has, the narrator says towards the end, 'enriched, by a new technique, the halting and rudimentary art of reading: this new technique is that of the deliberate anachronism and the erroneous attribution' (71).

Of course, what this fictional story proposes is not that we all start to copy historical works in order to update them. But there is an interesting point to make about the reversal Borges' narrator operates, without really saying so, between writing and reading. Writing, and by extension, painting, is an act of reading, and reading is a manner of rewriting or repainting. And such acts, Benjamin knew, don't occur in 'empty' time but in a time filled by the present. In the present, social agents, subjects with more or less easy access to the codes that direct the cultural integration of images, confront images and see mirrors held up to them. How to read, that is, how to give meaning to messages one vaguely senses but fails to analyse when only dogmatically restricted methods are consecrated as 'historical' or 'visual' enough: that seems to me a valuable contribution of semiotics to the understanding of art; art, not as a fixed collection of enshrined objects, but as an ongoing, live process. For some, even life-saving, for others just enlivening, for us all, part of life.

Notes

1 'Le portrait de face dédouble et anime visuellement, figurativement, la corrélation de subjectivité Le modèle est "je" et "tu" et son spectateur "tu" et "je" (Marin 1988: 86).

2 I have further developed this reading of Medusa in *Double Exposures* (1996).

3 The best reader of that book was Griselda Pollock (1993).

4 An exception is Pollock (1992). See also 'His Master's Eye' in Bal (1996).

5 Of course, their sex is not 'really' indeterminate; the figures are both women, and as far as the image evokes a sexual reading, the sexuality represented is lesbian.

6 This example is mentioned by Svetlana Alpers (1988). For a study of Rembrandt's self portraits, see H. Perry Chapman (1990). A semiotic perspective on his self portraits, related to psychoanalysis, is proposed by Bal (1991).

7 See his two best-known articles on this problem (1983; 1988a).

8 Foucault (1973). On Foucault's views of visuality, see Rajchman (1988) and Jay (1993).

9 Rather than ask the obvious question why seeing, thinking and speaking should be identical in structure, I want to address the symptomatic choice of examples. Searle's example of the 'I think' structure in fantasy is problematic; his 'I say' example is highly surprising.

10 On blindness as a self-reflexive theme in Rembrandt, see Bal (1991: 286–360).

11 Not coincidentally, this tautological confinement tends to reinforce sterotyping and 'othering'. Here, the blind and blinding horror automatically blames the woman figure; in *Heart of Darkness*, the horror is textually ambiguous but in the reception, easily translated as horror of black Africa.

12 On body-building in relation to cultural constructions of masculinity, see ch. 5 of Van Alphen (1992).

13 On the overlap and the distinction between these two methods, see Bal (1991: 177–215).

14 On the importance of constructing counter-coherences, see my study of the biblical book of Judges (1988).

15 Pollock, oral communication.

References

Alpers, Svetlana 1988 *Rembrandt's Enterprise: The Studio and and Market*, Chicago: University of Chicago Press.

Alphen, Ernst Van 1992 *Francis Bacon and the Loss of Self*, London: Reaktion Books.

Bal, Mieke 1988 *Death and Dissymmetry: The Politics of Coherence in the Book of Judges*, Chicago: University of Chicago Press.

——1991 *Reading 'Rembrandt': Beyond the Word–Image Opposition*, New York: Cambridge University Press.

——1996 *Double Exposures: The Subject of Cultural Analysis*, New York: Routledge.

Bal, Mieke and Norman Bryson 1991 'Semiotics and Art History', *Art Bulletin*, 73, 2, 174–208.

Barthes, Roland 1957 translated by Annette Lavers, Paris, Editions du Seuil.

Borges, Jorge Luis 1962 'Pierre Menard, Author of the Quichote', in *Labyrinths*, 62–71, Harmondsworth: Penguin Books.

Butler, George 1990 *Arnold Schwarzenegger: A Portrait*, New York: Simon & Schuster.

Chapman, H. Perry 1990 *Rembrandt's Self-Portraits*, Princeton: Princeton University Press.

Foucault, Michel 1973 'Las Meninas', *The Order of Things*, translated by Alan Sheridan, 3–16. New York: Vintage Books.

Innis, Robert E. (ed.) 1984 *Semiotics: An Introductory Anthology*, edited with Introduction by Robert E. Innis, Bloomington: Indiana University Press.

Jay, Martin 1993 *Downcast Eyes: The Denigration of Vision in Twentieth-Century French Thought*, Cambridge, Mass.: Harvard University Press.

Marin, Louis 1983 'The Iconic Text and the Theory of Enunciation: Luca Signorelli at Loreto (circa 1479–1484)', *New Literary History*, 14, 3, 253–96.

——1988a 'Towards a Theory of Reading in the Visual Arts: Poussin's *The Arcadian Shepherds*' in Norman Bryson, ed., *Calligram*, 63–90, Cambridge: Cambridge University Press.

——1988b 'Contrepoints', in R. Court *et al.*, *L'effet trompe-l'oeil dans l'art et la psychanalyse*, 75–104 , Paris: Dunod.

Pollock, Griselda 1993 Review of Bal (1991), *Art Bulletin* 75, 3, 529–35.

——1992 *Avant-Garde Gambits 1888–1893: Gender and the Colour of Art History*, London: Thames & Hudson.

Rajchman, John 1988 'Foucault's Art of Seeing', *October*, Spring, 89–117.

Searle, John 1980 '*Las Meninas* and the Paradoxes of Pictorial Representation', *Critical Inquiry* 6, 477–88.

Steinberg, Leo 1981 'Velásquez' *Las Meninas*', *October* 19, 45–54.

——1983 *The Sexuality of Christ in Renaissance Art and Modern Oblivion*, New York: Pantheon Books.

Chapter Three

The knotted subject:
hysteria, Irma and Cindy Sherman

Elisabeth Bronfen

While literary and cultural studies in the 1980s explored the potential of post-structuralist termi-
nology in an effort at describing how the subject – grafted onto a complex network of significatory
difference, deferral and displacement – came to embody and perform gender constructions, con-
cepts such as emplacement, ensoulment, coherence, closure, ethics and moral commitment seem
to be emerging as the compelling concern of the 1990s. In an essay called 'Identity and the Writer'
A.S. Byatt notes:

> Lately – and I think this is a cultural observation – I've replaced the post-romantic metaphor with one of a knot. I see
> individuals now as knots, in say, the piece of lace that one of Vermeer's lacemakers is making. Things go through us –
> the genetic code, the history of the nation, the language or languages we speak . . . the constraints that are put upon us,
> the people who are around us. And if we are an individual, it's because these threads are knotted together in this par-
> ticular time and this particular place, and they hold. I also have no metaphysical sense of the self, and I see this knot as
> vulnerable: you could cut one or two threads of it . . . or you can, of course, get an unwieldy knot where somebody has
> had so much put in that the knot becomes a large and curious, and ugly object. We are connected, and we also are a
> connection which is a separate and unrepeated object.
>
> (1987: 26)

I have chosen to quote A.S. Byatt at length because she articulates a shift in concern I will seek
to explore in this chapter, namely the transformation *from* emphasizing how a subject is inscribed
by multiple codes and understands her or himself as a result of this inscription, with each indi-
vidual subject to the symbolic discourses and representations of a given cultural context, *to* an
emphasis on the subject's particularity, to the very specific individually differentiated form of knot-
ting the subject. The pun contains the seminal ambivalence I am concerned with – connection
and negation – so that the point becomes not *that* the subject is split and multiple, but *how* this
multiplicity offers a new form of integration. For in the metaphor of the knotted subject one has
an image for the condition of being culturally determined, of an insertion in the symbolic, with
identity resulting from the inscription of cultural representations. At the same time this choice of
metaphor raises the issue of specificity or particularity, the uniqueness of each cultural determina-
tion. In so doing Byatt ultimately argues in favour of an integrated subject. Now, I find her metaphor
so compelling precisely because it allows me to move beyond a notion of the subject as exclusively
constructed by representations, indeed beyond the conventional postmodern dictum 'all is repre-
sentation', even as it doesn't deny the supremacy of symbolic inscription.

At the same time Byatt raises, albeit obliquely, another issue – the notion of constraint and vul-
nerability. In that sense, also, I find her metaphor compelling because I want to suggest that as we
move away from the conventional postmodern notion 'the simulacrum is all the reality we get' in
favour of a concept of subjectivity that argues for individual integration and uniqueness, we must
consider another element left out of the exclusive privileging of the simulacrum – namely the way

our body makes us vulnerable, the constraint our mutability imposes on us. Shifting our critical interest in this direction allows another moment of the unique in each subject, of the unrepeatable separate connection of the individual, to come to the fore. In one of the crucial marks of post-structuralist criticism, namely Derrida's famous claim for dissemination against Lacanian determination, as this emerged in their debate over Edgar Allan Poe's tale 'The Purloined Letter', the former countered the notion of fate addressed by Lacan when he suggested that 'a letter can always not arrive at its destination . . . that it belongs to the structure of the letter to be capable, always, of not arriving' (in Muller and Richardson 1988: 187). The post-post-structuralist critic (if you will allow me to designate him as such), Slavoj Zizek, counters shrewdly by inserting into the picture precisely the category so fundamentally neglected by post-structuralism, namely the notion of the Real. He suggests:

> We can say that we live only insofar as a certain letter (the letter containing our death warrant) still wanders around, looking for us . . . such is the fate of all and each of us, the bullet with our name on it is already shot . . . at the end of the imaginary as well as the symbolic itinerary, we encounter the Real.
>
> (1992a: 21)

That is to say, if I focus on the issue of the knotted subject I do so to emphasize that the cultured subject not only fades before the diacritics of the symbolic field that dictates its subjugation to language and cultural codes, i.e. subjects itself to symbolic castration. Rather there is another fading which I want to call 'real' or 'material' castration. The cultured subject also fades before the real law of mortality, so that with birth mutability inscribes all human existence. As the narrative of the Oedipal trajectory teaches us, sexual and symbolic castration stand in for a real lack. By being subject to symbolic laws *and* sexual anatomy, to representations *and* to the body, each human being is particular and connected precisely because subject to individual death. The inscription of mortality at birth – ironically called the great leveller – also marks the singularity of each mortal existence. Therein lies the crux of the ambiguity between connection and negation implied by the notion of the knotted subject.

Following Byatt, who says that 'the metaphor with which one thinks of one's self has much to do with the way one constructs both one's life and one's art' (1987: 26), I would like, in what follows, to pursue this metaphor of the knotted subject in order to discuss how the subject's self-representation involves a counter-directional movement that balances integration and dissolution, connection and negation, coherence and difference, that points to the vulnerability inhabiting the particular. To do so I would like to raise yet another theoretical point by returning to the critical categories developed by Roland Barthes in his 'Introduction to the Structural Analysis of Narratives'. I choose Barthes discriminately precisely because, even though we tend to think of him as the theorist of desire, deferral and dissemination *par excellence*, he was always also interested in analysing and describing what holds a narrative and, given that we construct our identity through narratives, what holds the subject together.

In this article, starting with the premise that any discourse is a long 'sentence', Barthes argues that any structural analysis involves distinguishing several levels or instances of description, and placing them within a hierarchical (integrationary) perspective. To understand a narrative, he claims, 'is not merely to follow the unfolding of the story, it is also to recognize its construction in "storeys", to project the horizontal concatenations of the narrative "thread" onto an implicitly vertical axis' (1977: 87). The three levels he proposes – *functions* (irreducible units), *actions* and *narration* – are bound together according to a mode of progressive integration, or to remain with our metaphor, a process of knotting. Similarly, I want to add, the individual is constructed of storeys – precisely the genetic and cultural codes, bound together by a process of integration to the language of the body.

Crossing psychoanalytic with structuralist discursive models, Barthes explains that the 'essence of a function is, so to speak, the seed that it sows in the narrative, planting an element that will come to fruition later', a polyvalent detail whose final meaning is fixed only once the narrative is considered as a whole. But even at the most basic level, Barthes distinguishes two narrative forces. Units either have correlate units on the same level, belonging to what he calls the distributional function and involving a metonymic relata, or their saturation requires a change of level, so that they belong to the class of integrational functions and they form a metaphoric relata. In the act of interpreting, we treat each narrative element both as a polysemic detail, which spreads its meaning in a seemingly unrestrained manner on the selective level of each individual sequence, even as we try to integrate each individual narrative moment into a coherent meaning on the combinatory level of narration. That is to say, by virtue of an interpretive gesture, details on the distributional axis are knotted together on the higher level of narration, so that the structural trajectory of each narrative analysis moves from an interpretation of the distributional form to the production of an integrated meaning. Integration joins what has been disjoined, guides the understanding of discontinuous elements, simultaneously contiguous and heterogeneous. Narrative – and analogously any construction of identity employing narrative – works through the concourse of two movements. In a gesture of sublimation, it 'recovers itself, pulls itself together', while in the counter-gesture of desublimation 'the structure ramifies, proliferates, uncovers itself' (1977: 122). What a return to Barthes' enmeshment of the integrational and distributional axes affords for our discussion of identity and representation, I suggest, is not only a recognition that a distributional free play of signification always also calls for the necessity of integration, but also the vulnerability of such knotting, i.e. an awareness of the way that any gesture at integration, even as it is fundamentally necessary, also constructs itself over and out of what I have already invoked by virtue of the Lacanian category of the Real, the negating ground and vanishing point of imaginary and symbolic processes.

With these framing questions installed, I wish to discuss two examples that introduce the issue of gender and feminine subjectivity into my general discussion of representation and the knotted subject. First the reconstruction of hysteria at the beginning of our century, in the early writings of Freud, where indeed Freud's own self-representation both as analyst and as object of analysis lets him identify with the voice and the symptoms of the hysteric, indeed places him into her position. Then, in a second move, I will discuss a return to hysteria as a strategy of artistic self-expression at the end of our century. Here I follow Juliet Mitchell, who rejects the notion of an authentic woman's voice, arguing instead for

> the hysteric's voice, which is the woman's masculine language . . . talking about feminine experience. It's both simultaneously the woman [artist's] refusal of the woman's world – she is after all an [artist] – and her construction from within a masculine world of that woman's world.
>
> (1984: 290)

For this second example I will present the work of the American photographer Cindy Sherman, who self-consciously uses the spectacle of her body to deconstruct representations of femininity. My interest will be to show how Sherman's self-representation, like Freud's, employs the language of hysteria.

My interest in hysteria, to clarify this before starting, lies precisely in the fact that it is considered to be a so-called 'disorder' that performs the problematic relationship of identity, gender and representation. The English physician Thomas Sydenham, one of the first to write on this illness during the period of the Enlightenment, propounds the notion that hysteria is an illness of imitation, it 'imitates other diseases', indeed imitates culture, given that, as G.S. Rousseau puts it, hysteria is 'produced by tensions and stresses within the culture surrounding the patient or victim . . . the symptom leading to the condition of hysteria "imitated" the culture in which it (the symptom) had been produced' (1993: 102). In a similar vein the nineteenth-century French psychiatrist Pierre

Janet apodictically calls hysteria a *maladie par representation*, where the histrionic somatization serves as a repetition by proxy of an earlier trauma. At the same time recent criticism, notably the work of Georges Didi-Hubermann, has shown that, as the hysteric uses her body to represent in converted or displaced manner traumas that have not been abreacted sufficiently, she performs to excess precisely the representation of femininity her culture ascribed to her. One could say she imitates and represents at her body the role-images of western art. Furthermore, the hysteric's self-performance in some sense is always self-reflexive in the sense that the hysteric is precisely one who has 'the tendency to experience herself and show herself in difference to the way she is, a quasi-altered self-representation' (cf. Mentzos 1980: 92). It performs an overt disjunction between 'true being' and 'appearance'. Thus the hysteric emerges as a seminal figure for a discussion of how the subject is constructed through representations, even as something in this imitation and perpetration of simulacra goes awry. The self-reflexivity of her psychosomatic performance continually draws our attention to how she knots together the representations within which she is emplaced in a fashion particular to her, and through this particularity moves beyond the realm of imaginary and symbolic inscriptions, indeed performs their limit.

My first illustration is a rereading of the specimen dream in Freud's *Interpretation of Dreams* – the dream of Irma's injection – because it serves as the linchpin for the way gender differences are written into the psychoanalytic project from the start, It is after all from the discourses of the hysteric – designated as an 'abnormal' speaking body, deviant because she resists a containment within clearly designated gender categories – that Freud gleans the first insights into the processes of the unconscious that will allow him to discover and develop theories on psychic and cultural representations and their interpretations. Seeking to establish his theory that dreams are in essence always a form of wish fulfilment Freud arrests his discussion by invoking the metaphor 'navel of the dream'. That is to say, in this inaugural dream-interpretation Freud has resort to this pivotal metaphor to illuminate the moment of psychic self-representation that marks the absolute specificity of the dreamer but with it that which resists interpretation as well. Invoking a knot that is cut and severed, this impenetrable moment of connection would lead Freud, so he thinks, 'too far afield', yet in its unfathomable and fatefully inevitable quality it is precisely this detail which suggests a story about individuation that enmeshes connectedness with vulnerability. That is to say, both Freud's self-representation and his critical technique are intimately linked with resistance to normative containment – thematically his identification with hysteria, rhetorically his invocation of the navel of a dream. And in so doing Freud, at the onset of psychoanalysis at least, unfolds a different story of the individual's acquisition of a self-representation marked by specificity – a narrative that does not limit itself to positioning the subject in relation to the phallus as privileged signifier of the symbolic, but rather also positions it in relation to the body in its mutability and the analyst's as well as the hysteric's responsibility towards this inevitable vulnerability. Gender here emerges as the moment that both inaugurates and resists an integrated narrative, even as it very definitely marks the point of connection between representation and the body.

Let us recall Freud's preamble to his interpretation. He explains that, although Irma was on very friendly terms with him and his family, her relatives did not look favourably at the psychoanalytic treatment he was giving her. In the course of analysis she had been relieved of her hysterical anxiety without, however, losing all her somatic symptoms. Yet she had been unwilling to accept the solution he had proposed and instead broken off the treatment. Freud's dream directly responds to the report of a junior colleague returning from the summer resort where Irma and her family were staying, stating that she was better, but not quite well – a report Freud reads as an implicit critique of his psychoanalytic work by his friend Otto, as this echoes the relatives' displeasure (they, incidentally, are also old-established friends).

In one sense he names directly what is at stake in his dream representation – a form of uncon-
scious self-representation, an attempt to knot desires and anxieties together over a sequence of
images – namely his reputation as a friend and as a theorist. This reputation is endangered by his
failure to relieve his patient of her bodily pains as well as by his failure to determine the right
moment of closure for this case history of hysteria, which we must remember is considered an ill-
ness by representation, an illness imitating culture. Freud's preamble, however, also articulates,
though more obliquely, how the resistance of his patient – both psychically in that she breaks off
the treatment, and physically in that her pain persists – takes away his power to terminate the case,
to integrate her pain and her hysteric self-representation into his narrative solution. Irma's resis-
tance 'castrates' him in the sense that it points to his vulnerability as an analyst, the moment of
failure in his interpretive system, that which eludes it. In the gesture of turning this failure once
again into an integrated narrative – writing out Irma's case history so that he can show it to Dr
M and build a new alliance confirming his authority as a scientist – the conscious Freud hopes to
gain power over what is experienced as a wounding of his analytic potency. Yet the unconscious
Freud responds with a dream that gives figure to precisely this moment of failure. The recupera-
tive interpretation is meant once again to patch up the wound. Yet in his interpretation Freud
resorts to a term, namely the metaphor 'navel of the dream' (1900–1: 111), and in so doing under-
takes a rhetoric gesture which I seek to privilege in my discussion of the knotted subject. The
rhetoric gesture I am concerned with is one of counter-movement, a simultaneous movement in
two opposite directions, enmeshing integration and dissolution.

The relevant passage in the dream is recorded by Freud in the following way:

> I took her to the window and looked down her throat, and she showed signs of recalcitrance, like women with artifi-
> cial dentures. I thought to myself that there was really no need for her to do that. – She then opened her mouth properly
> [Der Mund geht dann auch gut auf] and on the right I found a big [white] patch; at another place I saw extensive
> whitish grey scabs upon some remarkable curly structures which were evidently modelled on the turbinal bones of the
> nose.
>
> (1900–1: 107)

What we have here quite explicitly as one, though crucially not the only point of identification for
Freud in this unconscious self-representation, is the image of a female patient resisting an investi-
gation of her oral cavity and, upon submitting to Freud's gaze, presenting the spectacle of a void
marked by white scabs, which after all, are crustlike exudate or cracked dead tissue that cover a
healing skin wound. We must, however, bear in mind that Irma complains of pains in her throat
and stomach and abdomen choking her. It is precisely in order to discover the organic origin of
this sense of a knotted throat, indeed a knotted body, that Freud tries to visually penetrate the inte-
rior of Irma's body. We must also remember that later on in the dream representation, as Freud
and his colleagues investigate Irma's body they discover 'a portion of the skin on the left shoulder
was infiltrated'. Freud comments that this is the rheumatism in his own shoulder but, above all,
that the comment 'I noticed this, just as he did' was to be understood as 'I noticed it in my own
body'. This discovery Shoshana Felman in turn reads as Freud finding the hysteric's complaint
inscribed in his own body, leading to an identification between the two: 'The subject of the dream
is saying: I am myself a patient, a hysteric; I am myself creative only insofar as I can find a locus
of fecundity in my own suffering' (111). This in an oblique manner forms the epicentre of the
dream representation.

Starting then with the somatization of a knot, Freud interprets the figure of Irma as a represen-
tational knot – as his own psychic condensation of various women. An oral examination revealing
bad teeth allows Freud first of all to associate a governess he had treated in the past. She 'seemed
a picture of youthful beauty', he claims, but her opened mouth revealed 'false teeth' (109). Freud
presents this governess as an example of the way medical examinations may reveal 'little secrets'

that satisfy neither party. But I would argue that this governess could also refer to the *vanitas* tradition – where feminine beauty is shown as the illusory tissue that covers and diffuses the reality of the human body, namely its process of decay. Freud's term 'little secret' I then read as a metonymic displacement for bodily mutability. This image of a woman with bad teeth, usually pale, looking puffy and recalcitrant, is further decoded as a displaced representation of Freud's wife, though the footnote attached to this observation omits explaining that her 'pains in the abdomen' refer to his wife's pregnancy (Felman 1985). Once again, even as Freud decodes the composite parts of Irma, he elides what is obliquely at stake, namely the way the feminine body evokes anxieties about mortality, in that beauty hides decay and in that pregnancy proleptically invokes both the death of the maternal body and the mortality of the child. The third woman replacing the real-life Irma, who remains unnamed, is in turn a reassuring figure. She is an intimate friend of Irma's, also a hysteric, whom Freud wanted to treat. She also is reserved and recalcitrant. Since the hidden agenda of Freud's interpretation of this specimen dream is that he wants to lead to his dictum that 'a dream is the fulfilment of a wish', it is this third woman whom he privileges in his reading (replacing not only Irma, but also the duplicitously beautiful governess and the pregnant wife).

The explanation he offers for the exchange is the following:

> Either I felt more sympathetic towards her friend or had a higher opinion of her intelligence. For Irma seemed to me foolish because she had not accepted my solution. Her friend would have been wise, that is to say she would have yielded sooner. She would then have opened her mouth properly, and have told me more than Irma.
>
> (110–11)

The whitish grey scabs, in turn, are glossed by Freud as a composite index for his anxiety about a serious illness of his eldest daughter and his own ill health due to the use of cocaine. The misuse of cocaine was particularly troublesome for him because it had led to serious disorders in a patient and death in a friend.

Significantly, Freud situates his footnote exactly in between the comment about the feminine mouth that opens properly in a figurative sense so as to give him the solution he seeks, and his reading of the whitish grey spots that can literally be seen inside a woman's mouth, which he interprets as a condensed index for potentially fatal bodily symptoms. In this footnote he explains:

> I had a feeling that the interpretation of this part of the dream was not carried far enough to make it possible to follow the whole of its concealed meaning. If I had pursued my comparison between the three women, it would have taken me far afield. – There is at least one spot [Stelle] in every dream at which it is unplumbable [unergründlich] – a navel, as it were, that is its point of contact with the unknown [mit dem Unerkannten zusammenhängt].
>
> (111)

I want to argue that this footnote mediates two moments in which Freud's dream articulates his effort to construct an integrated self-representation over an experience of the vulnerability of such a construction. Furthermore, this footnote interjection separates what is syntagmatically combined in the dream narrative, namely the two images of the scar that remains after a wound – the navel and the scabs. The first refers to his need to acknowledge a point resisting interpretation in a dream representation, the second to Freud's helplessness before the possibility of fatal bodily disturbances. Irma's pain serves as this index of his own mutability. Furthermore, both the navel and the scabs refer to the feminine function, to an entering and/or being resisted by the dark interior realms of the feminine body. The footnote itself seems like a recuperative displacement. It puts closure on one moment of failure by turning it into a metaphor that signifies necessary curtailment of the analyst's ability. In a later passage Freud reiterates that the 'navel of the dream' marks that moment which 'has to be left obscure'. He justifies his interpretive impotence by stating that this 'tangle of dream-thoughts cannot be unravelled' because a reading of it 'adds nothing to our knowledge of the content of the dream', contenting himself instead with the figure of 'a spot where the dream

recedes down into the unknown' (525). However, this rhetorical shift is particularly salient, I want to argue, because the insertion of the footnote forecloses what it also foreshadows, namely the alliance between an 'unplumbable spot' leading 'too far afield' and 'reaching down into the unknown' on the one hand, and the greyish white spots that offer themselves specularly to Freud as he penetrates Irma's oral cavity, leading him down into the unknown of the body, and far afield from hysteria as the suffering of sexuality, into issues of hysteria pointing the way to bodily mutability on the other hand.

Shoshana Felman has persuasively argued that the navel of Freud's dream, knotting as it does three moments of feminine resistance, speaks the 'unaccountability of female difference', condensing the hysteric's non-acceptance of the analyst's solution and her pain to the issue of maternity and female sexuality. In this navel she locates Freud's discovery 'that resistance is a textual knot, a nodal point of unknown significance . . . that the psychoanalytic dialogue is a new way of reading and working with, the pregnancy of this unknown and the fecundity of this resistance' (1993: 118). The navel of the dream contains the counter-movement of connection and disconnection, for here Freud can construct a narrative of integration over a distributional detail (Barthes' categories) which 'separates as much as it unites'; a site he does not command and whose meaning he is not entirely in possession of. By emphasizing that 'the navel is a knot that is cut' and suggesting that its metaphoric value for Freud lies in the fact that it sanctions a theoretic blindness – 'to sever what cannot be disentangled' – Felman seeks to align Freud's 'navel of the dream' with de Man's 'prosopopeia': 'By which the dead are made to have a face and a voice which tells the allegory of their demise and allows us to apostrophize them in our turn' (1985: 122). The navel as the scar of a cut, as a knotted scar, commemorates that which is lost, namely the prenatal maternal body, which is dead, forgotten, unfathomable. When Freud resorts to the metaphor 'navel of a dream', what he does is apostrophize the lost maternal body, by turning the vanishing point into a figure of the unfathomable. He constructs a narrative, explicitly acknowledging that his interpretation was not carried far enough because he insists that the concealed meaning would take one too far afield. This rhetoric gesture of alleviating oneself of a responsibility is in turn the final interpretation Freud offers. He presents the dream as a cypher for his wish to be innocent of Irma's illness. Rhetorically, 'the navel of the dream' articulates and elides mortality as that which resists the interpretation. It does so, however, in the gesture of a counter-movement, knotting together and cutting off that dream material which seeks to articulate an anxiety about death.

Felman follows Freud in jettisoning rather than knotting together what is specularly at the very least the correlative of the metaphor 'navel of the dream', namely the whitish grey scabs. In this narrative about resistance, where a woman won't readily speak about her complaint, where a moment in a dream resists interpretation, these scabs mark a resistance on Freud's part which allows him to leave untouched those parts which he admits 'are not so obviously connected with my exculpation from Irma's illness'. These elided moments of the dream representation, furthermore, are significantly all indices to bodily ailments and potential mortality, namely his daughter's, his wife's, his own, his friend's – those vulnerable points in the knot of identity that thwart without entirely undoing its connectedness. However, if we focus not on the metaphor 'navel of the dream' but rather on its specular realization, the white scabs, we can reintroduce not only the theoretical notion of the limit of an investigation (that which has to be left obscure because it can't be unravelled) but rather precisely that which pierces an integrated narrative about how rhetoric replacement can produce exculpation, and as such the integrated self-representation of Freud resulting from it. What pierces this recuperative gesture is mortality as the final and urgent referent of all bodily disorders but also of all systems of representation. These scabs, interpreted and resisted by Freud, indicate the wounding to any sense of innocence or potency that the disorder of the body recalls and whose absolute master is in fact death. By jettisoning these scabs from his narrative, Freud rhetorically

stages their actual function in his dream. For one could interpret the open mouth of Irma as a dream representation of that limbo which leads to what Lacan calls the Real – in Freud's terms 'the spot reaching its depth down into the unknown' – with the whitish grey scabs representing the residue or remains of this Real, the *objet petit a* which Zizek (1992a) calls the traumatic.

The navel of the dream, the point of unique connectedness, is, I want to argue, split: a counter – movement. Irma, a representational knot (condensation) of three other women, signifying the enigma of Woman, draws the text into one direction; the scabs, symptoms for a body-knot and signifying mutability, draw the text into the opposite direction. The footnote self-reflexively marks the spot of the representation of representation. The double navel (the metaphor 'navel of the dream' and the representation of the white scabs) mediates between symbolic sublimation and desublimation, the return of the non-symbolized Real. The symbolic sublimation occurs as narrative interpretation transforms the lack of a signifier into a signifier of lack (the designation 'navel of the dream' to mark that which must remain obscure). The non-symbolized Real appears in the guise of a traumatic object-stain, the sight of the white scabs in Irma's knotted throat, non-symbolized because, even though these blots appear in Freud's dream-representation, he can find no interpretation for them.

As a biographical aside one can also note that, ironically or fatefully, Freud died of mouth cancer. If, in a sense, he embarks on the journey of psychoanalysis with a dream about the horrific vision inside a hysteric woman's mouth, his identification with this woman and his bonding with other male doctors, he ends with the illness inside his own mouth. The last photographs show this master-narrator of the unconscious with a bandaged mouth.[1]

In such a rereading, the moment of knotted subjectivity reflecting Freud – the figural knot pointing to the way a subject is the connection of various representations and the somatic knot pointing to the way the body makes all representation vulnerable – that is to say the navel-cum-scabs points not only, as de Man's prosopopeia suggests, to death as a rhetorical moment underlying the commemorative gesture of any image, but also points to real mutability as a traumatic truth which the integrated representation evades even as it refers to it. For to read this counter-directional moment – navel-cum-scabs – as a meta-representation illustrates precisely the double gesture through which subjectivity, vulnerability, connectedness and representation are mutually implicated.

At stake then, when we encounter the knot of the subject and of representation, lies the issue of vulnerability and the desire to reassert an integrated notion of connectedness, resistance of an enigma and its encroachment upon the subject, failure and exculpation, castration as it structures symbolic relations, sublimation as it diffuses the threat of the Real.[2]

Zizek (1992a) uses Lacan's terms to sketch two modalities of the way the primordially repressed Real returns in representations in the guise of an outstanding surplus element. He defines the *objet a* as a 'stain of the Real, a detail which sticks out from the frame of symbolic reality' while he defines the *phallus* as the master or surplus signifier. To distinguish these two modalities, he describes the former as a surplus of the Real over the Symbolic, the latter a surplus of the Symbolic over 'reality'. In my own discussion, the scabs function as the surplus of the Real over the Symbolic, the condensed representation of Irma and then the trope 'navel' in the footnote as the surplus of the Symbolic over reality. The latter, in the Freud text the dream, can be read as a symptom, signifying the return of the repressed, of which Zizek writes, 'what is excluded from reality reappears as a signifying trace on the very screen through which we observe reality' (238). The former, in Freud's text the scabs, signifies the return of the non-symbolized in the guise of a traumatic object stain. Of these two modalities Zizek writes, 'Vorstellungs-Repräsentanz designates a signifier which fills our void of the excluded representation, whereas a psychotic stain is a representation which fills out a hole in the Symbolic, giving body to the "unspeakable"' (239). Sublimation tames the Real, integrates distributional elements, turning the lack of a signifier (where words fail) into a

signifier for lack ('navel of the dream'). Functioning as a constitutive exclusion, sublimation is likened by Zizek to a 'primordial metaphor' which translates a non-symbolized stain into an empty signifier. At the same time a remainder of this excluded Real always eludes the significatory process, persists as a non-symbolized stain, to induce moments of desublimation. One can then say, sublimation allows the subject to knot itself into an integrated self-representation at the same time that the stain of this real knowledge persists to point to the vulnerability of this construction.

To speak of the knotted subject, then, allows me to designate the connection and mediation point between two modalities. In Freud's dream transcription and its interpretation we have on the one hand sublimation, namely his metaphor 'navel of the dream' and his interpretive narrative, which is representative for an excluded, unnameable representation. On the other hand, we have indexes of mortality, signifying the finitude where words fail, the facticity which grounds life. These are obliquely represented in Freud's dream by the white scabs visible in the void inside Irma's throat. The moment I wanted to highlight was precisely the counter-directional gesture which knots symbolic death, incrued by any troping or narrativization to real mutability, even as the knotting is also a form of severing; the oscillation between the *surplus signifier* (the phallic master-signifier of the symbolic function), and the *objet a* (signifier for the traumatic stain), as it is this counter-movement which grounds and perpetuates psychic and cultural representations. The epicentre of my interpretive narrative is the moment where the Real – trauma, mortality – encroaches on the field of representation.

If I now turn to Cindy Sherman's photographs as my second counter-example, I do so to illustrate precisely such a moment, where the viewer's gaze oscillates between an unbearable sight of the vulnerable body and a recuperation of this traumatic moment by virtue of the aesthetic coherence inherent in any representation and with it the integrated narrative an interpretation of this image affords. For what Sherman repeatedly stages are such traumatic disturbances connected to the body as it is turned into a series of representations that themselves hysterically perform the disturbance in the image/of the image. My interest in the dream of Irma's injection had to do with the way Irma's hysterically knotted body translates into an image for the vulnerable connectedness of Freud's dream and then analytic self-representation. My interest in Sherman is the way she performs a language of the body that moves ever more urgently towards the crisis of representation. The analogy I want to offer is that, as with the resistance of the hysteric's pain to an integrated analytic solution, here too the crucial effect is that of dissolution of the integrity of the image, a disintegration which nevertheless allows a particular voice to emerge.

I would like to speak of Sherman's self-representations as a hysteric language of the body because she performs – albeit self-consciously in the way the early patients of Freud did not – the disjunction between feminine identities traditionally offered by western culture and what feminine subjectivity 'actually' is. As Laura Mulvey argues: 'Because Sherman uses cosmetics literally as a mask she makes visible the feminine as masquerade' (1991: 142). In her first photographs, the *Untitled Film Stills*, she presents reconstructions of film scenes of the 1950s and 1960s – *film noir, melo, nouvelle vague* – in which she poses as the stereotypical heroine, indeed turns her body literally into a representation (Figures 3.1 – 3.4) In an uncanny manner she calls forth reminiscences of these films even though her photographs are pure simulacra – authentic copies without originals, the represented subject and the representing image identical. If the classic hysteric suffers from reminiscences, finds herself subject to belated memory traces whose origins are unknown to her, Sherman provokes, though now for the viewer, the analogous effect of being confronted with freely floating and overdetermined memory traces.[3] Above all, however, in so doing she presents the subject as a knot of given cultural representations precisely because the constructed subject is neither in reference to any one earlier representation nor in reference to herself as model but rather the

function of the act of self-representation, the nodal point of multiple identities. The subject appears to be wandering (and that, too, suggests a reference to the wandering womb of hysteria), appears to be not a firmly established character but the integrational sum or knot of curious disintegrational details.[4] That is to say, Sherman deconstructs the tradition of western iconography, which equates Woman with Image. She discloses the performance of femininity as a fake in the gesture of the hysteric's dissimulation – woman pretending to be somebody else, but never quite getting fully into the role.[5] She thus self-consciously demonstrates how her feminine subject exists only as

a knotting of signifiers, the integration of distributional details from our collective image repertoire without any material non-semiotic referent. As Rosalind Krauss (1993: 32) argues, the portrayed feminine subject is imagined and embodied by virtue of the function of the signifier, and as such her identity is the pure function of framing, lighting, distance and camera angle.

Sherman has repeatedly insisted that these photographs are not to be read as self-portraits, that indeed her identity emerges only obliquely as the conglomerate performance of her many masquerades, that beneath the surface of the photographic image no intact, authentic self can be found. This is a hysterical self-representation given that she articulates herself by taking on other bodies, by resorting to the histrionics of different self-fashionings and a *belle indifference* towards any one of them, traits Freud noted for his hysteric patients as well.[6] Indeed her self-explanation resonates with the language of the hysteric:

The level of energy brought to the otherwise faked emotions . . . leaves me drained. The only way I can keep objective towards the characters I'm portraying is to physically distance myself from the activity . . . I don't see that I'm ever completely myself except when I'm all alone. I see my life as a training ground because I'm acting all the time.[7]

Figure 3.1 Cindy Sherman, *Untitled Film Still no. 6,* 1977

Nevertheless, Laura Mulvey will argue that 'each of the women is Sherman herself, simultaneously artist and model, transformed, chameleon-like, into a glossary of pose, gesture and facial expression' (1991: 137). Judith Williamson argues against such an essentialist reading, suggesting that because Sherman offers a lexicon of represented feminine identities each image calls upon the viewer to construct the inextricability of femininity and the image. For her Sherman's work is

Figure 3.3 Cindy Sherman, *Untitled Film Still no. 54*, 1980

Figure 3.4 Cindy Sherman, *Untitled Film Still no. 56* 1980

neither exclusively a witty parody of media images of femininity, a deconstruction of the supremacy of the simulacrum, nor merely a series of self-portraits in a search for identity: 'the two are completely mixed up, as are the imagery and experience of femininity' (1983: 106). The knotted subject Sherman fashions herself into proves to be an enmeshment of representation and peculiarity. Where the classic hysteric performs femininity as a symptom without a clear lesion, Sherman, self-conscious and self-controlled, elicits the false search for a real, coherent, homogeneous identity – performs a *maladie par représentation*, given that we have 'a surface which suggests nothing but itself, and yet in so far as it suggests there is something behind it, prevents us from considering it as a surface' (1983: 102). Clearly we should question the univocal allegorical reading many critics offer of Sherman's work, such as Arthur Danto, who reads Sherman's photographs as the representation of the essential Woman, eternally the same amidst all her guises (1900: 11). He calls her a composite-heroine, an allegory for something deeper and darker in a collective mythic unconsciousness. Yet this is clearly an inadequate means of producing an integrated interpretive gesture, because far from knotting difference, such a reading seems to deflect the disturbance that emerges from Sherman's self-conscious staging of a stereotype by transforming it into a stabilizing tropic reading. On the contrary, these photos produce an effect of uncanny and irritating recognition that elicits precisely the gesture of counter-direction I am advocating. They seem to call for an interpretive oscillation between integrating the free-floating signifiers into a narrative that resorts to metaphors of danger, desire, fantasizing *and* acknowledging that the engendered composite is inhabited by an internal dissolution, the Real as ground and vanishing point of any representation and its interpretation. These photos perform that to be subject to representation means neither an image-produced falsification of the represented self (signifier without signified) nor an identity between image and self (transparency between signifier and signified) but rather the production of a connected identity by virtue of a dissolution in the image.

This move was in a sense only performed technically in the first two series of photographs (the untitled film stills, and the untitled rear projection stills), namely, as Krauss argues, by virtue of the lighting, the grain, the cadrage (1993: 56). In these photographs the depicted feminine figure, though a hysterical body representing representations, nevertheless remained intact as a body. In her later works, this move of counter-direction between integration and dissolution, sublimation and de-sublimation becomes both subject and strategy (Figures 3.5–3.7). Here the integrated subject fades almost completely, is distributed in a field of vision that compiles objects indexically pointing to the absent subject, appears as a fractured, wounded, disintegrated body, appears in the traces of abject body fluids, replaced by or supplemented with prosthetics, 'a monstrous otherness behind the cosmetic facade' (Mulvey 1991: 144). At the same time these photographs more explicitly allow a conflation between the depiction of the disintegrated body and a disintegration of the cohesive formal organization of the photographic image. They self-reflexively stage bodily fragmentation as an aesthetic principle, the horrific underside to hysteria as an illness by representation. The represented body, along with its form of representation, seems to be caught up in a movement of desublimation – dissolving, disseminating – yet in this dissolution nevertheless still connected. For in some sense each one of the photo series stages on the one hand the hysteric's proclivity to daydreaming and fantasizing,[8] on the other hand, the hysteric's oscillation between fixed identity positions: in response to the question 'Do I exist or am I the mere repetition of an image?' (in the *Untitled Film Stills*); in the *Centrefolds* the classic hysteric indecision 'Am I feminine or masculine?' (Figure 3.8), in her *Disaster* and *Fairy Tales* series 'Am I human or animal?' (Figure 3.9), 'Do I exist as an animate body or negate my existence through deanimation?' (Figure 3.10). It is precisely the gesture of oscillation that makes up Sherman's knotted subject.

Bryson has poignantly described the transformation in Sherman's work as that from the conventional postmodern notion that 'all is representation' to a reformulation of the body 'as horror',

Figure 3.5 Cindy Sherman, *Untitled no. 167*, 1986

Figure 3.6 Cindy Sherman, *Untitled no. 175*, 1987

Figure 3.7 Cindy Sherman, *Untitled no. 177*, 1987

Figure 3.8 Cindy Sherman, *Untitled no. 112*, 1982

Figure 3.9 Cindy Sherman,
Untitled no. 140, 1985

Figure 3.10 Cindy
Sherman, *Untitled no. 91*,
1981

from a notion that the simulacrum is reality to the breakdown of the simulacrum into a body of disaster (Krauss and Bryson 1993: 217). What I have wanted to present is the representation of the body, whose integrity is in the early series threatened, in the later series disturbed, and within an aesthetic strategy that duplicates this representational disintegration by performing the threat to the coherence of the representation itself, in that sense formally repeating the gesture of oscillation which characterizes the depicted hysteric's performance.

The analogy between Sherman's self-representation and Freud's is then the following: in the early *Untitled Film Stills* the composite heroine functions as a knot of representations and in that sense corresponds to the dream-representation of Irma, who in Freud's interpretation emerges as a knot of significant women in his life at the time (resisting and submissive patients, his wife, his daughter). The latter images turning surface beauty inside out to reveal the mutable bodiliness inhabiting and sustaining the integrated image in turn stage the counter-direction. They correspond to the other knot Freud represents in his dream, a knot which draws both the producer and reader of the representation from tropes of femininity to the non-semiotic body in its mutability – the specular horrific vision inside Irma's throat. The two positions are, then, on the one hand woman-as-fetish, a seemingly integrated body-symptom covering the truth of castration – the simulacra-heroines of the *Untitled Film Stills* – and on the other hand the truth of the human wound, its non-integratable mutability – the inside of the feminine body and its abject body fluids, fragments, distortions in the disaster photos (Krauss 1993: 192).

Both Freud's dream-representations and Sherman's phantasmagoria – this was my argument – encircle the issue of knotting as a move 'beyond' post-structuralism. This move involves the issue of constructing an integrated narrative, constructing connections as this turns into a narrative about the Real which points to the vulnerability of connection. It involves not the privileging of either the integrational or the distributional axis of meaning but rather a counter-directional enmeshment; not the privileging of representational sublimation or desublimating disturbance of the images of narcissistic fantasy and cultural codes – but rather an oscillation between these two gestures.

Notes

1 I want to thank Judy Simons for pointing out Freud's mouth cancer to me.
2 At this point it is necessary to recall that Freud (1915) uses the concept *Vorstellungs-Repräsentanz* (ideational representation as distinct from affect) to designate the drive's representative within the psychic apparatus. The relation of the somatic to the psychic is that of the drive to its representation. The somatic drive can be repressed and thus inscribed in the unconscious only in so far as it is fixed onto a representation. This is a moment of knotting severment itself resembling the structure of the production of the navel:

> We have reason to assume that there is a primal repression, a first phase of repression, which consists in the psychical representative of the drive being denied entrance into the conscious. With this a fixation is established; the representative in question persists unaltered from then onwards and the instinct remains attached to it.
>
> (148)

Lacan in turn translates *Vorstellungs-Repräsentanz* as 'représentant de la représentation' – a representative not of the drive but of what the representational field excludes, a primordially repressed or forgotten representation of the Real.
3 See Rosalind Krauss and Norman Bryson, *Cindy Sherman. Arbeiten von 1975 bis 1993* (Munich: Schirmer & Mosel 1993), p. 17.
4 See Thomas Kellein, 'How Difficult Are Portraits? How Difficult Are People!' in *Cindy Sherman* (Basle: Edition Cantz 1991), pp. 5–10.
5 Carla Schulz-Hoffman, 'Cindy Sherman – Commentaries on Noble Art and Banal Life' in *Cindy Sherman*, pp. 27–31.
6 'Cindy Sherman: "Ich mache keine Selbstporträts"', interview with Andreas Kallfelz, *Wolkenkratzer Art Journal*, no. 49:

> Ich versuche immer, in den Bildern soweit wie möglich von mir selbst wegzugehen. Es könnte aber sein, daß ich mich gerade dadurch selbst porträtie, daß ich diese ganzen verrückten Sachen mit diesen Charakteren mache . . . daß ich tatsächlich irgendeine verrückte Person unterhalb von mir auf diese Weist rauslasse.

7 Cindy Sherman. Photographien. Westfälischer Kunstverein Münster.

8 As Peter Schjeldahl argues:

> was sogleich erkennbar ist bei Shermans neuen Bildern, ist der universale Zustand von Tagträumerei oder Versunkenheit, die Momente harmloser, notwendiger Psychose, die einen wiederkehrenden Mechanismus in der mentalen Ökonomie eines jeden darstellt. Es sind Momente, wenn sich das Bewußtsein in sich selbst auflöst, wenn Wunsch und Wirklichkeit, persönliches und kollektives Gedächtnis eins sind und die physische Wlet aufhört zu existieren.

(quoted in Krauss 1993, no. 89)

Bibliography

Barthes, Roland (1977). *Image, Music, Text*, New York: Hill & Wang, 79–124.

Bronfen, Elizabeth (1992). 'From Phallus to Omphalos' *Women a Cultural Review* 3, 2, 145–58.

Byatt, A.S. (1987). 'Identity and the Writer', *Identity. The Real Me. Postmodernism and the Question of Identity*, London:ICA Documents 6.

Danto, Arthur (1990). *Untitled Film Stills. Cindy Sherman*, Munich: Schirmer & Mosel.

de Man, Paul (1984). *The Rhetoric of Romanticism*, New York: Columbia University Press.

Didi-Huberman, Georges (1982). *Invention de l'hysterie. Charcot et l'iconographie de la Salpêtrière*, Paris: Macula.

Felman, Shoshana (1985). 'Postal Survival, or the Question of the Navel', *Yale French Studies* 69, 49–72.

——(1993). *What Does a Woman Want. Reading and Sexual Difference*, Baltimore: Johns Hopkins University Press.

Freud, Sigmund (1900–1). *Interpretation of Dreams. Standard Edition IV-V*, London: Hogarth Press.

——(1915). 'Repression', *Standard Edition XIV*, London: Hogarth Press.

Janet, Pierre (1931). *L'état mental des hystériques*, Paris: Librairie Félix Alcan.

Kallfelz, Andreas and Cindy Sherman (1984), 'Ich mache keine Selbstportaits' (interview), *Wolkenkratzer Art Journal*, September/October, 45–9.

Kellein, Thomas (1901). 'How Difficult Are Portraits? How Difficult Are People!", *Cindy Sherman*, Basle: Edition Cantz, 5–10.

Krauss, Rosalind and Norman Bryson (1993). *Cindy Sherman. Arbeiten von 1975 bis 1993*, Munich: Schirmer & Mosel.

Lacan, Jacques (1981) *Four Fundamental Concepts of Psycho-Analysis*, New York: Norton.

Mentzos, Stavros (1908). *Hysterie. Zur Psychodynamik unbewußter Inszenierungen*, Munich: Kindler.

Mitchell, Juliette (1984). *The Longest Revolution: Essays in Feminism, Literature and Psychoanalysis*, London: Penguin Books.

Muller, John P. and William J. Richardson (eds) (1988). *The Purloined Poe. Lacan, Derrida, and Psychoanalytic Reading*, Baltimore: Johns Hopkins University Press.

Mulvey, Laura (1991). 'A Phantasmagoria of the Female Body. The Work of Cindy Sherman', *New Left Review* 188, 137–50.

Rousseau, G.S. *et al.* (1993). *Hysteria beyond Freud*, Berkeley: University of California Press.

Schulz-Hoffmann, Carla (1991). 'Cindy Sherman – Commentaries on Noble Art and Banal Life', *Cindy Sherman*, Basle: Edition Cantz, 27–31.

Williamson, Judith (1983). 'Images of "Woman"', *Screen* 24, 102–16.

Žižek, S. (1992a). *Everything You Always Wanted to Know about Lacan but Were Afraid to Ask Hitchcock*, London: Verso.

——(1992b) *Enjoy Your Symptom. Jacques Lacan in Hollywood and Out*, London: Routledge.

Chapter Four

Gossip as testimony:
a postmodern signature

Irit Rogoff

KNOWLEDGE AS SURREPTITIOUS APPROPRIATION

In the struggle to locate and articulate new structures of knowing and alternative epistemologies which are actually informed by the conjunctions of subjectivities, pleasures, desires and knowledges, gossip deserves serious consideration. As gossip is invariably located in the present and avoids any imposition of, to quote Foucault, 'an origin of hidden meaning'[1], gossip turns the tables on conventions of both 'history' and 'truth' by externalizing and making overt its relations to subjectivity, voyeuristic pleasure and the communicative circularity of story-telling. For feminist theory and feminist practices of producing counter-historical narratives, gossip provides some opportunities for a gender-specific variant on Foucault's notion of genealogy. The disruptive claims he made for genealogy, such as:

> if interpretation is the violent or surreptitious appropriation of a system of rules, which in itself has no essential meaning, in order to impose a direction, to bend it to a new will, to force its participation in a new game, and to subject it to secondary rules, then the development of humanity is a series of interpretations'

have been imperative for a feminist epistemology which does not pursue a broadening of existing categories to include female subjects but revises those very categories, questions the historical narrative structures which produced them and dares to imagine alternative narratives. So many of the struggles of feminist history and theory – to contemporize history and to insist on its constitution from the perspective of the present, the efforts to unyoke it from the authority of empirically sanctified 'experts' and the effort to write the subjectivities of both writers and readers into the text through perceived and imagined structures of identification, as well as the perception of 'community' that coheres around these identifications – already exist within the very definition of gossip.

Unauthored, untraceable and unfixed in historical time, gossip can offer a troubling of simple faith in historical and political representation. Gossip within trajectories of historical evidence exemplifies in Derrida's words 'a principle of contamination, a law of impurity, a parasitical economy . . . a law of abounding, of excess, a law of participation without membership'. Reviled in relation to empirical and verifiable factualities, relegated to the recesses of femininity or feminized masculinity and moralized as a reprehensible activity, gossip seems to bear a multiple burden.

The categories which structure and inform much of scholarly literature on gossip are reflective of the need to contain that 'unruly contamination' Derrida speaks of. In the first of these arenas which I think of as 'anthropologizing' gossip is studied as the discourse of 'others', the strange communicative habits prevalent in remote communities of distant exotic tribes who exist outside the structured knowledges of western civilization. Another dominant tenet, which I think of as 'moralizing', is one which makes exhaustive efforts to vindicate gossip from its morally inferior position and earnestly tries to find some purpose in its activity. In these studies authors seem to attempt to

decouple gossip from two of its apparently constitutive and locative components: 'idleness' and 'maliciousness'. In such moralizing discourses on gossip, authors seem to pay little attention to the fact that both of these terms are highly feminized in culture and to discount the fact that they may in fact serve for the inscription of subjectivities or as the sites of defiance or resistance.[2] The third form, stemming from sociology, deals with 'celebrity' and assumes that gossip is a by-product of mass culture and that it is the distance between celebrities and audiences refracted through the apparatuses of mass, popular culture that produces the activity of gossip in lieu of proximity.[3]

My argument is markedly different from these scholarly discourses as I do not wish to cleanse gossip of its negative associations (of distinctly feminized communicative activity) and turn it into an acceptable cultural artefact, but rather to argue that we can find in it a radical model of post-modern knowledge which would serve us well in the reading and rewriting of gendered historical narratives.

To this end I shall read through a couple of research situations in which I was engaged in efforts to narrate highly gendered histories within visual culture, in order to locate and characterize the implications of knowledge which circulates as gossip. The first of these concerns bohemian circles in the pre-First World War avant-garde in Munich. In trying to substantiate and narrate the lives of women artists, collaborators and household members within the unconventional ménages of bohemia, we keep coming across persistent rumours speculating on illicit love affairs and illegiti-mate children and domestic arrangements, none of which can be substantiated. Their presence speaks of the investment we have in the imaginary concepts of bohemia as linked to radically inno-vative art and to heroic artistic agents.

The second example has to do with the media sensationalization of the death of Cuban artist Ana Mendieta in New York in 1985. The unclear circumstances of her death and her position within third world feminist politics in relation to the New York art world produced an immensity of gos-sip and speculation which assumed the form of response to the critical positions Mendieta represented.

But to open up the discourse of gossip as radical knowledge is to take on the dangers of the same ridicule which is visited on the activity of gossip itself, for it negates the scholarly distanciation between what is said, who it is said by and who is being addressed. Thus my friend Abigail, deeply knowledgeable in the perils of feminist academic investigations, is extremely worried about me. She wonders why I keep going off to conferences with papers on such topics as nagging, embar-rassment, ambition, and now, gossip. She is concerned that I get the reputation of someone whose work is somehow not quite respectable, who writes about issues that no one takes very seriously, that I will become another variant of the dotty woman, the female eccentric, like Bella Abzug with her hats.

Initially I thought that the project I was engaged in was a reassessment of these marginal, empir-ically unquantifiable and not-quite-respectable emotions and activities and the attempt to theorize them. For as long as they remain outside theoretical activity, as long as they are not critically acti-vated and mobilized, they remain in the form of essentialized, feminized 'human frailties'. At some level I thought that these might come together into an alternative, feminist, sexual history of Modernism, an alternative history in which the concept of Modernism gets undone not by a par-allel cultural heroism gendered female, but by a set of small-scale actions and receptions taking place at the margins: the pleasures of conversations, the conflicts of domesticity, the agony of rejec-tion and failed love, the spreading of rumours, the support systems that promote ideas and make activity in the public sphere feasible. All the low moments which invariably precede and follow the high moments. All of the moments and all of the emotions which make up the fabric of Modernism just as surely as the great drama of 'the birth of Cubism' ever did. So conditioned are we by the hierarchical values of what constitutes serious cultural endeavour, that we either co-opt these small-scale narratives into the grand schemes of heroic activity or we allow them to slip into a kind of

domesticated netherworld. But if one is to work theoretically and historically as a feminist, then one of the tasks is to bring into theory, by which I mean to bring into critical consciousness, that which has always languished outside it, which has remained untheorized for very good reasons: because the very act of acknowledging its legitimacy begins to undo the lofty categories in which we have all been working. I am sure everyone remembers the opening of Michel Foucault's *The Order of Things*, in which he quotes Borges' short story about the Chinese encyclopaedia and its odd categories. After enumerating the categories, Foucault says:

> In wonderment of this taxonomy, the thing we apprehend in one great leap, the thing that by means of the fable, is demonstrated as the exotic charm of another system of thought, is the *limitations of our own*, the stark impossibility of thinking *that*.[4]

For me that is the point of theoretical activity, to locate that which is outside theoretical frameworks – or as Derrida says when speaking of telepathy, 'everything in our conception of knowledge is so constructed that telepathy is impossible, unthinkable, unknowable'[5] – to understand why it is situated outside the paradigms and to activate that condition of exile as a form of critical, political mobilization. The politics of this particular critical, theoretical activity address the gendered, racialized and sexualized exclusions and discriminations which come into being in the *choices* of what is of sufficient importance to be theorized. It is not exclusively in establishing an alternative set of cultural values that this activity's importance lies but also in the making strange and apparent the very seamlessness of these choices, and by reference, attempting to figure out what they exclude which we are not necessarily aware of.

Equally it is the very concept of investigation which is interrogated through my inquiry, the statuses of gendered knowledge and of how it is arrived at. I call as a witness Lord Peter Wimsey, Dorothy Sayers' detective hero and for many years, my ideal fantasy of worldly masculinity: here he is in conversation with a police inspector, a representative of official investigation and officially structured knowledge, while he himself represents, as all private investigators do, the realm of oblique and unsanctioned knowledge; he is speaking of an elderly gentlewoman he has enlisted for his investigations:

> 'Miss Climpson' said Lord Peter 'is a manifestation of the wasteful ways in which this country is run. Look at electricity, look at water power, look at the tides. Millions of power units being given off into space every minute. Thousands of old maids, simply bursting with useful energy, forced by our stupid social system into hotels and communities and hostels and posts as companions, where their magnificent gossip powers and units of inquisitiveness are allowed to dissipate themselves or even become harmful to the community, while the ratepayers' money is spent on getting work, for which these women are providentially fitted, inefficiently carried out by ill-equipped policemen like you.'[6]

This is one reason for my choice of subjects. The other is the necessity so many of us feel of integrating the study of mass and popular culture with the study of high and privileged culture. One of the ways in which we do this is to integrate in one study high cultural images and popular cultural discourses and claim for both the immense power of constituting identities. Another way, one which interests me at present, is to take up issues like gossip, or complaining, or spectatorship and to use them as a model through which to track and examine some narratives in visual culture. Part of the attraction of trying to work in this way is that the use of a common term as investigative tool works to undo the divisions between high/low, materially present/electronically mediated and bring them into a proximity of sorts.

Thus if gossip, by its troubled relation to historical realism, has been postmodern all along, it can serve to destabilize the historiography of Modernism. If the rewriting of the histories and theories of modern visual culture can be geared towards an investigation of narrativity and of the structures of spectatorship, then gossip can be inscribed into these as the voices of numerous cultural unconsciouses.

To recap, gossip which is unauthored, untraceable and unfixed in historical time can offer a troubling of simple faith in historical and political representation. Gossip within trajectories of historical evidence exemplifies Derrida's 'principle of contamination'.[7] In the arena of 'scientific study' gossip is reviled in relation to empirical and verifiable factualities. It does not arise out of the structures of knowledge which connect notions of truth with empirical, verifiable evidence and with the scientific researcher's moral obligation to assume personal responsibility for a truth. 'I don't know, but I heard at the café last night that . . .' absolutely does not fit in with those concepts of truth, research and responsibility. Rather it falls within the domain of what Louise Collins calls 'excessively thin accounts of moral personhood'.[8]

Furthermore, gossip as a form of social or cultural activity is relegated to the recesses of femininity or feminized masculinity and moralized as a reprehensible activity. It is interesting to note that social scientists who theorize or analyse gossip rely primarily on interviews with women and with gay men. There is some tacit understanding here that 'men of the world', men busy making the world in their own form, do not gossip, that gossip is for those 'who have nothing better to do'.[9]

Thus gossip seems to bear a multiple burden: in Foucauldian terms it serves the purpose, through negative differentiation, of constituting a category of respectable knowledge, 'trivial' discourse allowing for the emergence of 'serious' discourse etc. In Derridean terms gossip allows for the constitution of the formal boundaries of the genre and its outlawed, excessive and uncontainable narratives. We are all aware of the mysterious power and mobility of gossip as it winds its way through subterranean and unacknowledged channels and continuously constitutes communities within its listeners. (This is being used strategically within current Queer Theory, as in the film *L is for the Way You Look* by Jean Carlomusto, in which gossip about Fran Leibowitz and about Dolly Parton constitutes a community of alliance between a group of young women wandering through the night-spots of New York city one summer night.) Finally, in Freudian terms a serious examination of gossip opens a possibility for the intersections of psychic narratives with historical narratives. In refuting his earlier theory of infantile seduction and yet allowing it to maintain its narrative (as opposed to factual) hold on the patient, Freud acknowledges that it is not necessarily *what* specifically happened, or even whether the seduction of the female infant had actually taken place, that is of such importance, but the certainty of the subject that it had, and the centrality that this certainty assumes within the subject's narrative. In terms of gossip and audience reception dynamics, which is what I am preoccupied with here, Freud's argument opens up possibilities for reading gossip as a projection of various desires by the audience onto narratives in culture.

ROMANCING VISUAL CULTURE

I would like to take these thoughts through a few examples from specific moments, moments perceived as those of historical romance, in the academic work of studying twentieth-century art, revisiting in the process some work I have done recently in a different vein. The first of these occurred recently, while I was working in Munich on a study of women's artistic production at the margins of Modernism's historical avant-garde and in which hearsay as evidence arose in a startling manner. I had become interested in the unconventional households of the pre-war avant-garde in which an economy of desire between an official wife, an equally official and acknowledged mistress, usually herself an artist, and a housekeeper-cum-model/lover revolved around the male artists positioned at their centre, a new economy of bohemian desire. My research assistant, vastly knowledgeable in the labyrinthine ways of local Munich histories, burst into the office one day with the following news. She had just heard that Paul Klee might have had an illegitimate child with the woman who worked as a maid within his household. Where had she heard the news? I asked. At

one of the local Schwabing cafés which had been at the centre of bohemian life for more than a century, was the reply. I remarked about the fact that the event, if true, had taken place more than eighty years ago. She replied that I had no idea of how to go about historical research. Certainly the time lag and ephemeral nature of the evidence seemed to make no difference to the seriousness with which such a rumour was to be taken, and she immediately set out to research it through personal interviews and correspondences, outside the official archival structure, where, needless to say, no such evidence existed.

In trying to substantiate and narrate the lives of women artists, collaborators and household members within the unconventional ménages of bohemia, we keep coming across persistent rumours which speculate on illicit love affairs with men, on lesbian love affairs and on illegitimate children and domestic arrangements, none of which can be substantiated. Their presence speaks of the investment we have in the imaginary concepts of bohemia as linked to radically innovative artistic gestures and to heroic artistic agents. The greater the depression suffered by Gabriele Munther after Wassily Kandinsky left her, the more illicit lovers taken by Franciska von Reventlow, 'the fabulous countess' of Munich bohemia, the more extravagant the homosexual culture of the photographic studio Elvira presided over by the lesbian couple Sophia Goudstikker and Anita Augsburg, the greater our faith in the tumultuous and operatic arena of innovative creativity and in the bohemian transgressions which allow its full release.[10] The dull and conventional middle-class domesticity of the Klee household, if that is how it really was, becomes an irritating opaque surface which needs to be disturbed if we are to read the period and its activities in the ways we have been accustomed to doing in order to meet with our expectations. Thus gossip serves as an arena for the cathexis of phantasmic projections by audiences which can alert us to the way in which we shape narratives through our own desire. The hours my research colleague and I spent in our office and the nearby café speculating about the nature of the Klee household were as important as the archivally substantiated facts we unearthed. We had decided for once to let our imagination run away with us and follow the rumours with verve and audacity. We constructed scenarios involving wives, and lovers and maids who were both and neither, with shameless abandon, which probably said a great deal more about our investments in cultural histories and our structures of identification than it did about our historical subjects. It was clear to us that a kind of counter-transference had taken place within our emergent art-historical discourse, an unconscious projection of the investigator's feelings and conflicts onto the lives of the subjects being studied. In the process we understood something about gendered historical specificity we had not understood before, about the possibility of hearing gossip as a way of alerting us to the specificity of our own subject positionality. In historical realism, as Diane Elam says,

> History is preserved from fantasy and its anachronisms, only by the becoming-fantastic of the female. The fantastic returns as the gendered complement of the real historical male that sought to exclude it. Woman that is, may permit the past to be represented as romance, but the price of this is that she herself cannot be adequately represented.[11]

Gossip, then, is one of the main tools by which the past can be represented as romance.

The questions which this episode has raised go far beyond the limitation of the archives as the sources for historical evidence, the categories by which they order their materials, the periodization and historical and generic nominalism by which documents and facts are marshalled.[12] Instead, I would like to pose a series of questions regarding subject positionality, desire and historical narrative as well as the gendered relation between historical realism and its accounts. Using Freud's original model of psychic fantasy in relation to the accounts of infantile seduction, I would like to understand what the persistent appearance and reappearance of gossip in close vicinity to master narratives, in particular to grandiose historical moments or achievements in Modernism, actually represents. If indeed it represents the possibility of giving articulated form to a series of unspeak-

able desires for which no narrative structures exist, as in Freud's model, then its ability to trouble the surface of historical factuality and narrative deserves some theoretical consideration.

Traditionally gossip is related to romance, to sexual activity and to sexual identity as well as the possibility of constructing what Patricia Spacks calls 'a new oral artifact'. Furthermore, she claims,

> The relationship such gossip expresses and sustains *matters more* than the information it promulgates; and in the sustaining of that relationship, interpretation counts more than the facts or pseudo facts on which it works . . . gossip involves exchange not merely, not even mainly, of information, and not solely of understanding, but of *point of view*.[13]

In terms of cultural historiography and issues which theorize concepts of evidence, we have to ask ourselves, what does it mean to have evidence of someone's sexuality, of their intimate lives? Does it not shift the field from historical subjects to contemporary desiring subjects who, by constructing new oral artefacts and projecting their own desires onto the historical field, are in fact devising reading strategies, through which the arena of artistic activity is constantly reanimated? If we acknowledge that one of the main limitations to broadening the study of Modernism has been the singularly narrow and phallocentric narrative structure which has been available to us in recounting it, we can recognize some of the potential in theorizing gossip. 'Gossip is not fictional, but both as oral and written form, it embodies the fictional . . . as subject matter gossip impels *plot* . . . while gossip's fascinations are; voyeurism, secrets, stories'.

In looking at some accounts which have circulated around the official recorded lives of the main protagonists of the pre-war Munich avant-garde, accounts which are supposedly of little value because they shift the attention from the serious business of chronicling artistic production, I would like to try and shift the very nature of the historical account. I would not want to suggest, or even to speculate, that they be accepted as an alternative factuality, but rather that their persistent presence be used to destabilize the claims that art-historical discourse has made to historical realism. In her recent analysis of Romance as a model of postmodern discourse, Diane Elam states that ' If real history belongs to men and women's history is merely the phantasy of historical romance, then postmodern cultural analysis of history and the "real" offers a way of revaluing female discourse.'[14] Thus if gossip, by its troubled relation to historical realism, has been postmodern all along, it can serve to destabilize the historiography of Modernism by pointing to both alternative economies inscribed in the business of cultural production as well as to the psychic fantasies whose constant dissatisfaction with existing accounts continues to generate unproven speculation.

Furthermore, since we have been arguing across the theoretical board for located and situated knowledge, we must recognize the degree to which gossip provides a mode of relational knowledge: who is speaking to whom about whom is part of the narrative structure, as is the conscious destabilization of a confident 'knowing', since gossip is usually accompanied by certain qualifying frames.

My second example has to with the media sensationalization of the death of Cuban artist Ana Mendieta in New York in 1985. The unclear circumstances of her death (her husband the minimalist sculptor Carl Andre was twice accused and twice acquitted of hurling her to her death from the window of their 34th-floor apartment) and her own position within third world feminist politics in relation to the New York art world, produced an immensity of scandalous gossip. The literature on the subject is immense and spans tabloids, art journals, feminist publications and academic research. It has even produced a 420-page tome of excruciating, laborious detail, five years in the making and luridly entitled *Naked by the Window – The Fatal Marriage of Carl Andre and Ana Mendieta*.[15] In the weeks following her death, burial and the trial of Andre the papers were full of descriptions of the pair as 'wild, extravagant drunks' and as 'virulent left wingers'. He had 'endless affairs with other women' she 'went into continuous jealous rages and bouts of despair'. Their lives were described as a constant orgy of drink, political activism, artistic creativity, endless

rows, extravagant threats and equally extravagant reconciliations, all of which apparently took place in restaurants in the company of large numbers of invited friends. She was described as jealous of his position in the art world, the possibility of her having committed suicide was dismissed in *New York Magazine* with the words that 'She was too pushy, too ambitious to do herself in'. Her memorial service was described as 'A demonstration by two hundred of the art world's dispossessed'; apparently no art world celebrities turned up since most of them seemed to think that this was a way of protesting the innocence of Carl Andre. One brave journalist said: 'It's really coming down to this class thing and this race thing – He is museum class, she isn't. He is Anglo, she isn't'.[16]

Within this hyped-up atmosphere of gossip and rumour, Mendieta's actual political and artistic activity played virtually no role. Her feminist activism, her co-founding of 'Heresies', her third world politics, the constant contact with Cuba, her promotion of Cuban artists in the United States, none of these were mentioned.[17] Her work as an artist: earth works and burning banners, flimsy and transient objects located in remote regions, not commodifiable as objects for sale and known primarily through photographic representations, were seen as events taking place far from the New York art world with its narcissistic sense of its own centrality and importance. All of these certainly constituted an oppositional stance to the rules by which the New York art world existed in the 1980s. To address them, however, would have been the acknowledgement of another, alternative set of possibilities which were being followed by various groups involved with critical, oppositional practices. Instead Mendieta's entire world of art and of politics becomes gendered and racialized through vehement gossip to re-establish the operating rules by which the art world lived and to legitimate her death. 'She was this loony Cuban, so what can you expect?' quotes one of the newspapers.

The complex drama of a third world woman's life in the heart of the West's art world becomes reduced to a saga of sex and violence. In the above-quoted feature article in *New York Magazine*, the subtitle of the cover page asks: 'Did Carl Andre, the Renowned Minimalist Sculptor, Hurl His Wife, a Fellow Artist, to Her Death?' He has a name and a designated stylistic affiliation while she remains unnamed, without an artistic style, anchored in the art world as 'his wife'. The entire article is illustrated by grave simple images of Andre the man and of his grave simple minimalist work, while the numerous pictures of Mendieta show her with wine glasses, bottles of alcohol, plates piled up with food, or laughing an uproarious, open-mouthed laugh at various companions of the evening. In the same article her art work shows only those works which she did using her own naked body (rather than her more common use of a loose formal reference to the female figure) and which are directly related to sexual violence. The caption underneath these images reads 'A Death Foretold?' and implies that her death was a result of some form of sexual violence, a claim for which there was absolutely no empirical basis. In all these images Mendieta is essentialized through an association with wild appetites and with unbounded female sexuality. She is racialized and sexualized as the 'other' and the animating force of this narrative of doomed and wild passions.

Here again we can recognize the constitution of a discourse of gossip about artistic dissolution and unruly immigrants, as signalling the regrouping of a serious discourse on the subject of art, its demand for an attitude of responsibility, of commitment, of realism.

I want to revisit the site of the Mendieta narrative as told through the New York art world journalistic gossip with my earlier question: What does it mean to have evidence of someone sexual activities? of their sexuality? How can one even begin the assumption of that kind of knowledge except through the structures of phantasmatic projection? Therefore I would need to ask, is it possible to have gossip function *simultaneously* as a policing action for the reinstatement of contained and controllable genres *and* as the site for our most cherished fantasies about transgression and unruly excess?

In summary I want to go back to my original argument and repeat and expand on it. Undoubtedly gossip, by its troubled relation to historical realism has been postmodern all along, and it can serve to destabilize the historiography of Modernism by pointing to both alternative economies inscribed in the business of cultural production as well as to the psychic fantasies whose constant dissatisfaction with existing accounts continues to generate unproven speculation. In addition, the moments at which we pause, listen, are affected and attempt to theorize gossip, are the moments of a 'queering' of culture, in Alexander Doty's term; moments at which we not only distrust the false immutable coherence of master narratives but also perhaps the false, immutable coherence of our identities as subjects and tellers of those narratives.[18]

Notes

1 Michel Foucault:

> If interpretation were the slow exposure of the meaning hidden in an origin, then only metaphysics could interpret the development of humanity. But if interpretation is the violent or surreptitious appropriation of a system of rules, which in itself has no essential meaning, in order to impose a direction, to bend it to a new will, to force its participation in a new game, and to subject it to secondary rules,, then the development of humanity is a series of interpretations.

> (Nietzsche, Genealogy, History in *Language, Counter Memory, Practice,* New York, 1977, pp. 151–2)

2 See, for example, Robert F. Goodman and Aron Ben-Ze'ev (eds), *Good Gossip,* University of Kansas Press, 1994. Both of the editors' chapters in this volume exemplify such a laborious effort to address the 'moralization' of gossip.

3 See, for example, Joshua Gamson, *Claims to Fame – Celebrity in Contemporary America,* University of California Press, 1995.

4 Michel Foucault, *The Order of Things – The Archaeology of the Human Sciences,* London, 1985, preface, p. xv.

5 Jacques Derrida, *Telepathie,* Paris, 1978, p. 216.

6 Dorothy L. Sayers, *An Unnatural Death,* London,1977, pp. 42–43.

7 Jacques Derrida 'The Law of Genre', *Glyph* 7, 1980, pp. 206–??

8 Louise Collins, 'Gossip – A Feminist Defense' in *Good Gossip,* p. 109.

9 It is interesting to note that contemporary social scientists who study gossip, such as Patricia Spacks, Leo Braudy and Joshua Gamson, rely primarily on interviews with women and with gay men as the subjects of their interviews.

10 See Brigitte Bruns and Rudolph Herz *Hof Atelier Elvira 1887–1928,* Stadtliches Museum, Munich, 1987.

11 Diane Elam, *Romancing the Post Modern,* London and New York, 1992, pp. 14–15.

12 I have dealt with these limitations in a recent article on rewriting the relationship between women and Modernism in the historical avant-garde, 'Tiny Anguishes – Reflections on Nagging, Scholarly Embarrassment and Feminist Art History', in *Differences* 4.3, 1993.

13 Patricia Spacks, *Gossip,* New York, 1987, pp. 4, 7.

14 Diane Elam, '*Romancing the Post Modern*', pp. 14–15.

15 Robert Katz, *Naked By the Window,* New York, 1990.

16 All the quotes reporting on the scandal and which I have included here are taken from Joyce Wadler's 'A Death in Art – Did Carl Andre, the Renowned Minimalist Sculptor, Hurl His Wife, A Fellow Artist, To Her Death?' *New York Magazine,* 16 Dec. 1985, cover and feature article.

17 For a documentation and analysis of her work see *Ana Mendieta,* a retrospective catalogue, The New Museum of Contemporary Art, New York, 1987; Luis Caminitzer, 'Ana Mendieta' in *Third Text,* no.7, 1989, and Luis Camnitzer's recent book *New Cuban Art,* New York, 1994.

18 Alexander Doty, *Making Things Perfectly Queer,* University of Minnesota Press, 1993.

PART III

The body

Chapter Five

The Venus Pudica:

*uncovering art history's 'hidden agendas' and
pernicious pedigrees*

Nanette Salomon

To write history, and perhaps most particularly the history of cultural objects, is to engage in creating coherences. Art historians make sense in (and of) their discipline by connecting objects and events with seamless narratives that appear to tell logical stories.[1] There are several master narratives to choose from, although fewer than one might imagine. Within traditional art history, no more satisfying explanatory connection can be made for a work of art than to link it to classical antiquity. Classical survivals, revivals, rejections, reconstructions and deconstructions are the bread and butter of graduate student papers, dissertations, scholarly articles and university press books. They are among the most rock-solid proofing grounds of the discipline. The recognition of self-conscious artistic references to ancient art, as even more covert allusions to it, produces an immediate if controlled thrill for the art historian and the general 'student' of art.[2]

Writers are not the only ones to produce and reproduce these coherent narrative histories. They are also worked through artists, who consciously or unconsciously operate within prearranged historical tropes so that their work can easily be inserted into these well-valued discourses. Classical references can, of course, come in a variety of different shapes and sizes. These involve a sliding scale from explicit to implicit connections with ancient art: for example mythological subject-matter, classical form, classical pose or classical disposition. Such connections do much more than validate any work by placing it within a recognizable, and highly prestigious, historical genealogy. They bestow an instant sense of knowledge and mastery upon the viewer who sees the connections and place him/her in the league of a cultural elite. Ever since the Italian Renaissance, the infinitely elevated regard for classical works of art has been matched only by the elevated intellectual gratification produced by the historian's coherent narratives, which revel in unending reaffirmations of 'classicism' as the adherent stuff of western culture's 'high' history. The potency of Greek cultural inventions are underscored by the high status conferred on the whole of classical antiquity in general as a 'reservoir of powerful archetypal images which lay claim to some privileged kind of truth about human nature'.[3] From origin to copy, from teacher to student, from generation to generation, from period to period, the history of western man is made to cohere along classical values presented as rational, logical and universalist. They echo the originary structure of Genesis, 'And God made man in his own image'. How right it all seems. How logical and reassuring. Or is it? Or more accurately, for whom is it?

Current academic debates on representation, interpretation and history have opened the act of writing art history to such questions. History-writing itself as the object of feminist study has recently been transformed to be seen as an active and productive, rather than an objective and passive, social project. That is, among its most compelling properties, history-writing actively participates

in generating ideology. It has been feminist writers who have begun specifically to question the nature of the value associated with revivals of antiquity.[4] In that spirit, this chapter, then, offers the story of a different set of classical coherences: a feminist history. This history tracks the incredibly durable set of power relationships structured on gender difference and defined as sexual which are figured by the so-called *Venus Pudica*, the depiction of an idealized female nude who covers her pubis with her hand.

Female nudes fashioned as covering their pubises were and continue to be a most favoured subject/pose/gesture in the art of the western world. The subject/pose/gesture was first mainstreamed into western culture by the fourth-century Greek sculptor, Praxiteles. Given the highly restrictive conditions of inclusion into the art-historical canon, that is, possessing the twin virtues of innovation and influence, Praxiteles' *Aphrodite* stands as *the* paradigmatic canonical work of the western world.[5] His creation stands at the head of a long, laboured list of famous paintings and sculptures from every period of western art from the advent of the Hellenistic period to our present day. A complete list exhibiting the wealth and breadth of the subject is clearly impossible, and a partial indication seems unsatisfactory. It is nevertheless necessary, particularly because I am making such broad claims about the subject. This list would include works by well-known artists like Van Eyck, Bosch, Titian, Cranach, Rembrandt, Rubens, Renoir, Manet, Matisse and Picasso as well as little-known, virtually unknown and completely anonymous artists. It would include male and female artists. Perhaps the best well-known of the latter is by Suzanne Valadon.

While we may not wish to support the same sense of significance given to innovation and influence in traditional art history, we can rethink those conditions as the terms which testify to the advent and continuation of certain shared, culturally constructed expressions of power hierarchies. In fact, for a feminist, there is much to be learned from the moment of innovation and from the terms of influence produced by Praxitéles' *Knidian Aphrodite*. The past and current occurrences of this pose and its position as a site for the construction of social *qua* sexual 'realities', despite and beyond their different historical contexts, enter into the composition of social relationships with the accrued force of their shared message.

The endemic presence of this pose has become so normalized, so 'natural', that it is made invisible or transparent. If the female pudica is said to signify anything at all, it is the embodiment of western 'high' aesthetics or artfulness. No doubt for that reason, it has become the 'classic' pose assumed by models in academic learning situations, and is represented as such in many paintings and prints of the academy *per se*.[6] Through the combined effects of incessant artistic repetitions and the concomitant art-historical, critical apparatus that sustain them, connotations of the pudica can reach into the profoundest preserves of our personal sexual identities.

My intention here is to render visible or rather, to reinstate to vision the political significance of this subject/pose/gesture in its endless permutations in western art; to denaturalize it and underscore its configuration as ideological artifice; to make it strange. Only then can we see the work done by this subject/pose/gesture in the ongoing construction of female sexuality in the western world and recognize the unequal relationships inherent in the terms of that sexuality.

THE KNIDIAN APHRODITE BY PRAXITELES

Praxiteles' monumental sculpture, usually called the *Knidian Aphrodite*, was produced in the volatile period around 350 bce.[7] It is known to us by the best surviving copy now in the Vatican museum (Figure 5.1). The *Knidia*'s claim to innovation is made by its position in ancient Greek art as the very first monumental cult statue of a goddess to be represented completely nude.[8] Moreover, and most significantly, it is the first monumental female nude sculpture to be positioned with her hand over her pubis, which at some undetermined moment in ancient times was given the highly manip-

ulative name 'pudica' or so-called modest pose. The politics of this name and its meanings, along with the general sexual cast of ancient legends surrounding the *Knidia*, will be discussed presently. For now it is significant that the literature on this work, in fact dating from antiquity to the present day, claims it to be 'the most popular of all statues in antiquity'.[9] Its popularity was expressed not only in the accolades of ancient writers but also in the countless Hellenistic and Roman copies, adaptations and derivations 'inspired' by Praxiteles' concept.[10] After the middle of the fourth century bce the female nude indexing her pubis was the most represented artistic configuration in the western world.

Yet, despite popular misconceptions that the female nude was always the classical subject *par excellence*, Praxiteles' introduction of the monumental female nude occurred at least three centuries after the introduction of its counterpart, the monumental male nude statue. It was, in fact, the male nude that dominated the early artistic avant-garde in ancient art of the archaic and classical periods. It is there we must seek the connections and constructions which provide the background for the advent of female nudity into the mainstream of western culture.[11] Before coming to an understanding of the sexual and erotic definition of the female nude in Greek art, we must first explore/expose those of the male nude.

A survey of Greek monumental sculpture of men and women in the sixth and fifth centuries readily reveals the strong differentiation along gender lines already inherent in their definition. In the archaic period the *kouroi* (athletic male youths) are fabrications of an idealized humanity defined as male, youthful and heroically nude.[12] The correspondent female *korai* are, on the contrary, consistently draped.[13] Further, given the collaborative project of Greek artists over generations and the resultant homogeneous nature of their art, the male anatomy continued in fifth-century classicism to be the form in which primary creative energy was invested. Its treatment is ever more precisely scientifically informed, culminating in Polykleitas' *Doryphoros*, a work nicknamed the canon in its own time.[14] The corresponding development traceable in monumental female sculpture, again by contrast, demonstrates ever greater virtuoso handling of drapery and the progressively plastic implications of hair arrangement. The male figure is portrayed as coherent and rational from within; the female figure is portrayed as attractive from without; the male body is dynamically explored as an internally logical, organic unity; the female body is treated as an external surface for decoration.

The asymmetrical treatment of the nude male and clothed female in archaic and classical Greek art can be matched with the by now well-known social and legal inequities between men and women in ancient Athens.[15] In the formation of the *polis* or city-state, women were legally positioned somewhere between slaves and citizens, and under the law they fell closer to slaves than to citizens.[16] The disfranchised state of women led to a progressive condition of total seclusion even within the walls of the home.[17] Greek literary traditions, mythological, scientific, philosophical, from Homer to Aristotle, focused on gender differences and mutually corroborated the misogynistic position that women were less than men.[18]

The artistic practice also coincided with the differentiated social practices of the city-state where young men in the gymnasium exercised in the nude in 'daily life', while women in public places were always discreetly covered.[19] The practice of nudity in Greek athletics and art has been understood as a means they used to demarcate themselves from other ancient societies whom they deemed barbaric.[20] For work produced in the sixth and fifth centuries it was also a cultural sign that differentiated male from female. In a deeper sense, the practice of preserving an idealized concept of youthful nudity exclusively for the masculine subject had a strong historical relationship with the Greek definition of beauty, which was defined specifically as a male attribute and ultimately with Greek homoerotic desire.[21] For the Greeks, as in nearly all cases where the object of aesthetic admiration is the male form, the enjoyment of the male body is conjoined with homoerotic desire. Much has been written in recent times on Greek 'homosexuality' and its practice cannot but have bearing on the invention

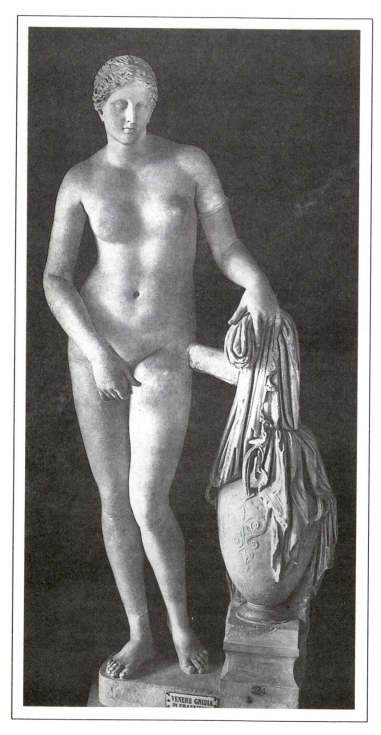

Figure 5.1 Praxiteles, *Knidian Aphrodite c.* 340 BCE (Roman copy).
Museo Pio Clementino, Vatican Museum, Vatican State. Credit: Art Resource, NY

and dissemination of heterosexual desire as embedded in the histories of the *Knidia*.[22] Homoerotic impulses were considered natural in ancient Greece, and that socially legitimate desire contributed to the forming of the male nude as an ideal. In our context, it is significant that overt sexual references are not part of the conventions or codes of monumental sculptures of nude men. That is to say, male sexual organs are presented like any other body part, having no special claim to our attention. The penis is represented in the same straightforward manner that an elbow, knee, nose or foot are. Indeed, a boy's sensuality is defined by the gracefulness and coherence of his body in its entirety rather than by explicit reference to any particular body part. This is, however, not the case when the monumental female nude is introduced into Greek sculpture.

Praxiteles' Aphrodite is in the condition of both complete nudity and self-conscious nakedness. The idea of Praxiteles' nude Aphrodite covering her pubis soon became an enormous success, generating an endless stream of derivations, imitations and replicas. The *Knidia* can be seen as the starting point of a new history in art. It is a history that privileges the female over the male nude. Further, it is a history that sexually defines the represented woman by her pubis and, on that account, keeps her in a perpetual state of vulnerability.

A comparison between Praxiteles' *Hermes with the Babe Dionysus*, representing the end of the *kouros* tradition, and the *Knidian Aphrodite*, representing the beginning of the Venus pudica tradition, immediately reveals the asymmetrical terms of their nudity (Figures 5.1 and 5.2). It establishes the artistic codes of female

nudity as fetishized, and provides the visual basis for the concomitant unequal power relations. In contrast to the heroic, iconic nudity of Hermes, the *Knidia*, more naked than nude, is sexually coded by the ambiversive placement of her right hand in front of her pubis. The issue of whether she, like the various pre-archaic, Mesopotamian or Mesopotamian-inspired Greek archaic statuettes usually cited as her heritage, points to herself as to her powers of fertility, or whether she is, in fact, covering herself before the eyes of an intruder, can never be resolved.[23] Praxiteles' intentions, like his original work, have long since disappeared.

In any reading, the hand that points also covers and that which covers also points. We are, in either case, directed to her pubis, which we are not permitted to see. Woman, thus fashioned, is reduced to her sexuality. The immediate and long-term implications of this fiction in the visual arts are incalculable. The form taken for Aphrodite reincarnate results in an endemic and inescapable presence of Woman as exposed and vulnerable. What is at stake here, then, is fundamental to our understanding of ourselves and our images of self as a sexual, deployed 'other' through the conditioning of culture.

An aspect of the critical literary history of the *Knidia* becomes particularly relevant here. The history of the *Knidia*'s reception is plagued by a vacillation between appreciating it as a work of art or as a real woman. This informs, although it does not thoroughly explain, how realistic works like this affect expectations and evaluations of real women. As an underlying principle, the mimetic naturalism of all Greek art must stand as a contributing factor. More than one

Figure 5.2 Praxiteles, *Hermes with the Infant Dionysus c.* 340 BCE, from Olympia.
Archaeological Museum, Olympia, Greece. Credit: Alinari/Art Resource, NY

classical myth (such as Pygmalion) deals with the miraculous conversion of sculpture to life. Praxiteles, in particular, was renowned for naturalizing the gods, making them more human and life-like than ever. His virtuoso ability to miraculously transform cold marble to the look of real vibrant flesh, vulnerable and sensual, is frequently acknowledged. The contraction and collapse of art and life is especially dire in the reception of the *Knidia*.

Ancient legends retold by Pliny, Lucian and others add to the implosion of meaning of art and life, profoundly confusing the approach to a sculpted Greek goddess, albeit the goddess of love, and the approach to a sexually vulnerable woman. The stories include one of a sailor so enamoured of the *Knidia* that he contrived to be locked in the shrine with her overnight, leaving semen stains on the sculpture as a testimony of his lust. Another story tells of the shrine's caretaker, who, for extra payment, would open the back so that her buttocks could be admired. On another level of myth-making and adding further dimensions to the sexual discourses of the work is the ancient story told of Phryne, a courtesan renowned for her beautiful breasts, who as Praxiteles' lover served as the *Knidia*'s model. Such discursive activity which abets, as Martin Robertson put it, 'the indistinguishability of the statue from a beautiful and desirable woman' ideologically tells us what the conditions of that desirability are and causes those conditions to appear unaccountably 'natural'.

The conditions of desirability presented in Praxiteles' creation shed light on its enduring popularity as a benchmark for the construction of woman as perpetual rape victim in western European art. The *Knidia* is portrayed holding drapery in her left hand above a vase. This gesture, like the work as a whole, functions on the level of both icon and narrative. Iconically, this type of image recalls Aphrodite's connection with water as she was born from the sea. On the level of narrative, it communicates that she, as a grown woman, was in the process of bathing. The rest of her body language, such as the slight crouch of her body, the turn of her head to one side and the way she pulls her free leg in to press her legs together firmly, weight a narrative over iconic reading. In general, Praxiteles' works such as the *Apollo Sauroktonos* or *Hermes with the Baby Dionysus* show how invested he was in developing narrative in monumental cult art.

The most telling gesture, however, is that of the right hand before the pubis. The gesture constructs a sexual narrative of protective fear that is conveyed by her body language as a whole. As she leaves her bath, the goddess hears someone coming and in modesty and fear urgently protects herself. Praxiteles has created a goddess vulnerable in exhibition, whose primary definition is as one who does not wish to be seen. In fact, being seen is here undeniably connected with being violated. Praxiteles has installed in us much more than the controlling male gaze. He has transformed the viewer into a voyeur, a veritable Peeping Tom. We yearn to see that which is withheld. The viewer's shameful desire to see matches the sculpture 'modest' desire to not be seen.

It is this gesture, which so dominates the *Knidia*, that has given the artistic type its name of pudica. The word 'pudica' is etymologically related to 'pudenda' a word that simultaneously means both shame and genitalia.[24] This appalling conflation goes back to the doubled meaning of the Greek root word *aidos, aidoios*.[25] The earliest application I have found of this linguistic doubled meaning and the artistic gesture/pose is in the *Erotes* by the Pseudo-Lucian. There, in his description of the sculpture, he says it is the *Knidia*'s '*aidos*' that she covers with her right hand.[26] His ideological, political choice of word for that body part has given the gesture/pose its art-historical name ever since. It should, then, be revealing to explore, if only summarily, what is communicated by the ancient Greek notion.

First and foremost, the etymological connection situates those 'things about which one must have *pudor*, modesty, shame, and respect' with sexual demeanour.[27] Although theoretically *aidoios* is used for both male and female sexual organs, tracking the practically differentiated significance of the ethical term for men and women confirms those differences already seen in their artistic formations. It also reminds us that cultural sexuality is a discursive cipher for so much more than 'actual' sexual relationships.

For the Greeks, *aidos* is a virtue to be taught as part of a young boy's education between the ages of fourteen and twenty to balance out his natural tendency to *hubris* or arrogance.[28] Plato defines this modesty as the fear of seeming perverse when we do or say something that is not good.[29] It is commonly applied to the sexual realm. Moreover, *aidos* is related to the all-important Greek notion of *sōphrosyne*, meaning soundness of mind, sobriety and self-control, the trait which allows one to master one's desires by exerting rational control.[30] While the term is used with complex and profound implications for the male's physical and psychological well-being, feminine *sōphrosyne*, according to Anne Carson 'always includes, and is frequently no more than, chastity'.[31] Even when *sōphrosyne* does concern both male and female chastity, as it comes to in the second half of the fifth century, the conditions of that chastity are differentiated. 'Masculine chastity derives from self-control, the opposite of *hybris*, feminine chastity from obedience.'[32] Aristotle makes clear that for the man *sōphrosyne* is rational self-control, for the woman it is dutifulness and obedience. For the man, control comes from within, for the woman, since she cannot control herself, it must be exerted from the outside.[33] He finds that women are equally incapable of possessing *aidos*, and that society must work to impose modesty on them.[34] Once again man, as his image, is constructed as managed internally, woman, as her image, is constructed as managed externally.

The sculpture, coming after three centuries of repressed female nudity, commands a situation loaded with titillating and erotic possibilities. It stimulates desire by fashioning a sexual reading onto the nude female body

Figure 5.3 Aphrodite, Knidian type, *c.* 150–100 BCE.
Credit: The Metropolitan Museum of Art, NY, Rogers Fund, 1912 (12.173)

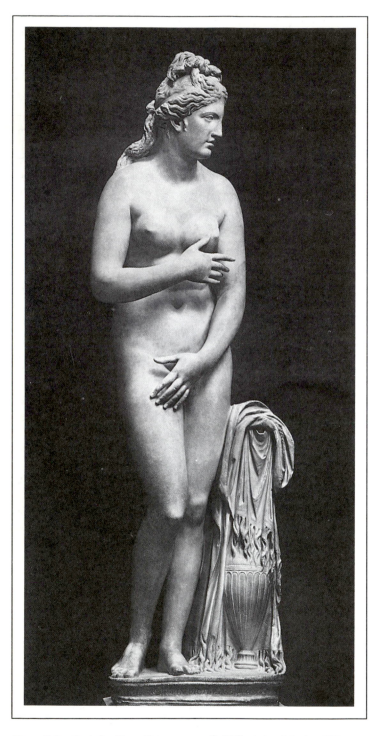

Figure 5.4 *Capitoline Venus.* Roman copy of a Hellenistic original, c. 120 BCE. Musei Capitolini, Rome, Italy. Credit: Alinari/Art Resource, NY

and into the sight of the spectator. By covering her pubis, Praxiteles makes her pubis the most desirable thing to see/have; the unjaded viewer *cannot not* think about her pubis while standing before her. We, however, as habitual viewers of an art tradition that is so saturated with this gesture, ingest but no longer see Aphrodite's pubis.

While the term 'pudica', shameful or modest, often describes this gesture, it does not actually convey the motivation behind the body language. It does, however, define an aspect of female sexuality as it was constructed in the ancient world. It does so by constructing the female as the opposite of the aggressive unseen male. Foucault, and Dover before him, discusses Greek sexual relations as always conceived of as 'being of the same type as the relationship between a superior and a subordinate, an individual who dominates and one who is dominated, one who commands and one who complies, one who vanquishes and one who is vanquished'. While such sexual practices were apparently equally operative in the love of boys and women, in monumental Greek sculpture they find expression only in the female form.

For us the real issue lies not in retrieving the 'original' meaning of the subject/pose/gesture, whatever that may have been, but rather in how the work was absorbed as ideology; how it was most often and consistently understood and how it may have been creatively, ideologically misunderstood. The initial reaction to Praxiteles' innovation in subsequent ancient sculpture stresses what was considered the most rewarding and exciting aspect of his work. The Hellenistic bronze sculpture now in the Metropolitan Museum eliminates

any trace of Praxiteles' brilliant ambiguity in the gesture and presents instead an explicitly defensive one (Figure 5.3). Just as the rest of this work's visual language describes a true surge of adrenalin, the crouch of her body and turn of her head are more pronounced and produce with greater unity an image of protective fear against unwelcome surveillance. She is titillating and provocative in her overt sexual vulnerability.

More insidious still are the many slightly later artistic derivations of the *Knidia* created in the Hellenistic and Roman periods which repeat the gesture without any of the other visual indications of the narrative.[35] The female nude, thus, has her hand placed over her pubis and frequently also over her breasts in a completely abstract way, with no other apparent explicative gesture or expression. This is the case, for example, with the most oft-cited derivation, the *Capitoline Venus* (Figure 5.4). Aside from covering their pubis and breasts, these figures express neither pride in the source of their fertility nor shame for their exposed sexual organs. In fact, a peculiar feeling of vacuousness characterizes the representation of women in these works. This form of dissimulation results in the disenfranchised gesture/pose which can then only be understood as some sort of deep and enduring attribute of women in general rather than a momentary reaction to a specific situation.

THE PUDICA IN THE CHRISTIAN ERA/VENUS AS EVE

If the late Hellenistic and Roman periods often divorced the pudica pose from its narrative implications, the Christian period capitalized on that very aspect. In fact, the pudica pose may well be the most successful, popular and most often recited fabrication of classicism in Christian art history. As a sign of sexual vulnerability and shame, the rarely if ever acknowledged intrinsic aspect of the Greek originals, the word 'pudica' is never applied in traditional art history to Eve.[36] Because our conception of the medieval is defined as a rejection of classicism, such connections do not fit the classic and classical narratives of art history. Nevertheless, the pudica pose is the one classical trope which is maintained without break throughout the medieval period.[37] It was, in fact, as Christians of the period saw, a perfect formulation for images of Eve as the embodiment of sin in general and female weakness specifically. The ancient form of female nudity 'fits' the Christian disdain for the human body, especially the female body, so well.[38] Again, without any consciousness of how it had, and had always, constructed and defined an attitude of humiliation and fear, we automatically take for granted its prevalent appearance in a Christian ambiance. We unthinkingly accept it as the natural way to illustrate certain Christian texts and the Christian appropriation of biblical narratives, which in turn seem to substantiate misogynist agendas.[39] Most of all, because of its endemic presence in scenes representing moments after the Fall, it is accepted as a natural and normal way to depict Adam and Eve's action of hiding their nakedness. However, Genesis 3: 7 clearly says, 'The eyes of both of them were opened, and they knew that they were naked; and they sewed fig leaves together and made themselves aprons.' The hand-to-genitals gesture/pose, then, is represented as a normal way to hide nakedness, not because the Bible describes it that way. It is represented because it is, once again, a successful form of culturally produced ideological artifice. It is taken from the Greeks and Romans for the work it does in defining the female nude as essentially sexual and, on that account, in a state of perpetual fear and vulnerability. It also maintains its power to define gender difference. Within the medieval visual scheme, man has been subjected to the worst form of humiliation: by being defined as a pudica, he has been feminized. Carolingian and Romanesque manuscripts, Northern Gothic art in general and fifteenth-century Netherlandish painting specifically tend to show both Adam and Eve in the same pudica gesture/pose as they flee paradise in humiliation and shame (Figures 5.5 and 5.6).

Figure 5.5 Limbourg Brothers, *The Terrestrial Paradise:* Très Riches Heures du Duc de Berry, 1413–1416.
Musée Conde, Chantilly, France. Credit: Giraudon/Art Resource, NY

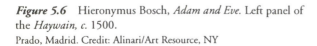

Figure 5.6 Hieronymus Bosch, *Adam and Eve.* Left panel of the *Haywain, c.* 1500.
Prado, Madrid. Credit: Alinari/Art Resource, NY

The function of the pudica gesture as a specific means of creating differentiated men and women resurfaces as an enterprise in early modern Italian art.[40] Masaccio's Adam and Eve in the *Expulsion from Paradise* from the Brancacci Chapel, Sta Maria del Carmine, Florence goes far in constructing a contrasting formulation of shame and humiliation for him and her. Adam covers his face, keeping his emotional expression of grief and shame from the viewer's gaze; Eve covers her breasts and pubis. Indeed, the prominent sight of his penis has recently created quite a stir now that the frescos have been properly cleaned.[41] Once again, while the torture of Adam's shame is an emotional internal affair, Eve's is indexed by reference to her primary and secondary sexual organs.

True Renaissance connections

The 'true' revival of classical antiquity is standardly located in the culture of early fifteenth-century Florence, the initial seat of the Italian Renaissance. It is there that the human nude is no longer exclusively relegated to the shameful Adam and Eve. The very sound of those words, Italian Renaissance, sets educated and cultured twentieth-century hearts aflutter with admiration and yes, love. We may, however, want to rephrase Joan Kelly's well-known feminist query, 'Did Women Have a Renaissance?' and ask 'Did woman want a Renaissance?' – which essentially meant a revival of classical concepts and values that were deeply homocentric – misogynist, classist and racist.[42]

The fifteenth-century classical revival in Florence as it is currently constructed in art history uncannily re-enacts the conditions of the gender-differentiated artistic nude in the same sequence and using the same terms as the ancient Greeks. What this means is that the celebration of the male nude precedes that of the female nude; that the former is loaded with homoerotic implications; and that it is described as a beautiful, youthful, self-contained, rationally constructed and unselfconscious male. Donatello's bronze sculpture of *David* is not just a case in point, it is *the* case in point (Figure 5.7). Although it may initially appear as an isolated instance, its impact – both in its own time and in ours – cannot be underestimated. This is so, if for no other reason than for its impact and influence on Michelangelo's statue of the same subject. Both works have been associated with homoerotics of the times and of the artists who produced them. In his monograph on Donatello, Janson writes that, in order to understand the *David*, 'we must take account of an aspect of Donatello's personality which, for understandable reasons, has not been mentioned in the literature: his reputation as a homosexual' and further, 'For an understanding of the emotional background of the work, it may be useful to recall that its creation coincides with the publication . . . *Hermaphroditus*, extolling the delights of pederasty.'[43] The homoerotic aspects of Michelangelo's *David* are well known and have been discussed by James Saslow and others.[44]

As sexually unselfconscious as Donatello's *David* is, the reintroduction of Venus proper into the western European artistic tradition was predictably as a pudica.[45] Created around fifty years after *David*, Botticelli's *Birth of Venus* in the Ufizzi in Florence is as acclaimed a 'first' in the narratives of the traditional art-historical canon as Praxiteles' and Donatello's work (Figure 5.8). Among the connections woven for Botticelli and his painting in, for example, Janson's ubiquitous *History of Art*, are those with Pollaiuolo's engraving, the *Battle of the Ten Naked Men*; with the patriarchal ruler of Florence, Lorenzo de'Medici; with the Neoplatonic philosopher Marsilio Ficino, whose arcane theories reconciled the 'celestial Venus' as interchangeable with the Virgin Mary; and with classical antiquity. He says, '*The Birth of Venus*, in fact, contains the first monumental image since Roman times of the nude goddess in a pose derived from classical statues of Venus.'[46]

Several strategical moves and elisions in Janson's paradigmatic text are worthy of note here. A comparison with Donatello's *David* seems warranted but it is, in fact, never overtly made. Particularly striking for us is the connection of both the *David* and the *Venus* with classical works via their poses. Yet Janson's text in the *History of Art* names the pose of Donatello's *David* as contrapposto. The

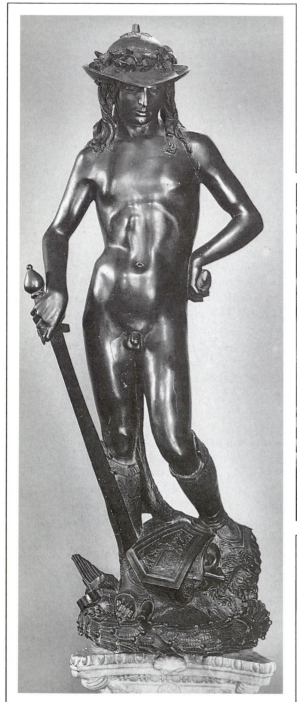

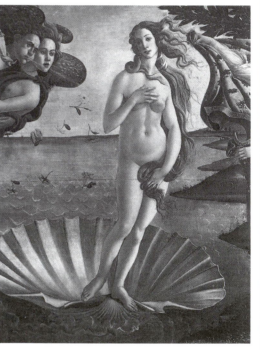

Figure 5.8 Sandro Botticelli, *The Birth of Venus*
c. 1480. Detail of Venus.
Uffizi, Florence, Italy. Credit: Alinari/Art Resource, NY

Figure 5.7 Donatello, bronze *David. c.* 1430.
Museo Nazionale del Bargello, Florence, Italy. Credit: Alinari/Art
Resource, NY

posc is invoked as a justifying pedigree but it is not named pudica. Contrasting the history of both terms is telling, particularly since each could theoretically refer to the stance of either a male or female figure. Contrapposto is, however, consistently discussed in art-historical literature as a pose seen and explained in the representation of men. The term is a highly developed art-historical and intellectual concept unfolded in dense and heavily footnoted texts.[47] Standing for the masculine model, the term is explained as rational, mathematical, philosophical and authoritative. The countervalent term 'pudica' is used, if at all, in the discussion of female figures. Invariably it is used without any sense that a description, definition, a history of the term, or even an explanation is required. Mostly, as is the case in Janson, it is invoked by simply referring to 'it' as the pose for Venus in classical times. Alternatively, 'it' is conjured by simply referring to it as the pose of the *Knidian* or *Capitoline Venus*.[48]

Any real description, definition or recognition of that pose would lead to uncomfortable considerations of the sexual and power relations inherent in it. Less even than homoerotics, which have at least found some place in specialized and ghettoized art-historical literature on Donatello and Michelangelo, the western world's cultural construction of feminine sexuality through the endlessly repeated terms of the pudica remains a harrowing art-historical silence.

The pose's intrinsic work in constructing female sexuality could be accessed by acknowledging its shared use with the representation of Eve, as in Masaccio, or in its difference from Donatello's *David*, as two examples. But the agenda set for Christian shame in the story told by contemporary and traditional historians will not let such connection openly be made with Botticelli's Venus – or its ancient source. The two latter images share a vacuous, 'unknowing' look. They gesture as if in a trance or through some agency outside their own volition. Again, the gesture is divorced from a narrative reading of a particular figure or moment and thus free to work as an essentialist definition of woman in general through this all-telling attribute.[49]

THE SUPINE PUDICA

The expansion of the Venus pudica throughout the western artistic tradition took on even greater dimensions when it was conceived of as a reclining figure. For this development we must credit the sixteenth-century Venetians, Giorgione and particularly Titian, who popularized the gesture in their mythological paintings of recumbent Venus. In the *Sleeping Venus* by Giorgione and Titian's *Venus of Urbino* (Figure 5.9) the Venus pudica is couched, literally and metaphorically, in passive terms.[50] Her one act is to draw her hand to her pubis, again both directing attention there while blocking its full view. Accent on the pubis is further abetted by the formal technique of tipping that part of the female body up and presenting it forward so that it is fully exhibited. The female body is thus formally constructed to participate in the spectator's space rather than in the illusionistic, fictive space of the rest of the representation.[51] The reclining female figures' pubis and gesture are, therefore, no small part of the pictures' message, which ultimately conveys a form of licensed voyeurism and ownership. Even Manet's *Olympia*, the most famous challenge to the convention of the exhibitionistically tipped-up pelvic area, maintains the pubis as the defining aspect of woman (Figure 5.10).

As in the early Hellenistic period, the proliferation of the artistic nude female pudica from the early sixteenth century onwards is in a proportionally inverse relationship to that of the nude male. As one gains in popularity, the other loses. To a great extent, here too, as there, the pudica as a form that culturally promotes and instigates a certain kind of heterosexual desire can be seen as a reaction against the homosexual erotics carried by the artistic male nude. Some evidence for this may be gleaned from the sixteenth-century's discursive terms of the latter. They can be isolated for observation in and around the reaction to male nudity in Michelangelo's art.[52]

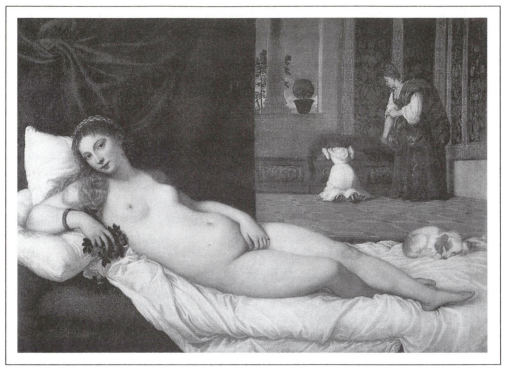

Figure 5.9 Titian (Tiziano Vecellio), *Venus of Urbino* 1538.
Uffizi, Florence, Italy. Credit: Alinari/Art Resource, NY

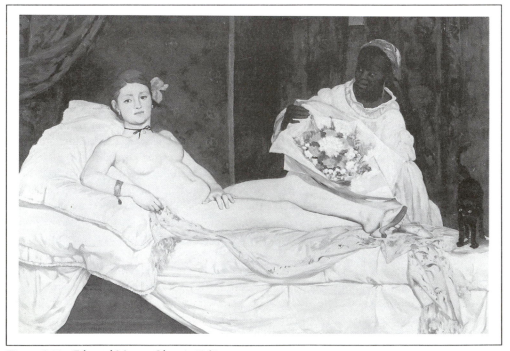

Figure 5.10 Edouard Manet, *Olympia* 1863.
Musée d'Orsay, Paris, France. Credit: Giraudon/Art Resource, NY

For the counter-reformation writers Michelangelo's love of male nudity and its open display in the *Last Judgement* in 1541 signified all that was lewd and its destruction was contemplated even before it was unveiled.[53] Michelangelo's athletic musculature, proportions, free balance and, above all, beauty of the youthful male body connected his art more directly than any other Renaissance artist, save perhaps Donatello's *David*, with the homoerotic sculptures of classical antiquity.[54]

A letter by Pietro Aretino of *c.* 1545 is remarkable for bringing together the several concerns of this chapter: Michelangelo's impropriety in the *Last Judgement* with its insinuations of homosexuality, ancient art, and the pudica gesture/pose. In his letter Aretino asserts that Michelangelo's figures are more suitable to a bath house than to the highest chapel in the world. He invokes the 'modesty' displayed 'even by the Ancients', although significantly he can cite only sculptures of female deities: Diana clothed and Venus where they were 'careful that the chaste gesture of her hand should replace her vestment'. Further, Aretino recommends that Michelangelo follow the example of the modest Florentines, who have covered the genitalia of his *David* with leaves.[55]

The censorial practice of mutilating and then covering with fig-leaves the genital area of ancient and classicizing male figures became a commonplace during the counter-reformation.[56] The result may be compared to the pudica gesture as an expression of prudery but its effect is fundamentally different. The former is clearly applied from outside the figure and recuperates the imagery as social and religious, that is Christian (as in the fig-leaf of Adam). The pudica is presented as part of the volition of the figure herself. It is designed as both the narrative and inner character of ideal femininity. The fig-leaf is seen as a social imposition; the pudica gesture is seen as a personal condition. Moreover, while the fig-leaf has gone 'out of fashion' and is recognized as the repressive expression of prudish mentalities, the pudica gesture remains the quintessential artistic pose for the female nude.

BY WAY OF A CONCLUSION

Clearly, the endemic presence and impact of the Venus pudica can be appreciated only when its history is fully written. This chapter can be no more than a mere beginning for writing such a history. Yet even so, some of the conditions that foster the incidence of the pudica in western art may be suggested. Its initial, historically significant appearance occurred at the crucial moment when the citizen/slave structure of the ancient *polis* gave way to the far more complex social order and division of the Hellenistic empire. The division of labour and power was fractionalized into segmented classed hierarchies that required new kinds of bridges and conduits for communication and co-operation. This modern world required a more flexible and, in a sense, more 'universal' sign for men of different social positions to feel they had something in common. The vulnerable, sexualized female nude is the culturally fabricated site and the public display of heterosexual desire for that male bonding ritual.[57] It effectively overrides male differences of nationality, class or age without destroying the power relationships inherent in those differences. The representation of 'pudicated' women therewith allowed for the diversification of the western male population into power hierarchies by providing them all with a common 'natural' and 'essentially manly' site of mastery.

The forced sense of male heterosexual desire allows for the practice of homosocial bonding without the stigma of homosexual innuendo. Indeed, the shared locker room expression of heterosexuality works as social confirmation and is necessary to repress and deny the existence of homosexual desire. Manly men can then come together over their shared sexual appreciation of, not one another, but 'woman'. The pudica gesture directly addresses and continues to address many needs of an increasingly intricate male community which were new and modern in the fourth century and are unfortunately still operative today.

Notes

1 For a full discussion and bibliography of this issue in history and art history see the forthcoming book by Michael Holly, *Past Looking*, Cornell University Press. My thanks to her for making a chapter of this important work available to me. I wish here also to thank Griselda Pollock, whose ideas and insights have been an enormous source of inspiration for me.

2 While this point is illustrated in endless studies of western European art (especially Italian Renaissance and Baroque studies), several texts have surveyed the classical tradition and its afterlife as their proclaimed subject. These include Benjamin Rowlands, Jr, *The Classical Tradition in Western Art*, Harvard University Press, Cambridge, Mass., 1963; Cornelius Vermeule, *European Art and the Classical Past*, Harvard University Press, Cambridge, Mass., 1964; Michael Greenhalgh, *The Classical Tradition in Art*, Duckworth Press, London, 1978; and Graham Bader, *The Persistence of Classicism*, Sterling and Francine Clark Art Institute, 1995.

3 See Froma Zeitlin, 'Configurations of Rape in Greek Myth', *Rape*, edited by Sylvana Tomaselli and Roy Porter, Basil Blackwell (Oxford 1986), pp. 122–51, p. 123.

4 For example, ibid, and Carol Thomas Neely, 'Recent Work in Renaissance Studies: Psychology. Did Madness Have a Renaissance?' *Renaissance Quarterly*, 44, no. 4, Winter 1991, pp.776–91.

5 Although it is clear from H.W. Janson's *History of Art*, Prentice-Hall/Abrams survey text, that these are his conditions of inclusion, he overtly says so in his 1979 interview with Eleanor Dickinson. See Eleanor Dickinson, 'Sexist Texts Boycotted', *Women Artists News*, 5, no. 4 (September–October 1979), p. 112. This statement and his ideologically loaded construction of the art-historical canon are discussed in my article, 'The Art Historical Canon: Sins of Omission', in *(En) Gendering Knowledge: Feminists in Academe*, edited by Joan E. Hartman and Ellen Messer-Davidow, University of Tennessee Press, Knoxville, 1991, pp. 222–36. Janson's work remains essential to an understanding of art history as it is presently constituted in the academy.

6 An interesting example is Johann Heiss' painting of an academy with five female models in the Staatsgalerie in Stuttgart. Several examples of the female model in the pudica pose before the working male artist are reproduced in France Borel, *The Seduction of Venus: Artists and Models*, Rizzoli, New York, 1990.

7 My ideas on the *Knidia* were first presented in February 1990, as 'The Knidian Aphrodite by Praxiteles: Disclosure from the Outside', College Art Association annual meeting, New York, and in December 1994 as 'Making a World of Difference: Gender, Asymmetry, and the Greek Nude', Archaeological Institute of America annual meeting, Atlanta, Georgia, in a session chaired by Shelby Brown. A brief discussion of the *Knidia*'s importance in the art-historical canon can be found in my article, 'The Art Historical Canon'. Ellen Davis generously offered advice and support in the early stages of the *Knidia* project and Elizabeth Millaker provided important bibliographical references. I want to thank Shelby Brown and the editors of *The Naked Truth*, Claire Lyons and Ann Koloski-Ostrow, where an expanded discussion of the Knidia will be published, for intelligent suggestions and counsel.

8 The sculpture was first extensively studied by Chr. Blinkenberg, *Knidia: Beitrage zur Kenntnis der Praxitelischen Aphrodite*, Levin & Munksgaard, Copenhagen, 1933. See pp. 118–89 for a list of the copies and pp. 190–3 for some literary sources. A more complete list of copies, derivations, adaptations can be found in *Lexicon Iconographicum Mythologiae Classicae (LIMC)*, vol. 2, part 1, 'Aphrodisias–Athena', Artemis Verlag, Zurich and Munich, 1984. A more complete compilation of the ancient literary sources can be found in J.J. Pollitt, *The Art of Ancient Greece: Sources and Documents*, Cambridge University Press, Cambridge, 1990, pp. 84–6. Derivations are discussed in an important book which analyses the social function of sculptures of Aphrodite in the Hellenistic world: Wiltrud Neumer-Pfau, *Studien zur Ikonographie und gesellschaftlichen Funktion Hellenistischer Aphrodite-Statuen*, Dr Rudolph Habelt GMBH, Bonn, 1982. A new study by Christine Havelock devoted to the Knidian Aphrodite and its derivations is forthcoming.

9 The quote is from Martin Robertson, *A History of Greek Art*, vol. I, Cambridge University Press, Cambridge, 1975, p. 390.

10 See note 8.

11 Given the extraordinary heterogeneous nature of the Greek artistic project from the archaic period onwards, this approach makes far more sense than seeking the *Knidia*'s origins in atavistic and marginal prehistoric, Mesopotamian, or Cretan/ Cypriot archaic fertility figurines. They do, however, remind us that there is never really a 'first' or 'original' in history. The designation of the *Knidia* as one is a political one. The archaic and archaistic statuettes are discussed in Blinkenberg, op. cit., pp. 205–12.

12 The standard work on the history of the *kouroi* remains Gisela M.A. Richter, *Kouroi, Archaic Greek Youths: A Study of the Development of the Kouros Type in Greek Sculpture*, reprint edition, Hacker Art Books, New York, 1988.

13 Here, too, the standard work remains Gisela Richter, *Korai. Archaic Maidens: A Study in the Development of the Kore type in Greek Sculpture*, reprint edition Hacker Art Books, New York, 1988.

14 For the relationship between the *Doryphoros* and Polykleitas' lost theoretical text entitled *The Canon* see Ernst Berger, 'Zum Kanon des Polyklet', and Hans von Steuben, 'Der Doryphoros', in *Polyklet: Der Bildhauer der griechischen Klassik*, exhibition catalogue Liebieghaus, Museum alter Plastik, Frankfurt am Main, 1990, pp. 156–84 and pp. 185–98 respectively.

15 While women's legal position changed from period to period, as it did from city-state to city-state, the dominant role played by the classical Athenian legal system, which determined much of the imagery, has often been acknowledged. See M.R. Lefkowitz and M.B. Fant, *Women's Life in Greece and Rome: A Source Book in Translation*, Johns Hopkins University Press, Baltimore, 1982; Roger Just, *Women in Athenian Law and Life*, Routledge, London, 1991; and Eva Cantarella, *Pandora's Daughters: The Role and Status of Women in Greek and Roman Antiquity*, Johns Hopkins University Press, Baltimore, 1991.

16 See Just, op. cit., chapter 3, 'Legal Capabilities', pp. 26–39 and Cantarella, op. cit., chapter 3, 'Exclusion from the *Polis*', pp. 38–51.

17 Cantarella, *op. cit.*

18 See Froma I. Zeitlin, 'The Dynamics of Misogyny: Myth and Mythmaking in the Oresteia', in *Women in the Ancient World: The Arethusa Papers*, edited by John Peradotto and J.P. Sullivan, State University of New York Press, Albany, 1984, pp. 159–94, and Lesley Dean-Jones, 'The Cultural Construct of the Female Body in Classical Greek Science', in *Women's History and Ancient History*, edited by Sarah B. Pomeroy, University of North Carolina Press, Chapel Hill, 1991, pp. 111–37.

19 According to Andrew Stewart, *Greek Sculpture: An Exploration*, Yale University Press, New Haven and London, 1990, vol. 1, p. 105, 'By ca. 750 male nudity is all-pervasive in sculpture and painting, whether the subject be god or mortal, warrior or mourner; women, on the other hand, are now decorously draped.' As for the practice of nudity in the Olympic games, he reports that the first athlete recorded as naked (and then only by accident) is documented in 720 bce.

20 Ibid. pp. 105–6. The meaning of nudity for the history of art in other ancient societies is discussed in a series of essays in *Source: Notes in the History of Art*, guest edited by Larissa Bonfante, vol. 12, no. 2, Winter 1993.

21 For a discussion of this subject see John Boswell, 'Revolutions, Universals and Sexual Categories', *Salmagundi*, 58–9, Fall 1982/Winter 1983, pp. 106–9.

22 For the history of homosexuality in ancient Greece see K.J. Dover, *Greek Homosexuality*, 1978 (reprint, Vintage, New York, 1980), and, more recently, Michel Foucault, *The Use of Pleasure: The History of Sexuality*, trans. Robert Hurley, vol. 2, Pantheon, New York, 1985. Debates continue whether the term 'homosexual' is of any descriptive use at all for an understanding of ancient proclivities, given the late date of its introduction in the nineteenth century. See Boswell, op. cit. and the introduction to *Before Sexuality: The Construction of Erotic Experience in the Ancient Greek World*, edited by David M. Halpern, John J. Winkler and Froma I. Zeitlin, Princeton University Press, Princeton, N.J., 1990. pp. 3–20. See also Jasper Griffin's review of the literature 'Love and Sex in Greece', *The New York Review*, 29 March 1990, pp. 6–12.

23 The pros and cons are discussed in Neumer-Pfau, op. cit., pp. 166–72, where the *Knidia* copy in the Vatican is analysed for evidence of either nonchalance (relaxation) or adrenalized vigilance (tension). I agree with her conclusion that, though both exist, the latter seems to dominate. See also the much abbreviated version of her argument, Wiltrud Neumer-Pfau, 'Die Nackte Liebesgöttin: Aphroditestatuen als Verkörperung des Weiblichkeitsideals in der griechisch-hellenistischen Welt', *Visible Religion*, vol. 4/5, 1985–6, pp. 205–34, and Hans von Steuben, 'Belauschte oder unbelauschte Göttin? Zum Motiv der Knidischen Aphrodite', *Istanbuler Mitteilungen*, vol. 39, 1989, pp. 535–46.

 The issue of the sculpture's meaning in the eyes of her female devotees often comes up. While I cannot wholeheartedly agree with Robin Osborne, 'Looking On – Greek Style. Does the Sculpted Girl Speak to Women Too?' *Classical Greece. Ancient Histories and Modern Archaeologies*, edited by Ian Morris, Cambridge University Press, Cambridge and New York, 1994, pp. 81–96, that the *Knidia* has nothing at all to say to women (p. 85), I do agree that 'the recuperation of the female genitals as the imagery of a celebratory affirmative exposure of female sexuality is highly problematic'(p. 95 note 2). See his references to the work of Griselda Pollock and Lisa Tickner.

24 J.N. Adams, *The Latin Sexual Vocabulary*, Johns Hopkins University Press, Baltimore, 1993, p. 51 and pp. 55–6. I have not been able to find the word 'pudica' as an art term in any Latin or Italian dictionary. Nor does the word appear in any dictionary of art terms so far as I know. It is, however, frequently used and only sometimes defined, and then with only a phrase or sentence that is more of a description than definition. The only cited examples I have found are Bianca Maria Felletti Maj, '"Afrodite Pudica": saggio d'arte ellenistica', *Archeologia Classica*, vol. 3, Rome, 1951, pp. 33–65, and *LIMC*, p. 49.

25 Adams, op. cit., p. 51. *A Greek–English Lexicon*, compiled by Henry George Liddell and Robert Scott, new edition revised and augmented by Sir Henry Stuart Jones, Oxford University Press, Oxford, 1940, p. 36. Bonfante, op. cit., states on p. 11:

 As in the Bible, the mention of sexual organs was avoided by using euphemisms. The Greek word for 'sexual organs,' *aidoia*, means 'things to be ashamed of,' the equivalent of the Latin *pudenda*, 'things about which one must have *pudor*, modesty, shame, and respect.'

 Rather than interpreting this information as an avoidance of mentioning sexual organs, I would say that sexual organs are given social meaning by so-called 'euphemisms'. Similarly, the rather complicated connection of the word with the

act of covering and uncovering should not, in my view, be confused for any 'natural' or 'intuitive' associations with the sexual organs, as in Gloria Ferrari, 'Figures of Speech: The Picture of *Aidos*', *Metis. Revue d'anthropologie du monde grec ancien. Philologie – Histoire – Archéologie*, n.d., p. 189, but again rather as a form of ideological regulation of sexuality. While I am here concerned only with the two most common uses of the root word *aidos*, her discussion of its use as a sign of vulnerability and disadvantage and its connection with *phobos*, fear, are relevant to my argument. For these and other ancient uses and associations see pp. 191–3 and the sources Ferrari is condensing, as in her note 15, p. 191.

26 The quote is from *Lucian*, The Loeb Classical Library, translation by M.D. MacLeod, Harvard University Press, vol. 8, 1967, pp. 168–73. Given the loaded doubled meaning of this word and the fact that English is the only language which does not combine these concepts linguistically, it is interesting to see how modern authors translate Lucian's text into English. The Loeb Classical Library uses the sophomoric (yet oddly equivalent) euphemism 'private parts' (p. 169). Pollitt (op. cit., p. 86) translates, 'for her nudity is complete except insofar as she holds one hand in front of her to hide her modesty'. Similarly, Stewart (op. cit., p.280), 'except that she unobtrusively uses one hand to hide her modesty'. In Osborne (op. cit., p.82), 'she nonchalantly conceals her crotch'. I encountered this language problem when my article (as in note 5) was translated into German. I had to insist that the word *Scham* was an unsatisfactory translation for pubis as it reinscribed the very ideology I was trying to undo. See Nanette Salomon, 'Der kunsthistorische Kanon – Unterlassungssünden', *Kritische Berichte: Zeitschrift für Kunst-und Kulturwissenschaften*, guest editor Kathrin Hoffmann-Curtius, vol. 4, 1993, p. 36 and note 51, p. 40.

27 The definition is taken from Bonfante, op. cit., p. 11 and differs in intonation from her own in 1989: Larissa Bonfante, 'Nudity as a Costume in Classical Art', *American Journal of Archaeology*, vol. 93, 1989, pp. 543–70, where she says that sexual organs were, in fact, 'shameful things', (p. 545 and note 14).

28 Jean-Paul Vernant, 'Between Shame and Glory: The Identity of the Young Spartan Warrior', in *Mortals and Immortals: Collected Essays, Jean-Paul Vernant*, edited by Froma I. Zeitlin, Princeton University Press, Princeton, New Jersey, 1991, p. 242.

29 Plato, *Laws* 1.647a8–11, quoted from ibid., p. 242 note 46.

30 See Helen North, *Sophrosyne: Self-Knowledge and Self-Restraint in Greek Literature*, Cornell University Press, Ithaca, 1966.

31 Anne Carson, 'Putting Her in Her Place: Woman, Dirt, and Desire', in *Before Sexuality*, p. 142.

32 North, op. cit., p. 76 note 105.

33 Aristotle, *Politics*, 1260a20–4; 1277b20–4, cited in Carson, op. cit., p. 142.

34 Ibid.

35 *LIMC*. Especially peculiar are the portrait heads of Roman matrons placed over youthful 'pudica' bodies. See M. Bieber, *Ancient Copies*, New York, 1977.

36 It is, in fact, defined as the opposite or at least alternative in Kenneth Clark, *The Nude: A Study in Ideal Form*, Doubleday, New York, 1956, compare chapters 3 and 8.

37 For the continued interest in the medieval period in the *Knidian Aphrodite* and the ancient derivations after her, see Michael Camille, *The Gothic Idol: Ideology and Image Making in Medieval Art*, Cambridge University Press, New York, 1989, pp. 83–8 and p. 366 note 27.

38 Christian attitudes towards the body in general and the female body specifically have been studied extensively. See, for example, Caroline Walker Bynum, *Fragmentation and Redemption: Essays on Gender and the Human Body in Medieval Religion*, Zone Books, New York, 1991. For a study on the concept of Eve see John A. Phillips, *Eve: The History of an Idea*, Harper & Row, San Francisco, 1984.

39 For the fallacies in logic and distortions of the original biblical text in Paul's misogynist interpolation of Genesis see Mieke Bal, 'Sexuality, Sin and Sorrow: The Emergence of Female Character (A Reading of Genesis 1–3),' in *The Female Body in Western Culture: Contemporary Perspectives*, edited by Susan Rubin Suleiman, Harvard University Press, Cambridge, Mass., 1986, pp. 317–38.

40 Even before the 'founding fathers' of the Italian Renaissance, Donatello, Masaccio and Botticelli, the pudica pose used to differentiate the terms of masculinity and femininity was reinscribed by the late Gothic Pisan sculptors Nicola Pisano and his son Giovanni. In their proto-Renaissance works of Heracles and Temperance, respectively, we find once again the ancient Greeks' asymmetrical conditions of nudity.

41 For the details on the cleaning of the Brancacci Chapel see Umberto Baldini, *The Brancacci Chapel*, Abrams, New York, 1992.

42 Joan Kelly, 'Did Women Have a Renaissance?' reprinted in *Women, History, and Theory: The Essays of Joan Kelly*, University of Chicago Press, Chicago, 1984, pp. 19–50.

43 H.W. Janson, *The Sculpture of Donatello*, 2 vols, Abrams, New York, 1970, p. 85.

44 For a recent discussion of Michelangelo's homosexuality and a review of the literature on this subject see Andreas Sternweiler, *Die Lust der Götter: Homosexualität in der italienischen Kunst Von Donatello zu Caravaggio*, Verlag Rosa Winkel, Berlin, 1993, pp. 102–211.

45 For the documented presence in the Renaissance and after of copies and derivations of the *Knidian Aphrodite*, including the *Capitoline Venus* and the *Venus de' Medici*, see Francis Haskell and Nicholas Penny, *Taste and the Antique: The Lure of Classical Sculpture 1500–1900*, Yale University Press, New Haven and London, 1981: *The Capitoline Venus*, no. 84 pp. 318–20; *The Venus de' Medici*, no. 88 pp. 325–8; and *The Standing Venus*, also known as *Venus Emerging from the Bath*, *Pudic Venus* (sic), no. 90, pp. 330–1. See also P.P. Bober and R.O. Rubinstein, *Renaissance Artists and Antique Sculpture: A Handbook of Sources*, Harvey Miller Publishers, London, 1986, pp. 59–61.

46 Janson, *History of Art*, pp. 469–70.

47 See, for example, the dense article by David Summers, 'Contrapposto: Style and Meaning in Renaissance Art', *The Art Bulletin*, vol. 59, no. 3, September 1977, pp. 336–61.

48 A case in point is the text accompanying Renoir's *Baigneuse (La Baigneuse au griffon)* in *Origins of Impressionism*, exhibition catalogue by Gary Tinterow and Henri Loyette, The Metropolitan Museum of Art, New York, 1995. The reference to the pose is given as 'Although Renoir, as Salomon Reinach has noted, may have given his *Baigneuse* the pose of the Aphrodite of Cnidus, . . .' (p. 457).

49 The standard monograph on Botticelli remains R.W. Lightbown, *Sandro Botticelli*, University of California Press, Berkeley, 1978. He gives examples that indicate how the elitist and cumbersome allegorical trappings of Botticelli's Venus were deleted in the derivations and copies by Botticelli and his workshop.

50 For the painting by Giorgione see Millard Meiss, 'Sleep in Venice: Ancient Myths and Renaissance Proclivities', reprinted in *The Painter's Choice: Problems in the Interpretations of Renaissance Art*, Harper & Row, New York, 1976. For a recent review of the various interpretations of Titian's *Venus of Urbino* see Mary Pardo, 'Artifice as Seduction in Titian', in *Sexuality and Gender in Early Modern Europe: Institutions, Texts, Images*, edited by James Grantham Turner, Cambridge University Press, New York, 1993, p. 59 and pp. 86f. note 11.

51 For a fuller discussion of the history and ideological consequences of this artistic practice see my article, 'Courbet's *Woman with a Parrot* and the Problem of "Realism"', in *Tribute to Lotte Brand Philip, Art Historian and Detective*, edited by William W. Clark *et al.*, Abaris Books, Inc., New York, 1985, pp. 144–53, esp. p. 147.

52 Michelangelo's homosexuality has most recently been discussed in James Saslow, *Ganymede in the Renaissance: Homosexuality in Art and Society*, Yale University Press, New Haven, 1986, and Sternweiler, op. cit., pp. 102–211.

53 The controversy around the nudity in Michelangelo's art is summarized by André Chastel, 'First Reactions to the Ceiling', in *The Sistine Chapel: The Art, the History, and the Restoration*, text by Carlo Pietrangeli *et. al.*, Harmony Books, New York, 1986, pp. 149–75.

54 A hint of how the problem of Michelangelo's forms was identified with homoeroticism is given by Nino Serini in 1541 and repeated by Gilio in 1564 that some 'complain that he made Christ a beardless athlete', a coded remark which is illuminated by Savonarola's earlier invective against homosexual practices among Florentine priests, 'Abandon your concubines and your beardless youths, Abandon . . . that unspeakable vice.' Another anonymous letter refers to Michelangelo as the inventor of 'bestialities'. See Chastel, op. cit.

55 Pietro Aretino, *The Works of Aretino*, translated by Samuel Putnam, vol. 2, Pascal Covici, Chicago, 1926, pp. 292–7.

56 The history of the practice of covering or replacing penises with fig-leaves on ancient and classicizing sculpture has never been written. The only discussion I have found is in Leo Steinberg, *The Sexuality of Christ in Renaissance Art and in Modern Oblivion*, Pantheon/October, New York, 1983, pp. 174–83. Steinberg cites Montaigne, *Essays* (III,5), where Pope Paul IV's practice of 'castrating many beautiful and antique statues' and replacing them with fig-leaves is mentioned (1555–9).

57 My ideas have been stimulated by Eve Kosofsky Sedgwick, whose important work deals with English literature of a later period. Eve Kosofsky Sedgwick, *Between Men: English Literature and Male Homosocial Desire*, Columbia University Press, New York, 1985.

On viewing three paintings by Jenny Saville:

rethinking a feminist practice of painting

Alison Rowley

HOW TO FRAME AN INTERVENTION: AN INTRODUCTION

'This is Jenny, and this is her Plan.' So announces the title of the Hunter Davies Interview in the *Independent* newspaper of Tuesday, 1 March 1994. 'Jenny' is the painter Jenny Saville, seven of whose paintings were shown between January and August 1994 at the Saatchi Gallery in London in the exhibition *Young British Artists III. Plan* is the name of the painting she stands in front of in the large photograph which accompanies the article (Figure 6.1) 'She doesn't look the artist, more like a lower sixth-former, so young, so small, so conventionally dressed,' says Davies in his piece and goes on, as he watches her, presumably at the exhibition opening, 'Jenny says "yes, I used myself for that pose, that face is actually me", and at once there was a crowd around her disbelieving at first that such images could spring from this sweet fresh-faced girl.' Against this text the photograph reads ambiguously. Does it give back to her the phallic status culturally attributed to the male artist that the written description of her appearance takes away? For there she stands between the thighs of the painted woman (which, remember, is actually her) as her own erect penis. Or does she stand in front of the pubic area of the painting of herself both to cover *and* to emphasize her own lack? And then doesn't this photo also have a masturbatory insinuation? Her own figure could be read as penetrating her own painted figure. Jenny Saville into herself, you might say.

I begin with this photo-text combination because in its crudity and its ambiguity it is emblematic of the complex of issues I want to address in this chapter. To start from where we are with the newspaper review: the recent exhibition of Jenny Saville's paintings provides the perfect opportunity to watch the construction of a young painter, with a declared feminist consciousness about the female body and representation, within the discourse of British arts reviewing and criticism, as it happens. In the *Independent on Sunday Review* of 30 January 1994, one of the very first pieces about her work to appear, Jenny Saville talked to David Sylvester about *Plan*, about her working methods, the use of her own body as a model and her concern with making images of women who do not possess the kind of beauty that is associated with the current cultural fantasy of what the female body should be. This augurs well for the beginnings of a feminist practice. Except that for British art, the name David Sylvester signals something quite different. He is probably best known for his book of interviews with Francis Bacon, he has written about Lucian Freud and has been associated, since at least the1950s, with a specific masculine homosocial, and in part homosexual, network of painters and critics working in Britain. Jenny Saville has chosen for the construction of her female bodies a technique of paint application immediately recognizable as that developed by Freud from about the 1960s onwards. This, presumably, was the cue for Sylvester's arrival at

her studio door. Freud is often referred to as Britain's greatest figurative painter. The name David Sylvester, then, signals Saville's arrival as a serious figurative painter with the potential for future greatness. For me this raises a question: can a feminist intention survive or coexist with the essentially masculine, modernist discourse Sylvester represents, with its watertight categorization by medium, and its league table of bad, good, great? Another review might point up the problem, this time one by Richard Dorment in the *Daily Telegraph*.

> Saville paints big, fat, ugly, naked women, and she does so with such panache that we feel we've just collided with a Mack truck ... None of this would be of much interest were Ms Saville not such a wonderful painter. As though to demonstrate that beauty is independent of subject matter, she proceeds to dazzle us with a painting technique so confident it defies us to look away.[1]

In her important 1981 *Screen* article, 'Re-viewing Modernist Criticism', Mary Kelly observed that: 'Modernist discourse is produced at the level of the statement, by the specific practices of art criticism, by the art activities implicated in the critic/author's formulations and by the institutions which disseminate and disperse the formulations as events'.[2] In analysing the way modernist criticism functions as a practice, Kelly notes two things, first of all that 'the normalisation of a mode of representation always entails the marginalisation of an alternative set of practices', and secondly that 'marginalisation is not simply a matter of chronological displacement or exclusion: it can also be effected by incorporation'.[3]

We can see the operation of both marginalization and incorporation at the level of mainstream critical discourse even more clearly when William Packer writes:

> But whatever their feminist or fattist programme might be, they are more interesting for their formal and practical qualities. Simply to control the paint and sustain such images across these extensive surfaces is to declare Miss Saville a painter of considerable natural ability. Certainly she deserves better than to be celebrated only for her imagery.[4]

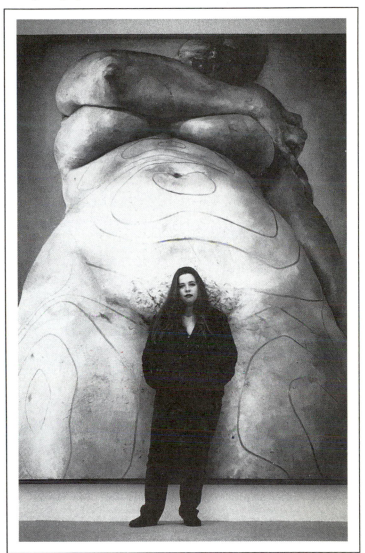

Figure 6.1 Glynn Griffiths, *Jenny Saville in front of 'Plan'*, *The Independent*, Tuesday 1 March 1994

So however confrontational the imagery might be, it is mitigated by its formal qualities, the 'virtuoso feats of pure painting'. The conjunction feminist and figurative painter proves to be problematic

in this critical context; the former is subsumed by the latter. Feminism, at best, becomes a sub-category of figurative painting, at worst, it is simply synonymous with 'fattist'.

The question with which this chapter must begin then is: how am *I* going to write about whatever it is that happened between the works hanging on the walls of the Saatchi Gallery made by this woman who is called Jenny Saville, and myself as I viewed them in the space of the gallery?

BRANDED: A FIRST ENCOUNTER

I want you to imagine now that enormous, white, rarefied space through which I walked for the first time one February afternoon straight up to a painting which had the title *Branded* (Figure 6.2). A photograph called *Exiled* by Jo Spence (Figure 6.3) immediately came to mind. The juxtaposition undoubtedly occurred because we had recently looked at the work of Jo Spence on the MA in Feminism and the Visual Arts course I was at that time undertaking. I looked at the words drawn into the paint following the form of the woman's body in *Branded* and thought angrily: 'How dare you employ as a rhetorical device words, which in Spence's case she actually wrote on her own ill, ageing, working-class body to both confront us with, and to defend herself from our judgement of it?' It seemed to me horribly insensitive, insulting almost, 'and Jo Spence is no longer here to comment on it,' I thought. I spoke to others who had seen this painting and they did not express anger about it at all. My own body had obviously suddenly become the site of a complex of memories and experiences where the painting and the photograph, Spence and Saville, the environment of the Saatchi Gallery collided to produce an anger which threatened to colour any other view of the work I might have. So what was, what is my specific position? A woman with one sort of working-class background enough like Spence's to trigger, for a start, an identification with her whole painful exploration of working-class aspiration and all its resulting pulls of loyalties and desires. And then I'm also a painter trained at a provincial, and then a London, art school in the mid to late 1970s. Was my own choice of painting, on some level at least, perhaps a form of social aspiration? It didn't help that someone had recently reminded me that John Golding referred to painting as the 'most aristocratic art'. And here was the spectre of Jo Spence tapping me on the shoulder saying,

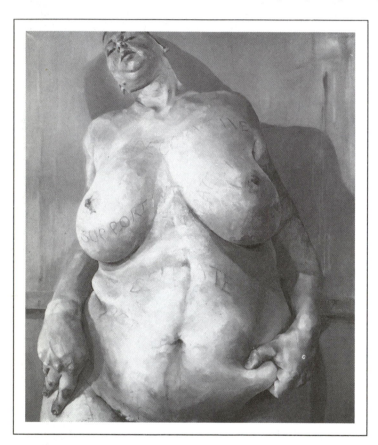

Figure 6.2 Jenny Saville, *Branded*, 1992, oil on canvas, 7' × 6'.
Saatchi Collection, London

Remember she's in this gallery, she has been paid to make this work, because it's painting, moreover painting of a certain kind, because she is young *and* she's middle class.[5] Do you think that Charles Saatchi would have supported me, an ageing working-class photographer in the work I made?

(The real Jo Spence would never have spoken like this at all I'm sure.) Where does this comparison get me? In this form, absolutely nowhere.

When I try to unravel my reaction to *Branded* it gets quite complicated but it goes, put simply, something like this: I had been caught in my class-determined over-closeness to Jo Spence, and I had identified with Jenny Saville as the young painter I once was. The work of Jo Spence and Jenny Saville marks a history of feminist practices. The very possibility of Jenny Saville being able to make *Branded* points to her awareness of this at one level, but her total misunderstanding of it at another. Nowhere that I have been able to discover in her conversations with the press does she refer to any knowledge of Jo Spence's work. She does, though, perhaps pushed by her interviewers, comment upon the influence of Lucian Freud on any painter dealing with the human figure today. I think back to my own training in the painting department of that London art school in the 1970s. It would have been rare indeed for it to have occurred to any one of us to acknowledge work such as that of Jo Spence, even if we had known it, because it was work in photography and we were painters, so we could borrow what we liked from another medium without acknowledgement. We may not even have found it necessary to locate ourselves historically as painters and acknowledge our *painted* debts, for painting was regarded as the expression of an individual who must 'make it new' with every work.

Another strand of my reaction in front of *Branded* was undoubtedly outrage that Jenny Saville's training

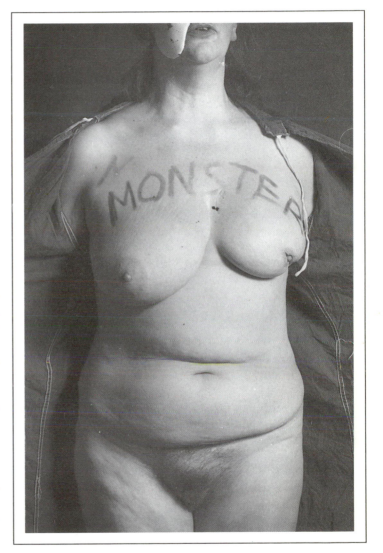

Figure 6.3 Jo Spence, *Exiled*, undated.
Jo Spence Memorial Trust, London

at Glasgow School of Art could have been, fifteen years later, as much like my own for her to be either unaware of Jo Spence's work or not to have found it necessary to acknowledge an awareness of it, because it is not painting. If we understand feminism in the visual arts as a historically con-

tinuous (however diverse) movement of practitioners, art historians, theorists to analyse and under-
stand the politics of representation in a dominant patriarchal order, our work is never 'our own' in
the way I was trained to use that phrase, and in the way I sense that Jenny Saville still thinks about
what she does. Mary Kelly's 'Re-Viewing Modernist Criticism' could be extended to point out that,
as practitioners, we ourselves are 'produced at the level of the statement, by the specific practices
of art criticism' and that this is the site, as much as the work itself, for strategic intervention. What
a marvellous opportunity it would have been, had she been in the position, for Jenny Saville to
have used her work in painting as a vehicle with which to carry a discussion of the relations between
Jo Spence's work and her own into a review under the imprimatur of David Sylvester! It would
have, at once, interrupted the beginnings of her own construction for the category 'painter' in the
mode of Freud and Bacon with its attendant marginalization of her feminist intentions, and it
would have brought into view the photographic work of Jo Spence right at the centre of the priv-
ileged (and not least as it bears upon the end of Jo Spence's life, the financially privileged)[6] masculinist
discourse around British painting. With an understanding of her very person as a site for the pro-
jection of masculine fears and desires, Jenny Saville might also have been able to avoid being set
up, framed by the *Independent*'s photographer.

What I have just written, translated into visual terms, runs the risk of looking itself a lot like
the *Independent* photograph, a picture of *my* embarrassing over-closeness to my subject matter.
Luce Irigaray has spoken of this touching/touching upon oneself as the very condition of female
desire and female language. The work of both Jo Spence and Jenny Saville is concerned with self-
examination as a place from which to begin to speak a corporeal and psychic specificity. From the
distance of masculine, mainstream critical discourse around painting, in art institutions as much
as in press reviewing, the connection has not been made. In a piece written after the recent death
of Clement Greenberg, Griselda Pollock described feminism as having 'punctured a hole' in the
strand of modernist thinking Greenberg and his school of criticism represented:

> Not only are issues of gender untouched in Greenberg's writings, they would seem to be utterly irrelevant, part of the
> unnecessary baggage that ambitious painting had to discard in order to perform its heroic act of self-protection against
> the mess of ideological struggle characteristic of capitalist societies. Gender, as much as class struggle, would fall under
> this interdiction.[7]

It was precisely my historical feminist awareness in front of *Branded* which allowed the paint-
ing to activate the particular 'mess' of conflicting desires and identifications across both gender and
class that form and inform my viewing position. My writing, from this unavoidable, and I might
now hazard, *necessary* close position becomes the instrument with which to 'puncture' the current
construction of Jenny Saville as a serious figurative painter, who just happens to be a woman with
a temporary feminist agenda which she will no doubt outgrow as she realizes her skills as a painter.
It also becomes the place where the work of Jo Spence and Jenny Saville can inhabit the same dis-
course to be considered in both its similarity and its difference.

This does not mean to say, however, that we can ignore the way Jenny Saville's paintings are
made, and here a difficulty arises. How can we talk about the formal decisions Saville makes in the
construction of her works, decisions about size, scale, composition, colour, paint application, with-
out falling back into that language of formalism which was the very basis of a feminist criticism
for women in the visual arts like Lucy Lippard, who 'refused to see games with flatness and colour
as the be-all-and-end-all of art'?[8] I want to start first by changing the terminology slightly and sug-
gest that we talk about *technical* procedures rather than formal qualities.[9] Then I want to read the
use Jenny Saville makes of the technical resources and devices painting offers (and this includes
her studio procedures) as both symptomatic of her cultural placement as a white, middle-class
woman who paints, and as revealing the inscription of a structure of female subjectivity explored
in feminist reworkings of the psychoanalytic theories of Freud and Lacan.

Carolyn Steedman begins her book *Landscape for a Good Woman* with these words: 'This book is about lives lived out on the borderlands, lives for which the central interpretative devices of the culture don't quite work.'[10] One of those central interpretative devices is psychoanalysis. Writing about the availability for middle-class women of the conventions of romantic fiction and fairy-tales for telling their life stories, she says:

> The myths tell their story, the fairy-tales show the topography of the houses they once inhabited. The psychoanalytic drama, which uses the spatial and temporal structures of all these old tales, permits the entry of such women to the drama itself. Indeed, the psychoanalytic drama was constructed to describe that of middle-class women (and as a drama it does of course describe all such a woman's exclusions, as well as her relationship to those exclusions, with her absence and all she lacks lying at the very heart of the theory). The woman whose drama psychoanalytic case-study describes in this way never does stand to one side, and watch, and know she doesn't belong.[11]

Steedman does not dismiss the validity of the psychoanalytic discourse *because* it is founded upon the experience of those women most centrally related to the culture; she argues for its reframing in each particular instance as it intersects with the lived social experience of classed and gendered individuals. In the case of working-class childhoods she see the 'first loss, the earliest exclusion (known most familiarly to us as the Oedipal crisis) brought forward later, and articulated through an adult experience of class and class relations':[12] felt, that is, as the experience of exclusion through material deprivation, the desire of people for 'the things of the earth'. In this way I want to let my encounter with *Branded* interrupt a psychoanalytic account of female desire, as I shall suggest it might be articulated using the particular resources painting offers, with whatever 'painting' meant to me in terms of what Steedman calls, in *Landscape for a Good Woman*, 'a proper envy'.

PLAN: LARGE WOMAN OR LARGE CANVAS? A CONFUSION OF SIZE WITH SCALE

> Her canvases are very large, conventionally so, but that she should then impose upon them out-size images of the figure that are often too big for them, is rather less expected. That these images should then be positively outrageous – fat, bloated, distorted female nudes, scratched and scrawled with slogans and graffiti, gleefully flouting all canons of taste and decency – only compounds the visual shock.
>
> (William Packer, *Financial Times*, Friday 28 January 1994)

There tends to be, in the rhetoric, itself overblown, surrounding Jenny Saville's work, a conflation of very large woman and very large canvas. In this respect also the Hunter Davies Interview photograph can be read as symptomatic. The 'small' figure of Jenny Saville posed in front of *Plan* does indeed produce the effect of the hugeness of the depicted woman. The canvas is obviously much larger than the figure of Saville herself, yet to reiterate her own words about *Plan*, 'The head is mine, in fact the painting is really based on me'. This might prompt us to ask the question: *is* this a huge woman, or is it a canvas a good deal larger than the size of a human being, on which a composition is constructed so that the frame is nearly all filled with the head, torso and hips of a female figure? The canvas in fact measures 9' × 7'. Why Saville might choose a canvas 9' × 7', how she manages to fill it with almost all body, and why she should want to do so must now be considered if we are to unravel wherein lies the hugeness of *Plan* (Figure 6.4).

The figure is, to begin with, hugely foreshortened. This allows Saville, first of all, to fill well over the bottom two-thirds of her canvas from edge to edge with painted flesh and hair: the thighs and pubis of her female figure. But is the figure lying down or standing up? The bottom edge of the canvas stops it at the thighs. The surface around where the torso begins, from the hips, to recede towards the head is painted a neutral grey, tonally modulated enough to allow it to read as space but with nothing to indicate whether it might be floor or wall. Does the depicted female figure look down at us to where we might imagine ourselves positioned in the space of the picture in relation to her at roughly knee height? Does she look along her own body at us from where she is lying to where we

might imagine ourselves sitting or crouching somewhere by her knees? Are we really allowed a viewing position within the represented space of the picture at all? Can we imagine how we would place ourselves as the painter in the space of the studio in order to paint this view of the model? The picture is spatially ambiguous, the figure seems neither to stand nor to lie but to be tilted at a 45-degree angle between the two. The effect is as if the canvas is a large mirror which has been placed on the floor to catch the woman's reflection and then tilted upwards slightly from the back. The narrative of the depicted space is not one in which we can easily imagine ourselves as part of the story as a character (except perhaps, and perhaps revealingly, as a child hanging onto or sitting on her knees). Neither, in the imagined narrative of painter and model in the studio, is it easy to determine what would be their spatial relationship. If the painter is indeed her own model, the narrative is one of self-examination to which we as viewers are witnesses.

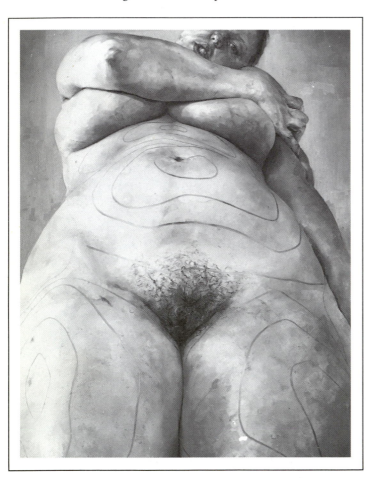

Griselda Pollock has argued that the fraught relationship between painting and feminism can be 'rhetorically tracked in the contradictory placements and significations of two bodies: the "body of the painter" and the "feminine body"'.[13] In Matisse's painting *The Painter and His Model* of 1917 Pollock identifies as represented 'three orders of space which define modern western art-making':

It is a social space shaped in the concrete social and economic relations in one particular studio in Paris in 1917 in which a white bourgeois man paid a probably working-class woman to work for him. Then it is a representation of the symbolic space of art, the studio, and it makes a statement about the basic components of art-making – the artist, the model and the site of their one way transaction, the canvas. Finally it presents to us the space of representation, that canvas, upon which is painted a fictive body which has been invented by the combination of the painter's look and gesture. A social and sexual hierarchy are pictured: the artist is canonically male (signalling the fusion of Culture with masculinity); his material is female (the assimilation of nature, matter and femininity). By its formal disposition of man/artist: woman/model, the painting articulates the symbolic value and symbolic gender in western modernism's discourse of the 'body of the painter'.[14]

Figure 6.4 Jenny Saville, *Plan*, 1993, oil on canvas, 9' × 7'. Saatchi Collection, London

With *Plan*, Saville collapses all three of these spaces. Working mainly from her own middle-class white body she renegotiates the social and economic relation between painter and model. The studio, then, is no longer the space of a one-way transaction; this is *self*-examination. From the third space, the space of representation, the painting *Plan*, we can consequently read a rearticulation of western modernism's discourse of the 'body of the painter'. The represented body is no longer 'the supine female object body' but the active *female* creative body examined in the practice of the 'woman's body'.[15]

But why, it might still be asked, does Jenny Saville use a canvas as large as 9' × 7' for her image, why not paint life-size? To begin to answer this question I want to continue with the idea of self-examination and turn to Saville's own words. Talking to David Sylvester about the contour lines incised into the paint of the figure in *Plan*, Saville says: 'The lines on her body are the marks they make before you have liposuction done to you.' Speaking about the image of the marked-up woman in The Hunter Davies Interview she says:

> I'm not painting disgusting, big women. I'm painting women who've been made to think they're big and disgusting, who imagine their thighs go on forever. . . . I haven't had liposuction myself but I did fall for that body wrap thing where they promise four inches off or your money back.

Does Saville then, worry about her own size? In the company of thinner women, looking at photographs of the models in *Cosmo*'s exercise regimes, does she feel that her body occupies a vast amount of space by comparison? Informed by the work of Freud and Foucault, it would be possible to read as signified by the size of the canvas for *Plan* Saville's figuration of the psychic dimensions of her own body, as it is constructed at the intersection of her physical body with all those discourses, of the fashion and cosmetics, the diet, health products and plastic surgery industry, that operate to produce the sign 'desirable feminine body' for this culture as something other than her size and shape. The composition of the figure within the frame strengthens this signification: not only does it need a canvas 9' × 7' to accommodate it but even then it's a squash to get it in. In her work on Degas, Heather Dawkins has referred to the body as a 'memorable space'.[16] On one level it is perhaps the memory of the mismatch, as it is lived from day to day, between a female body of a particular appearance and the culture's sign for the desirable, feminine body that is caught in the dimensions and represented space of *Plan*.

I would now like to evoke another memorable space, that between my own body and *Plan* in the Saatchi Gallery. At my height of 5' 7" if I stand at painting distance from the canvas (by the size of the marks this is closer than arm's length as these are manipulations of the brush by fingers and wrist, not swings from the shoulder), I have in my focused vision a group of oblongish marks of flesh tones modulated to simulate the play of light over a smooth but slightly uneven surface. Into this surface break some small brownish black curved marks of raised paint which I can imagine as having been made by gently laying a fine, long-haired brush loaded with colour onto the surface of the canvas and quickly lifting it off again. The memory from my own experience of manipulating paint, of the controlled combination of amount of paint, weight of hand, movement of fingers needed to execute marks like these is very pleasurable. At this distance from the canvas I'm lost in the memory of the tactile pleasures of paint application. And literally lost in the space of the canvas with nothing to locate myself, I cannot see any whole shapes or the edges of the canvas. How does this area of painted marks relate to those on the rest of the canvas, and to construct what? To find out, I have to pull a good way back from touching distance before I have the whole canvas within my field of vision and can see that what the marks make is where pubic hair peters out into the smooth skin of the stomach. But at this distance my memories are of another order, in another register: they are memories of other images of women without clothes, from other paintings and photographs with which I begin to compare *Plan*. By moving back to hold the whole canvas within my view so that I can see how the marks coalesce into the bounded shape I look for as standing for the human figure in the conventions of western painting, I have to forfeit the tactile pleasure of an imaginary application of marks to the surface of *Plan*, the memory of my own body in contact with a canvas. But I can move in and back again at will. I want to suggest here that at the level of the lived space of the viewer moving back and forth in the Saatchi Gallery, it is the attempt to accommodate these two modes of looking, of both proximity and of distance within the space of the same canvas, that we can account for the large, 9' × 7' dimensions of *Plan*.

As it turns out, the viewer experiences in *Plan* traces of the working space Jenny Saville sets up in her studio. In interviews she has referred to her need to paint large areas of flesh at close range, and to the fact that she 'gets nothing' from the model in the life room. But she also remarked that she finds the presence of the model intimidating.[17] She takes close-up photographs of parts of her own body, those of her friends, and sometimes a model from which to work alone in the studio. The room she works in on canvases as large as *Plan* (9' × 7') is small. There is no space to stand back to see the whole of the composition as she works so she sets up a series of mirrors into which she glances, over her shoulder, to see how her marks at close range are hanging together to make the figure as a whole.[18] I want to suggest that in her studio practice these procedures are set up, consciously or not, to allow Jenny Saville a fantasy of tactile contact with a body as she constructs it. To Clare Henry, in the *Herald Review*, Saville says: 'I didn't want an illusion of flesh, but the feel of it; the body of flesh.' At the same time, they also provide for her recognition that a certain distance is necessary to allow for the production of meaning in the register of sight.

THE SPACE OF DESIRE: HOW CLOSE CAN YOU GET?

In her study of the woman's film of the 1940s, Mary Ann Doane reveals the representation of female subjectivity in that discourse as an image of a debilitating over-closeness, simultaneously projected in the construction of the female characters, and assumed by the female viewer in her identification with them. Here, she points out, is where cinematic representations of female subjectivity and those provided by psychoanalysis coincide. With The Hunter Davies Interview photograph in mind, one might well note how closely, in its projection of the image of Jenny Saville as a female painter, it coincides with Freud's thoughts on what he calls 'the feminine form of erotic life' in his essay, 'On Narcissism: An Introduction', when he concludes:

> Women, especially if they grow up with good looks, develop a certain self-containment which compensates them for the social restrictions that are imposed upon them in their choice of object. *Strictly speaking, it is only themselves that such women love with an intensity comparable to that of a man's love for them* (my italics).[19]

In Lacan's account of the formation of the human subject the condition of desire and the accession to language is predicated upon the irrecoverable loss of the Real, felt in the separation from the mother as a separation from the fullness of being, the loss of her as the loss of part of the 'self' which can never again be felt as complete and sufficient. The signifier, the representative of this loss, is the phallus as it intersects with the Freudian family drama, the cultural prohibition against incest for which castration is the punishment. So although the phallus is *not* the penis, the male child has, *in* the penis, a representation of that which must be given up in order to achieve meaning and entry into what Lacan calls the symbolic order. 'It signifies that thing whose loss inaugurates desire.'[20] For the female child, in this formulation, there is no representation of the loss which activates desire and its concomitant cry, language.

It is precisely this absence of a representation of lack for the female that Michelle Montrelay locates in the girl child's precocious discovery of vaginal sensations and her privileging of the interior of the body 'from the start'.[21] She argues that if this 'inflects all psychic movement according to circular and closed schemas it compromises woman's relation to castration and the law'.[22] Female eroticism maintains itself outside the representation of castration. The woman 'enjoys her body as she would the body of another'.[23] This is exactly the basis of Luce Irigaray's feminine Imaginary where female desire seems to be equated with sexual pleasure at the site of the physical female body. Female desire is her very inability to separate herself from herself: 'When you say I love you – staying right here, close to you, close to me – you're saying I love myself.'[24] Kaja Silverman has argued that sexuality cannot be read directly off the body in this way, for it is as much a psychic as a

physical construction, requiring 'the internalization and fantasmatization of both the subject and the object – the installation of both as *corporeal images* within the psyche'.[25] In adult sexual relations both object and subject are social, economic, racially diverse, classed corporeal images built, as Silverman puts it, out of 'reminiscence and deferred action'.[26] The bodies we desire, indeed the very condition of our desire for them, is their resonance as memorable spaces.

Irigaray's image of femininity as a 'nearness so pronounced' that it would make the 'discrimination of identity impossible',[27] and her consequent privileging of touch over sight in feminine pleasure, is an attractive one for women who paint. Here a theory of femininity coincides with a medium in which lapsing into the 'undifferentiated', coupled with a displaced eroticism associated with touch, is both an occupational hazard and a temptation. As has been pointed out, the temptation of Irigaray's work for female painters is to use it as a spring out of sociality *through* sexuality into non-figurative painting which characterizes femininity as that which resists representation.[28] In technical terms this often translates into paint as a metaphor for the female body experienced as tactile sensation. In some works a direct analogy is made between paint and skin.[29] In the register of sight (which is, after all, the only place where a painting can be experienced by the viewer) the all-over application of paint and barely differentiated paint surface that this idea generates closes down all but the most minimal pictorial space. Here not only is the 'discrimination of identity impossible' but the discrimination of *anything* begins to become impossible. As I shall attempt to argue, to close down the potential of painting as a sophisticated device for spatial construction is to destroy the very possibility of it as a resource for catching the trace of any kind of female subjectivity and pleasure.[30]

But what about Jenny Saville's paintings which are 'of' the female body, in the sense that they are that bounded set of shapes which we recognize as standing for the female form in western painting, albeit redeployed, but which also seem to insist that we acknowledge another dimension to both making and viewing the female figure? That dimension undoubtedly has to do with the desire for the inclusion of tactile sensation and an experience of proximity. To explore this I would like to take up Kaja Silverman's rethinking through of Freud's idea of the negative Oedipus complex. The Oedipus complex in its positive form appears as the sexual desire for the parent of the opposite sex and the desire for the death of the rival, the parent of the same sex. In its negative form the reverse happens, there is a desire for the parent of the same sex and a jealous wish for the removal of the parent of the opposite sex.[31] The implication here is that desire and identification are mutually exclusive. What Silverman proposes, through a very careful rereading of Freud's texts, is that the child's negative Oedipus complex turns not only upon its desire for the mother but also its identification with her. Silverman argues that after the child's physical separation from the mother's body, its identity is formed in relation to the mother thus:

> The child gropes its way toward identity by incorporating the mother's facial expressions, sounds, and movements, not just before that mythical moment at which it catches sight of its own reflection, but afterwards, as it begins to assimilate the system of language. It would thus be more correct to suggest that the little boy is 'feminine' until his castration crisis than to suggest that the little girl is masculine until hers, although both concepts come into play only retroactively, after sexual differentiation.[32]

A vital point that Silverman makes is that castration should not be restricted to the absence of the penis as it is in Freud, but that castration is for the male child a *cultural* re-echoing of a series of earlier separations from the body and the presence of the mother. This she calls 'symbolic castration'. She describes castration for the female child as a projection of the male child's fear of dismemberment, which she must take upon her own body as the image of a missing organ. In the sense of symbolic castration, then, there *is* a separation of the girl child from her mother / a loss of her being as plenitude. What is not available is a culturally sanctioned representation to hold whatever that loss might mean in terms of desire and language.

Silverman describes relations between the girl child and the mother as a 'conjunction of identification and eroticism' and goes on:

> Significantly, the symptoms which Freud adduces as proof of the girl's love for the mother slip almost imperceptibly into the symptoms of her imaginary investment in that figure. As he puts it in 'Femininity', 'What is most clearly expressed is a wish to get the mother with child and the corresponding wish to bear her a child' (p.120). In effect, the girl aspires both to possess and to be possessed by the mother, or to state it in more classically Oedipal terms, both to seduce the mother and to be seduced by her. Of course, what is *not* classically Oedipal about this situation is that the girl's aspiration to occupy the place of the mother does not imply the latter's exclusion from her erotic economy, *but the endless reversibility of their relative positions* (my italics).[33]

I want to suggest that it is this psychic space that we can see particularly clearly inscribed in another painting by Jenny Saville in the Saatchi exhibition, the work called *Interfacing*.

INTERFACING: AN 'ENDLESS REVERSIBILITY'

> When I did the head I had a wart on my face too, like her. Everybody used to look at it. It became quite an obsession, so the whole painting grew out of this idea: that all everybody ever sees of you is this wart. So there is no background. The whole thing's flesh.[34]

Jenny Saville refers to *Interfacing* (Figure 6.5) as a head and not necessarily a self portrait. She says: 'When I did the head I had a wart on my face too, *like her*.' She compares herself to the woman in the painting as another woman, not as a likeness of herself. Neither does the work follow one of the conventions of self portraiture in western painting in that the maker does not look directly out of the picture and at the viewer. This more usual point of view, in conjunction with the label 'self portrait', is conventionally understood by the viewer to represent the artist's self-scrutiny, in a mirror, or from a photograph for which she has looked directly into the camera. In this sense the painting belies one of Saville's stated intentions: for the viewer in the space of the gallery it does not read as intense self-examination but as a face exposed for close scrutiny by someone else. In the lived world of adult relations few would breach the bounds of personal space to get this close. A curious child might, though, or a concerned mother. In several respects *Interfacing* differs quite noticeably from the other six works in the exhibition. First in colour, the flesh tones here are far warmer, redder, than elsewhere. Then, the face is modelled as pudgy with brush marks rounder and more irregular than the oblong, slab-like marks of *Plan* and *Branded*. This gives a soft look to the whole painted surface; it suggests, in fact, the face of a young child. This impression is reinforced by the exclusion of the hair in the framing of the composition and in the deep soft creasing of the neck characteristic of babies and young children. Although we could be looking at a child, there is also another way of looking at this painting, and for this we have to once more take into account the size of the canvas. *Interfacing* measures 48 × 40 inches, unconventionally large for a self portrait or the portrait of a child. This, in conjunction with the close-up framing of the face allows the viewer the potential for *taking the place of* a child looking up at the face of the mother from a position very close-to. The encrusted paint surface on the cheek at exactly the point in the fictive space of the painting closest to the viewer (and it's tempting to read the wart as a nipple here) activates a sensation of tactility and triggers the image of a child's fingers reaching out to touch the mother's face.

The potential for an interchangeable viewing position that the ambiguity of this child/woman image prompts recalls nothing so much as Silverman's scenario of the child/mother relationship in the negative Oedipus complex as one of identification that does not exclude desire, and of desire that does not exclude identification but the 'endless reversibility of their positions'. This is a *reversibility*, not a sameness. This does not mean to say that the female subject's desire is not relocated when the father intervenes to separate child from mother with the threat of castration (the cultural pres-

sure for it to be so is, after all, overwhelming) but that it is never quite fully relocated, that it is relocated to a greater or a lesser extent, and that it is relocated only at the expense of the devaluation of the mother. In Freud's formulation, when she moves into the positive Oedipus complex, the girl's realization that neither she nor her mother possesses a penis leads to a hatred of the mother for her incompleteness, a disappointment in her inadequacy as a love object, and a rivalry ensues, a desire to be in the place of the mother and to get a child from the father as a substitute for the penis.

To continue to read the painting from within Silverman's negative Oedipal space of subjectivity it could be said that with *Interfacing* Jenny Saville has made the 'child' she both wishes to give the mother and to receive from her. However, in the context for which, and the style in which these paintings are made, the idea of *Interfacing* as a 'child'

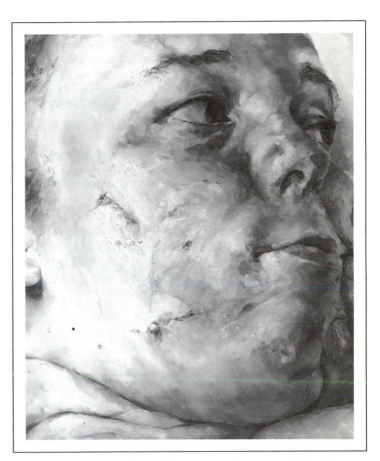

suggests another reading. The paintings were made *for* Charles Saatchi and *in* the style of Lucian Freud. This is more redolent of the girl child's position in the positive Oedipal situation. Here *Interfacing* is a child for British figurative painting (gendered male) with its concomitant devaluation of feminism (the mother). It is the work of Jo Spence which is devalued when the conjunction of identification with and desire for the mother remains, as Silverman suggests, the 'censored element'[35] of the feminine in patriarchal culture. Read from this perspective, the painting *Branded*, with its unacknowledged employment of the mother's imagery dressed up in clothes acknowledged as the father's, speaks poignantly of the daughter's drama of rivalry and the devaluation of the mother in her bid for a speaking part in an order of representation defined by 'the law of the father'. The vital importance for feminism of Silverman's attention to the structure of the negative Oedipus complex is its model of generational respect and admiration and a sense of historical continuity. In this formulation we might find our place as daughters without the destruction, the replacement of the mother as the condition.

Figure 6.5 Jenny Saville, *Interfacing*, 1992, oil on canvas, 48" × 40". Saatchi Collection, London

This is not to devalue Jenny Saville's work which is so vital for the way it both reveals this dilemma, and intuits an area outside it in paintings like *Plan* and *Interfacing*, with their space of both eroticism (her need to paint areas of flesh in close-up) and identification (her retention of the recognizable female body). What I want to suggest now, though, is that the resources of painting allow for ways of holding this unrepresented area of female subjectivity without (in the British context at least) such a close alignment in technical terms with all that is associated with the devaluation of the feminine.

COLOUR: NEITHER HERE NOR THERE

In an essay called 'Matisse and Arche-Drawing'[36] Yves-Alain Bois calls upon the work of Jacques Derrida to support a re-examination of the relationship between colour and drawing in the work of Matisse, or to be more precise, to elaborate a thesis about the practice Matisse called 'expression by [drawing]'.[37] Bois explains his notion of arche-drawing as follows:

> We are dealing with two concepts of drawing: drawing in the restricted sense . . . and drawing in the larger sense, as a generative category Drawing in this larger sense could be called *arche-drawing* by analogy with the 'concept' of 'arche-writing' developed by Jacques Derrida. Just as 'arche-writing' is 'prior' to the hierarchization of speech and writing, and, being productive of difference itself, forms their common 'root' (which goes for all the hierarchical oppositions out of which western metaphysics is woven, notably the opposition between sign and meaning), so 'arche-drawing' would be 'prior' to the drawing/color opposition, that is, without in any way denying the specificity of drawing and color in the history of painting, it would constitute the 'originary' source from which both emerge.[38]

Bois maintains that it is this 'arche-drawing' which governs Matisse's drawing practice in the 'restricted sense' (what we would conventionally regard as drawing), as well as his most important discovery with colour, namely, the relationship between quantity and quality, that 'the colors, which are the same, are nonetheless changed; as the quantities differ, their quality also changes: the colors applied freely show that it is their quantitative relation [leur rapport de quantité] that produces their quality'.[39] It is Bois' contention that the quantity–quality relationship became apparent to Matisse first, not in his paintings but in the making of two black and white woodcuts in 1906, *Seated Woman* (*Femme assise, petit bois clair*) and *Seated Nude* (*Nu profil sur une chaise longue*). The exploration of its possibilities prompted the pen-and-ink and brush-and-ink drawings Matisse made throughout the rest of his life. In these drawings, weight of line, the closeness or distance of one mark from another, what Matisse called 'neighbourings',[40] modifies the whiteness of the paper in different areas, makes the relationships between, the concentration of, lines and marks act to divide up the paper into areas that differ in quality, into in effect 'coloured' areas.

The most important outcome of Matisse's exploration of the quantity–quality relationship in his pen-and-ink drawings was his discovery that modelling, the creation of the illusion of depth, could be produced without recourse to either conventional perspective systems or the mimetic reproduction of the play of light across the surface of depicted objects. The significance of this 'drawing' in its larger sense as 'arche-drawing' is that it allows the whole spatial construction of a work to be taken on by the organization of colour. Colour is then simultaneously a proportional arrangement of flat shapes across the surface of the canvas, a distribution of surface quantities, *and* a quality of depth, the production of the illusion of space. Bois sees this as 'putting what Derrida calls *spacing* to work'.

I now want to think about spacing more specifically in terms of Derrida's word *differance*.

> The order which resists this opposition [between the sensible and the intelligible] and which resists it because it transports it, is announced in a movement of *differance* (with an *a*) between two differences or two letters, a *differance* which belongs neither to the voice nor to writing in the usual sense, and which is located, as the strange space that will keep us together here for an hour, *between* speech and writing.[41]

It is in the sense of *differance* that I want to think about colour as something like the letter *a*: visible, but invisible as the transporter between surface and depth, that which, in never being present as one thing at a time, makes possible the condition of viewing as a constant moving between two things: proximity and distance.

So far I have been speaking of colour as if it is a quality without material substance, applied always in the same way, with a consistent density, on the same surface, and indeed, in the same way all over the one canvas. This is quite obviously not so. I now want to go one step further to argue that there is a specific application of colour that maximizes its potential as spacing by har-

nessing the innate quality of paint in general to activate a certain kind of perception. But I can only do this by way of a diversion.

In his book *Painting as an Art*, Richard Wollheim describes a distinct kind of perception which he calls 'seeing-in'. He writes:

> [I]t is triggered off by the presence within the field of vision of a differentiated surface When the surface is right, then an experience with a certain phenomenology will occur, and it is this phenomenology that is distinctive about seeing in The distinctive phenomenological feature I call 'twofoldness', because when seeing in occurs, two things happen: I am visually aware of the surface I look at, and I discern something standing out in front of, or, (in certain cases) receding behind something else.[42]

Finding faces in clouds, landscapes in damp stains on a wall, are examples he gives. Wollheim stresses the complexity of what he calls 'twofoldness'. Seeing the surface of the wall and whatever the shape of the stain suggests are two aspects of a *single* experience, they are distinguishable but also inseparable. Interestingly enough, with Bois' notion of 'arche-drawing' in mind, Wollheim regards 'seeing-in' as logically prior to representation because, although something might be seen in a surface, it neither is nor is it believed to be a representation by the person who views it. A stain on a wall is likely, in terms of everyday experience, to be regarded first and foremost as a stain on a wall, which we will think about removing or covering. A stain on a canvas, though, is quite another matter.

It is impossible for me to think about stains on canvases without thinking about the work of Helen Frankenthaler, and it is with reference to her technical approach to painting that I want to try to bring together the notion of colour as *differance*, spacing, or 'arche-drawing', and Wollheim's concept of the 'twofoldness' of 'seeing-in'. In the early 1950s Helen Frankenthaler abandoned canvas stretchers and began unrolling lengths from bolts of canvas along the floor and pouring colour, heavily diluted with turpentine, onto their unprimed surface. One of the traditional purposes of priming a canvas with many layers of a glue/white pigment mixture is to fill the gaps between the woven threads of the material to make its taut surface (pulled tight over the frame of a canvas stretcher) perfectly even. Frankenthaler's decision to dilute her pigment to the consistency of a wash, to lay her canvas flat on the floor, and to leave its surface unprimed set the conditions for certain things to happen. First the liquid colour would be soaked up by the material of the canvas, in effect dying its thread, becoming part of the body of the material. But it would neither soak in, nor dry evenly. Because the canvas was laid directly onto the floor the liquid paint would have a tendency to pool in some areas, seep thinly into others, creating an uneven saturation of colour, setting precisely the conditions to activate the 'twofoldness' of Wollheim's 'seeing-in'. In the case of Frankenthaler's 'abstract' paintings a seeing of no-thing in particular in the way of faces, figures, identifiable landscape, but importantly, a seeing of depth, an illusion of space triggered by the flat, dyed material, but *differentiated* surface: a surface maximizing the potential of coloured paint as *differance*, as the space of the movement between the proximity of surface and distance as illusion of depth.

In a series of works begun around 1962, of which *The Bay* (1963), *Buddha's Court* (1964, Figure 6.6) and *Blue Head On* (1965) are probably the best examples, Frankenthaler brings her staining paint application into play with the 'quantity–quality equation', the proportional dividing up of the canvas in terms of colour relations to create the spacing Bois calls 'arche-drawing'. I want to argue that in this group of 'non-figurative' works Frankenthaler, using colour as both a switch and a stop, holds in balance a space between surface and depth which is neither a falling into the undifferentiated, a collapse into the inscription of femininity as a claustrophobic engulfment in tactile surface qualities, nor a distance so great as to deny the possibility, the pleasure, of a tactile involvement. I want to go so far as to suggest that in her particular use of colour as spacing in these works, the product of what art historically we know as a point of high formalism, we might begin to read 'against

the grain' for an inscription of Silverman's space of symbolic castration, not unlike that caught in Saville's figurative paintings *Plan* and *Interfacing*. This group of paintings by Frankenthaler may be 'non-figurative' in that they do not depict the figure, but they resonate with that eroticized, not very deep space where the range of sight is arm's length, touching distance, but where sight is vital for the forging of an identity as a knowledge of separation from, but also in relation to, a *non-I*.[43]

With Frankenthaler's technical procedures in mind as a resource, can we now return to the paintings of Jenny Saville (where both colour and sensitivity to the quality of canvas as material ground are barely utilized as spatial devices), to imagine how this idea of colour as spacing might be played across the representation of a female body in a conventional 'figurative' painting (or if indeed it can, or needs to be at all)? To begin to think about this I want to turn to a group of paintings made by Dorothea Tanning between around 1954 and the late 1970s. With the extraordinary painting *Tableau Vivant* (1954) Tanning broke with the meticulous, highly wrought paint surfaces for which she is best known as a Surrealist in paintings like *Eine Kleine Nachtmusik* (1943). As I have tracked elsewhere,[44] her gradual adoption of a looser paint application, beginning with *Tableau Vivant*, through paintings such as *The Ill Forgotten* and *Insomnias* (1957), and her abandonment of plausible local colour for a range of opalescent pink, lemon and mauve skin tones into which she embeds part-figures, seemed to signal a need (not unlike that I have been trying to argue a case for with both Saville and Frankenthaler) for a representation of sight–touch relations. Here also there seems to be a desire to create a shallow pictorial space which will hold the sense of a body, parts of which can be seen as an entity separate from oneself, parts of which are apprehended as a tactile merging. It is my contention, however, that in the mid-1960s with a painting like *To the Rescue* (Figure 6.7) Tanning came very close, in her desire for a visual representation of closeness, of sensations on the surface of the skin, to signifying tactility as a suffocating inseparability and loss of identity. In *To the Rescue*, figure and ground are shapes almost indistinguishable in their similarity. The brushwork has an all-over softness and thickness of application, and the colour has changed from opalescence to a chalky tonal modulation of blues, yellows and greens. Here there is no space at all; we are in danger of suffocating in paint.

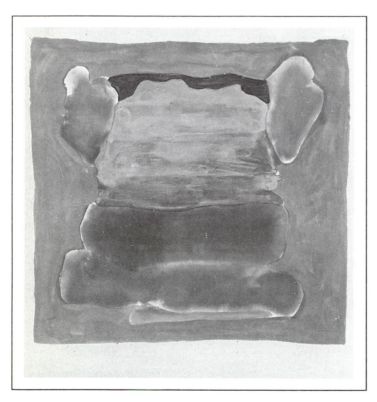

Figure 6.6 Helen Frankenthaler, *Buddha's Court*, 1964, acrylic on canvas, 96¾" × 93".
New York, Private Collection

It seems to me that Tanning recognized the danger of relinquishing all existing conventions for representing the body as self-defeating; that rather than ditching altogether the convention of the bounded shape that stands for the body in western painting it could best be strategically redeployed

to reveal all that those conventions would not hold of her lived experience of her own body. A desire for proximity can only be created through an experience of separation, and to experience the loss of boundaries we have to have known their presence. In the late 1970s Tanning back-tracked and reintroduced, as devices to signify a body aligned at least in part with sight, traditional modelling and a foreshortened perspective. She combined this, however, with a flattening of the ground towards the top of the composition into which the figures merge from about the shoulders upwards (Figure 6.8). The flattened ground, where perspective gives way to a reading of the

canvas as material surface, and the headless figures evoke tactility both materially and metaphorically. With the close-toned colour and the all-over sameness of paint application she was employing during the period of *To the Rescue*, the move into 'non-figuration' that the paintings seemed to pull towards, would certainly have been a fall into chaos for Tanning. The traditionally constructed figure was, it is my guess, reintroduced to act as a stop against the evacuation of *all* meaning that these techniques were leading to. We might speculate upon what it might have been possible to achieve had Tanning not backtracked into traditional perspectival and tonal modelling procedures, but thought rather in terms of colour as a solution to her problems of surface differentiation. If she had, that is, employed colour as spacing to build a body, still to an extent conventionally recognizable, but relying for the switch between the signification of sight and touch on techniques such as those explored by Helen Frankenthaler.

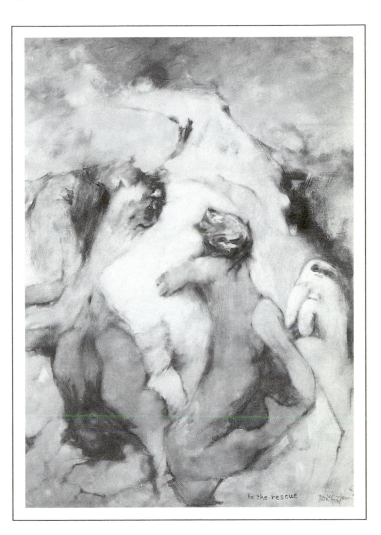

Figure 6.7 Dorothea Tanning, *To the Rescue*, 1965, oil on canvas, 205 × 147.5 cm.
Collection of the Artist, New York

A SURPLUS OF SUBSTANCE, AN EFFECT OF PLEASURE

In his paper 'Eight Theses For (or Against?) a Semiology of Painting', Hubert Damisch defines an image as it is produced in painting in the following way:

> Painting would be an image, but an image of a particular, if not specific type: an image which would be characterized by a surplus of *substance*, from which would come its weight, its charge, its title of painting, and which would produce, under that title, an effect of pleasure specific to it.[45]

With this definition in mind I want to try to end this chapter with a return to the relationship between the photgraphic work of Jo Spence and the paintings of Jenny Saville as they intersect my own history as a practitioner, in a way which turns out to be wholly in keeping with Kaja Silverman's model of negative Oedipal mother/daughter relations.

In terms of generations I am placed more or less midway between Jo Spence and Jenny Saville, young enough to be Jo Spence's daughter, just old enough to be Jenny Saville's mother. The beginning of my art school training at eighteen coincides almost exactly with that moment in the mid-1970s which made Jo Spence's *Narratives of Dis-Ease* photographs possible. This was the time when British feminists involved with the visual arts began to engage with a range of political and cultural theories, Marxism, semiotics, psychoanalysis, deconstruction, to 'reclaim other media and skills outlawed by modernism's hierarchies'.[46] To reclaim them, that is, from a painting associated with modernist formalism. Laura Mulvey's groundbreaking essay 'Visual Pleasure and the Narrative Cinema', was published in *Screen* in the second year of my Fine Art degree course at Middlesex Polytechnic.

As a 19-year-old from the North of England what exactly *did* 'painting' mean to me then? Certainly my knowledge of American modernism and Clement Greenberg was nonexistent. Griselda Pollock has suggested that the attraction modernist formalism held for female painters in the 1930s, 1940s and 1950s, was that the pursuit of 'pure form', 'pure spirit' provided a space in which they could be free from a Victorian legacy of 'overfeminization'.[47] Thinking back to my own situation, this analysis could be expanded to include the possibility of 'painting' as an escape from 'over-classedness' also. Imagine a child with a poor formal, but just good enough, state education to foster a desire for aesthetic and cultural experience. How was such a child to channel the excitement of its discoveries in an

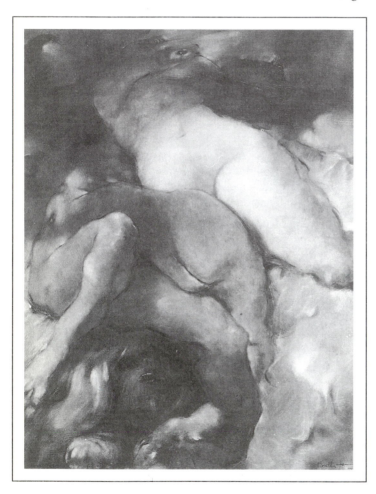

Figure 6.8 Dorothea Tanning, *Family Portrait*, 1977, oil on canvas, 145.5 × 114 cm.
Private Collection, Washington

environment which, whilst not positively hostile, was not particularly encouraging? With not much space (I always wanted a piano but there was no room for one), very little spare money, and no confidence with language, messing around with paint was, for me, a good option. A full Local Education Authority grant then made art school a possibility.

But this is only part of the story. Another was a child, not particularly good at drawing people and horses that looked the way they were supposed to, and certainly having trouble fitting the whole of them on the page, but who was completely riveted by that quality of paint as 'substance'; by its ability to be at once both material and the representation of something in the world, and being best pleased when it hung just between the two, flipping back and forth in front of her eyes. She was later to find out that those who managed this with the most skill (although not at all in the way that she would have done it) were mainly middle class, and for the most part men. A 'proper envy' on both counts set in. The point I am trying to make here is that Steedman's description of the desire of those excluded through material deprivation might not only be for 'the things of the earth' but also for the things of the mind, even when accessed through that most earthy of means, paint.

In terms of time, place, historical circumstances, life experience, temperament, Jo Spence's journey to the Polytechnic of Central London was entirely unlike my own route to art school. Her progressive questioning of both the photographic image as a 'realistic' document of lived social experience, and how she herself was positioned both as female and working class in relation to political and social structures, came first through her jobs as an assistant in photographic businesses, then as a high street photographer, and later through her involvement with documentary projects with the Hackney Flashers group and the Photography Work Shop. At the Polytechnic of Central London Spence was exposed to what she described as 'interpenetrating theories of communication, culture, psychoanalysis, semiology, sensitometry, history, feminism, and social and political discourses' .[48] The presence of Victor Burgin at PCL signalled an example of work in photography made possible by the re-evaluation that had taken place throughout the seventies by Marxist and feminist theorists/practitioners, largely in the pages of *Screen* magazine, of German and Soviet political modernists, particularly the work of Berthold Brecht. This intersection of her empirical knowledge with the thorough analysis of the technical/formal resources of film and photography within a political, historical and social theoretical framework provides the context of Spence's subsequent photo-therapy work around her own ill, ageing, working-class female body. In formal terms the photograph *Exiled* uses Brechtian techniques of distanciation (the word written across the body and the mask) to disrupt the documentary 'reality' of the female body otherwise framed as in medical photography.

The value painting had for me in 1974 most certainly did not coincide with the cultural environment of the Fine Art Department of Middlesex Polytechnic (then still referred to as 'Hornsey' and, it is important to point out, isolated from the rest of the Polytechnic in the Badminton Suite at Alexandra Palace). The British sculpture revival was just beginning and the most informed teaching, although exclusively by men, was concentrated in that area. There was what was known as the 4D Department, which had film and video equipment but offered no theoretical, and very little technical, underpinning to its use. One or two boys from the North, ex-Royal College, occasionally hung around the studios, supposedly tutoring in painting, but more often attempting to pick up female students, and there was, with certain younger part-time and visiting male practitioners, hints of the possibilities of a return to figurative painting with the beginnings of an interest in Bomberg, Kossoff, Auerbach and Freud.[49] There was one woman, a traditional printmaker, working full-time in the department, and our half-day-a-week painter/installation artist did not have her contract renewed at the end of my second year. In terms of access to 'things of the mind' (as a female painting student you were much more likely to find yourself in tutorials fending off 'things of the body') painting in the Fine Art Department at Middlesex Polytechnic had little to offer. There was no theoretical framework available, comparable to that which gave Jo Spence's empirical knowledge support at PCL in 1979, to offer me an explanation in either social or psychic terms of what began to feel like a more and more perverse, and finally unsustainable, attachment to painting.[50]

The conditions under which Jenny Saville entered Glasgow School of Art were vastly different. The *A New Spirit of Painting* exhibition at the Royal Academy in 1981 (which, it must be remembered, did not include one woman) brought the 'grand tradition' of painting back into a central position in British art schools. The work of European expressionist figurative painters such as Chia and Baselitz was shown alongside works by that earlier generation of British figurative painters, Freud, Bacon, Auerbach, Kitaj, giving the signal for the general resurgence of figurative painting in Britain, and support to those small pockets of interest in the 'School of London' that I have suggested were already appearing around 1975–6. The figurative painting of the Scotsmen Steven Campbell, Ken Currie and Stephen Conroy, Saville's immediate predecessors at Glasgow School of Art, emerged out of this environment.

By 1988 at Glasgow School of Art, Jenny Saville had, then, ample support for her use of painting as a vehicle to carry her feminist intention but, I want to suggest, still completely without the rigorous formal/technical analysis of her medium that was the context for Jo Spence's understanding of how photography might best challenge its own cultural and sexually over-determined conventions to hold her particular lived experience of the female body. I want to return here to Damisch's definition of the image as it is produced in painting as characterized by a 'surplus of *substance*' and to end by once again juxtaposing the photograph *Exiled* and the painting *Branded*.

A return to an involvement with the materiality of paint in the 1980s remained, in Britain, largely at the level of 'the gesture as authenticating mark and index of the author',[51] and as the craft of 'skilful' handling of oil paint as simulation. For me, Jenny Saville's reliance on paint to *simulate* flesh produces, like all simulations, a sure, disappointing and wearying foregrounding of its falling short of that which it attempts to simulate. This is surplus paint, and highly unpleasurable. Even in photography, where there is a strong convention of the photograph as a 'true' record of life, Jo Spence understood that the mimetic, the documentary photograph was the thing least likely to hold the complex of physical and psychic space that is lived experience. Where there is no longer a convention of a painting of something in the world as anything like a 'true' record, the words scratched around the body of the woman in *Branded* can, at best, read, in the mode of simulation, as simulated scarification, or they can play a purely formal painterly distanciation game of purposely wrecking a time-consuming, painstaking simulation of flesh in oil paint. At worst they stand as a gratuitous appropriation of a device absolutely integral to the operation of Spence's photograph.

In an interview with Clare Henry, Jenny Saville talked about her decision not to paint for a period:

> I had a term in Cincinnati. I spent time in the libraries; joined discussion groups questioning the politics of painting. Painting is such a male dominated activity; I decided I'd never paint again. On my return to Glasgow I did photo and installation work, but in the end I felt starved. So I picked up my brush.[52]

My own stay away from painting was much longer, nearly eight years, but my return was prompted by a similar need. Is it not horribly ironic, though, that Jenny Saville on *her* return to painting should turn for nourishment to a technique so totally identified with the man whose work dominates her activity in England? One reason for this may be that she simply does not know what her options are; that she has never been taught any understanding of painting as an image whose 'surplus of *substance*' is *not* a modelling material with which to perform dazzling feats of simulation but its central device for the structuring and articulation of pictorial space. 'Surplus of *substance*' as a perceptual trigger which can activate the 'twofoldness of seeing-in' and colour as spacing is, in Jenny Saville's work, an unexplored resource which would seem particularly well suited to her apparent desire to hold her images of the female body in a space between sight and touch.

CONCLUSION

It has been one of my aims in this chapter to argue that we might read, in certain paintings by women, for the inscription of areas of female subjectivity and pleasure located, not outside language and the symbolic but rather, as Silverman suggests, which have not been lent representational support. To be able both to read painting for such inscriptions, and to explore the medium further in practice as a way for pointing to them, we need to understand at a technical level exactly what its resources are. But I use the phrase 'for pointing to' advisedly.

Hubert Damisch, thinking painting through in terms of *formal* regression as Freud conceives of its operation in *The Interpretation of Dreams*, argues in 'Eight Theses', that painting:

> only produces its effect, outside any relation of interpretation, in playing the divergence – and the tension which it generates – between the register of the visible (of what can be shown, figured, represented, staged) and that of the readable (the register of what can be said, stated, declared).[53]

This should not be taken to support an argument for a total silence around painting, least of all by women who make it. How we speak and write about painting must be a catching of precisely that divergence, that tension between the visible and the readable that painting generates, not to return it to the work as *interpretation*, but to free it as an independent complex of ideas. Bracha Lichtenberg-Ettinger puts this another way, more specific in terms of a feminist exploration in paint: 'Throughout painting as evocation of the *invisible screen beyond appearance*, theory can attempt to abstract matrixial meanings. In art, the invisible screen is theory producing and not merely the product of theory.'[54]

It has been my larger aim to achieve in this chapter a much broader definition of what, within a historical feminist critical discourse, 'painting' might provide access to and generate; what it might be able to tell us about 'women, their position in the world'.[55] The problem of how to circulate painting as generator of ideas (as a practice/theory, theory/practice activity) remains as the 'question of institutions, of the conditions which determine the reading of artistic texts and the strategies which would be appropriate for interventions'.[56] How, where, and with whom we show our work in painting, who we make our work for and how we contextualize it must become, in turn, an integral part of a feminist art historical and critical practice. We have to make possible a *physical* space for the encounter between the work of Jo Spence and Jenny Saville in an historically informed feminist dialogue where they need neither assimilate nor reject one another.

Notes

1 Richard Dorment, 'Virtuoso Mountains of Flesh', *Daily Telegraph*, Wednesday, 9 February 1994.
2 Mary Kelly, 'Re-Viewing Modernist Criticism', *Screen*, vol. 22, no. 3 (1981) p. 41.
3 Ibid.
4 William Packer, 'Energy on a Grotesque Scale', *Financial Times*, 28 January 1994.
5 My supposition here comes from the Hunter Davies Interview, where we are told that both Saville's parents were teachers, her father eventually becoming a Director of Education, and where Saville herself is quoted as saying, 'I didn't get a grant, because my parents' income was too high.'
6 During Jo Spence's last illness a fund was set up to provide her with financial assistance.
7 Griselda Pollock, 'Pollock on Greenberg', *Art Monthly* (July–August 1994) pp. 14–18.
8 I quote this phrase from an important letter from Griselda Pollock to *Women Artists Slide Library*, no. 26 (December/January 1988).
9 I borrow this terminology from an essay by Yves-Alain Bois on Hubert Damisch, called 'Painting as Model' in the book which takes the name of that essay as its title.
10 Carolyn Steedman, *Landscape for a Good Woman*, London (1986) p. 1.
11 Ibid., pp. 17–18.
12 Ibid., p.14.
13 Griselda Pollock, 'Painting, Feminism, History', in *Destabilizing Theory, Contemporary Feminist Debates*, ed. Michele Barrett and Anne Phillips (1992) p. 140.

14 Ibid., pp. 138–40.

15 Ibid., p. 141.

16 Heather Dawkins, 'Frogs, Monkeys and Women: A History of Identifications across a Phantastic Body', in *Dealing with Degas*, ed. Richard Kendall and Griselda Pollock, (1992) p. 206.

17 I find working from life really intimidating. I couldn't draw or paint on a size like that [indicating a medium-sized sketch-book]. I find it so hard to do unless I do a detail of an enlargement or something. There is no point in me doing a study like that. It's just more natural for me to use larger areas of flesh. I don't like working in a life class. There's no recognition from the model; he or she's sort of indifferent. I don't get anything from it.
 (Jenny Saville talking to David Sylvester, 'Areas of Flesh', *The Independent on Sunday Review*, 30 January 1994)

18 Ibid.

19 Sigmund Freud, On Narcissism: An Introduction, the Standard Edition of *The Complete Psychological Works of Sigmund Freud*, vol. XIV, London (1957) pp. 88–9.

20 Kaja Silverman, *The Subject of Semiotics*, New York (1983) p. 183.

21 Michelle Montrelay, 'Inquiry into Femininity', *m/f*, no. 1 (1978) pp. 83–102.

22 Ibid., p. 262.

23 Ibid.

24 Luce Irigaray, 'When Our Lips Speak Together', in *This Sex Which Is Not One*, New York (1985) p. 206.

25 Kaja Silverman, *The Acoustic Mirror*, Bloomington and Indianapolis (1988) p. 147.

26 Ibid.

27 Irigaray, *This Sex Which Is Not One*, p. 31.

28 Pollock, 'Painting, Feminism, History', p. 206.

29 I am thinking particularly of some of the work of Laura Godfrey-Isaacs, but this could apply more generally to certain works by Rebecca Fortnum, Rosa Lee and Therese Oulton.

30 See Margaret Whitford on Irigaray's own views on art by women in 'Woman with Attitude', *Women's Art Magazine*, no. 60 (August 1994).

31 J. Laplanche, J.-B. Pontalis, *The Language of Psychoanalysis* London (1988) p. 238.

32 Silverman, *The Acoustic Mirror*, p. 150.

33 Ibid., p. 153.

34 Jenny Saville talking to David Sylvester in the article 'Areas of Flesh', *Independent on Sunday Review*, 30 January 1994.

35 In *Inquiry into Femininity*, Montrelay asserts that feminine eroticism is 'more censored, less repressed than that of the man'.

36 This essay appears in the collection *Painting as Model*, Cambridge, Mass. (1993) pp. 3–63.

37 Bois argues that Matisse's term was translated incorrectly as 'expression by design' when the text in which it appeared, 'Modernism and Tradition,' was published in English in *The Studio* in 1935. This is his correction.

38 Yves-Alain Bois, 'Matisse and Arche-Drawing', *Painting as Model*, Cambridge, Mass. (1993) p. 22.

39 Matisse in a letter to Alexander Romm, 1934, quoted in ibid., p. 22.

40 Matisse, 'Notes of a Painter on His Drawing', quoted in ibid., p. 23.

41 Jacques Derrida, 'Differance', in *Margins of Philosophy*, Brighton, Sussex (1986) pp. 5–6.

42 Richard Wollheim, *Painting as an Art*, London (1987) p. 46.

43 Reference here is to Bracha Lichtenberg Ettinger's matrixial space of subjectivity where the intra-uterine relationship between mother and unborn child is formulated as one of the I and the non-I, a relations-without-relating constantly retuned and adjusted in what she calls the matrixial borderspace of subjectivity as encounter. The I and the non-I neither assimilate nor reject one another, their experience is one of distance-in-proximity and differentiation-in-co-emergence. See Bracha Lichtenberg Ettinger, 'Metramorphic Borderlinks and Matrixial Borderspace in Subjectivity as Encounter' (1993) Conference photocopy edition, Leeds University.

44 Alison Rowley, '"A Lapse of Taste": Considering Some Paintings by Dorothea Tanning', MA Feminism and the Visual Arts essay, University of Leeds, January 1994.

45 Hubert Damisch, 'Eight Theses For (or Against?) a Semiology of Painting', *Enclitic*, vol. 3 no. I (Spring 1979) p. 12.

46 Griselda Pollock, Letter to *Women Artists Slide Library*, no. 26 (December/January 1988) p. 23.

47 Pollock, 'Pollock on Greenberg', p. 14.

48 Jo Spence, *Putting Myself in the Picture*, London (1986) p. 135.

49 There was an Arts Council travelling exhibition of the work of Freud in 1974, and late works by David Bomberg were shown at the Whitechapel Gallery in 1979.

50 I want to note here that Mary Kelly's Marxist analysis of painting as productive of 'artistic authorship in the fundamental form of the bourgeois subject; creative, autonomous and proprietorial' ('Re-Viewing Modernist Criticism', p. 46), whilst undoubtedly correct in market terms, leaves no room for an identification of the vital role it might play at an earlier moment in cases like my own.

51 Kelly, 'Re-Viewing Modernist Criticism', p. 44.
52 Clare Henry, 'Stinging Salvos of Flesh', *The Herald*, 4 February 1994.
53 Damisch, op. cit., p. 14.
54 Lichtenberg Ettinger, 'Metramorphic Borderlinks', p. 20.
55 Pollock, Letter, p. 23. This is a reference to the question posed in that letter, 'Can painting as a practice tell us about women, their position in the world?'
56 Kelly, 'Re-Viewing Modernist Criticism', p.57.

Chapter Seven

Orlan: artist in the post-human age of mechanical reincarnation:
body as ready (to be re-) made

Michelle Hirschhorn

INTRODUCTION

I first noticed the man in the purple coat, gazing confrontationally through two pieces of a broken mask which had apparently once been of a woman's face. 'How far would you go for beauty?' wryly questioned the words printed beneath the image on the back cover of the paperback. Hmm, I thought, and flipped it over to continue reading inside:

> 'Jamie Angelo: a man obsessed with perfection. He's a genius, a sculptor in human flesh. Using the most advanced technology and his artistic flair, he can create age-defying beauty from the plainest of materials. Women famous for their looks all over the world owe their success to him. Movie actresses, television stars, models and socialites revolve around him in New York's glittering highlife, desperate to ward off age and ugliness.
> But despite all his skill these women are not perfect. Jamie dreams of the ultimate female icon: a blend of Marilyn, Marlene, the Mona Lisa – and some indefinable extra quality – to create a masterpiece.'[1]

Despite the move from Dr Frankenstein's dingy lab to the hippest artist loft in SoHo, and the periodic interjection of contemporary art and philosophical theory, the basic story here is nonetheless one which is all too familiar. Man, driven by his desire to discover the absolute truth of beauty, desperately attempts to reconstruct, and thus control, the female form. But when the recreated form cannot sustain the illusion, when it can no longer contain the corporeality of matter, then horror, monstrosity and destruction ensue.

I came across the novel *Beauty* while researching the work of French multimedia/performance artist, Orlan. In her current project, *The Ultimate Masterpiece: The Reincarnation of St Orlan*, she utilizes the technology of plastic surgery as a medium with which to articulate self-transformation. Sculpting in her own flesh, she has taken art into the operating theatre and quite literally taken 'matter into her own hands'.

In the spring of 1994, shortly after she gave a presentation at the ICA in London, several newspapers and magazines responded with articles which bore rather catchy titles and large colour photo spreads depicting carnivalesque scenes that were taking place inside operating theatres. Intrigued by the highly sensationalized and largely hostile accounts, I decided to investigate this curious woman and her unorthodox practice. As I began searching the *Art Index* and the pages of numerous art journals for some sort of critical analysis or historical contextualization of Orlan's work, I was disappointed and somewhat surprised by what I *didn't* find. Not only had she been constructed as an aberration in the popular press, and therefore denied credibility as an artist, but seemingly she had been substantially excised from the corpus of contemporary art history as well.

What I *did* discover, however, is that Brian D'Amato, the author of *Beauty*, is himself an artist (who has exhibited in New York and Paris) as well as a regular contributor to *Flash Art*. Sensing an obvious influence for the story, I looked to the pages of *Beauty* for a point of reference. But amongst all of the contemporary artists, dealers, galleries and theorists whose names crowded the text, Orlan's was clearly missing. Hmm, I thought again; Orlan began her surgical interventions in 1990. *Beauty* was published in 1992. From the references made to Renaissance portraiture and the computer-generated composites of female icons, to the very use of plastic surgery as a means of artistic expression, it seems a bit dubious, if not highly suspicious, to assume that someone as apparently well informed and on the 'cutting edge' as Brian D'Amato, could not have been aware of Orlan's enterprise.[2]

Why are there no references to Orlan within the pages of *Beauty*? Perhaps an explanation can be found in precisely that which differentiates Orlan from Jamie Angelo, the story's main protagonist, and the familiar story line itself: her position as both creator and created. By directing the reconstruction of her own body, she problematizes the traditional gendered relationship between the active male subject position as artist/creator and the passive female object position as matter awaiting transformation. Orlan's surgical reconstructions are certainly not an attempt to 'ward off age and ugliness' (she has never had a conventional face-lift). On the contrary, she questions the very basis of self-perception and bodily identification when she says that 'being a narcissist isn't easy when the question is not of loving your own image, but of re-creating the self through deliberate acts of alienation'.[3]

The Reincarnation of St Orlan began in 1990 when Orlan underwent the first in a series of seven planned cosmetic surgery operations/performances required for what she envisions as total self-transformation. Using her own body as medium, she has devised an elaborate orchestration in the operating room which combines Baroque iconography, medical technology, theatre and mass communication networks to critique the male-defined notion of idealized female beauty, and to challenge prevailing western concepts of identity. By insisting on local rather than general anaesthesia, Orlan remains cognizant during the operations so as to maintain control throughout the process. She choreographs and directs each performance, which features the reading of psychoanalytical and literary texts, interactive communication with an often international audience via fax and live satellite telecast, music, dance and outlandish costumes, frequently designed by a famous couturier, such as Paco Rabanne (Figure 7.1).

She carefully chose the images of five famous Renaissance and post-Renaissance representations of idealized feminine beauty as the basis for her project, not only for their physical attributes, but each one for its particular mythological or historical importance. She chose the nose of an unattributed School of Fontainbleau sculpture of *Diana* – because the goddess was aggressive and refused to submit to the gods and men; the mouth of Boucher's *Europa* – because she looked to another continent and embraced an unknown future; the forehead of Da Vinci's *Mona Lisa* – because of her androgyny; the chin of Botticelli's *Venus* – because of her association with fertility and creativity; and the eyes of Gerome's *Psyche*, because of her desire for love and spiritual beauty. Each operation was planned to alter a specific feature of Orlan's physiognomy, and she generates computer composites which combine her own features with those of each icon for the surgeon to use as a guide.

Orlan's practice is shocking, often contradictory, and quite troubling, particularly because the issues she confronts run much deeper than the skin and morphology. Her work raises serious questions concerning identity, societal taboos against opening the body, the mind/body dualism, the often acrimonious relationship between women and technology, the limits of art and language, physical pain, representations of the female grotesque, myths of femininity, private and public domains, the long legacy of colonization that western medicine has exerted over female bodies, as well as the historic relationship between art and life that is inherent within the tradition of avant-

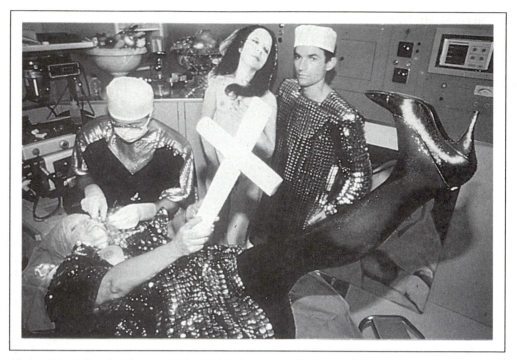

Figure 7.1 Orlan, fourth operation/surgical performance, *The Mouth of Europa and the Figure of Venus*, 8 December 1990, technique: Cibachrome, Diasec Vacuum sealed (110 × 165 cm). Photo: Joel Nicolas

garde performance throughout the twentieth century. Although the most obvious aspect of Orlan's project is a critique of the masculinist *mould* which has been imposed onto the female form through the practice of plastic surgery, she refuses to limit her enquiry to purely sociological terms. Rather, her approach encompasses a perspective whereby she explores these more complex issues within the multiple contexts of the French avant-garde, philosophical, psychoanalytical, art historical, and religious traditions.

Even as Orlan assures us that she is not in pain, there is something profoundly destabilizing about watching a woman's face being sliced open, seeing her bleed, seeing medical instruments moving indiscriminately under her skin, that words alone would simply not convey (Figure 7.2). The oscillation between fascination and repulsion which I experienced as I watched a videotape of Orlan's most recent operation suggests a level of sophistication in the work which deserves critical debate, rather than immediate dismissal as the antics of a madwoman, or the equally reductive alternative, which is to ponder over whether such a practice is to be considered Art at all. It is therefore not my intention to valorize or romanticize Orlan's actions, but rather to examine the issues which are generated through the visceral response her work seems to provoke. As Barbara Rose points out, to conclude that Orlan's practice is an aesthetic action

> rather than pathological behavior, forces us to reconsider the boundary that separates normality from madness, as well as the line that separates art from non-art. Indeed such an examination of the limits of art is a crucial objective of her confrontational actions.[4]

Perhaps, as Rose suggests, the unwillingness to discuss her work seriously lies precisely in that 'her focus on the fine line separating the committed artist from the committed lunatic is a direct challenge to the ease of integration of much so-called critical art'.[5]

A CRITICAL HISTORY

Contrary to the conspicuous inattention that her work has received from critical discourse, Orlan is in fact no stranger to the institutions of contemporary art. She has been represented by many prestigious galleries, and holds an extraordinarily extensive and international exhibition record that ranges more than twenty years (including the Paris, Sydney and Venice Biennials, just to name a few). She asserts that for art effectively to critique the society from which it is made, it must retain a degree of marginality and risk. However, without any reference to her artistic evolution or her position within art history, Orlan will continue to be constructed as mad or trivial and her current project will continue to circulate throughout the press as the flavour of the month, on the human-oddities-as-art page. It is therefore crucial that her work be discussed within an analytical framework that draws upon her own rich and diverse history, without merely claiming a space for her practice within the very canon that marginalized it in the first place, and without infringing upon her strategic critique of that same canon. To devise an effective methodology for doing so, we must first examine the mechanisms which art criticism has so vigorously implemented in order to camouflage its deficiencies, and thus expose the covert sexism which is inherent in the formulation of such devices.

Throughout the history of Modern Art, whenever an artist or a particular genre have taken art into new territory or created an aesthetic dimension for something which hadn't previously had one, the most immediate response has always been to claim that it just isn't Art. In 'Re-Viewing Modernist Criticism', Mary Kelly examines the nature of this tendency, explaining how the 'normalisation of a mode of representation always entails the marginalisation of an alternative set of practices',[6] and contends that the principles upon which the dominant forces of contemporary art determine such standards are firmly rooted within modernist discourse.

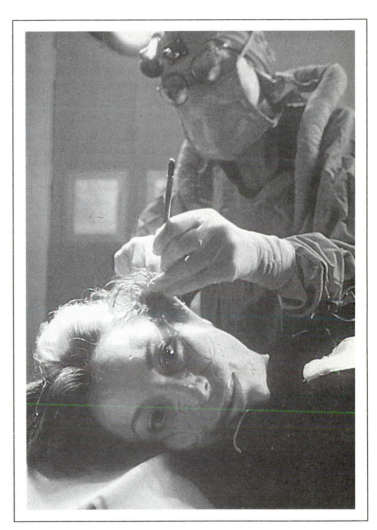

Figure 7.2 Orlan, seventh operation/surgical performance, *Omnipresence*, 21 November 1993. New York, technique: Cibachrome, Diasec Vacuum sealed (110 × 165 cm).
Photo: V. Sichov/Sipa press

Spawned by the same network of discourses which both establish and govern patriarchal society, she asserts that 'modernist discourse is produced at the level of the statement, by the specific practices of art criticism, by the art activities implicated in the critic/author's formulations and by the institutions which disseminate and disperse these formulations as events'.[7] She cites the effectivity of this discourse, and its predominance within the hierarchy of discourses that constitute modernism as a discursive field, as the production of a norm for pictorial representation which does not necessarily correspond to definite pictures, but rather to a set of assumptions concerning 'Modern Art'. The norm constructed by these assumptions defines art as the essential, creative expression of the artistic subject, which produces a unique, original object whose form can be contemplated and reflected over in the field of pure aesthetic experience, and whose 'authentic' signature can be exchanged for any currency.

Because these assumptions are not formed abstractly, but within the 'calculated practices of reviewing, publishing and exhibiting art for a specific public, the reading of artistic texts is always in some sense subjected to the determining conditions of these practices, crucially those of criticism'.[8] It is therefore no surprise that the authors of 'art history' not only refuse to acknowledge, but actually cannot even conceive of, any other model existing beyond the duality upon which this one is premised. Hence, popular notions of art are always mediated by what becomes a closed circuit between these contrived assumptions about art, art criticism and art history, which continually reauthorizes its utterly exclusive and limited mandate. The implicit authority of this norm is thus generated by its perpetual circulation throughout the institutions of Modern Art, which effectively ostracizes any practice that dares to transgress the frame of such a homogeneous pictorial paradigm.

Consequently, even when a 'marginal' practice manages to penetrate the prohibitive barriers of the normative museum or gallery exhibition schedule, it often does so as a renegade and is commonly exploited for its entertainment value or its 'outsider' status. Therefore, when mainstream institutions want to create a profile for themselves which appears to support cutting-edge work, or when the term 'marginal' itself becomes temporarily chic, practices such as Orlan's will then get taken up by these institutions. But without a proper context in which to be reviewed, such empty gestures merely reinforce the distance of these practices from the 'centre' of dominant visual practice.

Where did such an incredibly narrow standard for defining art and judging artistic practice evolve from? And how is it specifically inimical to women? If we peruse this model as a derivative of Enlightenment aesthetics, then Immanuel Kant's The *Critique of Aesthetic Judgment* (1790) can be seen as particularly influential. Kant's project sought to discriminate between aesthetic and sensory pleasure, bestowing great social importance on the former, while condemning the latter as common or vulgar. He believed that a true aesthetic experience requires a level of reflection on the object, which is what distinguishes it from a 'lowly' sensory encounter. By implying that visual appreciation requires an amount of intellectual activity which is innately ascribed to men, and subsequently assumed to be lacking in women, this theory attempts to ground the misogynist maxim of 'mind over matter' within the 'law of nature', and thus produces the necessary rhetoric required to maintain a dominant position within the field of aesthetic discourse.

Kelly points out that, according to Kant, 'genius is the mental disposition through which nature gives the rule to art',[9] thereby presupposing that not only the appreciation of art, but its actual production, must also be based in the 'higher' faculty of rational contemplation. The artist must demonstrate 'genius' in order to produce an object worthy of the title Art, as well as to ensure that the viewer will remain uninterested in the materiality of the object and not in any way be distracted from the consideration of its intrinsic form. In other words, it is precisely the evidence of such a supreme mental state, within the object itself, that signifies the boundary between art and non-art, artist and non-artist. Any 'unformed matter' or work which requires conceptualization, or

motivates a physical response in the viewing subject, is consequently rendered unsuitable for aesthetic judgement.

Lynda Nead traces this tradition back even further, to the roots of western philosophy and the Platonic concept of ideal forms. Plato argued that sensory experience is merely an echo or a trace of absolute form, which lies beyond the reach of our senses and beyond sensory experience. She continues that, for Descartes, reason was the only true basis of judgement, whereas the body confused and obscured all rational thought. He sought to create clear boundaries within one's sense of self, by creating an absolute distinction between the spiritual and the corporeal (the goal being complete transcendence of mind over body). Knowledge could then be thought of as something acquired objectively, assuming the separation of knower and known. By reconceptualizing the scientific mind, Descartes effectively shifted knowledge and reason away from the natural (commonly associated with the feminine) and recast them as masculine attributes. Correspondingly, this process asserted the primacy of the masculine over the feminine, by associating the term 'male' with creativity and rational thought while the term 'female' became aligned with passivity and biological reproduction.[10]

In her book, *The Female Nude: Art, Obscenity and Sexuality*, Nead argues that the female nude has become emblematic of the boundary which separates form from matter in the field of representation, and illustrates this paradigm in order to identify the social and cultural meanings of the female nude within the history of western art. She asserts that the female nude has come to signify the transformation of 'natural' matter into the elevated forms of 'culture', thus producing a means within aesthetic discourse of containing femininity and female sexuality, in accord with, and in relation to, other dominant discourses within western ideology which perpetuate male domination. By sealing all of her orifices, western art has effectively 'framed' the female sexual body within the nude, preventing all marginal matter from transgressing the boundary of representation. Orlan's use of the physical body (specifically, her own *female* body) as the foundation of her practice, and her exposition of both its interior, and the matter with which it produces, exists in complete contradistinction to the nude defined as such. Her project re-presents the actual, lived-in female body and can therefore be seen as a metonymic reminder of sexual difference. Because Orlan challenges the logic of a system which privileges form over matter, male over female, she exists as a prime example of how this injunction systematically strips the female artistic subject bare of her position within the critical discourse of contemporary art.

THE INCARNATION OF ST ORLAN

In 1990 Orlan was asked to participate in a festival which showcased artists working on the theme of art and life in the 1990s. The timing of this invitation was highly appropriate, as she had become very angry with what she viewed as a negative return from performance to the fetishization and commodification of the object, indicative of the art world during the 1980s. Throughout the 1980s Orlan had worked extensively with video and computer technology, but not for the market; she believed it had become far too comfortable and complacent, thereby losing its investment in artistic commitment. Hence, *The Reincarnation of St Orlan* was in no way motivated by nostalgia, but rather, it emerged as the culmination of a long and thoughtful process whereby Orlan was able to create a performance for the future, by combining multiple elements and recurring themes from her past work.

For more than twenty years, she has worked with the relationship between her own image and that of Baroque religious iconography, utilizing art historical references to relate religious imagery to contemporary artistic practice. In 1971 she baptised herself St Orlan. Draping her body in black vinyl and white leatherette, she began wearing elaborate sculptural costumes in staged *tableaux*

vivants, whereby she used high-contrast colour photographs, photo collages, film and video to illustrate St Orlan as both mortal flesh and divine sculpture. The prototype of St Orlan was a sculpture she carved out of marble, then sent out 'in the tradition of academic sculpture since the Renaissance' to be enlarged to full scale.[11] She focused on the hypocrisy with which society splits the female image into madonna and whore, and represented this paradox by exposing only one breast.

Orlan's move to incorporate surgery into her work was inspired as the result of an emergency operation for an extra-uterine pregnancy which she underwent in 1978. While preparing to speak at a symposium, she fell ill and was rushed to the hospital just hours before she was scheduled to appear. She took a video crew with her to document the operation, and because she was given local anaesthesia, she was able to explore the roles of both passive patient and active participant. She describes the surgical experience as being very dense and cathartic, and explains that it was during the operation that she began to draw strange parallels between the operating theatre and the Baroque imagery she had been using in her work; for example, the light emanating from above, the surgeon assuming a God-the-Father-like position, and all the medical assistants gathered around in the same manner as when the priest celebrates mass. In an effort to demystify the medical procedure, to transform the experience from one of distress to one of progress, she sent the tapes back across town to be shown in her absence.

Figure 7.3 Orlan, computer morph, detail from *Omnipresence (Entre-Deux)*, 1993/4.
Sandra Gering Gallery, New York

Drawing on surgery, psychoanalysis and self-portraiture, Orlan then began working with computer imagery and actually sculpting her own flesh, in order to change the reference and produce new images. She contends that what she is making is a psychological self portrait, a self portrait such as no artist has produced before, because it is completely reworked. By scanning the features of her chosen models into the computer, and then combining her own features, she produces a composite which is unique. She explains that it would be completely impossible to replace your own features with totally different ones, and it is exactly the resulting synthesis which is produced from both images that is a fundamental component of her project (Figure 7.3).

So, contrary to the most common misinterpretation of her endeavour, Orlan aims not to combine multiple elements of beauty in the hope of becoming the ultimate ideal woman, but rather to deconstruct the very notion that such a thing could actually exist. Critics who claim that Orlan is 'a woman undergoing facial surgery in an attempt to look like an idea of beauty',[12] or that her use of cosmetic surgery is a 'mindless acceptance of socially imposed ideals of beauty',[13] whereby she is

striving to 'progressively sculpture her face into the quintessential female form',[14] not only miss the point but inadvertently collude with the social assumptions that cannot conceive of a woman altering her appearance outside such a paradigm. Descriptions of Orlan as 'a slightly plump woman of average height',[15] 'a beautiful woman who is deliberately becoming ugly',[16] or '46 and still rather ugly – even after six operations . . . her pug-like face would need something more than the skill of a surgeon's knife to reach the Grecian ideal of perfection',[17] are indicative of, and therefore perpetuate, precisely that very system which measures female worth against an utterly unachievable standard of perfect beauty.

FEMINISM AND PLASTIC SURGERY

Traditionally, the relationship between feminism and plastic surgery has been extremely volatile and contentious. Viewing the practice exclusively as yet another invasive assault on women's bodies and an erasure of individual identity, many feminists have condemned the practice entirely. A crucial aspect of Orlan's deployment of plastic surgery, and what differentiates it from conventional applications, is her exposition of the actual surgical process and its immediate aftermath. She contends that 'in plastic surgery nobody sees what you go through and what you look like afterwards', and explains that initially doctors had refused to work with her 'because they believe that plastic surgery should be kept in mystery – all that should be revealed is the perfect result'.[18] Each performance is videotaped, photographed, and some have been telecast live, thereby making public what has traditionally been kept an extremely private event. Not only does she grant *us* visual access to the procedure, but through her refusal to undergo general anaesthesia, she becomes an active participant herself. In so doing, she adds a third term, *during*, to the rigid binarism of 'before' and 'after', and thereby poses a direct challenge to the myth of magical transformation performed on helpless women by the omnipotent medical establishment.

Figure 7.4 Orlan, *Three Days After Operation*, 24 November 1993, New York, technique: Cibachrome, Diasec Vacuum Sealed (220 × 165 cm). Photo: V. Sichov/Sipa press

After each operation, Orlan ritualistically photographs her bruised and bloated post-operative face – first thing in the morning, every morning – for 41 days, referring to the amount of time that quarantined people are kept hidden from the world (Figure 7.4). These brutal and shocking images are then exhibited, coupled with the ethereal computer morphs, becoming a new series of self portraits which are entitled *In Between Two*. Although the violence of the post-operative images powerfully attests to the traditional female relationship between beauty and pain, when viewed in conjunction with the computer composites they take on a new level of meaning. Whereas the former images allude to a hidden process which is endured in order to produce a static result, the latter ones refuse the notion of a female beauty which is frozen in time and space, suggesting instead a definition which foregrounds process and change.

These images in particular also illustrate the discrepancy between Orlan's use of cosmetic surgery as a means of building on her own facial features in order to create a new specificity, and the industry's desire to maintain a standard based on complete homogeneity. Regardless of whether Orlan has chosen the features of women who fit a male-defined stereotype of beauty, in each instance what she begins with is a distinctive feature of a particular woman, which exists in radical opposition to the dominant surgical practice that would rather make all women look identical. This is a problem which troubles her deeply, and is thus a primary reason for using the process of plastic surgery precisely to break apart the norms which are constantly reinforced through the unquestioned acceptance of such a cognate end result. She sees plastic surgery as a means of inventing her own body, of creating her own self portrait, and therefore wants to use it to disturb the notion of the 'normal'; of the perfected, the fixed and the standardized. She points out that while society insists that women are their appearance, the implementation of a standard or norm of appearance simultaneously asserts that they are all to be one. Rather than bring our diversity as women in line with an external standard of beauty which is imposed upon us, she is suggesting that we remake our bodies to reflect our own sense of personality. To make it immediately obvious that she is using cosmetic surgery in this manner, Orlan went a step further during her last operation and had very prominent implants (commonly referred to in the press as 'horns') inserted above her eyebrows.

The unequivocal nature of such a critique is also a principal cause for much of the hostility she has received. Although rejecting masculinist notions of beauty may be a useful political strategy, it doesn't completely absolve us of the deep-rooted psychical stake we nonetheless invest in the 'normality' of our appearance. Orlan admits that her work has been hard on her, both physically and emotionally. She explains that it is difficult to sustain because it is an act of aggression against herself that is often interpreted by others as an act of aggression towards them, who in turn frequently respond aggressively towards her. For example, she recalls attending a dinner party in New York where she was in the company of many prominent dealers, curators and collectors, whom she understood were interested in speaking to her about her work. Many of these guests were women, and initially she was quite puzzled by what appeared to be their obvious and immediate disdain for her current work. Then, 'in a flash', she suddenly realized what had motivated their ostensibly unwarranted reactions – they all had the same nose! Because she actually uses plastic surgery to comment on its prevailing ruses, she unavoidably offends those who have used it to conform to a standard model. Seen from this perspective, Orlan's actions are thus perceived as deliberate acts of disfigurement which she inflicts upon herself, and so pose a threat to our own hidden fears of disfigurement, and the underlying feelings of physical inadequacy that the feminist project has so relentlessly fought against. Is it possible, then, to assume that a large degree of the aggression which is informed by this type of interpretation, and the accusations which charge Orlan with self-loathing, are perhaps a denial, or a projection onto her, of our own self-loathing?

As one can imagine, the conservative nature of western medicine hardly welcomed Orlan's ideas with open arms. Initially she was met with bewilderment and resistance from the medical estab-

lishment, and it took her quite some time before she was able to find a surgeon who was willing to co-operate. The first six operations were performed in France and Belgium by surgeons who were men, but Orlan 'worried that they were trying to keep her "too cute"',[19] concentrating on the conventions of plastic surgery rather than attending to the concepts informing *The Reincarnation of St Orlan*. Her seventh and most recent operation, though, was performed by Dr Marjorie Cramer, a New York state-certified surgeon who also describes herself as a feminist. At first Dr Cramer was sceptical, but after discussing Orlan's intentions with her in depth, she became convinced that Orlan was, in fact, a serious artist. Dr Cramer sees the project as a social commentary, and believes that what Orlan is doing is 'actually a piece of body art, an incredibly complicated and sophisticated theatre'.[20] The doctor understood entirely the conceptual nature of Orlan's request, and was therefore prepared to go beyond the standard practices and explore the possibilities of plastic surgery from a different perspective. Taking the ethical implications very seriously, she explains that

> It's a complicated issue: I consider myself a feminist, yet I spend a good deal of my life making women look pretty, because that's what society wants. I came to terms with that some time ago. Women do rather ghastly things to themselves.[21]

We must be extremely careful, however, not to conflate our outrage at the ideological structures of power that systematically enable the abuse of technology with the technology itself. Because the fear of technology has routinely been exploited negatively to affirm social values such as individualism, freedom and the family, technology is frequently used as a metaphor for everything that threatens 'natural' social arrangements. Conservative values associated with nature are therefore often mobilized to counter such threats. As Michael Ryan and Douglas Kellner point out, when viewed in relation to a conservative ideology, technology represents 'modernity, the triumph of radical change over traditional social institutions'.[22] Accordingly, these institutions are 'legitimated by being endowed with the aura of nature, and technology represents the possibility that nature might be reconstructable, not the bedrock of unchanging authority that conservative discourse requires'.[23] Donna Harraway also stresses the importance of taking responsibility for the social relations of science and technology by insisting that we refuse an anti-science metaphysics, a 'demonology of technology'. She suggests instead that we create an alternative to the dualism that situates science and technology as a means of great human satisfaction on the one hand, and as a matrix of complex dominations on the other.[24] If we avoid a critical and cultural analysis of bio-medical technology and all its implications, we run the risk of reiterating the traditional patriarchal binarism which aligns women with nature and opposes them to culture.

Cosmetic surgery has become emblematic of this precarious double bind: to embrace it is to suggest conformity to an oppressive norm of beauty, whereby to reject it reinforces the notion of the 'natural woman', which is locked into the political dead-end of biological determinism. Jeanne Silverthorne notes this inherent contradiction within a feminist critique of plastic surgery. If the construction of 'woman' within patriarchal society 'is formed by the imperative to look as attractive as possible to an indeterminate viewer, [plastic surgery] both reinforces this definition and challenges the limited term of viability allowed the subject so defined'.[25] She has also observed that a guilty pleasure/secret vice of many feminists is to discuss face-lifts, particularly when those feminists are artists. She explains that in its suggestion that beauty is only skin deep, the face-lift

> also suggests a belief in transcendence – the belief that we are not what we see in the mirror, that there is more to us. Rooted in crude materialism, the face-lift rebels against crude materialism, prodding the 'merely' physical into subservience. Its popularity is what's left of a belief in the soul.[26]

Orlan addresses these issues when she says that 'in this era, when a woman decides to change her body she is attempting to conform to the norms of this society. I'm challenging what plastic surgery

is used for today, criticising the mould that everyone puts themselves into,'[27] asserting that 'in the same way that we take antibiotics to stop ourselves from dying a physical death, there's no reason why we shouldn't take advantage of plastic surgery'.[28]

It must be noted, however, that even if we could muster the courage to go against society and radically reconstruct ourselves, the reality of actualizing such an endeavour would most likely be overwhelmingly financially prohibitive. Although Orlan is responsible for funding her performances, the surgeons she has worked with have waived their personal fees in the service of Art.[29] Difficult as it was for her to find this type of sympathy, Orlan nonetheless has found it, and therefore occupies a privileged position as artist whereby she is absolved of the monetary burden that we ordinary folk would certainly have to bear. As well as economic constraints, her engagement with such an exclusive practice also poses difficult questions relating to race and ethnicity, whereas one could argue that a white woman commenting on western notions of beauty merely reinforces the centrality of such notions while pushing all other concepts of identity further into the margins. Of what use is her project to those who never subscribed to this particular notion in the first place? Orlan's investigation of identity is by no means definitive, but we have to accept that it is her own identity and tradition that she has chosen to explore. And as we continue to witness the transmutation of Michael Jackson and other non-white public figures, it seems as if the pervasiveness of the desire to emulate the white, Eurocentric ideal within Western society suggests that such a critique is still quite necessary.

'THIS IS MY BODY, AND THIS IS MY SOFTWARE'

When asked whether she believes in a separation of mind and body, Orlan explains that she has no idea what a soul, a spirit or a conscience might be, nor does she have a concept for a distinct entity that one might call a mind. She responds instead with the statement, 'This is my body, and this is my software.'

She refers to the human body as obsolete, describing it as a form of crude machinery that is old-fashioned and out of date, but which nonetheless houses a creative software called intelligence. Drawing on the ideas of Antonin Artaud, she uses the term 'obsolete' to contrast the incredibly primitive or low-level activities that the body must perform in order to sustain itself (eating, sleeping, breathing, etc.), while at the same time, within that same body, there is an extraordinary capacity to create. In one of her performances she read a text by Artaud, whereby he calculates how many times a poet must chew and do a variety of other bodily things, in order to produce fifty pages of poetry. She terms this production 'magical creation', explaining that it is precisely the enormous weight that the body exerts on life, which in turn effects a great disproportion between what is actually created through the body, and the effort that is needed in order to sustain the body.

The materiality of mind and body was a major theme in the work of Artaud, which is perhaps why we can draw so many parallels to Orlan's work, and why they seem to resonate so strongly. One such correlation is especially evident in the writing on Artaud by Susan Sontag. She quotes him as saying that the 'artist is consciousness trying to be', and explains that in Artaud, the artist as seer crystallizes into a figure that is pure victim of his own consciousness. The metaphors he used to describe his mental distress posited the mind as property which one never fully possesses, or as a physical substance that is intransigent, fugitive, unstable and mutable. She notes that Artaud argued against the hierarchizing of levels of consciousness, contending that no perception should be excluded as too trivial or too crude. Art should be able to report from anywhere, and for Artaud 'to bar any of the possible transactions between different levels of the mind and the flesh amounts to a dispossession of thought, a loss of vitality in the purest sense'.[30]

Artaud therefore attaches his ideal of consciousness to a psychological materialism: '[T]he absolute mind is also absolutely carnal'. In other words, intellectual distress is at the same time physical distress, and each statement about consciousness is simultaneously a statement about the body. 'What causes Artaud's incurable pain of consciousness is precisely his refusal to consider the mind apart from the situation of the flesh.'[31] One of the most fundamental questions raised by Orlan's project is that of finding a way to think about the unthinkable: about how body is mind, and mind is body. Orlan's name could very easily be interchanged with Artaud's in this instance, as this paradox is mirrored equally in the desire of both to produce art that is also anti-art, and in the desire of each to close the gap between art and life. Each regards art as a function of consciousness, whereby individual pieces are merely a fraction of the whole of the artist's consciousness. Accordingly, works of art acquire value and vitality only as metaphors for consciousness.

Perhaps another way of understanding Orlan's conception of the body and consciousness can be found in the writings of Deleuze and Guattari, following their theory of the Body without Organs. In *A Thousand Plateaus*, they write: '[W]here psychoanalysis says "stop, find yourself again," we should say instead, "let's go further still, we haven't found our body without organs yet, we haven't sufficiently dismantled our self."'[32] They explain that the BwO causes intensities to pass; it is matter that occupies space to a given degree, which corresponds to the intensities produced. It is intense matter and the matrix of intensity when intensity equals zero. Matter equals energy, and production of the real is an intensive magnitude starting at zero.

They explain that the 'BwO is not at all the opposite of the organs. The organs are not its enemies. The enemy is the organism. The BwO is opposed not to the organs but to that organisation of the organs called the organism.'[33] They identify the three great strata which bind us most directly as the organism, signifiance and subjectification. 'You will be organised, you will articulate your body – otherwise you're just depraved. You will be signifier and signified, interpreter and interpreted – otherwise you're just a deviant.'[34]

In this sense, what Orlan is doing with plastic surgery can be seen as an attempt to dismantle such a confining organization of the self, or as a radical disarticulation of the organism defined as such. Orlan is fully aware that such an extraordinary feat must be approached with caution, because dismantling the organism does not mean killing yourself, but rather a way of opening the body to connections that presuppose an entire assemblage. They contend that dismantling the organism is no more difficult than dismantling the other two strata, signifiance and subjectification, and explain that:

> tearing the conscious away from the subject in order to make it a means of exploration, tearing the unconscious away from signifiance and interpretation in order to make it a veritable production: this is assuredly no more or less difficult than tearing the body away from the organism. Caution is the art common to all three.

Once again the words of Artaud are extremely relevant when he says that the conscious

> knows what is good for it and what is of no value to it: it knows which thoughts and feelings it can receive without danger and with profit, and which are harmful to the exercise of its freedom. Above all, it knows just how far its own being goes, and just how far it has not yet gone or does not have the right to go without sinking into the unreal, the illusory, the unmade, the unprepared.'[35]

Most importantly, Deleuze and Guattari stress that enough of the organism must be kept in order for it to regenerate each day, and enough signifiance and subjectivication to turn them against their own systems, while still enabling the subject to respond to the dominant reality. 'The BwO is not "before" the organism; it is adjacent to it and is continually in the process of constructing itself.'[36] Orlan is fully aware of the risks involved each time she undergoes surgery. She is also aware of precisely what she can ask of a surgeon, what a surgeon is capable of doing within the context,

what she can expect of the viewers, and also of herself. Moreover, she is fundamentally engaged with the process itself, thereby taking each stage slowly in order to reflect on both the physical and the psychological effects of her transformation.

Orlan explains that she has always felt distanced from her body, not in the sense of a psychological problem, but rather as a feeling of strangeness and unfamiliarity upon confronting her image in the mirror. She believes that most people experience this sensation, that is, a kind of gap between *who* they feel they are and *what* their image tells them they are. Because she has worked so much with images of her body in various ways, she is somewhat indifferent to the image produced by her body. She doesn't have a feeling of narcissistic recognition through her body, but rather through her voice. So for her the body is not 'separate', but to some extent it is something a little bit distanced, something on which she can work.

Orlan begins each performance by reading from the same psychoanalytic text, *La Robe*, by Eugenie Lemoine-Luccioni, which describes the skin as deceptive. She translates that 'one never is what one has, and there are no exceptions to the rule'. Saying that you are never what you have implies that what you *are* is the interior and what you *have* is the exterior: the skin. In our present era, cosmetic surgery makes it possible to recreate the borderline between what one feels inside, and what one has on the outside. Orlan employs plastic surgery principally for this purpose; she sees it as a site of intervention, a place where she can work on that borderline.

She also wants to confront all the taboos which surround the body, specifically in relation to the prohibitions against touching and opening it. She thinks that these are very old and primitive legends which demand that the body remain intact, and explains that the contemporary forms of Christianity and other secular forms of religion, such as psychoanalysis, continue to uphold these beliefs. She sees an incredible contradiction between the advancements in modern technology and these ancient fears of the body, which she again relates to the incapacity of our bodies to keep up with our 'software'.

Although Orlan has disclaimed the notion of a soul, or the immateriality and discreteness of the mind, she still retains a notion of an inside and an outside in regard to the construction of consciousness. She contends that there is something within us which we term 'personality'; some sort of locus of the self which is not *determined* by the outside appearance of the body, but is nonetheless in constant communication with it.

THE POLITICS OF PERFORMANCE

Orlan identifies art with life and views performance as the means most conducive for relating art to social processes. Since the beginning of this century, nearly every genre of avant-garde practice has seized the opportunity to incorporate live theatre and performance into its programme, precisely because these activities provide the most immediate means for articulating a broader philosophy. For example, just prior to the First World War, the *Technical Manifesto for Futurist Painting* declared that the artistic gesture would 'no longer be a fixed moment of universal dynamism', but rather would become 'decisively the dynamic sensation made eternal'. By insisting on activity and change, the Futurist painters turned to performance as the most direct approach for forcing their audience to take note of their ideas.[37] By the mid-1920s, performance had become established as a viable art form and proliferated throughout Europe. The influence of many early pioneers can be detected in the ideology from which *The Reincarnation of St Orlan* emerged. For instance, Hugo Ball and the Cabaret Voltaire believed that living art would always be 'irrational, primitive and complex', and would therefore speak a secret language, not of edification, but of paradox.[38] The contributions of Dada and of Surrealism can also be noted, especially in the sensibilities of Apollinaire and Cocteau, who anticipated a new mixed genre in French performance that would remain on the

edges of theatre, dance, opera and art, but would allow a new generation to experiment with the fantastic, dance, acrobatics, mime, drama, satire, music and the spoken word. The first public exhibition of the Bauhaus school in Germany must be mentioned as well; entitled *Art and Technology – A New Unity*, the show included performances which utilized satire and parody, drawing upon the legacy of Dada to ridicule all that smacked of solemnity or ethical precepts, and thus allowing the grotesque to flourish.[39]

Throughout the 1970s Orlan staged performances which called into question the relationship between the institutional structures of religion and art, and the roles which women have been relegated to within these institutions. Orlan, like so many other artists, took up performance precisely as a means of attacking societal values and art world protocol. Her use of live art can be seen as the result of a frustration with the limitations of conventional art practices, and the desire to facilitate an alternative means of disrupting a complacent public. However, because her work is nonetheless produced within the frame of fine art, she inevitably invokes the same art/anti-art polemic which has traditionally set performance artists at odds with the very institutions on which they depend for both critical acclaim and financial support.[40] In a performance piece from 1977, she decided to retaliate against this predicament by literally putting herself into circulation, so as to parody the commercial exchange of the artist's personality in the form of a commodity. She positioned herself outside the Grand Palais (site of FIAC, the French Art Fair) next to a life-sized photo of herself which she had transformed into a slot machine. Orlan called it an automatic kiss-vending object, and invited customers to insert 5 francs into a slot located between the breasts. Upon watching the coin descend to the crotch, the artist would then jump down off her pedestal and compensate the participant with a real 'French' kiss. Catherine Millet, in response to the scandal which was provoked by this performance, made the same analogy when she said that 'this sexual union was like an X-ray of the frenzy of exchange of contracts in the contemporary art world where the merchandising of the artist's personality replaces the merchandising of art'.[41]

In the late 1960s, many artists responded to the recuperation of the avant-garde into academia by staging happenings and performances which reintroduced both genuine pain and potential endangerment into their work. Drawing on the myth of the suffering artist, practitioners such as Vito Acconci, Chris Burden, Bruce Nauman, Dennis Oppenheim and Gina Pane, as well as Herman Nitsch, Rudolph Schwarzkogler and the Viennese 'Aktionismus' group used their own bodies and worked in real time in an effort to reject formalist concerns and easy institutional integration. Mary Kelly makes the case that performance art itself rebels against the foundations of modernist discourse when she says that, in performance, 'it is no longer a question of investing the object with an artistic presence: the artist is present and creative subjectivity is given as the effect of an essential self-possession'.[42] In performance, it is precisely the materiality of the art 'object' (the body) which becomes the most potent signifier deployed by the artist. The body as artistic text therefore challenges the norm engaged by art criticism, by providing a universal object whose authenticity no longer resides in the inscription of a signature, or the truth of a visible form, but rather in the artist's incontestable experience within her/his own body. Accordingly, it is the artist's 'irreducible, irrefutable experience of *pain*',[43] presented in real time, and experienced directly by an audience, which sets performance apart from other forms of representation.

Lea Vergine takes this point even further, explaining that within the realm of body art these experiences are 'authentic, and they are consequently cruel and painful', insisting that it is particularly within the authenticating imprint of pain that the artist's demand to be taken seriously is legitimated. Artaud also associated cruelty with authenticity in his attempt to revolutionize theatre over sixty years ago. In his manifesto for 'A Theatre of Cruelty', Artaud explained that 'cruelty' need not mean blood, but a theatre that is difficult and cruel for the performer first of all. He asserted that to

practise art is to deprive a gesture of its reverberations throughout the anatomy, whereas these reverberations, if the gesture is made in the conditions and with the force required, impels the anatomy and through it, the whole personality to adopt attitudes that correspond to that gesture.[44]

He declared that there can be no spectacle without an element of cruelty, and that in our present degenerative state, metaphysics must be made to enter the mind through the body.

Orlan refers to her current work as 'Carnal Art' to differentiate it from Body Art, although she acknowledges common sources. Her performances are undoubtedly 'difficult and cruel', for performer and audience alike, but the question of pain poses other problems. Although Orlan's project invokes an *aesthetic of pain*, she insists that she is not a masochist and that she does not 'suffer' for her work. This is not to say that it is not hard on her, both physically and emotionally, but she does not employ masochism as a political or an aesthetic strategy. In describing the work of Gina Pane, Kathy O'Dell points out that in 'Instincts and their Vicissitudes' (1915) Freud referred to masochism as 'sadism turned round upon the subject's own ego', whereby 'the active voice is changed, not into the passive, but into the reflexive middle voice'. She argues that it is precisely in this reflexive moment that a level of alienation is invoked by Pane's work, whereby her identity oscillates between the position of 'pure subject (with whom we empathise, for whom we feel) and pure object (to whom we do not wish to relate, just observe, keep at arm's length, too weird, too scary)'. Orlan's work is alienating for similar reasons; both artists could be characterized as having 'carried out actions that are painful to watch in the hopes of breaking through the social anaesthetisation of her audiences, pushing them to think about the violence contained in the everyday imagery that numbed them in the first place',[45] but what differentiates them is their relationship to pain. Pane's actions were not only painful to watch, but were in fact painful to herself during the performance. Orlan uses anaesthesia and embraces advancements in biomedical technology precisely because she wants to *minimize* physical pain; she wants to maintain as much comfort as possible throughout the entire procedure, both in surgery and in recovery.

In this respect, by disavowing her own physical pain, Orlan effectively shifts the focus away from an individual bodily experience by the performance artist, to the dominant ideological assumptions which determine what *types* of pain are considered socially and culturally acceptable. It is no longer relevant to question whether or not *she* suffers, but rather, we should ask, what are the configurations of power which determine *who* should suffer in the first place? As in athletics, Orlan explains that an aspect of her project involves the repeated 'testing' of the body to see how it will respond to certain situations and difficulties. It is common knowledge that athletes must put themselves through an incredibly gruelling training process in order to attain high levels of achievement in their field, yet they are not considered to be motivated by masochism because there is an enormous social value attributed to their cause. She refutes another such notion of 'acceptable pain' when she makes an analogy to natural childbirth; she contends that women who bear children without any medical intervention inevitably experience levels of pain which are far greater than any she subjects herself to. This type of pain, however, is not only considered normal, but is codified by the term 'natural', thereby implying that it is an expected price for women to pay. In other words, it's their 'debt to nature'.

Whether anaesthetized or not, there is something invariably destabilizing about observing any type of bodily mutilation; the act in and of itself bears witness to personal pain that can't be simulated. Difficult as it is to view another person's physical pain, it still exists outside our own corporeal existence, however, and therefore can only be comprehended as an idea. Elaine Scarry explains the distinction between understanding one's own physical pain and the pain suffered by someone else in precisely its unsharability, which also ensures its resistance to language; it is at once that which cannot be denied (by the sufferer) and that which cannot be confirmed (by the other). Physical

pain, she continues, does not simply resist language but actively destroys it, which is why 'it is not surprising that the language for pain should sometimes be brought into being by those who are not themselves in pain but who *speak on behalf* of those who are'.[46] In Orlan's case, it is 'the other' (the viewers) who speak of her pain (although they themselves cannot confirm it), yet she, 'the sufferer', denies it.

It is important to note here, that, even though body art and performance push the modernist notion of art which is static and separate from all other spheres of life, to the frenetic nature of lived, human experience itself, its effectivity as a political strategy actually remains even more limited to the confines of aesthetic discourse than more traditional media, and correspondingly, to the small segment of society which makes up the art-viewing elite. Because the efficacy of performance is premised on the experience of witnessing an event in real time, much of its 'meaning' resists conventional forms of reproduction and distribution. It is therefore unlikely to reach a larger audience, and thus to be taken seriously (within the art community itself, let alone larger society). Hence, even when artists defiantly 'take to the streets', their actions are generally received as a public nuisance and therefore only reinforce the popular perception of the artist as mad outsider. It then becomes apparent that this type of behaviour is at best tolerated, rather than accepted, because the role of the artist within Western society is actually considered to be utterly insignificant, and the artist is seen to occupy a position which is always exterior to the acquisition of power.

By using performance as only one of many visual mediums within her current project, Orlan narrowly escapes this type of classification. The video, photographic and computer-generated imagery of the operations, as well as the myriad of images which she produces during her recovery, form an integral component of the project, and exist as separate entities that are not necessarily dependent on the 'real time' of the surgical performance for their meaning. Whether viewed live or by analog representation, or in the form of photographic documentation, the 'real power' of Orlan's work lies precisely in its ability to have an impact on more than the cerebral register alone. What the work means cannot be separated from what the work does – in other words, the embodied reaction that it summons up for both artist and audience. It is precisely within this type of profound bodily reaction that verbal language disintegrates, identification is prevented, logic is denied, and assimilation is refused. Such intense mental short-circuiting demands that we forge an alternative means of communication, through representation and a language of the body.

The powerful, sometimes violent, physical responses which her work seems to incite, also render redundant any doubts as to whether Orlan really needed to inscribe her ideas into her own flesh in order to get the point across. Obviously she did. Orlan insists that the physical operation must be shown because it is the moment that the body is actually opened. It is very difficult to watch. It is vital, however, for people to see this process because the body is the literal material with which she is working, and she wants to show the actual work in progress. She likens the operating theatre to her studio; while she is on the operating table she is fully aware that she is also making a film, directing photography, producing videos and what she terms 'objet plastique'. She conserves everything that is taken from her or used during the operations (fat, skin, blood-soaked gauze, etc.), which she then uses to create autonomous pieces of art (Figure 7.5). The operations are therefore only one aspect of a much larger continuum, whereby the time which elapses between the operations is equally integral to the work as a whole. It is during this interim period that she also mounts exhibitions and installations which not only reflect on her experience of the project thus far, but also directly inform its next phase. Clearly, the live, surgical performances form the heart of the *Reincarnation* project; however, if we are to make sense of it in its entirety we must not overlook the many arteries which provide its sustenance.

One such area can be described as the relationship between the limits of the body and the limits of art. In addition to the operations Orlan has had on her face, she has also had liposuction,

whereby several kilos of flesh were removed from her body (Figure 7.6). She says that these operations were performed anarchically in order to get materials for her work, explaining that the body is her material and she is the factory, the site of its production. She then took this material and created pieces in the tradition of Catholic reliquaries, whereby she enclosed bits of flesh within small, round pieces of perspex. She mounted these reliquaries onto the text of Michel Serres,[47] each time using the same text but in a different language. She continued this process until she ran out of flesh, thereby highlighting the relationship between the flesh and the word – the limit of language determined by the limit of the body.

LOOKING BEYOND VISION

Although this project has been exploited for its sensationalism in the press, and therefore denied the context of its production, the images which have appeared publicly have nonetheless produced quite disturbing effects within a wide cross-section of viewing subjects. Whether seen in an art gallery or on the front cover of a tabloid, it is the content of these images and the deep psychological implications which they call forth, that cannot be ignored.

Orlan has been known to reverse an old artistic cliché, and add a bit of irony to her work, when she addresses her audiences with the warning: 'you are about to see videos which will make *you* suffer', suggesting that the mere act of looking might be an imminent cause of great psychological discomfort. Julia Kristeva describes suffering

Figure 7.5 Orlan, photographic transfer onto blood-soaked gauze, *Saint-Suaize*, number 10 (30 × 40 cm)

as the place of the subject. Where it emerges, where it is differentiated from chaos. An incandescent, unbearable limit between inside and outside, ego and other. The initial, fleeting grasp: 'suffering', 'fear', ultimate words sighting the crest where sense topples over into the senses.[48]

What is it about Orlan's work that is so incredibly difficult to look at? Why do we recoil so dramatically at the sight of facial surgery when we are constantly inundated with imagery that is much more violent on television and in popular films every day? In order to answer these questions, perhaps we should begin with Barbara Creed's analysis of the monstrous feminine within the genre

Figure 7.6 Orlan, fourth operation/surgical performance, *The Mouth of Europa and the Figure of Venus,* 8 December 1990, technique: Cibachrome, Diasec Vacuum sealed (110 × 165 cm).
Photo: Joel Nicolas

Figure 7.7 Orlan, seventh operation/surgical performance, *Omnipresence,* 21 November 1993, New York, *La Deuxieme Bouche.* Technique: Cibachrome, Diasec Vacuum sealed (110 × 165 cm).
Photo: V. Sichov/Sipa press

of science fiction and horror films. Drawing on Kristeva, she also locates the maternal body as a primary site of abjection, describing how it is often the maternal figure which is represented as monstrous – 'the treacherous mother, the oral sadistic mother, the mother as primordial abyss', 'the monster as fetish-object of and for the mother',[49] and the ultimate in sheer horror, 'the monstrous vagina, the origin of all life threatening to reabsorb what it once birthed'.[50] The image of the gaping and voracious black hole can be seen to signify female genitalia as a monstrous sign, threatening to incorporate everything in its path. In this sense, perhaps the sight of a surgical incision into a woman's face can also be perceived within patriarchal culture as a primeval 'black hole', another metonymic reminder of the 'hole which is opened up by the absence of the penis; the horrifying sight of the mother's genitals – proof that castration can occur' (Figure 7.7).[51]

She then goes on to explain that one of the most interesting structures operating in the screen–spectator relationship pertains precisely to the sight/site of the monstrous within the horror text. In contrast to conventional viewing structures working within the classic cinematic text, the horror film does not constantly suture the spectator into the viewing processes. Instead, the suturing processes are momentarily undone while the horrific image on the screen challenges the viewer to risk continuing to look. Here, she refers to those moments when the spectator cannot stand the images of horror unfolding on the screen, and is forced to look away. It is in this instance that

> strategies of identification are temporarily broken, as the spectator is constructed in the place of horror, the place where the sight/site can no longer be endured, the place where pleasure in looking is transformed into pain and the spectator is punished for his/her voyeuristic desires.
>
> Confronted by the sight of the monstrous, the viewing subject is put into crisis – boundaries, designed to keep the abject at bay, threaten to disintegrate, collapse.[52]

The image of 'horror' therefore puts the viewing subject's sense of unified self into crisis, when the imagery becomes too threatening or horrific to watch, thereby threatening to draw the viewing subject to the place 'where meaning collapses', the place of death.

> By not looking, the spectator is able momentarily to withdraw identification from the image on the screen and reconstitute the 'self' which is threatened with disintegration. This process of reconstitution of the self is reaffirmed by the conventional ending of the horror narrative in which the monster is usually 'named' and destroyed.[53]

Orlan offers a similar explanation, although she contends that the brain is able to censor things which are difficult to see, and that we *mentally* close our eyes in order to screen out those elements which deeply trouble our sense of self: of stable identity and of unified being. Her imagery almost pierces the body because, as we bear witness to one of the most ancient of social and religious taboos, the actual opening of the body, our mental capacity to filter out the unseeable is overridden. Our eyes become black holes and absorb what was previously deflected. It is precisely Orlan's subjective position as director of events that differentiates her from the pure object position of the victim in the classic horror or science fiction text. Her active role, authoritative voice and defiant gaze literally demand an alternative method of viewing, which automatically usurps the safe distance between self and other which is required in order to 'look away'. The body itself becomes the organ of sight, and thus disperses the impact over its entirety. Her work therefore challenges us to find a way in which we can 'look' long enough to gain a greater understanding of the precariously complex psychic constructions which constitute the very foundations of our identity.

Another speculation pertaining to the origin of power within Orlan's imagery to instil unmitigated horror, lies precisely in the fact that she chooses to cut open her *face*. In our culture, the face is deemed the most precious characteristic of human identification, and therefore enjoys a privileged status to the rest of the body. Deleuze and Guattari contend that this determination arises

from the assumption that the face is not a part of the body, but rather is a specific organization of human sociality. They explain the face as the intersection of signifiance and subjectification, whereas the former is 'never without a white wall upon which it inscribes its signs and redundancies', and the latter is 'never without a black hole in which it lodges its consciousness, passion, and redundancies'.[54] The head, they claim, is not a face. The face is produced only when the head ceases to be coded by the body, when it 'ceases to have a multidimensional, polyvocal corporeal code'.[55] In other words, when the body, head included, 'has been decoded and has to be overcoded by something we shall call the Face'.[56] In their estimation, in order to dismantle the organism, we must therefore also dismantle the face.

They suggest that the face is not a universal, it is not by nature an entirely specific idea. It is not even that of the white man, but rather, it is White Man himself. In this sense, the primary role of the faciality machine can therefore be seen as the computation of normalities, and subsequently, the detection of deviance from these normalities. They assert that racism, and I would include sexism, operate by the determination of degrees of deviance in relation to the White-Man face. From this point of view, there is no exterior, no people on the outside, only people who should be like him, or designed by him. 'The dividing line is not between inside and outside but rather is internal to simultaneous signifying chains and successive subjective choices.' Neither detect particles of the other, but rather propagate 'waves of sameness until those who resist identification have been wiped out'.[57]

They assert that the social production of the face is what constitutes our entire secular landscape, which is why it is absurd to suggest that the semiotic of either the signifier or the subjective operates through the body – unless that body has been completely facialized. Facialization can therefore be characterized as a direct result of the specific assemblages of power which determine that social production, indicating that the face itself is politics.

Consequently, they acknowledge that madness is a definite danger in the dismantling of the face. They point out that schizophrenics lose their sense of face (their own and others'), their sense of the landscape, and their sense of language (with its dominant significations), all at the same time, to reinforce that the organization of the face is clearly a strong one. Orlan knows this as well. Ultimately, she wants to dismantle her previous identity through the modification of her entire body. She wants to 'master' her own body, to see how far she can push the limits of her own body, through its alteration – especially her face – without going insane. So,

> if the face is a politics, dismantling the face is also a politics involving real becomings, an entire becoming-clandestine. Dismantling the face is the same as breaking through the wall of the signifier and getting out of the black hole of subjectivity.[58]

AESTHETICIZING THE OPERATING ROOM

On numerous occasions, Orlan has been derisively accused of making a spectacle of herself and she has been condemned for her blasphemous conduct in the operating theatre. She explains her use of costumes, music and props as an artistic strategy, as a way of recreating and completely transforming the medical environment. She challenges the implicit authority of the stark sterility which has become emblematic of medical iconography. She adds to it a completely new aesthetic dimension in an attempt to take away some of the drama, mystery and anxiety from the whole surgical procedure. When she undergoes surgery she is healthy and calm, whereas most people in the same pre-operative position are sick, vulnerable and afraid.

In our culture, there is a great fear of surgery, and the sick or ill body that is associated with it. In accordance with the archaic taboos which forbid the opening or the touching of the body, med-

ical discourse contends that such measures may be performed only when necessitated by absolute medical emergency. Because Orlan is not physically ill, her desire to undergo multiple surgery is often perceived as a means of wounding herself, of making herself ill. Susan Sontag explains that using disease as a metaphor for a wide range of social 'ills' has become common practice, and that 'every form of social deviation can be considered an illness'.[59] Disease becomes adjectival – a way of imposing its horror onto other things. Diseases that are thought to be multi-determined (mysterious, cause unknown) have the widest possibilities as metaphors for what is socially wrong. She also maintains that the fear of disease is most pronounced in those illnesses which are perceived not just as lethal, but rather as dehumanizing, and asserts that the most horrifying are those which attack the exclusive eminence of the face. In this respect, it is not Orlan who is making herself sick, but rather, what we are seeing is a desperate attempt on behalf of the public to construct her as ill.

There is also an element of humour to her work, and she likens the performances to the genre of 'tragic comedy' rather than 'high drama'. In this regard, it seems appropriate to examine her performances within the context of carnival theory. For the Russian scholar Mikhail Bakhtin, carnival is both a 'populist utopian vision of the world seen from below and a festive critique, through the inversion of hierarchy, of the "high" culture'.[60] He contended that an important principle of carnival resides in the spirit of carnivalesque laughter, and describes such laughter as ambivalent: it is gay and triumphant, while at the same time it is mocking and deriding (Figure 7.8).

Figure 7.8 Orlan, seventh operation/performance, *Omnipresence*, 21 November 1993, New York, *Plan Général et Lecture du Texte de 'La Robe' – Eugenie Lemoine Luccioni*. Technique: Cibachrome, Diasec Vacuum sealed (110 × 165 cm).
Photo: V. Sichov/Sipa press

Fundamental to the corporeal, collective nature of carnival laughter is what Bakhtin terms 'grotesque realism'. Grotesque realism uses the material body – flesh conceptualized as corpulent excess – to represent the spiritual, social and linguistic elements of the world. Orlan's project, when viewed in relation to this notion of the carnivalesque, raises interesting questions regarding the deployment of the 'grotesque body' within the realm of feminist politics. For Bakhtin, the grotesque body represents a powerful force. It is a body that is 'always in process, it is always becoming, it is a mobile and hybrid creature, disproportionate, exorbitant, outgrowing all limits, obscenely decentered and off-balance, a figural and symbolic resource for parodied exaggeration and inversion'.[61]

In summarizing the work of Bakhtin, Mary Russo describes the 'grotesque body' as the one which is open, protruding and extended, the body of becoming, process and change. The 'grotesque body' is opposed to the classical body, which is monumental, static and closed. She explains that the imagery of carnival resists, exaggerates and destablizes the distinctions and boundaries that mark and maintain high culture and organized society, and in this sense the carnivalesque suggests a redeployment of culture, knowledge and pleasure, thus becoming a site of insurgency.[62]

Even though the grotesque in this instance designates the marginal, we must not forget that 'what is socially peripheral may be symbolically central'.[63] Orlan's use of surgery can be seen as a deployment of carnivalesque inversion, because it denies with a laugh the ludicrous pose of autonomy adopted by the subject within the hierarchical arrangements of the symbolic; it does so by reopening the body-boundary which must remain closed in order to guarantee the level of repression necessary for the maintenance of organized subjectivity.

Russo points out, however, that although the body in constant semiosis may represent a liberatory ideal, it also risks recuperation by the very system it rebels against. She notes that, historically, mad women and hysterics have been locked up, 'their gestures of pain and defiance having served only to put them out of circulation'.[64] Orlan is a highly susceptible candidate for encountering exactly this type of societal retribution. When her project is described as 'carnivalesque', it is most often meant in a pejorative sense. From the popular resistance her work has received because of this type of classification, we must therefore ask whether utilizing the grotesque can work successfully to deconstruct a previously confining aesthetic, or are women 'so identified with style itself that they are as estranged from its liberatory and transgressive effects as they are from their own bodies as signs in culture generally'?[65] Dangerous as her embodiment of the 'female grotesque' is, however, it exists as an indication that the image of the female transgressor as public spectacle is still powerfully resonant, and it is precisely because Orlan's work induces such an impassioned, yet ambivalent, response that the possibilities of redeploying this representation have obviously not been exhausted.

In conclusion, it is Orlan's use of her most personal resource, her body, which demonstrates how art impacts on life, and life on art. Using her body as she does may be a logical progression in her quest for ultimate self-transformation, but it could have extremely detrimental consequences to her health. She has raised the stakes considerably in regard to the reintegration of risk within artistic practice, but with each operation she undergoes, the stakes become higher in respect to what the body can sustain. The human body may be obsolete, but at the present time it's the only one she's got, and it may betray her. She enters the minds of her audience through the impact of what they must look at. I find the intensity of the dialogue which has ensued as a result of this to be one of Orlan's most interesting achievements, as well as a point of primary importance within the project of Art in general.

Orlan's practice is extreme, but in a world of extremes such a methodology becomes increasingly imperative. Women have been 'speaking' for ages, but no one has been listening. Rather than contemplate her mental stability, we should appreciate the commitment of a woman who is willing literally to embody a feminist philosophy so completely. I am not suggesting that we should automatically take Orlan's findings at 'face' value. We should, however, use her project as a catalyst for

further debate, rather than simply reject her because her chosen technique doesn't suit our own individual needs for resolving our continually shifting position within a rapidly changing social order. We are complex beings, and therefore must use a variety of means to confront the multifaceted array of ideologies which determine our social, historical and psychological constitution.

Notes

1 Brian D'Amato, *Beauty* (London: Grafton, 1992).

2 I came across a review of *Beauty* by John Weir in *Art Forum* (December 1992), which was, ironically, illustrated by a photograph of Orlan. Obviously he had made the connection between her practice and the story; however, he failed to make the connection explicit by providing any text to explain who she was, or why he had used her image with his review.

3 Orlan, *L'Acte pour L'Art*, quoted by Barbara Rose, 'Is It Art? Orlan and the Transgressive Act', *Art in America*, February 1993, p. 83.

4 Ibid., p. 87.

5 Ibid.

6 Mary Kelly, 'Re-Viewing Modernist Criticism', *Screen*, vol. 22, no. 3, 1981, p. 42.

7 Ibid., p. 41.

8 Ibid., p. 42.

9 Ibid., p. 48.

10 Lynda Nead, *The Female Nude: Art, Obscenity and Sexuality* (London: Routledge, 1992), pp. 22–30. Another trajectory of Orlan's project is specifically concerned with the concept of mind/body separation, which I will discuss later in greater depth.

11 Rose, op. cit., p. 84.

12 Laura Cottingham, 'Orlan: Sandra Gering Gallery, New York', *Frieze*, Issue 14, January/February 1994, p. 60.

13 Roberta Smith, 'Surgical Sculpture: The Body As Costume', *The New York Times*, 17 December 1993.

14 Margalit Fox, 'A Portrait in Skin and Bone', *The New York Times*, Sunday, 21 November 1993.

15 Ibid.

16 Keith Dovkants, 'Cut Out to be Venus', *Evening Standard*, 23 March 1994, p. 13.

17 Nick Rosen, 'The Birth – by Surgeon's Scalpel – of Venus', *Sunday Telegraph*, 14 November 1993.

18 Orlan, as quoted by Keith Greenberg, 'Woman on the Cutting Edge of Modern Art', *European Elan*, 19–25 November 1993, p. 2.

19 Ibid.

20 Dr Marjorie Cramer, as quoted by Janice Biehn, 'The Art of Plastic Surgery for Plastic Surgery's Sake', *The Medical Post*, 30 November 1993, p. 5.

21 Dr Marjorie Cramer, as quoted by Rosen, op. cit.

22 Michael Ryan and Douglas Kellner, 'Technophobia', *Alien Zone: Cultural Theory and Contemporary Science Fiction*, ed. Annette Kuhn (London: Verso, 1990), p. 58.

23 Ibid.

24 Donna Harraway, 'A Manifesto for Cyborgs: Science, Technology, and Socialist Feminism in the 1980's', *Simians, Cyborgs and Women* (London: 1991), p. 100.

25 Jeanne Silverthorne, 'The Trouble with Gravity', *Artforum*, February 1993, p.10.

26 Ibid., p. 9.

27 Orlan, as quoted by Greenberg, op. cit., p. 2.

28 Orlan, as quoted by McClellan, 'Orlan Has Reversed an Old Cliché', *Observer*, 17 April 1994 p. 42.

29 Margalit Fox notes that the usual fee for such a procedure would be $12,000 to $15,000, op. cit.

30 Susan Sontag, 'Approaching Artaud', *Under the Sign of Saturn* (London: Writers and Readers Cooperative, 1983), pp. 18–22.

31 Ibid, p. 23.

32 Gilles Deleuze and Felix Guattari, *A Thousand Plateaus: Capitalism and Schizophrenia*, trans. Brian Massumi (London: Athlone Press, 1988), p. 151.

33 Ibid., p. 158.

34 Ibid., p. 159.

35 Ibid., p. 160.

36 Ibid., p. 165.

37 Roselee Goldberg, *Performance: Live Art 1909 to the Present* (London: Thames & Hudson, 1979), p. 10.

38 Ibid., p. 37.

39 Ibid., p. 65.

40 Because the performance artist has no object to sell, s/he must often depend heavily on public funding to supplement any revenue that might be generated through ticket sales or honoraria, assuming that the event is presented by an established venue (gallery, museum, theatre, etc.). If, on the other hand, the artist wishes to execute performances (especially of a socio-political nature, which call into question the active participation of such funding bodies in maintaining the status quo) in public places or small, alternative arts spaces, the odds of receiving public funding are basically nil.

41 Catherine Millet, as quoted by Rose, op. cit., p. 86.

42 Kelly, op. cit., p. 52.

43 Ibid.

44 Antonin Artaud, 'The Theatre of Cruelty (First Manifesto)', *The Theatre and its Double*, trans. Victor Corti (London: Calder Publications Ltd, 1993), p. 58.

45 Kathy O'Dell, 'The Performance Artist as Masochistic Woman', *Arts Magazine*, June 1988, p. 98.

46 Elaine Scarry, *The Body in Pain* (New York: Oxford University Press, 1985), pp. 4–6.

47 The text she uses is from *Le Tiers-instruit*:

> what can the common monster, tattooed ambidextrous, hermaphrodite and cross-bred, show to us right now under his skin? Yes, blood and flesh. Science talks of organs, functions, cells and molecules to acknowledge that it is high time that one stopped talking of life in the laboratories but science never utters the word flesh which, quite precisely, points out the mixtures in given place of the body, here and now, of muscles and blood, of skin and hair, of bones, nerves and of the various functions and which hence mixes up that which is analyzed by the discerning knowledge.

48 Julia Kristeva, *Powers of Horror: An Essay on Abjection*, trans. Leon Roudiez (New York: Columbia University Press, 1982), p. 140.

49 Barbara Creed, 'Alien and the Monstrous Feminine', *Alien Zone: Cultural Theory and Contemporary Science Fiction Cinema*, ed. Annette Kuhn (London: Verso, 1990), p. 128.

50 Ibid., p. 135.

51 Ibid., p. 136.

52 Ibid., p. 137.

53 Ibid.

54 Deleuze and Guattari, *A Thousand Plateaus*, p. 167.

55 Ibid., p. 170.

56 Ibid.

57 Ibid., p. 178.

58 Ibid., p. 188.

59 Susan Sontag, 'Illness as Metaphor', *Illness as Metaphor and AIDS and Its Metaphors* (New York: Anchor Books, 1989), p. 58.

60 Peter Stallybrass and Allon White, *The Politics and Poetics of Transgression* (Ithaca: Cornell University Press, 1986), p. 7.

61 Ibid., p. 9.

62 Mary Russo, 'Female Grotesques: Carnival and Theory', *Feminist Studies/Critical Studies*, ed. Teresa de Lauretis (Bloomington: Indiana University Press, 1986), pp. 218–19.

63 Stallybrass and White, op. cit., p. 23.

64 Russo, op. cit., p. 222.

65 Ibid.

References

Artaud, Antonin 'The Theatre of Cruelty (First Manifesto)', *The Theatre and Its Double*, trans. Victor Corti, (London: Calder Publications Ltd, 1993, originally published in Antonin Artaud: *Oeuvres complètes*, vol. IV. Editions Gallimard, Paris 1964).

Biehn, Janice 'The Art of Plastic Surgery for Plastic Surgery's Sake', *The Medical Post*, 30 November 1993.

Cottingham, Laura 'Orlan: Sandra Gering Gallery, New York', *Frieze*, Issue 14, January/February 1994.

Creed, Barbara 'Alien and the Monstrous Feminine', *Alien Zone: Cultural Theory and Contemporary Science Fiction Cinema*, ed. Annette Kuhn (London: Verso, 1990).

D'Amato, Brian *Beauty* (London: Grafton, 1992).

Deleuze, Giles and Félix Guattari *A Thousand Plateaus: Capitalism and Schizophrenia*, trans. Brian Massumi (London: Athlone Press, 1988).

Dovkants, Keith 'Cut Out to be Venus', *The Evening Standard*, 23 March 1994.

Fox, Margalit 'A Portrait in Skin and Bone', *The New York Times*, Sunday, 21 November 1993.

Goldberg, Roselee *Performance: Live Art 1909 to the Present* (London: Thames & Hudson, 1979).

Greenberg, Keith 'Woman on the Cutting Edge of Modern Art', *European Elan*, 19–25 November 1993.

Harraway, Donna 'A Manifesto for Cyborgs: Science, Technology, and Socialist Feminism in the 1980's', *Simians, Cyborgs and Women* (London: 1991).

Kelly, Mary 'Re-Viewing Modernist Criticism', *Screen*, 22, no. 3, 1981.

Kristeva, Julia *The Powers of Horror: An Essay on Abjection*, trans. Leon S. Roudiez (New York: Columbia University Press, 1982).

McClellan, Jim 'Orlan Has Reversed an Old Cliché. We Suffer for Her Art. She has the Benefit of Local Anesthetic', *Life, The Observer Magazine,* 17 April 1994.

O'Dell, Kathy 'The Performance Artist as Masochistic Woman', *Arts Magazine*, June 1988.

Orlan, *Collective Consciousness: Art Performance in the Seventies*, ed. Jean Dupuy (New York: Performing Arts Journal Publications, 1980).

——artist talk given at Nexxus Contemporary Arts, Atlanta, April 1994.

——interview, 27 July 1994 (translated by Griselda Pollock).

——interview, 7 August 1994 (translated by Griselda Pollock).

Rose, Barbara 'Is It Art? Orlan and the Transgressive Act', *Art in America*, February 1993.

Rosen, Nick 'The Birth – by Surgeon's Scalpel – of Venus', *Sunday Telegraph*, 14 November 1993.

Russo, Mary 'Female Grotesques: Carnival and Theory', *Feminist Studies/Critical Studies*, ed. Teresa de Lauretis (Bloomington: Indiana University Press, 1986).

Ryan, Michael and Douglas Kellner, 'Technophobia', *Alien Zone: Cultural Theory and Contemporary Science Fiction Cinema*, ed. Annette Kuhn (London: Verso, 1990).

Scarry, Elaine *The Body in Pain: The Making and Unmaking of the World* (Oxford: Oxford University Press, 1985).

Silverthorne, Jeanne 'The Trouble with Gravity', *Art Forum*, January 1993.

Smith, Roberta 'Surgical Sculpture: The Body as Costume', *The New York Times*, 17 December 1993.

Sontag, Susan *Illness As Metaphor and AIDS and Its Metaphors* (New York: Doubleday, 1989).

Stallybrass, Peter and Allon White, *The Politics and Poetics of Transgression* (Ithaca: Cornell University Press, 1986).

Chapter Eight

The anorexic body:

contemporary installation art by women artists in Canada[1]

Judith Mastai

INTRODUCTION

This chapter proposes that the financial and institutional conditions for art in Canada have led to support for the installation as a particular form of three-dimensional work by women artists. It is an investigation, not by an art historian, but by a senior manager in a public art gallery,[2] which seeks to link practice to the conditions for production. The study was severely limited by lack of available statistical data, as many of the original questions posed by Claudine Mitchell as a stimulus for the investigation seem to have been rarely asked, particularly with reference to specific media such as sculpture. While research by the Canada Council has examined equity in the awarding of grants by gender and by region, no research has been conducted according to categories of practice. In fact, this sort of categorization is deceptive in the face of the ways in which artists work today, often utilizing a variety of media in their practice.

The view presented here was not intended as a comprehensive survey of women's art or even three-dimensional work by women artists in Canada. It incorporates statistics which were available from the Canada Council about grants, awards and Art Bank purchases as well as information from the Vancouver Art Gallery which was used, more or less, as a case study of the practices of one institution.

Generally, in Canada, only one institution funds the work of contemporary artists – the Canada Council. Corporations support gallery exhibitions and also may commission individual works, but this is very erratic. Public art projects, such as monuments and site-specific works, may be funded by private or corporate donors. These are generally subject to guidelines laid out by civic municipalities and administered by a committee of informed citizens, who debate the project and may subject the proposal to public scrutiny and debate before approval. Public institutions do not generally commission works but recent 'percent for art' schemes have resulted in developers offering commissions for artworks for new buildings. In preparing this chapter, I talked with a number of women artists who work in three-dimensional media. They estimated that there might be about three calls a year for submissions for commissioned projects. But it is more likely that well-known artists are approached directly by the commissioning body and that no call for submissions is advertised.

DEFINING SCULPTURE

Before I present statistical information, it seems necessary to define what sculpture might mean in the Canadian context. Which type of works would be included in a survey and which might not?

Although I am not particularly qualified to present a considered historical definition of sculpture, in the spirit of grounded research, one has emerged from my investigations. After a cursory look through the comprehensive artists' files in the library at the Vancouver Art Gallery, my perception was that very little sculpture, in its traditional forms or materials, was being produced in Canada, especially by women, and that this had some link with the means of distribution for the work. As one artist pointed out, the cost of shipping traditional sculptural works for exhibition across the vast distances of Canada is no small consideration. One other fact was that the local art school in Vancouver, the Emily Carr Institute of Art and Design, does not have a sculpture programme, but one in 3D. I wondered if this signalled a generic shift in practice or perception and my discussions with various women artists supported my belief that the majority of work would more appropriately be described as 'installation', a term connoting use of mixed media, often site-specific, and generally organized to provide an environment for the viewer which seeks to promote the spectator's engagement with the work.

The question of the role of the viewer seems to be of direct relevance to the work of many women artists and the issues they investigate combine traditional questions related to materials and form with theoretical ones about female representation, subjectivity, agency and authorship. For Marian Penner Bancroft, for example, the choice to use five lecterns for her 1989 work (Figures 8.1 and 8.2), *Shift*, emanated from a desire to build a speaker's site which would allow female viewers to experience a podium built to their height. Bancroft's perception was that a podium would normally be too high, necessitating that the speaker stand on a box like a child in order to be seen, intensifying her sense of illegitimacy as a speaker. In addition to the other meanings inherent in this work about language, patriarchy and the family, by providing lecterns at a more appropriate height, Bancroft hoped to endow the viewer with the authority to speak. This role for the viewer as participant, whose presence brings the meaning of the work to light, seemed to be definitive in establishing this work as installation, rather than monument.

A FIRST ATTEMPT TO SYNTHESIZE

The place of the body of the maker in the work seemed a major preoccupation for the artists whose work I investigated. And the image that occurred to me as a metaphor for this preoccupation was the anorexic body: starving in the presence of a controlled and controlling overabundance. In the absence of a significant economic market for art in Canada, a hothouse effect has been produced through government support. The conditions for producing and distributing work have often relied on the availability of funds through the Canada Council and other branches of the federal, provincial and municipal governments. In my view, this has produced a signature style in women's work, the temporary installation.

THE NATIONAL SCENE: THE CANADA COUNCIL

The Canada Council was founded in 1957 in order to enhance the development of the Canadian arts community. The Liberal government of the day recognized the importance that such an organization could play in negotiating regional interests into a unified national context. The Liberals were 'intent on developing a cultural policy that would enhance national glory'.[3] The Canada Council was created through an Act of Parliament and operating funds were provided through an endowment of 50 million dollars, which has been supplemented by parliamentary appropriations over the years. Section 12 of the Act outlined the Council's arm's-length policy, designed to prevent political interference in the work of the Council through the establishment of ongoing peer review committees. Exhibition projects selected for funding by Council through the peer review

Figure 8.1 Marian Penner Bancroft, *Shift*, 1989, silver print, paper, cedar, 103 × 60.7 × 45 cm (H × W × D). Collection of the Vancouver Art Gallery

Figure 8.2 Detail

process are currently divided into three categories and applicants may apply for one or more of the following at a time: assistance for research, presentation or touring.

In the category of funding for exhibition research in 1991, the Canada Council provided $82,000 to 27 projects. Fifty-six per cent of these were granted to women curators or to curatorial teams which included a woman curator. This represented 51 per cent of the total amount granted for exhibition research. Of the 27 projects funded, 12, or 45 per cent, were group shows, which may have included women artists, but this information was not indicated in the title of the exhibition. Thirty-three per cent of the funding for exhibition research was for solo shows for women artists.

Of the 98 exhibitions funded for presentation in 1991, 51 per cent had women curators, alone or as part of a curatorial team, and again, 33 per cent were for solo shows by women artists. Of all the exhibitions funded for presentation in 1991, 12 per cent were for Canadian women artists doing three-dimensional installation work. This number would increase slightly if one included textiles as a category of three-dimensional work; however, most work of this sort would be categorized as craft. (The question of naming categories of work arose during informal telephone interviews with staff members at the Canada Council. Such categories for media are defined by the curators and the artists themselves in their applications for financial support. If an artist works with a variety of media, Council staff will categorize them under several codes.[4])

Another important aspect of the work of the Canada Council in supporting artists was the acquisition of work for the Art Bank. In 1989/90, 43 per cent of the work purchased by the Art Bank was by women artists. As the Council listed only the names of the artists and not the number of their works which were purchased, this figure could actually be higher. Also, as no mention was made of the media of the works acquired, it was not possible to identify which of these works might be three-dimensional. In order to compare prices paid for the work of women and men, researchers are required to make requests under the Freedom of Information Act, which governs matters considered to be confidential.

Generally, then, one would have to say that women were relatively well represented in support for exhibition research and presentation by the Canada Council as well as in Art Bank purchases. Other information on the national scene was presented by *Matriart* magazine in 1993.[5] The National Gallery of Canada reported that 9 per cent of the works in its collections were by women. In the Canadian collection alone, women's work accounted for 12.5 per cent of the total holdings. Judith Baldwin quoted 1991 census figures which showed that 49.7 per cent of people describing their profession as that of painter, sculptor or artist were women. Her profile of galleries registered with the Professional Art Dealers Association of Canada (PADAC) revealed that there had been little change from 1975 to 1990 in the number of women artists (approximately 20 per cent) being featured in PADAC's national directory.

THE LOCAL SCENE: THE VANCOUVER ART GALLERY

In the absence of a significant number of private collectors for contemporary art, purchases by government-funded galleries and museums are a major source of support for artists in Canada. At the Vancouver Art Gallery, the acquisitions budget is approximately $500,000 annually. This figure varies from year to year as it is determined through interest on an endowment fund, established through profits derived from the sale of the former art gallery building in the early 1980s. This money is designated for acquisitions, in perpetuity, and is protected from use for any other purpose.

While the focus of the gallery's programming and collections is contemporary, the mandate includes acquisition of historical works related to the development of art in British Columbia as well as works related to areas of strength existing in the collection before 1988. In 1990, 44 of the 86 works acquired, or 51 per cent, were works by women artists. Of these, 7 per cent could be

called three-dimensional works. One was a statue, *Night Flight*, a 1938 work by Beatrice Lennie. Lennie was commissioned to produce a number of decorative works for architectural projects during the 1930s and 1940s, a period of growth in Vancouver. *Night Flight* is a work in plaster, presumably a maquette for a larger work which was never executed.

Three of the other three-dimensional works acquired through purchase in 1990 were ceramic sculptures by Vancouver artist Gathie Falk. Falk, now in her sixties, became prominent during the first stirrings of feminism in the visual arts in Vancouver in the late 1960s and early 1970s. Many of her works from this time, such as the earthenware *30 Grapefruits* (1970) (Figure 8.3), parody minimalism in relation to domesticity as well as being ironic with respect to the traditional, monumental materials of sculpture. Falk's work also marked a moment when conceptualism was privileged and became a trend within Canadian art practice. The presence of strong government support contributed to more idealist, academic practices, removed from the exigencies of appealing solely to popular taste. This highly administered environment has had a stronger influence on Canadian practice than many artists generally acknowledge.

Like many women artists in the early 1970s, Falk began as a performance artist and one of the ways in which the installation form seems to have developed was as a remnant or record of performance. One simplistic view is that performance emerged as an important form for women at this time because it provided an active, public presence for women artists and an interactive presence as well. Artists and audiences co-produced the works, known as 'happenings' in much the same way as they participated in social and political events of the time. More of this later.

The final work purchased by the Vancouver Art Gallery in 1990 was Joey Morgan's *Fugue* (1984) (Figure 8.4). *Fugue*, an installation work, was originally conceived for an unfinished floor of a new office tower in downtown Vancouver. What the Gallery actually purchased was not the installation, which would have had to be recreated and permanently installed for a new site at the Gallery, but rather, the remnants of the installation, consisting of a dilapidated armchair, a large-format photograph of bulldozers destroying a block of Vancouver's characteristic wooden homes, a soundscape, and a number of wooden boxes containing the metal numbers from the destroyed houses, beeswax and wire. The original installation was a moody, evocative comment on urban development. When these fragments are displayed in the Gallery, they bear little resemblance to the original installation.

In 1991, 12 of the 80 works acquired by the Gallery, or 15 per cent, were by women and of these, one-third were three-dimensional works – all works by Falk from the 1970s, donated by a local collector. In 1992, 20 works by women were acquired through donation or purchase. In view of the fact that 291 works were acquired in total in 1992, the percentage of works by women dropped by approximately 50 per cent from the previous year to total 7 per cent. Of these, 2 or 0.7 per cent were three-dimensional works; one, a small, historical sculpture from the 1930s by Lilias Farley, and the other, *Sisyphus II* (1991) (Figure 8.6) by contemporary Canadian artist Jana Sterbak. During the first quarter of 1993, 15 of 65 works acquired, or 23 per cent were by women. None of these was three-dimensional.

In 1994, the Women's Committee of the Board of Directors of the Vancouver Art Gallery requested and received a survey of acquisitions from 1973 to 1993 which revealed that:

1 in the past 20 years, the VAG had acquired a total of 3,561 works of art, either through purchase or by donation; of that total only 9.5 per cent were by women artists;
2 not only was almost no work acquired by international women artists but more work was acquired by both European and US male artists than by Canadian women artists; and
3 of the 9.5 per cent of women's works collected between 1973 and 1993, approximately one-third (30 per cent) were three-dimensional works.

Figure 8.3 Gathie Falk, *30 Grapefruit*, 1970, earthenware, glaze, 30 × 49.9 × 49.4 cm (H × W × D).
Collection of the Vancouver Art Gallery

Figure 8.4 Joey Morgan, *Fugue*, 1984, audiotapes, photographic mural, chair, wood and wire cages containing wax, vaseline, metal house numbers, metal trays.
Collection of the Vancouver Art Gallery

THE RELATIONS BETWEEN PERFORMANCE AND INSTALLATION IN THE WORK OF EVELYN ROTH AND JANA STERBAK

This section offers a closer look at the work of two Canadian women artists working with multi-media, three-dimensional, temporary installations: Evelyn Roth's wearable sculptures from the early 1970s and Jana Sterbak's 'dress' works from the late 1980s. One of the reasons for comparing their work is to examine the relationship of performance to installation.

From the earliest days of her practice, Evelyn Roth has been concerned with the body. Trained as a dancer with Helen Goodwin at the University of British Columbia, Roth was at the forefront of fashion in the mid-1960s, designing, producing and wearing garments in the performance of her daily life, or for performances and exhibitions at Vancouver theatres and galleries. Moving away from fashion, but continuing with her investigations of the body, Roth eventually adopted the medium of videotape, discarded by the Canadian Broadcasting Corporation and recycled into works by Roth, through the technique of crocheting.[6] Roth's works for the human body, created under the name of the Evelyn Roth Moving Sculpture Company, were only available for investigation when worn, and movement was an important part of their realization (*Elastic Spots*, 1972) (Figure 8.5). This technology was also adopted for large pieces, investing everyday objects with a sense of monumentality and mystery, such as her *Crocheted Car Cozy* (1972). The parodic humour of these works is the form of their feminism. As Janet Wolff pointed out, such works represented

Figure 8.5 Evelyn Roth, *Elastic Spots*, 1972, stretch jersey fabric (size is indeterminable as this is worn as a moving sculpture by two dancers).
Collection of the Artist

an ironic programme in relation to social edifices and symbols of patriarchy,[7] and also in relation to materials such as yarn, and techniques such as crocheting, which were considered to be quintessentially 'women's work' when used in a domestic environment and for functional purposes. Perhaps the most famous of these works from domestic materials was Joyce Wieland's quilted *Reason Over Passion* (1968), created for Pierre Elliott Trudeau, then Prime Minister of Canada, from his favourite maxim and personal philosophy.

In one way, Roth's work participated in the feminist art practices current in North America at the time, centring on the body of woman. However, at the moment when her investigations were taking place, and within the context I am trying to clarify, this work avoided the pitfalls of what, in hindsight, we today might call 'essentialism'. The fact that Roth used her own body as the centrepiece of her performance work, at a time when the body of woman was generally being objectified and used by male artists such as Yves Klein and Nam June Paik, was a significant intervention into current practice in its day. It was an affirmative and empowering act.

In contrast, the recent 'dress' works by Jana Sterbak almost too perfectly illustrate the metaphor of the anorexic body – present through absence and therefore mourned. Writing in *Artforum* in 1992, Nancy Spector commented on Sterbak's most notorious work, *Vanitas: Flesh Dress for an Albino Anorectic* (1987). This work, she wrote, is

> a grotesque perversion of a fashionable ensemble sewn together from 60 pounds of raw flank steak. Glistening red and richly marbled with white veins of fat, the meat dress gruesomely approximates a flayed body, a being turned inside out, while alluding with the blackest of humor to that old cliché 'beauty is only skin-deep.' To emphasize the rather depraved affinity between this visceral, stylishly cut dress and the world of haute couture, Sterbak in fact photographed a woman modeling the slimy outfit.[8]
>
> While on display, the piece slowly desiccates, its sinewy substance shrinking into a hardened leathery material, a blackened carcasslike shroud. As clothing may be considered a surrogate for the corporeal in Sterbak's art, this over-mature garment brings to mind the inexorable aging of the body and our society's eschewal of the elderly, particularly the older woman – the denial of her sexual desirability, even visibility.[9]

Spector spent considerable ink speculating on Sterbak's title for the work. She said: 'bodily repression can initiate a false sense of omnipotence; command over physical desires is often confused with power in and of itself, providing a sense of control in a world where many people, especially women, have little real agency.'[10]

> The anorexic female body, as victim of self-induced starvation and intense self-discipline personifies this desperate attempt at control of a personal world rife with paradox. And Sterbak's meat dress, which literally shrinks, seeming almost to subsume itself, serves as a visual analogue to the anorexic's misguided attempts to use mind against body in response to her inability – or refusal – to satisfy our culture's demands of its women for self-restraint, acquiescence, measured ambition, maternal aspirations, and bodily perfection.[11]

To my mind, this is also a good example of a type of work being produced by Canadian women artists. For many good intellectual reasons, women artists evacuated the body from their work, primarily to avoid the historical subjugation of the female body to the male gaze. Part I (*Corpus*) of Mary Kelly's *Interim* (1984–5) exemplifies this point of view. Unfortunately, this position became extreme. As Lynda Nead stated, it became 'an assertion that within patriarchy the female body is beyond representation'.[12] Laura Mulvey, writing about *Corpus*, stated that Kelly's work achieved a balance between the repression of the body advocated during the 1970s and 'a recognition that such a reaction against the exploitation of women in images could lead to a repression of the discourse of the body and sexuality altogether'.[13] But I think that this delicate balance is only established and achieved through the presence of Kelly's accompanying texts, which are integral to the piece. If one attends to the visual imagery alone, Kelly's work has provided a strong case for the estab-

lishment of the canon against representation of the female body. Text, shadow and absence emphasize not just the repression but the loss of the female body and a crisis of subjectivity, in the Kristevian sense. Rather than transgressing the patriarchal canons surrounding the body of woman as chaotic and abject, these artists invoke it. The subject splits off from its corporeal presence. Text, not visual imagery, provides the intervention. And the artist's imagery evokes this split state.

Sterbak's works also seems to depict a phenomenon known as 'astro-travelling'. This term, used to describe the psychological state of victims of trauma, in particular victims of sexual abuse, depicts a situation in which the mind of the victim has split off in order to avoid feeling the body's real pain. Sterbak's *I Want You To Feel the Way I Do* (1985) is another poignant example of such works which recall Walter Benjamin's comments in 'The Work of Art in the Age of Mechanical Reproduction':

> Mankind, which in Homer's time was an object of contemplation for the Olympian gods, now is one for itself. Its self-alienation has reached such a degree that it can experience its own destruction as an aesthetic pleasure of the first order.[14]

These works aestheticize the politics of feminism in ways of which I think we must become conscious and wary. As Herbert Marcuse said of Goya's *Disasters of War*, they run the risk of aestheticizing the horror and thereby removing the possibility that any other action may be taken beyond the act of representing.[15]

Let me return to a comparison between the works of Roth and Sterbak and to the relations between performance and installation. Another Sterbak work, *Remote Control* (1989), was conceived within the context of a performance. A woman wears an aluminium crinoline on wheels. Inside this 'dress', she is incapable of movement, except in so far as she can rock her body to provoke it, because her feet don't touch the ground. However, a remote control device is stationed beyond her reach, and passing spectators to her plight may take up the controls and move her in any direction they choose. While a video of this performance may be played near the installed object, the 'work of art' is the crinoline itself which, when installed, includes all the component parts except the human body. Lest we think that the only reference for this state of frustration is women, in *Sisyphus II* (Figure 8.6) a man attempts to initiate movement by rocking a large inverted 'crinoline'. Again, a film of this performance accompanies the installation of the object, but the human body is only suggested through its absence.

CONCLUSIONS

My interest has been to understand why installation has become a predominant form of women's work supported by the culture industries in Canada. The most prominent form of patronage in Canada is state subsidy. As I've described earlier, this is a 'hothouse' environment, dominated by peer review, in which 'peers' are other artists and curators, most of whom have been trained within a relatively small circle of post-secondary institutions. These institutions are producing both the makers of this work and much of the 'public' for it.

My reading of these feminist works is that they evoke the absence, even the death, of the body of woman. Within the refusal of women artists to allow women's bodies to be subjected to the male gaze, a disturbing anorexia seems to have developed. The objects hold an expectation or a memory of performance – of a time when bodies were present – or they construct an environment which requires the body of the spectator in order for the work to be completed or enacted.

In her book *The Female Nude: Art, Obscenity and Sexuality*, Lynda Nead also discusses anorexia. Her thesis is that the female body has become 'a crucial site for the exercise and regulation of power', and representations of the nude, by which one always understands an unclothed female body, are

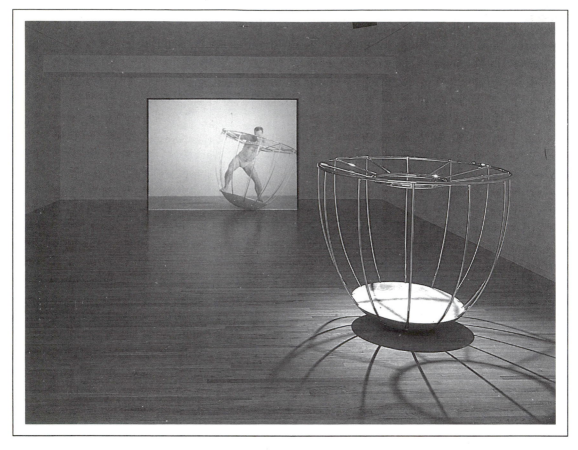

Figure 8.6 Jana Sterbak, *Sisyphus II*, 1991, aluminium, chrome, steel, mirror, paint, 16 mm projector and film loop.
Collection of the Vancouver Art Gallery

'a symbol of containment' for the regulation of female sexuality. For Nead, the nude in art is a 'frame' within which we may read the limitations imposed on women in society. Anything which falls outside the frame is considered chaotic and the anorexic's frame of mind is one in which 'woman acts both as judge and executioner'. In other words, the struggle to control the margins of the female body is conducted by the anorexic, herself, through self-regulation.

In Canada today, installation works are the predominant three-dimensional form of women's work supported by the institutions of art. It has been disturbing to investigate this phenomenon and to conclude that it may stand for a form of anorexic self-regulation. Even more disturbing is a further question: Is the representation of the disappearing, anorexic body a symptom of internalized mental regulation, learned by women as a result of their socio-political conditioning, or is it a representation of female desire, a representation of self-regulation, deprivation and disappearance as pleasure?

In conclusion, I must stress that this is not a call for a return to figuration. Rather, these comments speak to the ongoing dilemma of female representation, to the need for scrutinizing where installation, as a form, has brought us and to the loss of figuration in three-dimensional work by women. It seems an unfortunate paradox that we may have succeeded in shifting the paradigms of female representation by eliminating corporeality.

Notes

1 This chapter was originally written in response to a number of questions posed by Claudine Mitchell of the Department of Fine Art, University of Leeds, as part of an invitation to participate in a symposium on Women and Sculpture at the British Art Historians' Conference in 1992. A subsequent version was presented for the MA Programme in Feminist Studies at the Department of Fine Art, University of Leeds in November 1993.

2 Mastai was Head of Public Programmes at the Vancouver Art Gallery from 1987 to 1994.

3 George Woodcock described it in this way in his book *Strange Bedfellows: The State and the Arts in Canada*, Vancouver: Douglas & McIntyre (1985): 55.

4 I am grateful to Jacqueline Menard for her investigations as research assistant for this paper.

5 Penelope Stewart, 'Who Counts and Who's Counting?' and Judith Baldwin, 'Gender Representation in Canadian Commercial Galleries', *Matriart* 4:1 (1993): 12–19.

6 Evelyn Roth, *The Evelyn Roth Recycling Book*, Vancouver, BC: Talonbooks (1975).

7 Janet Wolff, *Feminine Sentences: Essays on Women and Culture*, Berkeley/Los Angeles: University of California Press (1990): 88.

8 Nancy Spector, 'Flesh and Bones', *Artforum* (March 1992): 95.

9 Ibid., 96.

10 Ibid.

11 Ibid., 98.

12 Lynda Nead, *The Female Nude: Art, Sexuality and Obscenity*, London: Routledge (1992): 76.

13 Laura Mulvey, 'Impending Time: Mary Kelly's *Corpus*', *Visual and Other Pleasures*, London: Macmillan (1989): 154.

14 Walter Benjamin, 'The Work of Art in the Age of Mechanical Reproduction', *Illuminations*, Ed. Hannah Arendt, New York: Schocken Books (1969): 242.

15 Herbert Marcuse, 'Art as a Form of Reality', *New Left Review* (1974).

PART IV

Artist's Pages

Beach House

Lubaina Himid

THE WORDS

Escape	Passion
Luxury	Grandiose
Self-sufficiency	Noise = quite
Creativity	Calm = activity
Gathering and Re-using	Looking to the future
Sea	Waving from the shore
Beach	Birds
Tides	Longing
Moon	Desire
Sky	Wind

THE FILMS

Julia	Fish Bar B Q
Beaches	The Boardwalk
A Star Is Born	The windows
Falling Down	The picket fence
The Garden	The garden

THE LOCATIONS

Beit el Ras	Barrow
Havana	Dieppe
Aldburgh	Malibu
Shanklin	St Ives
Brighton	Dungeness
Wells-next-the-Sea	Morecambe
Blackpool	Tourist brochure
Santa Monica	Fleetwood

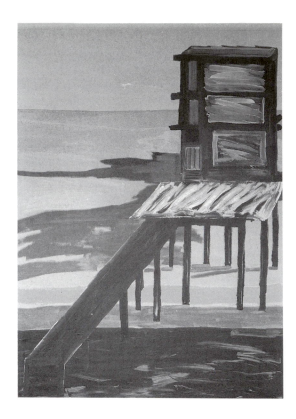

I was born on an island in the Indian Ocean and lived for the first four months of my life two hundred yards from the beach in a house at Biet el Ras in Zanzibar.

When my mother and I arrived in England on Christmas Eve, 1954, we flew into Blackpool Airport. One grandmother had waved good-bye with the sound of the warm sea around her; another welcomed me to her seaside home in the chilly north of England.

Early summers were spent making sand castles on the beach at Lytham. The sea was wet and good for basic architecture. The shapes were crisp and crunchy. The windmill stick entered the bucket shape perfectly its plastic sails pink, green, yellow and orange whizzed in the brisk air from the Irish Sea. I sat on the sand, had no desire to enter the water and often wondered how my grandmother knew when the tides came in and went out. Was she a wise old woman or did she read the evening paper? Piers – wooden magic walkways out into the waves, terrifying to look down between the boards to the swirling foam below.

The Isle of Wight, a school journey. My aunt is the teacher, I am the chubby little black baby along for the fresh air. I am spoilt and cared for, cosseted and fondled by small children who take comfort in one even smaller. There are countless delights, the ferry, stripey sand, orange juice from a can, BritVic 1957, rock pools. A visit to a lighthouse up and up and up and up, it is hot and smells of petrol? The sea below is grey-green, white and grey spotted, streaking, icy. The journey down and down and down backwards obscured any memory of delight.

Aldeburgh 1969 or '70. No sound of Peter Pears or Ben Britten just the tired and bossy shouts of yachters and their racers, spinnakers jibs painters buoys and anchors swishing back and forward to the yacht club.

On a strip of land 'twixt river and sea I sat with small children in my charge in the shadow of the dark martello tower. Teenage bemusement of ferocious male activity, much yelling, swollen

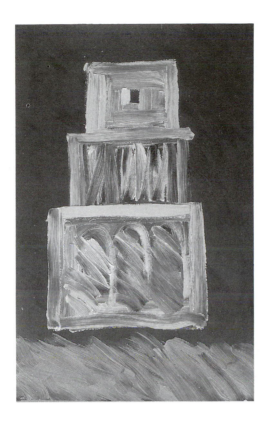

necks, bulging eyes. Tears followed, bickering in the car on the dark drunk drive back inland another race lost. Another day spent dreaming of hiding in the dark martello tower.

Secret weekend now revealed; Brighton. An endless row of beach huts pale pink, deep magenta, lilac, purple, salmon, apricot, sky, lemon, orange, banana, violet, pale green, turquoise; small and ready for flasks of tea with iced buns or white wine with chicken sandwiches. Shiny little buttons stitched neatly to the waistcoat shore. Down to pebbles and further the bubbly English Channel. I never saw inside but dream of folding tables, chequered tablecloths, a dustpan and brush and a neat pile of memories.

During World War One the painters of St Ives could not paint the sea or the coastline. Torture to have to turn their easels inwards, their backs to the world, the roar of the waves and the wind. The threat of war something to be glanced at furtively over one shoulder until the planes came.

After hours and years of looking at paintings at Kettle's Yard in Cambridge and from the letters of Francis Hodgkins recently read, I am not surprised to find that I long to sit and stare out from a stone house high above the waves and marvel at the light the warmth and the great distance from London. Quaint nostalgic small neat pretty and rather simpering St Ives until a storm rises and dashes hope and treasure onto the rocks.

At Wells-next-the-Sea in Norfolk in front of a pine wood, in which nestles the queen of England's beach house, is a huge and flat expanse of pink grey sand, it swells and floats up to the horizon. Five of us walked up and then down that beach; a famous five arguing parrying displaying conceding collaborating and isolating. All on a theme of women painting painting women. I looked out towards the sea and wished I could stay a year. The beach huts there are sturdy serious small wooden buildings on stilts with wooden steps leading up to the door and down to the sand. The owners (one day I hope to be one) sit a careful distance apart each on a platform. Some read, some stare, some draw.

Many simply gaze down at the poor mutts windswept, walking wishing for a place to stop and stare out to a far flat sister land. The paint has peeled, but worn is chic, sandpipers fish and chips funny rock shops ice cream vans and flatlands beckon. We leave. I with my photographs as talismans.

My friends lies on a table in wonderful downtown Burbank so while the magnificent surgeon removes a melon sized fibroid from her uterus I watch beach houses at Malibu burn. I transfer the terror I have for the room on the next floor to this monotonous drama unfolding on the screen. Occasionally I pray. The fire started in the hills overlooking LA and the air in the centre of the city is filled with ash. This is the second wave; the fire is spreading faster than anyone can believe. Nearer and nearer to the sea. It comes down the hills and leaps across the Pacific State Highway. It snakes in a flash to the Malibu beach houses and then into the sea. People in shorts and flip-flops are stunned; having taken to their boats to escape, they talk in bedraggled voices, staring at their magnificent shoreline jewels, black and broken. The sky stayed purple and dark, dark blue. The hills were charcoaled and blurred in the distance, smouldering. The houses on the beach were caught between fire and water and a dream of mine faltered.

The beach at Santa Monica was a tranquil place. Wooden huts painted blue on tall tall stilts, look-out posts for lifeguards, dotted the shoreline from Venice beach to the Santa Monica pier. Their colour changed with the day. At times they seemed witty and pert reminding me of 1950s American television, balsa wood and Coca-Cola. At night they looked like homes for large birds; dark and purple-covered perches for strong yellow-beak giants.

The heat in Havana is immense. In May the wet enfolds you, wraps you up and never ever leaves. Cuba a land of longing of leaving and departing. In May '94 no boats were ever seen on the horizon, no one came and no one left. The time before the raft of the Medusa. We watched the sea and the sky night after night from the rooftop restaurant of the Hotel Sevilla, the colours the deepest blues and blacks. The wildest oranges and pink speed in front of you in the hysterical fifteen

minutes between day and night. All night the sea changes colour; sometimes it is the same black as the sky and sometimes its deep purple allows you to tell where one begins and the other ends. The buildings on the Malecon are gorgeous – faded peeled cracked crumbling, once stunning yellow or pink and orange, blue, green, violet or white stone facades. The paint has nearly gone.

At Matanzas (slaughter) the nineteenth-century wooden houses, with pillars verandas and wide steps up are decorated with filigree. Elaborate Moorish Spanish African villas by the sea.

At Varaderos, Maud Sulter's favourite beach, is a house she remembers from a visit in 1984. Ten years later we visit it again. It is paradise. The ultimate house by the sea. Built by Dupont stockings/arms. Fabulous luxury, gorgeous bathrooms tiled and unique. Immaculate and comfortable bedrooms (preserved) blues and greens with a view of the waves and the sky. On the top floor is a bar to die for; a wooden panelled room with windows on three sides. The speciality is moquitos and olives. We luxuriate and dream while Cuba rumbles. Only tourists here, no Cubans are allowed to experience this house now; the dollar has seen to that. When Dupont built the house it was surrounded by sea and sand, now it is completely surrounded by hotels; the dollar has seen to that too.

The beach house stands on shifting sand constantly visited by shadows winds and waves.

There is solitude, quiet; the constant noise of the sea and the hundred of birds and small animals surround me.

Here is escape: the endless state of being, remaining on the shore, watching others leaving, waving goodbye.

The sea is a wild forest, it is filled with hunters and the hunted, looking finding killing dragging home the kill. The eaters and the eaten swim and float, drown and sink, duck and dive, shimmy

and shiver. From the house, dry and still, the moving mass is hypnotic.

On the shore the stones rock backwards onto shells. Sand oozes out of pools, birds hover run peck pick scurry wheel and swirl.

Three stripes: shore, sea, sky.

A shape which crosses all three: The Beach House. Outside wet windblown and salty. Inside warmer sandy and cluttered with objects brought from the real house and the real world.

At night blackness and then blacker blackness. Concentrate and you will see blue and purple deep green, deep and distant. Waves come in and in, go out come in and in go out in and in and in endlessly rolling foaming curling and whirling fat and foamy trickly splashy creamy. The building building wall of water ever coming nearer and nearer then comes collapses and disperses until the next inevitable wave builds and falls moving relentlessly towards the shore only to retreat and return again and again.

The furniture inside outside and on the threshold, even several yards from the house itself; the shore is a garden, the sea the dangerous world beyond. Design is mixed and materials various. Wood canvas metal plastic worn weathered second-hand, familiar. Stripes flowers spots, mixed unmatched with gathered-together casual informality.

In Dieppe we understand the English. The weather could be English, we look towards England. The colours grey white pinkish pale and beige. The food and the light are, however, French, we are grateful. How comforting it must have been to paint the familiar Channel in a new light with a good meal to end the day.

Une petite maison. Le Corbusier. The height of the house is two-and-a-half metres (the regulation minimum) it resembles a long box lying on the ground. The rising sun is caught at one end by slanting skylight and for the rest of the day it passes on its circuit in front of the house. Sun space and greenness – what more could be wanted?

We are on ground that has been embanked for a hundred years. This does not prevent the lake water, the level of which rises and falls eighty centimetres every year, from penetrating behind the supporting wall. This entails certain consequences of which we at first knew nothing. 'Four metres away from the lake!' said people; 'You are crazy! You will have rheumatism and the glare from the lake will be intolerable.' 'People' don't observe or think when a kettle boils over, where is the steam? Above the kettle, but not beside it. Rheumatism from damp (and rheumatism in general) attacks those living on the hills at an altitude of fifty to a hundred metres. The damp is above the kettle! And the glare from the lake? The sun passes in front of us from east to west and reaches its zenith only at the summer solstice. The angle of incidence will never pass through the little house. It reaches – and dazzles – those living on the hills at an altitude of fifty to a hundred metres. 'People' know nothing of the angle of incidence.

The beach house is a site of conflict. Invasion and departure. Lost hope, abandoned lives, decimated civilizations.

The slaves waited on land, in barracoons belonging to the various companies or merchants, existing on bread and water, the men chained, the women and children running loose. Some captains preferred to build a makeshift house of the upper deck – in these houses, constructed between the masts, their roofs thatched with mangrove branches and reeds, their walls made from woven bamboo shoots, were penned terrified Africans, many of whom had never seen the sea.

The beach house as a place of refuge. No telephone, just paint canvas a dog or two, some wine and sandwiches, a small radio for snatches of other people's music.

It is on the edge of time, a woman's place of contemplation. A place for passion and love where longing gradually transforms the day and desire turns slowly into night.

PART V

The maternal

Maternal figures:

the maternal nude in the work of Käthe Kollwitz and Paula Modersohn Becker [1]

Rosemary Betterton

Paula Modersohn-Becker's *Reclining Mother and Child*, 1906 (Figure 9.1), and Käthe Kollwitz' *Woman with Dead Child*, 1903 (Figure 9.2), are striking in their representation of motherhood. They depict the maternal state as one of physical absorption and psychic possession in a way which disturbs our preconceptions. Nearly a century after they were produced, the images still have the power to disconcert us by the directness of their vision. Both images stand outside the western cul-

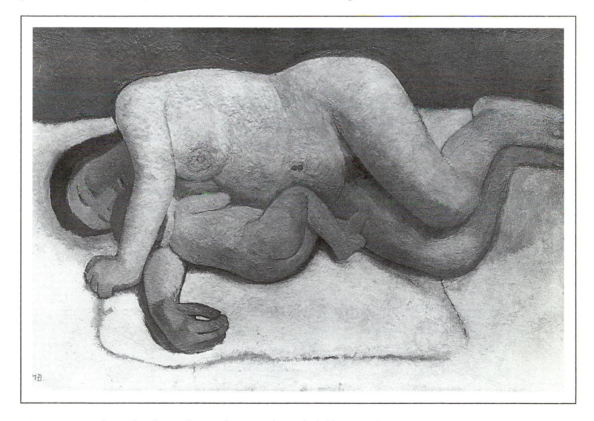

Figure 9.1 Paula Modersohn-Becker, *Reclining Mother and Child*, 1906, oil on canvas, 124.7 × 82 cm. Ludwig-Roselius Sammlung, Bremen

tural tradition of spiritual and dematerialized motherhood symbolized by the immaculate conception and virgin birth.[2] The two female figures remind us, in the solidity of their flesh and the strength of their enfolding arms, that it is through the body of the mother that the unique and irreplaceable intensity of birth is experienced. And yet the two images are very different: while Modersohn-Becker represents the blissful intimacy of the maternal relationship, Kollwitz shows us the unspeakable pain of maternal loss.

Unusually, both artists have chosen to combine two separate genres of visual representation, the figure of the mother and the figure of the nude. In so doing, Modersohn-Becker and Kollwitz have brought together two poles of femininity which are traditionally held apart, the representation of the female body as erotic and sexually available and as reproductive and private.[3]

In this chapter I want to explore the links between these two works and their location within contemporary discursive constructions of motherhood. I will suggest that the previously unremarked configuration of the 'maternal nude' in their work is a central metaphor through which Kollwitz and Modersohn-Becker were able to explore the contradictions for women between maternal and artistic identity.

Three types of material are used to frame the arguments here: biographical sources, drawing primarily on the artists' own published letters and journals; debates about the role of women and the status of motherhood in Germany before 1914; and psychoanalytic accounts of the formation of maternal subjectivity. The extent to which these materials can offer critical insights into reading the images themselves is one of the questions which this chapter seeks to address.

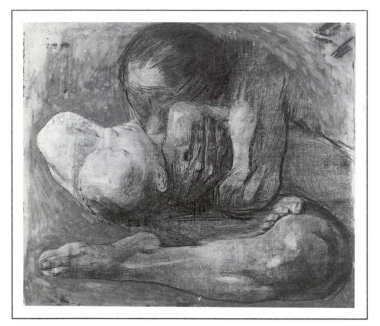

Figure 9.2 Käthe Kollwitz, *Woman with Dead Child*, 1903, etching with engraving overprinted with a gold tone plate, 47.6 × 41.9 cm.
British Museum Department of Prints and Drawings, London

REPRESENTATIONS OF MOTHERHOOD

The two artists, Käthe Kollwitz (b. 1867) and Paula Modersohn-Becker (b. 1876) had much in common. They were born within a decade of each other in the northern German cities of Königsberg and Dresden respectively, in the former state of Prussia. Both were brought up within liberal bourgeois families and received their training at women's art schools in Berlin and Munich, each achieving some measure of professional independence by the turn of the century. They moved in similar progressive circles, for example, both knew the brothers Hauptmann – Gerhart, whose radical play *The Weavers* was the basis for Kollwitz' first graphic cycle, and Carl, playwright and novelist, in whose house Paula Modersohn-Becker spent her honeymoon in 1901. There is, however, no evidence that they ever met or knew of each other's work.[4] In spite of these similarities, in feminist literature they have been more often described in terms of their differences from each other.[5] In this comparison, Modersohn-Becker is seen to embody the individualist figure of the

avant-garde artist, while Kollwitz represents the very model of proletarian, feminist activism. This is nowhere more evident than in discussion of their representations of motherhood.

This view was stated most succinctly by Linda Nochlin in her original analysis of the iconography of motherhood in the two artists' work. Arguing that Modersohn-Becker's images of motherhood derive from a nineteenth-century pictorial tradition in which the peasant mother becomes the 'very embodiment of fatalistic conservatism', Nochlin compared these with the political activism of Kollwitz' revolutionary heroine, Black Anna, in *The Peasant's Revolt* of 1902–8 (Sutherland Harris and Nochlin 1976: 67). Nochlin thus interpreted Kollwitz' representations of motherhood, in contrast to those of Modersohn-Becker, as social documents connected to specific feminist and socialist perspectives.

It has therefore been her public persona as an artist of strong political sympathies which has, until recently, been the primary focus of Kollwitz' interest for feminist critics. Through the lens of social criticism, her depictions of women as heroic mothers and resisting workers have received most serious critical attention. This construction of Kollwitz as first and foremost a political artist places emphasis on a crucial aspect of her work and beliefs, but at the expense of exploring some of the contradictions and ambivalences towards art and politics revealed in her journal and letters. In a recent reappraisal of Kollwitz' work, Elizabeth Prelinger has argued that a more considered approach to Kollwitz' artistic and political beliefs is needed, and has suggested that she lacked a 'clearly defined approach to political matters' (Prelinger 1992: 78). Prelinger also pays welcome attention to the study of the female nude in Kollwitz' work, an area hitherto neglected in feminist criticism. The nude makes up a significant proportion of Kollwitz' figure studies before 1920, particularly during the period when she was employed as a teacher at the Berlin School for Women Artists. And, although the nude does not constitute a central subject in Kollwitz' later work, when it appears it is frequently linked to the figure of the mother. Rather than representing a political ideology which can be simply read off the image, Kollwitz' 'maternal nudes', like much else of her work, suggest a complex and contradictory process of negotiation between the different meanings attached to motherhood.

The image of the mother, often breastfeeding her child, appears throughout Paula Modersohn-Becker's mature work, from her entry into the artistic colony of Worpswede in 1897 until her premature death, three weeks after the birth of her own daughter, in 1907. While her early studies of peasant mothers were influenced initially by the genre style of Fritz Mackensen, her teacher at Worpswede, she developed an independent approach culminating in the large naked mother figures of her late works. In her monograph on Modersohn-Becker, Gillian Perry suggested that 'These anonymous monumental mothers are themselves symbols of a mysterious life-giving process. In their detachment they seem to reflect some of Paula's own ambiguous attitude to motherhood' (Perry 1979: 59).

Modersohn-Becker's images have often been interpreted with reference to contemporary ideologies of primitivism.[6] In a number of self portraits, for example, her *Self Portrait with an Amber Necklace*, 1906, Modersohn-Becker did indeed represent her sexual identity in metaphors of nature, making visual connections between her own body and flowers and foliage, the symbols of fertility which surround her. While such paintings may reinforce a traditional encoding of the female body with nature, Modersohn-Becker was employing one of the few sets of terms available to a woman of her class at a time when the representation of female sexuality was problematic for a bourgeois woman artist. What we may see in her work is less an instinctive response to nature than a strategy with which to address the *absence* of a visual language of the body available to women artists in the 1900s.

But the contrast that is drawn between the two artists in terms of their respective iconography of motherhood also does not address adequately the complex political coding of maternal discourses in

Germany at the turn of the century. Moreover, it disguises the real conflict which *both* artists faced in addressing the representation of motherhood within the context of prevailing cultural attitudes to femininity and to art. For Modersohn-Becker, as indeed for Kollwitz, ambivalence in the representation of motherhood could not simply be a personal matter. It was the product of a profound cultural rupture between the role of the artist and the role of the mother. This conflict can be seen to operate through a number of parallel and related dualities in both artists' work: between the self portrait and the nude; the nude and the mother; and between visual representation and maternal origin.

THE BODY OF THE ARTIST AND THE BODY OF THE NUDE

By taking account of a specific set of configurations around gender, artistic identity and motherhood in Germany at the turn of the century it is possible to open up different readings of the maternal body in the work of Kollwitz and Modersohn-Becker. Both artists produced images which were informed by contemporary debates about women and sexuality in German political and cultural circles. By the 1900s, the 'good' mother had become the focus of widespread concern about women's function in the family and in the perpetuation of the race. For an artist who was also a woman to paint the nude and, moreover, the nude body of the mother, was to confront directly the contemporary inscription of gendered difference on the body.

Study of the nude was of crucial interest to women artists in the early modernist period because it was the point of intersection for contemporary discourses on gender and art. Mastery of the female nude was central to the construction of artistic identity in the nineteenth century and the site of a specifically gendered relationship between the male artist and female model. Its elements had come to represent a fundamental metaphor for creativity in modern European art: the artist as master of the gaze and of the natural world, signified through the naked body of a woman.[7]

By the 1900s, the relationship between the male painter and the female model was firmly entrenched as a central image by which to define artistic identity in both popular myth and painterly imagination. In a work by the German painter, Lovis Corinth, *Self Portrait with Model*, the artist placed himself high in the canvas, facing squarely out of the frame, his gaze and his body commanding the pictorial space. He looks over the head of the model, whose back is turned towards us, her face hidden against his shoulder and one hand laid on his breast. His arms frame her body but, rather than returning her embrace, he holds a brush in his left hand, a palette and brushes erect in his right. Corinth's bravura signature and the date and place of execution, 1903 Berlin, appear to either side of the artist's head, as though confirming his ownership of the image *and* its occupants.

The model here is his wife, Charlotte Berend. In painting himself with his wife, Corinth referred to a type of artist's self portrait established by Rubens in the seventeenth century. But the painting also recalls more recent precedents in nineteenth-century images of the ideal bourgeois couple, where the wife is shown as support and helpmeet to her husband, the man looking outwards to the world, the woman turning to him for her protection.[8] Corinth thus proclaimed his own status as a successful artist in command of the language and traditions of art. In so doing, he legitimated his position culturally through accepted norms, constructing an image which conflated two kinds of gender relationship, that of male artist and female nude, and of husband and wife. The portrait can thus be seen to authorize an expected, and gendered, reading. At one and the same time, *Self Portrait with Model* affirms the prescribed relationship between husband and wife, and effaces Charlotte Berend's professional identity as an artist practising in her own right.[9]

In the face of such phallic mastery, how was it possible for a woman artist to assert her own identity *and* to engage with such a deeply gendered terrain as the nude?[10] Those images which combine self portraiture with the nude articulate the problem in representing this psychic split between feminine and artistic subjectivity.

A self-portrait, like the act of writing a journal or a letter, constructs the self as other, making available to others a particular representation of the subject which the author has selected. The autobiographical is thus not an unmediated expression of inner being, but the production of a fictive self which functions as a form of self 're-presentation'. For a male artist like Lovis Corinth, this process could legitimate an existing and accepted public identity, but for a woman it was far more problematic, involving a conflict between the 'public' and 'private' self.[11] It is in this light that we may understand the significance of the repeated self portraits which Modersohn-Becker and Kollwitz produced throughout their lives in terms of a need to produce the self both as artist *and* as woman.

In an early work by Käthe Kollwitz, *Self Portrait and Nude Studies*, 1900 (Figure 9.3), the juxtaposition of the artist's head and the nude body is striking. This preparatory study was one of a series for an etching, *Life*, in which Kollwitz superimposed her portrait head on a group of standing nudes which appeared on the left-hand side of a symbolic triptych. In this drawing, the artist's vertical profile is marked off from the reclining nude torso by an area of intense shaded black which throws the face into harshly lit relief. In contrast, the female body is drawn frontally, the strongest accent of shadow, marked by a brown brushstroke, directing attention between the legs, a focus which appears to correspond to the artist's line of sight. The fragmenting and severing of the female sexual body in a way which both emphasizes the genitals and their exposure to the viewer, is more familiar today in relation to the pornographic gaze. It is with a sense of shock that we see it here. The image seems to suggest something of the sexual objectification implicit in the artist's control-

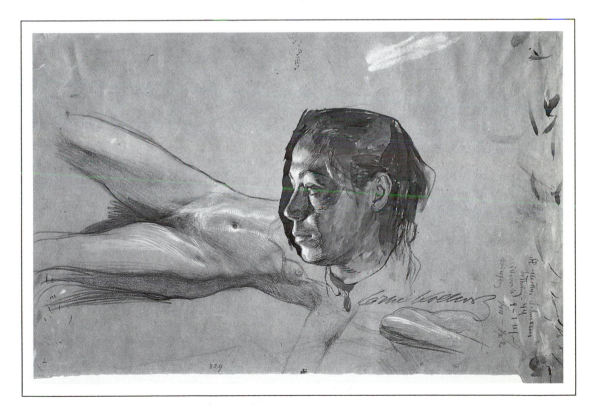

Figure 9.3 Käthe Kollwitz, *Self Portrait and Nude Studies*, 1900, graphite, pen and black ink. 280 × 445 cm. Graphische Sammlung, Staatsgalerie, Stuttgart

ling look but, by placing her own profile head in place of where the missing head of the nude would be, Kollwitz reveals that she too is the object of the gaze, she is looked at as well as looking.

At the time when Modersohn-Becker, Kollwitz and Corinth were producing their self portraits in the 1900s, questions of gender and creativity and women's dual role as biological and as intellectual producers were being fiercely debated in Germany. The identities of 'woman' and 'artist' were considered by many to be mutually exclusive. These issues had become a matter of public debate as a result of the emergent feminist movement in Germany in the last decade of the nineteenth century, a debate which centred on motherhood as a primary concern. Given the conservative bias of the official art world in Berlin, it is not surprising to find the art historian, Karl Scheffler, arguing in *Die Frau und die Kunst*, 1908, that women lacked the will and the talent to become creative artists, being better suited by nature to the performing arts.[12] But anti-feminists and feminists alike showed a surprising consensus in their attitudes towards women as creative artists. For example, the Swedish writer Ellen Key, whose ideas on motherhood became influential on the German women's movement in the 1890s, also believed that women's talent was for 'receptive' rather than 'creative' genius and that, lacking true originality, they were more suited to acting and singing. Even a radical feminist like Lily Braun could argue in *Die Frauenfrage*, 1901, that women were more capable in interpretative roles than in the creative arts.[13]

Such views simultaneously reinforced woman's traditionally exhibitionist role and prohibited her from entry into the sphere of cultural production on equal terms with men. Margaret Whitford has suggested that 'In the traditional repartition of roles, women *represent* the body for men. The resulting split between intelligible and sensible then becomes difficult to shift, because it appears to be the basis of all thought' (Whitford 1991: 62).

The normative pairing of male artist and female model reproduces that fundamental gendered division between the 'intelligible and sensible', mind and body, in western thought. In this division of roles, the artist may look at, but not inhabit, the body of the woman. And, as Jane Gallop has argued, 'if we think physically rather than metaphysically, of the mind-body split *through the body*, it becomes an image of shocking violence' (Gallop 1988: 1).[14]

Kollwitz' image suggests something of the violence that this split subjectivity might engender for the woman artist. Her inability to resolve the separation between the self portrait head and the nude body reveals the division between the artist who has the right to look and the female body as object of the gaze. In this violent splitting of head from body, she places herself at one and the same time in the masculine and feminine position, at once subject and object, a division which it was impossible to resolve within the terms of contemporary discussion of women and art.[15]

In feminist writing on science, the concept of detachment or objectivity has been connected to a specifically masculine subjectivity, to the desire for a separation between an observer and the thing known, the subject and object of knowledge. This has been linked further to the denial of maternal origin and the fantasy of self-generation, of being father or mother to oneself.[16] The fantasy of a self freed from connection to the mother is necessary, according to psychoanalytic accounts, for socialization into the symbolic order and the correct assumption of sexual difference. This psychic splitting between subject and object may suggest another level on which the dislocating effect of Kollwitz' *Self Portrait and Nude Studies* can be explained. Unlike the male artist, Kollwitz cannot simply occupy the position of detached observer, since to do so would be to negate her own body. Through the act of representing the female body as object, the male artist is able to re-enact an Oedipal separation of the child from its mother. But for a woman artist to paint the female body is to confront questions of likeness as well as difference, of proximity to, as well as distance from the maternal body. The body of the artist and the body of the nude: what is at stake here is the separation of the two. If the body of the artist was permitted to women, it was only in so far as their own bodies, and specifically their bodies *as* mothers were denied.

THE BODY OF THE MOTHER

Combining commitment to their work as serious professionals with responsibilities for children was a source of tension and anxiety for many women artists of the period. A reading of Modersohn-Becker's and Kollwitz' letters and journals reveals a continual process of negotiation between their professional commitment to work and personal expectations of marriage and motherhood. The struggle to define their artistic identities against the claims of family, friends and social convention was hard won. Käthe Kollwitz' sister students at the Munich School of Women's Art in the 1880s had believed that marriage and an artistic career were incompatible, demanding celibacy as the ideal state for a woman artist. She herself later recorded the tensions between motherhood and work in her diaries, emotionally committed to her two sons but resentful of the time taken up when she was unable to work.

For Paula Becker, marriage to Otto Modersohn in 1901 had offered the opportunity of continuing to work in the relative freedom of the artistic colony of Worpswede, the support and encouragement of an older, more established artist, and a degree of economic security and independence from her own family. But she began to feel constricted by the narrow artistic outlook of Worpswede and the expectations of a shared married life, which included taking on responsibility for Modersohn's daughter from a previous marriage. She sought escape in Paris, where she worked during 1903 and 1905, finally returning to Paris in 1906 after breaking with Otto Modersohn.

The years 1901/2 had marked a turning point in her work and, in a number of letters and journal entries written at the end of 1901 and in the following year, she linked her experiences of her marriage with statements on the development of her work. Significantly, she used imagery of birth and fertility to describe the progress of her painting: 'There have been three young wives in Worpswede for some time now. And the babies are due around Christmas. I'm still not ready. I must wait awhile so that I will bear magnificent fruit' (22. 10. 1901) and:

> There are times when this feeling of devotion and dependence lies dormant Then all at once this feeling awakes and surges and roars, as if the container would nearly burst. There's no room for anything else. My Mother. Dawn is within me and I feel the approaching day. I am becoming something. (6. 7. 1902)
>
> (Modersohn-Becker 1980: 201–11)

Becker's growing self-confidence in her abilities as a painter recurs as a theme in her letters and journal entries of these years. But the intellectual atmosphere in which she was working in the 1900s made it especially difficult to resolve the conflict between her identity as a woman and as an artist. The reiteration of her desire and will to paint must be read against the failure to recognize her independent status as a painter on the part of her fellow artists at Worpswede and of her family.[17] She appeared to need to represent herself as an artist, both to herself and to others, in her private writings and in a series of self portraits from these years.

In letters written home and diary entries during her fourth and final visit to Paris in 1906, Modersohn-Becker makes a number of references to her own sexuality and potential pregnancy. Her comments suggest an ambivalence in which the attraction of and desire for motherhood is mixed with an increasing sense of the failure of her own marriage. Having left Otto Modersohn behind in Worpswede, she felt herself to be standing between her old life and new identity as an independent artist. In a letter to her mother dated 8 May 1906 she wrote: ' Now I am beginning a new life. Don't interfere, just let me be. It's so very beautiful. This last week I've been living as if in ecstasy. I feel I've accomplished something good' (Modersohn-Becker 1980: 286).

It was in May 1906 that she painted *Self Portrait on Her Sixth Wedding Day*, in which she depicted herself pregnant, naked from the hips up, her arms gently encircling her swollen belly (Figure 9.4). Unusually, Becker signed and inscribed the canvas: 'I painted this at the age of thirty on my sixth wed-

ding day. P.B.', the date marking the fifth anniversary of her marriage on 25 May 1901. She thus deliberately chose to represent herself as pregnant at the precise moment in her life when she had decisively rejected the identity of wife and mother. This *Self Portrait* is often referred to as anticipating her actual pregnancy by some mysterious and intuitive process, an interpretation which confirms the prevalent critical view of Modersohn-Becker as a 'primitive' artist. Her premature death as a consequence of childbirth in the following year after she had returned, under pressure, to her marriage, has overdetermined this view of her work.[18]

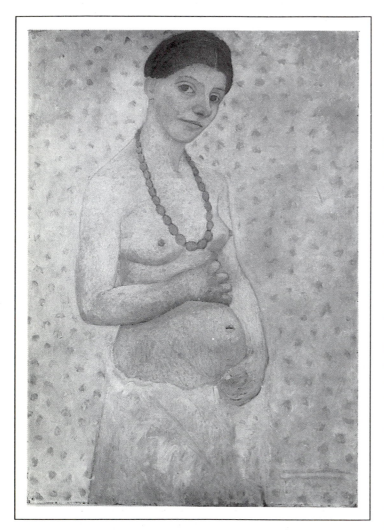

Figure 9.4 Paula Modersohn-Becker, *Self Portrait on Her Sixth Wedding Day*, 1906, oil on board, 101.5 × 70.2 cm.
Ludwig-Roselius Sammlung, Bremen

A different reading of *Self Portrait on Her Sixth Wedding Day* would suggest that, here at least, Becker is not representing motherhood as a natural state but as a metaphor, not least in the unusual combination of pregnancy with a nude self portrait. Becker confronts her own image as pregnant Other – that which she both desires and has refused – in order to maintain her separate identity as 'artist'. According to Lacan's account of the acquisition of sexed identity, the mirror image reflects the self as coherent, but this image of coherence is a fantasy, a necessary construct through which the human subject is able to enter into possession of language and make sense of the social world. In Becker's *Self Portrait*, the image of motherhood is just such a fantasy, a temporary moment of coherence, and this may explain how the painting can hold together disparate elements with such apparent ease. It is at one and the same time an individual portrait and an emblematic pregnant body, a private reference to her marriage and the public statement of a nude. These subjective contradictions are suggested in the formal contrast between the strong modelling of her head and right hand and the paler tonalities of the body and the left arm which cradles her belly. These latter are painted so that the form of the body merges into the grey patterned wall behind, suggesting an insubstantiality of the flesh itself.[19]

In her essay 'Stabat Mater', Julia Kristeva explores the implications of the cult of the Virgin Mary for the construction of femininity and motherhood. Within a psychoanalytic framework deriving from Lacan, Kristeva addresses the question of maternal subjectivity, examining the relationship

between the patriarchal ideal and the lived, non-symbolic aspects of giving birth. She defines the maternal as:

> the ambivalent principle that is bound to the species on the one hand, and on the other stems from an identity catastrophe that causes the Name to topple over into the unnameable that one imagines as femininity, non-language or body.
>
> (Kristeva 1986: 163)

Kristeva's definition of the maternal as 'bound to the species' recalls debates in Germany at the turn of the century in which the concept of motherhood was closely linked to eugenics. That it also represents a crisis of identity, in which the 'unnameable' feminine body is made present, suggests something of the conflicts underlying the repeated image of the body of the naked mother in Paula Modersohn-Becker's work. For, according to Kristeva's analysis of the maternal, it entails a separation and loss of self:

> So, to imagine a *mother* as the subject of gestation . . . is simultaneously to admit the risk of a loss of identity and to disavow it. It is to acknowledge that we are shaken by biology, by the unsymbolized drives and that this escapes social exchange, escapes representation of the given object, escapes the contract of desire. [20]
>
> (Kristeva 1981: 158–9)

By imagining herself as pregnant, Becker is able to give a symbolic form to the maternal state of lost identity and, simultaneously, to 'disavow' it. It is significant that she chose the visual prototype of the sacred womb, the *Madonna del Parto*, in which the Virgin Mary is represented in pregnancy.[21] For in such images, the Madonna's body becomes symbol of the 'virginal maternal', the impossible duality of inviolable and fertile body which is at the heart of the Christian ideal of womanhood. In representations of the Virgin Mother, the female body appears as a sealed vessel. As Lynda Nead has argued, one of the principal functions of the female nude in western art has also been the containment and regulation of the female sexual body:

> The forms, conventions, and poses of art have worked metaphorically to shore up the female body – to seal orifices and to prevent marginal matter from transgressing the boundary dividing the inside of the body and the outside, the self from the space of the other.
>
> (Nead 1992: 6)

But if, as Nead suggests, the function of the nude is to make 'safe' the permeable borderline between nature and culture, the maternal body potentially disrupts that boundary. For the maternal body points to the impossibility of closure, to a liminal state where the boundaries of the body are fluid. In the act of giving birth, as well as during pregnancy and breastfeeding, the body of the mother is the subject of a constant exchange with that of the child. Whereas the nude is seamless, the pregnant body signifies the state in which the boundaries of inside and outside, self and other, dissolve. In Kristeva's words, the maternal body is 'a thoroughfare, a threshold where "nature" confronts "culture"' (Kristeva 1980: 238).

In this respect, the figuration of the maternal nude is a contradiction in terms, a profound rupture in representation. But, as Kristeva argues, in the Christian image of the Madonna, the potential threat of the maternal body is contained within the imaginary construct of the virgin birth, the body inviolate. Such an inaccessible ideal of femininity cannot be achieved except by the sacrifice of sexuality or by, 'if she is married, one who leads a life that would remove from the 'earthly' condition and dedicate her to the highest sublimation alien to her body. A bonus, however: the promised *jouissance*' (Kristeva 1986: 182).

Paula Becker had removed herself from the 'earthly' condition of her marriage, to which she referred in the inscription on the self portrait. The *jouissance* which she chose at this moment over biological motherhood was the 'ecstasy' of creativity to which she referred in her letter of 8 May. Her desire for a child could be sublimated through symbolic representation. The 'immaculate con-

ception' of the *Self Portrait* was achieved in the production of the maternal body as representation, without the loss of identity which Kristeva argues is entailed in actual motherhood. The redoubling of the image of containment signified in the figuration of the nude and the virgin mother is also suggested by the self-possession of the figure herself. The inviolability of the pregnant body, protected gently by her enfolding arms, is held at a distance from the spectator by the artist's direct yet inscrutable gaze. It indicates a condition of temporary suspension between subject and object, between the virginal and maternal, and between the identity of artist as the maker of images and mother as the maker of flesh.

MATERNAL DISCOURSES

Both Modersohn-Becker and Kollwitz were producing their images in the context of fierce debates about the role of women, sexuality and motherhood then current in German political and cultural circles. The terms of these debates are particularly revealing for a reading of the representation of the maternal nude by both artists. In a period when attitudes to women's roles and to female sexuality were being reassessed, the debate about motherhood came to be a central strand of reformist as well as of reactionary politics. The difficulty of disentangling progressive from conservative thinking on the subject indicates something of the ideological and personal tensions women artists experienced between the desire for autonomy and the desire for children. This was reinforced by a prevailing biological determinism in scientific and popular discourses which was often shared by those who supported women's rights to social and sexual equality.

In Germany, as in Britain and France between 1890 and 1914, considerable political and social anxieties were being voiced about the decline in both numbers and 'quality' of the population, concerns which focused especially on the role and responsibilities of mothers as nurturers, homemakers and educators of the race.[22] While the rising concern about motherhood was expressly linked to the eugenic demands of the Wilhelmine state for improvement in the Imperial race, similar views were also voiced by feminists and socialists at the turn of the century. Social Darwinism and scientific socialism, anthropology and religion, were all contributory elements within a discourse which placed motherhood at the centre of social and sexual reform. As Felicia Gordon has pointed out, in debates on reproductive rights, positions 'operated in sometimes surprising relation to one another producing intriguing alliances and conflicts within left/right, feminist/anti-feminist, imperialist/anti-imperialist, pronatalist/neo-Malthusian groupings' (Gordon 1992: 388).

Becker's and Kollwitz' different representations of motherhood have often been linked respectively to the theories of two influential nineteenth-century male writers, Johannes J. Bachofen and August Bebel. In *Myth, Religion and Mother Right* (1861), Bachofen had argued that the most primitive stage of human development was represented by a matriarchal society which had the relationship between mother and child at its heart:

> The relationship which stands at the origin of all culture, of every virtue, of every nobler aspect of existence, is that between mother and child . . . Woman at this stage is the repository of all culture, of all benevolence, of all devotion, of all concern for the living and grief for the dead.
>
> (Bachofen 1967: 79)

Bachofen's theories of evolution, in which a universal matriarchal stage was superseded by an intellectually and technologically superior patriarchal society, were based on a reading of myth and symbol. Although his methods were largely discredited by empirical anthropology by 1900, his model of matriarchal culture continued to exert an influence into the twentieth century.[23] His ideas were certainly known in the Worpswede circle; for example, Rainer Maria Rilke read his work, and his theories held an appeal to the poetic imagination long after he ceased to affect scientific thought.

The view that motherhood was an essential female function also connected a socialist thinker like August Bebel with the earlier anthropological theories of Bachofen. For example, three chapters of Bebel's influential book *Women under Socialism* (1879) were devoted to questions of marriage, population and eugenics. His book, which was discussed by Käthe Kollwitz, her brother and friends in the early 1880s, presented powerful arguments on behalf of women's political and legal equality. Arguing against women's restriction to the domestic sphere, Bebel nevertheless maintained that motherhood was woman's 'natural' role, although this should not be used to exclude women from economic and political rights. Rather than opposing Bachofen, then, Bebel's ideas were influenced in crucial respects by prevailing maternal ideology, and both writers were influential in German progressive circles by the turn of the century. What otherwise very different political and theoretical positions held in common was the view that woman's role in modern society was still bound up with her *biological* function as mother.

While the writings of both men were clearly significant, a close connection can also be traced between Modersohn-Becker's and Kollwitz' maternal imagery and debates in contemporary German feminist circles, where pronatalism had a more profound effect on the women's movement than in Britain or the United States.[24] It is the emphasis on motherhood as essential to *all* women which also provided the ground for contemporary debates amongst German feminists. One of the most influential figures in this respect was the Swedish writer Ellen Key, whose ideas had considerable impact in Germany after the publication of her essay 'Missbrauchte Frauenkraft' (Women's Misused Energy) there in 1898. Opposing the emphasis on equal rights within bourgeois feminism, Key argued that women's entry into male professions was a misuse of their energies, which would be better spent on their innate talent for mothering, which she saw as women's 'highest cultural task'. Women, she argued, could not both achieve in the public sphere and successfully continue to mother. By competing with men they would lose their primary role and thus endanger the species. Key's writings emphasized a positive evaluation of sexual difference in which women's role as mothers should be highly valued and freed from economic dependence and domestic drudgery through social and legal reforms. She also, controversially for the time, supported the right of every woman to choose to bear children whether married or not, and was attacked for this stance by anti-feminists. In her later writing, Key explicitly linked sexual reform with eugenics:

> Motherliness must be cultivated by the acquisition of the principles of heredity, of race hygiene, child hygiene, child psychology. Motherliness must revolt against giving the race too few, too many, or degenerate children. Motherliness must exact all the legal rights without which woman cannot, in the fullest sense of the word, be either child-mother or social-mother.[25]
>
> (Key 1983: 175)

Phrases like 'race hygiene' seem profoundly shocking in an era of ethnic cleansing, but reveal the extent to which sexual reform and eugenics were linked in progressive feminist and socialist circles in the early twentieth century. Key's views helped to define the terms of debates about motherhood in the 1900s and were taken up by many German feminists. These included Helene Lange, editor of *Die Frau*, and Gertrude Baumer, leader of the bourgeois women's movement, who argued that women had a cultural mission to restore personal values and 'soul' to the German people. While Lange and Baumer represent a conservative strand within the women's movement, the argument that women's role should be to extend domestic values and a female viewpoint into the public sphere linked certain feminist positions to the critique of capitalism and materialism also to be found at the turn of the century in progressive artistic circles such as those at Worpswede. The attack on the overcivilization of contemporary life and a desire to restore essential German *Volk* values can be seen to share contemporary avant-garde preoccupations with primitivism and its association with directness of expression in art.[26]

Paula Becker's membership of the Worpswede colony put her in touch with progressive and reformist tendencies at the turn of the century. Her own attitude to feminism was ambivalent, but she was certainly aware of current feminist ideas, attending a feminist lecture in Berlin in 1897. Writing of a visit to Heinrich Hart's 'New Community' in Berlin in 1901, Becker dismissed the women she saw there with the comment 'Too much vanity, long hair, powder and too few corsets', clearly lacking sympathy with urban New Life socialists and feminists (Modersohn-Becker 1980: 178). She did identify very strongly with other women, however, both in an intensely felt relationship with the sculptor Clara Westhoff, and in frequent letters to her mother, her aunt and her two sisters, Milly and Herma.[27] But it seems likely that her provincial bourgeois background and her youthful identification with the naturalism of Worpswede predisposed her against the liberal 'equal rights' feminism she came across in Berlin. The emphasis on women's unique mission to restore personal values in a materialist society suggests a more likely sympathy with the cultural theories of Ellen Key's German followers.

The characteristics of Modersohn-Becker's late nudes are usually ascribed to the formal influences of archaic and modern art that she saw in Paris, for example the antique heads in the Louvre from which she made drawings in 1903, and contemporary artists' work she admired, particularly Rodin and Cézanne. Viewed within the context of contemporary maternalist debates, these late nudes can be seen to form a link between French avant-garde aesthetics and the positive evaluation of motherhood and female sexuality in the writings of Ellen Key and her German followers. This seems to be especially the case in the series of mother and child paintings of 1906–7, such as *Kneeling Mother with Child at the Breast*, 1907. Here, the monumental figure of the mother towers against a background of formalized fruit and foliage. As Lisa Tickner has described, these are 'images which glorify a protective, naked, fecund maternity' (Tickner 1980: 34). In this painting, the mother is shown in an exalted state of 'nature', in a symbiotic harmony with the child at the breast. It seems close in feeling to a passage from Ellen Key's later essay 'The Renaissance of Motherhood', written in 1914:

> In every strong maternal feeling there is also a strong sensuous feeling of pleasure . . . which thrills the mother with blissful emotion when she puts the child to her breast; and at the same moment motherliness attains its most sublime spiritual state, sinks into the depths of eternity, which no ecstatic words - only tears - can express.
>
> (Key 1983: 173)

Such an elevation of motherhood with its mysticism and biological essentialism was questioned by those German feminists committed to equality in the public spheres of politics, education and work. However, it is significant that even socialists like Clara Zetkin, leader of the proletarian women's movement in the Social Democratic Party, were affected by pronatalist arguments. While Zetkin rejected the biological basis of women's 'cultural mission', and argued for the rights of working women to political and economic independence, she nevertheless supported the view that women's participation in public life benefited them *as* mothers and was critical of the 'New Woman' in British and American feminist movements:

> The woman who, as a fully developed person, is at home outside the home will achieve the highest. She will bring her children a powerfully developed humanity and progressive strength. The goal of the women's movement is not the manly woman (*Mannweib*).
>
> (Zetkin, 1902, quoted in Goodman 1986: 120)

Zetkin's position was that woman's full humanity would only be achieved when she participated fully both as mother and as worker. But while she and other socialists did not subscribe to the essentialism of Key's maternalist views, nor did they fundamentally challenge the sexual status quo or the prevailing ideology of motherhood within monogamous marriage on which it rests.[28]

The Bund für Mutterschutz (League for the Protection of Mothers) was the organization which united radical, socialist and conservative strands of the German feminist movement around issues

concerning the improvements to maternity rights and benefits. The Bund was set up under the influence of Ellen Key, who spoke at its founding meeting in 1905. Like Key, the Bund programme argued for women's freedom to choose motherhood irrespective of their sexual status. Arguments on behalf of motherhood were thus linked to greater sexual freedom for women and, under the leadership of Helene Stoecker, the Bund became associated with the sexual reform movement in Germany before 1914. The Bund also presented eugenicist arguments concerning the fitness of the race alongside demands for women's rights in its campaigns on behalf of working-class women. In a petition to the Reichstag in 1907, the Bund called for comprehensive maternity insurance to be included in health insurance for working women on the grounds of both the health of mothers and children and the needs of the state for healthy citizens and soldiers.[29] Such a close connection between feminist demands for women's social rights and the elevation of the mother as guardian of racial identity seems incompatible to modern thinking. Yet it is in this context that different readings of Käthe Kollwitz' recurrent images of motherhood can be made. Her maternal iconography registers shifts between the different values and meanings attached to motherhood within German feminism. Her political sympathies were primarily with the socialist women's movement in the SPD although she never became a member of the party. But she also had direct links with the Bund für Mutterschutz, having donated two drawings to the Bund in Leipzig in 1909, including one of a mother and child. It is easy to see a similar commitment to improving the conditions of urban working-class women in her images of exploitation, poverty and homelessness, for example the series of drawings, *Portraits of Misery*, by which she produced for the Munich satirical journal *Simplizissimus* in 1909. Kollwitz may also have known of a play by Ida Strauss published in 1905 which was largely based on Ellen Key's ideas.[30] The play's theme of the death of a son as the result of his working-class mother's poor health and working conditions is very close to the social themes of Kollwitz' work of this period. Certainly, Key's concept of 'social motherliness' as a force within a society gripped by poverty, exploitation and war has strong resonances in Kollwitz' representations of urban and industrial life from 1908 to 1909.

What has generally escaped critical discussion is the extent to which the social and historical specificity of a series like the *Portraits of Misery* is counterposed by a strong tendency to universalize motherhood throughout Kollwitz' work.[31] This is particularly marked in those images where the figure of the nude and the mother are combined. Thus, in a later work like *The Sacrifice*, from the woodcut series *War*, 1922–3, Kollwitz seems closer to Modersohn-Becker in choosing to strip the figure of specific social reference. Indeed, the naked mother and child are enveloped in a dark womb-like shape which recalls the natural forms of a leaf or flower. In dealing with the elemental relationships of birth and death, then, both artists' work is shaped by contemporary discourses which represent the maternal as an intermediate state between nature and culture and between the biological and the social.

TWO MATERNAL NUDES

In *Reclining Mother and Child*, 1906 (Figure 9.1), Modersohn-Becker paints the mother and child as though they exist outside social discourse. The setting is minimal, a white sheet and pillow against a midnight blue ground, and the woman's body is removed from any context which might define her individual history. Unlike Modersohn-Becker's many paintings of peasant mothers, this is not a secular Madonna surrounded by symbolic flowers and fruits, but a figure whose only identity is literally *embodied*. In a number of preliminary studies for the painting, the artist explored various relationships between the mother and still unsexed child which differ in the ways in which the figures are shown, being either separated or linked by their different poses. In one drawing the child sits upright against its mother's thighs while she lies slumped, seemingly exhausted and

unaware, her breasts and arms slack. In another study, which prefigures the final painting, the body of the mother and child mirror one another in complete physical unity; the child's head is pressed against the mother's face. Like the moment after birth when a newly born baby is placed on the mother's belly, the image signifies a connection between internal and external space. It is as though the child, lying embraced in a foetal position, were still a part of the mother's own body.

In psychoanalytic terms, this is the state of primary narcissism when the infant does not yet perceive itself to be separated from the mother. Modersohn-Becker returns constantly in her representations of motherhood to this pre-Oedipal moment when mother and child are shown as one, either in the act of breastfeeding or, as here, in the intimate reciprocity of their two bodies. This intense physical relationship of the mother and child provides one means of access to the experience of the maternal body. As viewers, we are returned to the possibility of primal pleasure, to the buried memory of the maternal object. In representing the state before separation from the mother, before awareness of sexual difference occurs. Modersohn-Becker here 'escapes' the spectacle of the erotic. Pleasure in the power of sight – the voyeurism implicit in the nude – is replaced by the pleasures of touch.[32] The physicality of the maternal experience and its psychic grounding in the body is suggested by the pervading sensation of weight in the painting; the paint itself is dense and flat, and a dark line anchors the body to the ground. The painting offers us a representation of maternal origin rooted in the physical sensations of the intimacy and connectness of the infant-mother relationship.

Julia Kristeva describes this state before the child acquires language as the 'semiotic', anterior to the symbolic order of patriarchal structures and meanings and necessarily repressed on the child's acquisition of an independent social identity. She suggests that it is, amongst other things, through the creative processes that the experience of the semiotic can be recalled in adulthood.[33] The connection that Kristeva makes between the conditions of artistic creation and the maternal state is clearly relevant to the representation of the maternal nude, and yet her account of the semiotic presents a paradox for the woman artist. In her essay 'Motherhood According to Giovanni Bellini' Kristeva likens the position of the artist to that of the mother but argues that, although analogous, the two are incompatible:

> The speaker reaches this limit, this requisite of sociality, only by virtue of a particular, discursive practice called 'art'. A woman also attains it (and in our society, *especially*) through the strange form of split symbolization (threshold of language and instinctual drive, of the 'symbolic' and the 'semiotic') of which the act of giving birth consists.
>
> (Kristeva 1980: 240)

Here, Kristeva suggests that the relationship to the semiotic that is achieved through the making of art can be paralleled with that of giving birth. The 'artist' and the 'mother' represent two points of entry into the same experience, but while the artist may represent the maternal state, the mother may not 'represent' herself:

> the artist speaks from a place where she is not, where she knows not. He delineates what, in her, is a body rejoicing (*jouissant*). The very existence of aesthetic practice makes clear that the Mother as subject is delusion.
>
> (Kristeva 1980: 242)

The problem is not so much Kristeva's assumption that the artist is male, as her assertion that birth is a process *without a subject*. The 'artist' and the 'mother' represent two opposite poles in which, on the one hand, the mind can interpret the maternal experience and, on the other, the body merely enacts it. In separating artistic production from the subjectless, 'biological' experience of maternity in this way, Kristeva appears to reproduce the gendered mind and body split which is central to western systems of thought. Indeed, her formulation returns us to the terms of those debates in Germany at the turn of the century in which artistic production and motherhood were defined as mutually incompatible. Kristeva's account of the semiotic offers a means of thinking, then, about

how maternal origin might be represented, but only at the cost of denying subjectivity to the mother. But what happens when the artist is a woman *and* a mother?

In *Reclining Mother and Child*, Modersohn-Becker describes a subjective space in which self and other are inextricably linked. One way in which we can see this is in the unusual spatial construction evident in the painting as well as in some of the preliminary studies. The viewpoint is high: we look down upon the mother's body from above and yet, at the same time, it appears to tilt towards us in the upper part of the picture plane, curving around the foreground space. As viewers, we are thus placed both at a distance from and enfolded into the maternal body. The binary division between artist and mother in Kristeva's account, between the exterior and interior of the mother's body, is suspended. In its place, the 'maternal nude' simultaneously affirms artistic identity and opens up the possibility of representing the mother's body from her own point of view, in terms of likeness as well as of difference, of proximity as well as of separation. And yet, within Modersohn-Becker's painting, such maternal subjectivity can only exist in a space which is stripped of all social or symbolic reference. It is as though the dissolution of binary opposites can be represented only as taking place in a utopian space outside the realm of the social.

I want to suggest that the same problem in representing the maternal subject is also present in Käthe Kollwitz' images of motherhood. Like Modersohn-Becker, Kollwitz deals with the mother–child relationship, but if the former represents a pre-Oedipal state of unity, then Kollwitz is preoccupied with maternal loss. As most critics have noted, the death of a child is a repeated theme in Kollwitz' many images of mothers and children throughout her long career. Her choice of subject has frequently been linked both to the death of her younger son, Peter, who was killed in 1914 at the outset of the First World War, and to the experiences of the working-class women whom Kollwitz knew from her husband Karl's surgery, for whom the death of a child was a frequent occurrence. But while this biographical context is undoubtedly important, it cannot explain the frequent repetition of images of the death of children which occur even in her earliest work, for example in *Poverty* (1893–4), from the graphic cycle *A Weavers' Rebellion*. The psychoanalyst Alice Miller has located this obsession with a child's death in the repressed experiences of Kollwitz' own mother, who lost her first two babies in infancy.[34] In a fascinating reading of Kollwitz' childhood memories drawn from her Journal, Miller argues that it is the shadow of her dead siblings and her own mother's loss which haunts Kollwitz' work. In this analysis, Kollwitz' images take on a psychotherapeutic function, but in Miller's interpretation they are still located within an essentially biographical framework and, moreover, one which does not acknowledge the complex articulation of the relations of mother and artist in Kollwitz' own adult life.

This fundamental preoccupation with maternal loss can be seen at its most powerful in *Woman with Dead Child* of 1903 (Figure 9.2) where the naked body of the mother grips and enfolds the body of her dead son. Kollwitz used herself and her 7-year-old son, Peter, as models for the etching, although there is nothing specific in the image to suggest a self portrait.[35] In a similar treatment of the theme, *Pietà* 1903, for which she made numerous studies, Kollwitz drew directly on the Christian icon of the Virgin Mary mourning her dead son in her lap, and in this image the mother's face laid on the body of the child expresses an entirely human experience of grief and tenderness.[36] In the final version of *Woman with Dead Child* the glowing gold ground recalls its medieval and Renaissance prototypes, but the mother is rendered anonymous by the pain which convulses her. Her massive size and strength suggest a non-human quality and, as in Modersohn-Becker's *Reclining Mother and Child*, the figure exists outside any specific social space. In contrast to that blissful unity of mother and child, Kollwitz' mother bespeaks a terrible loss: the splitting of the maternal body. In *Woman with Dead Child* we see the violence of separation of the child from the mother in the process of gaining independent identity. In a reversal of the passage of birth, the mother absorbs the child into her own body; she possesses and is possessed by it. The intensity with which the

mother's face is pressed to her son's throat and chest suggests she is trying to ingest his body, to reincorporate it back into her own, as well as to breathe life into it. Kollwitz' friend Beate Bonus Jeep described her initial reaction to the image in perceptive terms:

> A mother, animal-like, naked, the light coloured corpse of her dead child between her thigh bones and arms, seeks with her eyes, with her lips, with her breath, to swallow back into herself the disappearing life that once belonged to her womb.
>
> (quoted in Prelinger 1992: 42)

The devouring mother is a familiar figure in representations from the Greek myth of Medea to the modern horror film *Alien*.[37] Psychoanalysis offers us an account of this monstrous oral mother in terms of the infant's fears of engulfment in the maternal body. In the theories of Melanie Klein, the mother's body functions simultaneously as an idealized love object and source of threat and object of hate.[38] But, in *Woman with Dead Child*, it is the mother's pain of separation rather than the child's which we are forced to confront. In a recent analysis of Kollwitz' treatment of the figure of the mourning mother, Angela Moorjani draws on Kleinian theory to argue that the dual themes of generation and sacrifice are central to her images:

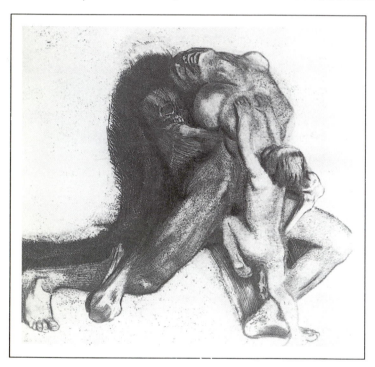

> At the same time projections of the dangerous oral mother fantasy and their denial, these images stage the maternal passion to preserve and absorb. The web of lines linking mother and child and the circular womblike compositions, containing life and death struggles, keep these images suspended between the destructive and reparative conceptions.
>
> (Moorjani 1992: 113)

Moorjani concludes that Kollwitz' imagery is caught in an impasse in which the maternal can only be represented in terms of primal fantasies of the archaic mother as either generative or destructive.

The duality of representation, which implies both the loss and the threat of the mother, is repeated in a later series of images which reinforce the connection Kollwitz made

Figure 9.5 Käthe Kollwitz, *Death and Woman*, 1910, etching and sandpaper aquatint, 44.7 × 44.6 cm.
Private Collection

between creativity, female generation and death. In an unusually explicit image, *Liebeszene I* (Love Scene), belonging to the series of *Sekreta* drawings made around 1910 during the period of her love affair with the Viennese publisher Hugo Heller, Kollwitz represents the act of sexual intercourse in an extraordinarily direct way. These drawings were never exhibited, and such a powerfully erotic image, with the suggestion of women's sexual passion, would have been unimaginable as a public statement by a woman artist, although there are some parallels in women's private writings of the period.[39] This drawing can be closely related to a series of symbolic etchings on the theme of death, woman and a child, also dating from 1910. In one etching, *Death and Woman* (Figure 9.5), the same pose for the woman in *Liebeszene I* is used in reverse. Here, however, it is not a lover

but Death which embraces her, while her child clings passionately to her body. The representation of the sexual act and death, like the birth and death of a child, have become mirror images for each other. Each represents a moment of engulfment and obliteration of individual identity, a passage of transition in which the fear of the loss of self is made present. It is not too far-fetched to suggest that the image of a child's death stood in this context for Kollwitz' continuing fear of loss of her own creative identity, in a transference in which she equated the maternal state with artistic productivity. In her Journal, Kollwitz recorded frequent period of creative block when she could hardly work for months at a time. In an entry dated April 1910, following a repeated dream in which she again had a small baby, she wrote:

> No longer diverted by other emotions, I work the way a cow grazes, but Heller once said that such calm is death. Perhaps in reality I accomplish little more. The hands work and work and the head imagines it is producing God knows what. Yet formerly in my so wretchedly limited working time, I was more productive because I was more sensual: I lived as a human being must live, passionately interested in everything.
>
> (Kollwitz 1955: 53)

Maternal subjectivity is represented here as the *condition* of artistic production rather than, as contemporary discourses insisted, its very antithesis.

Both Kollwitz and Modersohn-Becker can be seen to exemplify the difficult project of 'theorising and enacting (maternal) subjectivity and of finding adequate forms of representation for it' (to paraphrase Braidotti 1991: 137). But the problem for the woman artist still remained: how to represent the mother as subject within a culture which provided no language or discursive framework for her creative expression. The nude lay at the point of intersection between discourses of femininity and sexuality on the one hand, and the construction of artistic identity on the other. While the nude was readily available as an image through which to affirm male artistic identity, women had to find their own ways of reworking its meanings. For both artists, the 'maternal nude' was one means by which they could address issues of their own sexual and creative identity at a time when the roles of artist and mother were viewed as irreconcilable. The figure of the maternal nude enabled Kollwitz and Modersohn-Becker to develop an iconography which avoided the conventional voyeurism of the nude *and* could offer a metaphor for a specifically female model of creativity. It provided a means of exploring their conflicted desires to inhabit the body of the artist *and* of the mother by linking two opposing terms of sexual difference. But the repeated figuration of the mother in their work also alludes to psychic conflicts involved in making the 'unnameable' female body present in representation. For Modersohn-Becker, the maternal body as a site of plenitude could only be represented as existing outside social relationships. In Kollwitz' depictions of motherhood, the recurrent imagery of the dead child points to the fear of loss of her own identity as an artist. The artistic process could only mirror, but not resolve, the profound contradiction for women in a period when to be mother meant the loss of an individual and social self.

Notes

1 This is a substantially revised version of an essay, 'Figuring the Maternal: The Female Nude in the Work of German Women Artists at the Turn of the Century', which appeared in the catalogue *Profession ohne Tradition: 125 Jahres Verein der Berliner Künstlerinnen*, Berlin, Berlinische Galerie, 1992. The original version was written in the months immediately before and after the birth of my daughter when I was experiencing my own identity crisis as a 'maternal figure'.

2 The development of secularized forms of the Madonna and Child in eighteenth - and nineteenth-century art is discussed by Carol Duncan, 'Happy Mothers and Other New Ideas in Eighteenth Century French Art' in N. Broude and M. Garrard (eds), *Feminism and Art History*, New York, Harper & Row, 1982, pp. 201–219, and by Tamar Garb, 'Renoir and the Natural Woman', *Oxford Art Journal*, vol. 8, no. 2, 1985, pp. 5–15.

3 The combination of the nude or semi-nude female body and the figure of the mother was not entirely new. In the nineteenth century, a number of artists used the bare-breasted mother suckling her babies to represent the Republic or

Charity, political allegories of the female body which had their roots in classical and Christian iconographic traditions. Marina Warner discusses its symbolic significance in *Monuments and Maidens: The Allegory of the Female Form*, London, Weidenfeld & Nicolson, 1985, pp. 281–6.

4 Both artists studied at the Drawing and Painting School of the Berlin Association of Women Artists, Kollwitz attending in 1885 and 1886 and Modersohn-Becker between 1896 and 1898. Kollwitz returned to the School at the invitation of its director, Margarete Honerbach, to teach drawing and graphics in 1898. Although she may have overlapped briefly with Modersohn-Becker's period as a student, no contact between them is recorded. See Betterton 1992: 89–103.

5 Lucy R. Lippard suggests that Kollwitz had little in common with Modersohn-Becker 'except sex and occasional subject matter' (R. Hinz (ed.) *Käthe Kollwitz. Graphics, Posters, Drawings*, London, Writers and Readers, 1981, p. vii). See also Alessandra Comini in 'Gender or Genius? The Women Artists of German Expressionism' in Broude and Garrard, *Feminism and Art History*, pp. 271–91.

6 See Gillian Perry, 'Primitivism and the "Modern"' in C. Harrison, F. Frascina and G. Perry, *Primitivism, Cubism, Abstraction, The Early Twentieth Century* New Haven and London, Yale University Press, 1993, pp. 34–45.

7 This relationship is exemplified in Gustave Courbet's *The Painter's Studio*, 1855. In Courbet's painting, the nude model is replaced on the canvas by a landscape. Linda Nochlin discusses the gender relationships represented in which 'women and nature are interchangeable as objects of (male) artistic desire – and domination' (L. Nochlin, 'Courbet's Real Allegory: Rereading "The Painter's Studio"' in S. Faunce and L. Nochlin, *Courbet Reconsidered*, New York, Brooklyn Museum of Art, 1988, p. 32).

8 In a recent monograph on Lovis Corinth, Charlotte Berend's pose is described as: 'protected by his arms, but also shielding him, her gesture is at once suppliant and supportive' (H. Uhr, *Lovis Corinth*, Berkeley and Los Angeles, University of California Press, 1990, p. 140). Lynda Nead offers a similar description of a painting of husband and wife by George Elgar Hicks, *Woman's Mission: Companion of Manhood*, 1863, commenting: 'Norms of femininity and masculinity are constructed in this image' (L. Nead, *Myths of Sexuality, Representations of Women in Victorian Britain*, Oxford, Basil Blackwell, 1988, p. 13).

9 Charlotte Berend has given her own account of the relationship:

> When I think back to how I always managed to carry on painting in spite of pregnancy, household duties, cooking, acting as model, much illness, looking after, being careful with money in the early years, in spite of giving strength to Corinth and the children at all times throughout life, an inner voice would always however call out: 'Don't give up! Be mindful of your energy, think of yourself!'
>
> (C. Berend-Corinth, 'My life with Lovis Corinth' (1958), extracts in R. Berger, *'Und ich sehe nichts, nichts als die Malerie' Autobiographische Texte von Künstlerinnen des 18–20 Jahrunderts*, Fischer Taschenbuch Verlag, 1989, p. 281, trans. J. Brooks)

A revealing comment in Lovis Corinth's version of their marriage refers to Berend as 'A guardian angel in human form: that is my wife', quoted in *Charlotte Berend-Corinth: Eine Austellung zum 100 Geburtstag der Kunsterlin Malerie und Graphik*, Erlangen, 1980, p. 5 (trans. J. Brooks).

10 An extensive analysis of the gendered identity of the artist and the production of the nude is now available in feminist critical writing. For recent examples, see L. Nead, *The Female Nude, Art, Obscenity and Sexuality*, London and New York, Routledge, 1992, and T. Garb, *Sisters of the Brush. Women's Artistic Culture in Late Nineteenth Century Paris*, Yale University Press, 1994, and 'The Forbidden Gaze: Women Artists and the Male Nude' in K. Adler and M. Pointon (eds), *The Body Imaged: The Human Form and Visual Culture Since the Renaissance*, Cambridge, Cambridge University Press, 1993, pp. 33–42. For a useful overview of women's access to academic art education in the late nineteenth century see J. Diane-Radycki, 'The Life of Lady Art Students: Changing Art Education at the Turn of the Century', *Art Journal*, Spring 1982, pp. 9–18.

11 For an interesting analysis of the construction of the artist's public identity in male self portraiture of the same period, see Irit Rogoff, 'The Anxious Artist – Ideological Mobilisations of the Self in German Modernism' in I. Rogoff (ed.), *The Divided Heritage. Themes and Problems in German Modernism*, Cambridge, Cambridge University Press, 1991.

12 Scheffler's comments are quoted in S. Behr, *Women Expressionists*, London, Phaidon, 1988, p. 8.

13 For a further discussion of attitudes to female creativity amongst German feminists, see Kay Goodman, 'Motherhood and Work 1895–1905' in R.E. Joeres and M.J. Maynes (eds), *German Women in the Eighteenth and Nineteenth Centuries: A Social and Literary History*, Bloomington, Ind., Indiana University Press, 1986, pp. 110–27.

14 Jane Gallop places this idea in the context of a discussion of the opening and closing passages of Adrienne Rich, *Of Woman Born; Motherhood as Experience and Institution*, New York, Norton, 1976, in which a real-life incident of a mother's decapitation of her child is described.

15 In the final etched version of the print renamed *The Downtrodden*, 1900, the self portrait and female nudes were removed and replaced by a proletarian family group. For a detailed account of the development of the motif, see E. Prelinger, *Käthe Kollwitz*, New Haven and London, Yale University Press, 1992, pp. 26–30.

16 For a useful discussion of this idea, see R. Braidotti, 'Body Images and the Pornography of Representation', *Journal of Gender Studies*, vol. 1, no. 2, 1991, pp. 148–50.

17 For example, the poet Rainer Maria Rilke left her out of his monograph on Worpswede painters published in 1903 and she received no professional recognition as a painter before her second public exhibition held in November 1906 at the Bremen Kunsthalle (P. Modersohn-Becker 1980: 298 and fn. 26).

18 Linda Nochlin has suggested that the image was 'probably created when she was looking forward to motherhood', a view which collapses the reading of the work, inaccurately as it happens, into biography (A. Sutherland Harris and L. Nochlin, *Women Artists 1550–1950*, 1978, p. 67).

19 Martha Keans describes a *Self Portrait* (1892) by Kollwitz in which she shows herself pregnant with her first son, Hans, which suggests some similarities with Modersohn-Becker's work:

> she stands nearly full-length before us, her right hand by her side, her left hand lying gently across her breasts; she gazes out dreamily, preoccupied with a distant image. Unlike her other self portraits, this one conveys a light, drifting mood.
>
> (Kearns 1976: 64)

I have been unable to identify this image.

20 I have used this translation of the passage in preference to that which appears in 'Motherhood according to Giovanni Bellini', in J. Kristeva, *Desire in Language*, 1980, p. 238.

21 Shulamith Behr also makes this connection in S. Behr, *Women Expressionists*, 1988, p. 18. Examples of this type of pregnant Madonna can be found in the work of Renaissance painters such as Piero della Francesca and Jan Van Eyck.

22 For a fuller discussion of these issues, see F. Gordon, 'Reproductive Rights: The Early Twentieth Century Debate', *Gender and History*, vol. 4, no. 3, Autumn 1992. Tamar Garb discusses Renoir's representation of maternity in the context of debates about motherhood in the French Third Republic in 'Renoir and the Natural Woman', pp. 5–15. Anna Davin examined similar debates in Britain before the First World War about population, race and motherhood in 'Imperialism and Motherhood', *History Workshop Journal*, no. 5, Spring 1978, pp. 9–66.

23 Bachofen's ideas were variously taken up in Engels' *The Origins of the Family, Private Property and the State* (1884), Frazer's *The Golden Bough* (1890), and Freud's *Totem and Taboo* (1912). His theory of unregulated sexuality in the first stage of matriarchal society was attacked by Heinrich Schurtz in *Alterclassen und Mannerbunde*, Berlin, 1902, who argued that monogamous marriage was characteristic even of the earliest societies, a revealing critique in the context of contemporary debates on the responsibilities of motherhood within marrige.

24 American feminist Katherine Anthony charactized the women's movement in Britain and the United States as 'Votes for Women' whereas in Germany and Scandinavia it was *Mutterschutz* (Protection for Mothers). See Kay Goodman, 'Motherhood and Work 1895–1905' in R.E. Joeres and M.J. Maynes, *German Women in the 18th and 19th Centuries: A Social and Literary History*, 1986, pp. 110–27.

25 For a sympathetic discussion of Key's theories, see Cheri Register, 'Motherhood at Center: Ellen Key's Social Vision', *Women's Studies International Forum*, vol. 5, no. 6, 1982, pp. 599–610 and Jeffrey Weeks, *Sex, Politics and Society: the Regulation of Sexuality since 1800*, London, Longman, 1981, pp. 126–8. A more critical view is offered by Sheila Jeffreys, who argues that the exaltation of motherhood in Key's work and that of her English follower, Havelock Ellis, links neatly with the developing fascist ideal of woman's destiny in Germany of the 1920s and 1930s (S. Jeffreys, *The Spinster and Her Enemies. Feminism and Sexuality 1880–1930*, London, Pandora Press, 1985, p. 136).

26 The complex relationship between modernist and anti-modernist ideologies and their links to primitivism are very well explored in Jill Lloyd's essay, 'Emil Nolde's Ethnographic Still Lifes: Primitivism, Tradition and Modernity' in Susan Hiller (ed.) *The Myth of Primitivism*, London and New York, Routledge, 1991. See also G. Perry, op. cit.

27 Modersohn-Becker described her deep sense of loss on Clara Westhoff's marriage to the poet Rainer Maria Rilke, fearing that Westhoff's independent identity as a sculptor would be suppressed. This seems to have been intensified by her loneliness in her own marriage by 1902. On leaving her marriage, Becker also rejected responsibility for her step-daughter, Elspeth, which suggests that she did not wholly subscribe to maternalist ideology.

28 This brief summary does not exhaust the range of German feminist arguments about women's role and female sexuality in the 1900s, but it does suggest the strength of maternalist arguments within socialist and feminist positions. Karen Honeycutt ascribes the lack of radicalism to the predominance of married working-class women within the SPD women's organizations: 'Socialism and Feminism in Imperial Germany', *Signs*, vol. 5, no. 1, 1979, p. 38.

29 H. Stoecker (ed.) *Petitionem des Deutschen Bundes für Mutterschutz, 1905–1916* (Berlin 1916), reprinted in E.S. Riemer and J.C. Fout (eds), *European Women: A Documentary History 1789–1945*, Brighton, Harvester Press, 1983, p. 171.

30 The play by Ida Strauss is described in Goodman, op. cit., p. 124. Kollwitz gives her own moving account of the plight of a Frau Pankopf who suffered violence from her sick and depressive husband and the death of their child as well as having to support six remaining children alone, in her diary of September 1909 (K. Kollwitz, *The Diaries and Letters of Käthe Kollwitz*, Chicago, Henry Regnery, 1955, pp. 51–2).

31 Elizabeth Prelinger (1992) has noted that Kollwitz' work frequently combines social realism with symbolism, an approach which she derived from the theories of Max Klinger (1857–1920). Klinger was an influential figure in German artistic circles at the turn of the century. Kollwitz read Klinger's *Malerie und Zeichnung* (1885) as a student, a turning-point in her decision to commit herself entirely to graphic media. His series of etchings *Dramen*, 1883, with their highly dramatized social realism influenced Kollwitz' early attempt at a graphic cycle based on Zola's *Germinal*, as did his symbolist graphics cycles such as *Ein Leben* (1884). Modersohn-Becker also mentions reading a Knackfuss monograph on Klinger while she was in Paris in 1900 (*Letters and Journals*, p. 120).

32 Luce Irigaray explores the relationship between the significance of the gaze in western tradition and logocentric forms of knowledge, arguing for the desplacement of the visual by the tactile. She questions the primacy attached to vision in Lacan's account of subjective formation and suggests replacing his image of the flat 'mirror' with the curved surface of the 'speculum' to accommodate women's subjectivity. 'Woman finds pleasure more in touch than in sight and her entrance into a dominant scopic economy signifies, once again, her relegation to passivity' (L. Irigaray, 'This Sex Which Is Not One' in E. Marks and I. de Courtivron (eds), *New French Feminisms*, Brighton, Harvester Press, 1981: p. 101).

33 For an accessible discussion of these ideas see J. Kristeva, 'A Question of Subjectivity: Interview with Susan Sellars', *Women's Review*, no. 12, October 1981, p. 20.

34 A. Miller, *The Untouched Key: Tracing Childhood Trauma in Creativity and Destructiveness* (trans. H. and G. Hannum), London, Virago, 1990, pp. 19–35. My thanks to Andrea Duncan for pointing out this reference to me.

35 Kollwitz describes her drawing for the image thus: 'When he was seven years old and I was doing the etching *Mother with Dead Child*, I drew myself in the mirror while holding him in my arm. The pose was quite a strain and I let out a groan' (Kollwitz 1955: 164).

36 Although Mary is usually shown holding the adult Christ, some versions of the Pietà, for example by Giovanni Bellini, show Christ as a child in a pose which prefigures his death, a conception which Kollwitz' image echoes.

37 For a discussion of the mother figure as monster in *Alien*, see Barbara Creed, 'Horror and the Monstrous-Feminine: An Imaginary Abjection', *Screen*, vol. 27, January/February 1986, pp. 44–60, reprinted in B. Creed, *The Monstrous Feminine: Film, Feminism, Psychoanalysis*, London, Routledge, 1993, and Lynda K. Bundzen, 'Monstrous Mothers: Medusa, Grendel and now Alien', *Film Quarterly*, Spring 1987, pp. 11–17.

38 Angela Moorjani suggests that 'A Kleinian reading of Kollwitz's image, on the other hand, suggests the resurfacing of the phantasmatic oral mother devouring her child' (A. Moorjani, *The Aesthetics of Loss and Lessness*, Basingstoke and London, Macmillan, 1992, p. 111).

39 For example, Gwen John's sexually explicit correspondence with August Rodin and Edith Wharton's *Love Diary*, 1908. I am grateful to Mara Witzling and Judy Simons for calling my attention to these writings in a session of the Woman, Image, Text conference, Sheffield Hallam University, 13 November 1993.

Bibliography

Bachofen, J.J. (1967) *Myth, Religion and Mother Right*, trans. R. Mannheim, Princeton and London.

Behr. S. (1988) *Women Expressionists*, London, Phaidon.

Berend-Corinth, C. (1980) *Charlotte Berend-Corinth: eine Austellung zum 100 Geburtstag der Kunstlerin Malerie und Graphik*, Erlangen.

—— (1989) 'My Life with Lovis Corinth' in R. Berger (ed.), '*Und ich sehe nichts, nichts als die Malerie*' *Autobiographische Texte von Künstlerinnen des 18–20 Jahrhunderts*, Fischer Taschenbuch Verlag.

Betterton, R. (1992) 'Figuring the Maternal: The Female Nude in the Work of German Women Artists at the Turn of the Century' in *Profession ohne Tradition: 125 Jahres Verein der Berliner Künstlerinnen*, Berlin, Berlinische Galerie.

Braidotti, R. (1991) 'Body Images and the Pornography of Representation', *Journal of Gender Studies*, 1, 2: 148–50.

Bundzen, L.K. (1987) 'Monstrous Mothers: Medusa, Grendel and now Alien', *Film Quarterly*, Spring: 11–17.

Comini, A. (1982) 'Gender or Genius? The Women Artists of German Expressionism' in M. Broude and M. Garrard (eds), *Feminism and Art History*, New York, Harper & Row.

Creed, B. (1993) *The Monstrous Feminine: Film, Feminism, Psychoanalysis*, London, Routledge.

Davin, A. (1978) 'Imperialism and Motherhood', *History Workshop Journal*, 5: 9–66.

Diane-Radycki, J. (1982) 'The Life of Lady Art Students: Changing Art Education at the Turn of the Century', *Art Journal*, Spring: 9–13.

Duncan, C. (1982) 'Happy Mothers and Other New Ideas in Eighteenth Century French Art' in N. Broude and M. Garrard (eds), *Feminism and Art History*, New York, Harper & Row.

Gallop, J. (1988) *Thinking through the Body*, New York, Columbia University Press.

Garb, T. (1985) 'Renoir and the Natural Woman', *Oxford Art Journal*, 8, 2: 5–15.

—— (1993) 'The Forbidden Gaze: Women Artists and the Male Nude' in K. Adler and M. Pointon (eds), *The Body Imaged: The Human Form and Visual Culture since the Renaissance*, Cambridge, Cambridge University Press.

—— (1994) *Sisters of the Brush: Women's Artistic Culture in Late Nineteenth Century Paris*, New Haven and London, Yale University Press.

Goodman, K. (1986) 'Motherhood and Work 1895–1905' in R.E. Joeres and M.J. Maynes (eds), *German Women in the 18th and 19th Centuries: A Social and Literary History*, Bloomington, Indiana.

Gordon, F. (1992) 'Reproductive Rights: the Early Twentieth Century European Debate', *Gender and History*, 4, 3: 387–99.

Harrison, C., Frascina, F. and Perry, G. (1993) *Primitivism, Cubism, Abstraction. The Early Twentieth Century*, New Haven and London, Yale University Press.

Hinz, R. (ed.) (1981) *Käthe Kollwitz. Graphics, Posters, Drawings*, London, Writers and Readers.

Honeycutt, K. (1979) 'Socialism and Feminism in Imperial Germany', *Signs* 5, 1: 33–45.

Jeffreys, S. (1985) *The Spinster and Her Enemies, Feminism and Sexuality 1880–1930*, London, Pandora Press.

Kearns, M. (1976) *Käthe Kollwitz*, New York, The Feminist Press.

Key, E. (1983) 'The Renaissance of Motherhood' in E.S. Riemer and J.C. Fout (eds), *European Women: A Documentary History, 1789–1974*, Brighton, Harvester Press.

Kollwitz, K. (1955) *The Diaries and Letters of Käthe Kollwitz*, Chicago, Henry Regnery.

Kristeva, J. (1980) 'Motherhood According to Giovanni Bellini' in *Desire in Language*, Oxford, Basil Blackwell.

—— (1981) 'The Maternal Body' *m/f*, 5/6: 158–9.

—— (1986a) 'Stabat Mater' in T. Moi (ed.), *The Kristeva Reader*, Oxford, Basil Blackwell.

—— (1986b) 'A Question of Subjectivity: Interview with Susan Sellars', *Women's Review*, 12: 19–21.

Lloyd, J. (1991) 'Emil Nolde's "Ethnographic" Still Lifes: Primitivism, Tradition and Modernity' in S. Hiller (ed.), *The Myth of Primitivism*, London and New York, Routledge.

Miller, A. (1990) *The Untouched Key: Tracing Childhood Trauma in Creativity and Destructiveness*, trans. H. and G. Hannum, London, Virago.

Modersohn-Becker, P. (1980) *The Letters and Journals of Paula Modersohn-Becker*, trans. and annotated J. Diane-Radycki, Metuchen, N.J., and London, The Scarecrow Press Inc.

Moorjani, A. (1992) *The Aesthetics of Loss and Lessness*, Basingstoke and London, Macmillan.

Nead, L. (1988) *Myths of Sexuality, Representations of Women in Victorian Britain*, Oxford, Basil Blackwell.

—— (1992) *The Female Nude: Art, Sexuality and Obscenity*, London, Routledge.

Nochlin, L. (1988) 'Courbet's Real Allegory: Rereading "The Painter's Studio"' in S. Faunce and L. Nochlin, *Courbet Reconsidered*, New York, Brooklyn Museum of Art.

Perry, G. (1979) *Paula Modersohn-Becker*, London, The Women's Press.

Prelinger, E. (1992) *Käthe Kollwitz*, New Haven and London, Yale University Press.

Register, C. (1982) 'Motherhood at Center: Ellen Key's Social Vision', *Women's Studies International Forum*, 5, 6: 599–620.

Rich, A. (1976) *Of Woman Born: Motherhood as Experience and Institution*, New York, Norton.

Rogoff, I. (ed.) (1991) *The Divided Heritage, Themes and Problems in German Modernism*, Cambridge, Cambridge University Press.

Sutherland Harris, A. and Nochlin, L. (1976) *Women Artists: 1550–1950*, Los Angeles, County Museum of Art; New York, Alfred A. Knopf.

Tickner, L. (1980) 'Pankhurst, Modersohn-Becker and the Obstacle Race', *Block* 2: 32–37.

Uhr, H. (1990) *Lovis Corinth*, Berkeley and Los Angeles, University of California Press.

Warner, M. (1985) *Monuments and Maidens: The Allegory of the Female Form*, London, Weidenfeld & Nicolson.

Weeks, J. (1981) *Sex, Politics and Society: the Regulation of Sexuality since 1800*, London, Longman.

Whitford, M. (1991) *Luce Irigaray, Philosophy in the Feminine*, London and New York, Routledge.

Mother's anger and mother's desire:
the work of Re-Hyun Park

Young-Paik Chun

The geography of my work is Korea and its generation covers the early and middle years of the twentieth century. The reason I am interested in this particular period is that it is my mother's generation. I think that I should set the record straight about her in terms of feminist discourse and articulate what has not been said, which is crucial for making a space in which to represent her subjectivity and know myself better. My specific concern in this project is a reading of the works of a particular woman artist at that time: how did she negotiate the different languages of representation (the western) with her own (the traditional) in order to explore her femininity, which had much to do with Korean maternity? I think that the introduction of western representation (in the late nineteenth century) was important, not because it was 'western', but because it was another language as opposed to the traditional one. It meant that she could have *two* languages as opposed to *one*. I believe that the more languages we have, the better we can represent femininity in any culture.

INTRODUCTION

As Chris Weedon has summarized, post-structuralist feminist theory is premised on the notion that it is only in language that social reality can have any meaning. In other words, meaning is obtained through a range of discursive systems which support power structures. What is useful about this idea is its implication that certain experiences are at risk of not being articulated or legitimized just because they do not maintain the dominant order of social power. In fact, the main body of feminist theory has been engaged in extending current boundaries of articulation or exploring different modes of signification which are other to the language of the symbolic order.

Being termed the 'semiotic' by Julia Kristeva, 'écriture feminine' by Hélène Cixous or the 'matrixial mode' by Bracha Lichtenberg Ettinger, such *feminine modes of signification*[1] I have contributed a great deal to the new possibilities in negotiating between dominant discourse and repressed ones – obviously not in phallic ways. Although one specific concern of feminist discourse has been the issue of sexual difference, it seems that its basic mechanism helps to deconstruct any kind of antagonistic or hierarchical schema, in other words, the phallic order.

Referring to Edwin Ardener, when she asserted that one of the main characteristics of a repressed group is its 'inarticulateness' and 'mutedness', the Korean feminist sociologist Hae-Joang Cho re-emphasizes the fact that a repressed group has a great deal of difficulty in expressing itself because its ideas have to be delivered in the language of the dominant group.[2] However, what is crucial, according to Cho, is the possibility that the repressed could have its own culture which is not recognized by the dominant. According to Ardener, the cultural monopoly of the dominant group is a superficial phenomenon and, in reality, a 'muted' group has a counterpart model of its own.

Moreover, a 'muted' group has a certain order and mode which can relate and sometimes change the model of the dominant culture and fluctuate between the two worlds depending on the situation. J. Okely's perspective is quite similar when she hints that a repressed group's experiences, through its own model, produce a certain satisfaction and compensation that cannot be recognized by the dominant group.[3]

The matter of 'what is articulated' and 'what is not articulated' does, I think, absolutely depend on the position of a subject, which is quite often forgotten. It is at this point that Cho's simple diagram is useful (Figure 10.1). In the diagram, Cho illustrates the model of a process of acknowledgement between two unequivalent groups.[4] Seen as different shapes, which reflect the fact that the two groups have different experiences, the area categorized by the line is legitimized by the dominant acknowledging schema, whereas the area within the dotted line is not. And in the process of communication between the two, the repressed group is defined and identified as only B through the language of the dominant group. Here, according to Cho, representative culture is meant to be the category A+B. In this context, she asserts that the genuine meaning of the emancipation of the repressed group is the state in which it can go through its experience on its own without borrowing the language or the way of thinking of the dominant group.

I find this diagram quite useful as I am engaging with patriarchal discourse, colonial discourse and racial discourse and so on. In terms of post-structuralist feminism, what is supposed to be of concern, I think, is B+C, so that the culture represented in the dark area could be extended as much as possible in the direction of C. And it goes without saying that it is to be carried out not from the position of the dominant group but in the reciprocal relationship of the two. However, considering the fact that communicative zone B is very much A-oriented already, reading the code of the repressed group in it (from the position of the dominant) or articulating the experience through it (from that of the repressed) is not quite 'reciprocal' or neutral from the beginning. What matters is C–B and how to represent it strategically as part of the 'culture'.

Figure 10.1 Hae-Joang Cho, *Diagram*

As one of many cases, this kind of mechanism has involved the process of perceiving the East Asian woman, specifically the Korean woman. It is interesting that the stereotypical imagery and description of her 'here (dominant)' is, in fact, quite different from how she is defined or identified 'over there (repressed)'. (To me, 'dominant' and 'repressed' have meaning only as different locations. When I am at home (Korea), they are reversed, in other words, the dominant is Korean and the repressed or marginalized is the western world. Therefore, the two positions can never be fixed.)

Mitsuye Yamada points out in her article, 'Invisibility Is an Unnatural Disaster', the typical imagery of the Asian woman in American society as 'submissive, subservient, ready-to-please, easy-to-get-along-with'.[5] On the other hand, Chandra Mohanty reveals the hidden meaning behind descriptive words about third world women as 'religious ("not progressive"), family orientated ("tra-

ditional"), legal minors ("they-are-still-not-conscious-of-their-rights"), illiterate ("ignorant"), domestic ("backward") and sometimes revolutionary ("their country is in a state of war they might fight!").'[6] This is just the same way as men define women in general phallic terms.

It is quite evident to me, as a woman who has come from the dubious category of the 'third world' or the incredibly ambiguous world called 'Asia' (especially in the UK), that such descriptions belong only to area B. How about the rest, C–B, in this matter? It is the area that this chapter aims to articulate through its reading of works by the Korean women artists. What I am attempting to try in this project is a reading of their works on their own, without bringing them 'here' or having me go 'there'. It will be possible only by myself becoming a *place* where Korean femininity, explored through works of the women artists in Korea 'over there', can communicate with a feminist discourse which happens to be 'here'.

SOCIAL CONTEXT

On its way to industrialization, from its traditional agricultural system in early twentieth-century Korea, the many different socio-economic conditions caused a great deal of change in Korea's patriarchal system. At the beginning of industrialization, around 1900 to the 1950s, Korea had the most difficult time in her history including the Japanese colonization (from 1910 to 1945) and the Korean war in 1950. It was a desperate time, when the matter of national survival was at stake and Korean society had to fight for its independence from Japan. In this state of political unrest, men had to get out from their homes and take part in 'crucial' matters such as the national independence movement, people's demonstrations and the war. All the 'trivial' things, such as family matters, were left in women's hands.

In analysing Korean novels which represent the image of men at that time, Cho divides them into two groups: one is a powerless and weak image of men and the other is that of a fighter in the resistance movement against Japan. On the whole, what was most prevalent was the men who left their families behind.[7] Thus, the space where women could work was inevitably expanded outside the home regardless of their intentions, and they took over all kinds of economic and practical business within their families. However, quite ironically, in spite of the expansion of the woman's space and the absence of man, male identity in the family had never lost its meaning and value. On the contrary, it became even more crucial for the preservation of social status of the family – 'the absence of man was all the time regarded as *temporary* [original emphasis] by members of the family and man resides in their mind as *the symbolic* authority [my emphasis]'.[8]

Here, we can see the 'paradox of the phallus', that is, through its absence the phallus can get absolute power. As Althusser suggests, the power of ideology comes from its seeming absence.[9] Cho explains this phenomenon: 'It is mainly due to the fact that people could not go beyond the traditional ideology about preservation of pure family blood lineage throughout generations, which was inevitable for the individual's social status' and, in addition to that, it was also because of the Confucian way of thinking that 'although a family becomes very prosperous, it can not be honorable in the public domain without a man'.[10] In this respect, Korean patriarchy became more ideological than before, in that 'male dominance was emphasised in terms of identity of man itself, rather than actual male roles'.[11]

Whereas the life of western women was limited in the private sphere or domestic space according to 'social positionality'[12] in the modern era, what restricted Korean women cannot be exactly explained by the notion of the 'space of femininity'.[13] It was rather a matter of ideology – Confucian patriarchy – itself. In other words, in being involved in economic and social activity related to the family, doing housework, and taking responsibility for the children's education, Korean women have oscillated between the domestic and public spheres. None the less, it was only in the domes-

tic sphere that their activity was represented, visible and legitimized in those days. In the public sphere, there were supposed to be men, even if they had only the symbolic name. It seems to me that there were two exclusive worlds at the level of acknowledgement – one was real and the other was symbolic – moving along side by side without conversing with one another. It is obvious that women belonged to the real world and men to the symbolic.

Cho defines such a structure of the Korean family as a 'matrifocal family' defined by Tanner as 'where the mother is centred in the institutional, structural and emotional spheres'.[14] Throughout this period, the image of the strong Korean woman (especially the mother) was reinforced by the descriptions 'diligent', 'busy', 'decisive', 'strong-minded', 'unyielding', which are not very different from the traditional image of the Korean woman. As the actual head of the family, the mother was the *place* where every member of the family could feel comfortable and confident when Korean society suffered a great deal of disorder and confusion in its transitional period into modern era. And at the national level, it is undeniable that the rapid economic development that took place afterwards was possible on the basis of the Korean 'utilitarian family'[15] which was supported by such determined mothers.

THE KOREAN ART WORLD: THE GENRE OF WESTERN PAINTING

As Korean society began to open its door to the western world on its way to modernization, a lot of changes took place in the Korean art world. Most of all, the introduction of western painting in the late nineteenth century caused a great expansion of the boundaries of Korean visual language. Instead of one orthodox, traditional way of painting, from then on there have been two genres – traditional painting and western painting – side by side throughout Korean art history up to the present day.[16] However, western painting to the Korean art world in its very early period meant absolute 'other', which was certainly not an avant-garde other but rather a marginalized other. There were very few pioneering artists of western painting at that time, and they struggled a lot to get social recognition and to make some space for their work.

Among such artists, Hae-Sug Na (1896–1946), who graduated from Tokyo Women's Art College (Department of Western Painting) in 1918, was one of the most active members of all, travelling throughout Europe, especially Paris, many times and introducing western art through newspapers and art magazines in Korea. It is noticeable that in the first generation of the genre of western painting, Na was the first woman artist and almost the only one who carried on her career as an artist of western painting until the end of her life. (Her contemporary male artist, Hee-Dong Kho, who is said to be the first painter in the western genre, gave up his career and turned to the traditional painting in his later life.) When we consider the fact that most of those producing western paintings (usually male artists) were discouraged by the lack of social recognition and institutional support and returned to traditional painting, her continuous participation at the major exhibitions was more outstanding than anyone else in the 1920s.[17] Inasmuch as she was the only woman artist in the beginning of the history of western painting in Korea, and held a solo exhibition for the first time in the genre in 1921, Na became well known to the public in conjunction with the new recognition of oil painting.

As for the activities of art groups in her time, *Seo-Wha-Hyub-Whei* was the first modern art group constituted by Korean 'national' artists including Na in 1918 and it survived until 1936. Being under Japanese colonization, the group and its exhibition, called *Hyub-Jeon*, which was determined to keep the Korean national culture and identity, was suppressed by the Japanese government. In 1922, *Seon-Jeon* was organised by the government in order to overwhelm it, encouraging the Korean art world to be more influenced by Japan. Thus, there were two major exhibitions existing side by side, yet their political orientations were quite different. Understandably under the

circumstances, Korean artists are said to have had great difficulties in coping with the issues of nationality and artistic ambition at the same time. Most artists submitted their works to both of the exhibitions, since they were not able to have as many exhibitions as they wanted, and Na was eminent as the first runner in both exhibitions.

In her *Self Portrait* (Figure 10.2), painted around 1928, we can see the half portrait of a middle-aged woman painted mainly in changing tones of brown, black and yellow. So different from other paintings by contemporary male painters in which the object is woman, the painter described herself in a rather 'natural' way – natural as far as she could be a time when she was the only woman to receive recognition as a woman painter working in this area. Perhaps the word 'pioneer', which is quite 'masculine' in its signification, could not quite fit with the 'woman' or 'housewife' she was, after all. Looking exhausted and helpless, her gaze does not seem to have any particular focus in it – she is looking at something and at the same time she is not looking at all. Her lips are firmly closed and her two hands are carefully held on her lap in the same way as the button of her cardigan fastens tight the two lines of collar into one, as if it showed her determination not to lose her self-control. All these images seem to have something in common, that is, her refusal to open herself. Or, is it her refused openness?

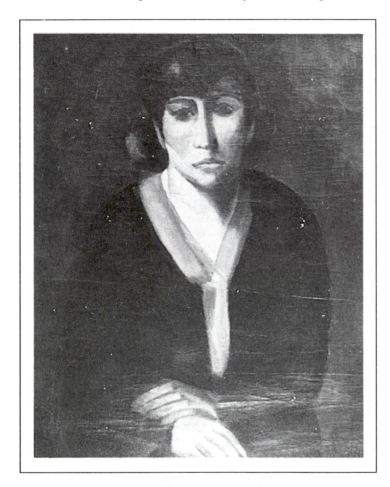

When we compare this work to the paintings by male artists in the same genre, it is obvious that it suggests another dimension, different from what they perceived as the image of woman at the beginning of modern era. That was, as a matter of fact, their fantasy and desire towards woman. What was visualized in their paintings can be roughly summarized as follows: (1) tense, uncomfortable and contracted body for posing, or half-unconscious body which is vulnerable to the gaze of the male artist in the nude paintings; (2) well-groomed woman not exposing her own emotional state – in many paintings, she sits on a chair brooding over something and some flowers, plants or other still life accompany her, in other words, 'woman as still life'; (3) women as part of landscape – such paintings do not distinguish people from nature, reflecting the idea that woman belongs to the natural world.

Figure 10.2 Hae-Sug Na, *Self Portrait, c.* 1928, oil on canvas

By using the different language of the Fauves (which was translated into Korean), Na was able to create some space where woman as a subjectivity might be represented which does not belong to any of the categories above. It is interesting that the way she represents herself in the *Self Portrait*

is quite ambiguous in terms of sexual difference. To put it another way, her strong-looking and almost man-like face – especially her long straight nose, thick neck and rough hands – are contained by the round and gentle contours of her head and upper body, which typically imply 'middle-agedness' or motherhood.

Noticeably, as the beginning line of her shoulders starts from a much higher position than the end of her neck, she looks enormously depressed and seems to be submerged inside herself – as if the image showed that her desire to explore masculinity and femininity at the same time could not be contained in reality. Without quite having a sense of masquerade, the two elements are exposed on either side quite naively in '[the] potential for a growing understanding of the profound ambiguities at the very heart of the modernist project'.[18] What western modernist discourse offered to her work seems to be an uncertainty in which she could articulate a different aspect of her feminine subjectivity from what would be defined in her society.

The most significant thing about her in terms of the history of western painting in Korea was the fact that she made direct contact with the western world, not through Japan. Studying painting in Paris for eight months, she was influenced by Fauvism, which was prevalent there at that time and contributed to an understanding of western style of art in Korea. In this respect, she has been regarded as a crucial painter by art critics because it has been an important issue to distinguish genuine Korean aesthetics from that of Japan. Kwang-Su O, who is an art critic in western art history in Korea, points out that it was such a pity that the introduction of western painting in Korea was accomplished by the route of Japan, by the translation through Japanese sensibility. In other words, the style of western painting understood by Japan became its orthodox form in the Korean art world at that time.[19]

Since most of the pioneering artists in the western style of painting and many modern painters in the traditional way were educated in art institutions in Japan during the period of colonization, the Korean art world struggled a great deal in order not to lose its identity. After its national independence in 1945, a strong sense of being 'anti-Japan' became a major social issue, and severe criticism about 'pro-Japan' representation took place throughout the entire culture including the art world, which is in fact an ongoing issue to the present day.

THE KOREAN ART WORLD: THE GENRE OF TRADITIONAL PAINTING

In the category of western painting in the early twentieth century, the issue of self-identity was problematized by the triangular relationship of Korea, Japan and the West. On the other hand, in the late 1950s, when it began to negotiate with western representation, what Korean traditional painting was concerned with in terms of modernization was the relationship between Korean aesthetics and the western one. (From the point of the traditional aspect, it was of primary concern to remove the traces of Japanese representation like stains on a white dress, which Koreans would regard as 'low art'. Although they belonged to the same category as oriental painting, the styles of Korean and Japanese paintings were distinguishable to a certain extent by both peoples. And the painters who were trained on Japanese soil had to readjust somehow to the representation of Korean painting after returning home, in order to be accepted as 'genuine Koreans'. In this sense, Japanese colonialism seems never to have overwhelmed the pride and self-identity of Korean aesthetics.)

In the process of defining and understanding western painting, it is obvious that there were evident binary oppositions about western value and that of the East, at the level of representation. Quite frequently, we come across many phrases which indicate to us that western painting has been perceived by artists and art critics as representations of the 'ego' and that of the oriental or traditional painting has been redefined as 'nature', in other words, 'not-ego', in order to differentiate itself from western painting. This distinction was maintained at the cultural level as well, empha-

sizing that the westerners 'control' nature (antagonistic relationship) and the easterners 'harmonize with' nature (reciprocal relationship).

At the conceptual level, it seems to be crucial and inevitable to define the discourse of western painting in a way 'different' from the traditional in terms of an affirming self-identity. At the level of art practice, Korean artists in the field of traditional painting seem to have had a great deal of difficulty in negotiating the *one* and the *other* when the division between the two cultures was conceived in such a way. What was at stake was the encounter of the style and meaning of two different representations and it had to be resolved on their canvas, to be precise, in the soft, thin paper of traditional painting. In addition, they had a great deal of pressure from within their own field not to lose their identity as traditional painters and at the same time they had to meet their own demands and those of the outside art world within the changing society. Their job was to walk on the line which was neither solely the *one* nor solely the *other*, without losing balance.

Figure 10.3 Re-Hyun Park, photograph

A READING OF THE MATERNAL IMAGE

There have been several women artists who were relatively radical among the traditional Korean artists in the modern era. They have been radical enough to risk their identity as traditional painters by trying to expand the language of traditional painting and look for ways of exploring their femininity in their representations. Perhaps they were more eager than male artists to find different ways to represent their experiences, that had not been articulated within traditional languages of art. Without having to submit to a phallocentric principle and male domination of the power structure which pertained in the field of traditional painting, these women could explore possibilities for their own self-representation in western painting forms. Whatever the reason was, their works showed a different level of negotiation between the traditional representations and western ones.

As one of the artists who belonged to the first generation of women painters in modern terms, Re-Hyun Park (1920–76) (Figure 10.3) started her career as a traditional painter in the 1940s and constructed her own space for the representation of femininity while negotiating with the language of western painting. Educated at Tokyo Women's Art College,[20] which was the most academic and prestigious art institution in Japan at the time, Park came to be recognized in the traditional art world from a very early stage in her career (she was awarded the grand prix with *Grooming* (Figure 10.4) at *Seon-Jeon*, [21] the Korean national exhibition sponsored by the Japanese government in 1943).

In the series of paintings produced in the 1960s by Park, entitled *Work* (Figures 10.5 and 10.6), she carefully accumulated layers of colours which were constructed and supported by black-stained yellow lines. Having to do with a sense of memory and the tracing of a long period of time, the accumulated mass in *Work 22* (Figure 10.5) looks like a huge fossil and reminds Korean people of the old craft of knitting with straws. After a little while, we come to find that the object which looks so solid and dense is tearing apart, as we see in the bottom right corner and the top of the painting. And we do not know whether there are more cracks and, if there are, where they would be, because the representation seems to be extending beyond the frame of the painting itself.

However, it is not by the few cracks but by the big holes that the solid mass is being ruptured to its total deconstruction. Through the holes the view is being led to the infinite space of the background and the incredibly accumulated and heavy-looking mass seems to be hung up in the air without any weight. It is quite ironic that after she has built up and completed the object into a certain order and system with such great care, she demolishes it with these abrupt and violent holes.

Figure 10.4 Re-Hyun Park, *Grooming*, 1943, oriental painting, 154.5 × 131 cm

Figure 10.5 Re-Hyun Park, *Work 22*, 1965, oriental painting, 135.5 × 169.5 cm

Figure 10.6 Re-Hyun Park, *Work 14*, 1963, oriental painting, 89 × 104.5 cm

(Such a hole (or holes) appears in the series of *Work* consistently and in her later prints in different ways.) As we can see in *Work 14* (1963) (Figure 10.6), the hole changes its literal meaning gradually. It is rather a small glimpse into another domain behind that of the present order which is believed to be the real and only one.

In Park's print, the *Bottom of the Sea* (Figure 10.7) in 1973, she explores a different level of femininity. As we notice from the title itself, what is represented here is at a very deep location – as deep as the bottom of the sea. All sorts of creatures of the sea, such as fish, seashells, rocks, seaweeds, etc., are compounded in an amorphous form which is in mixed scarlet and jade. Far away from the turbulent surface of the sea there is absolute tranquility and quietness, interrupted only by a gentle and irregular movement of the water, which is warm and soft enough to remind us of the mother's womb. And then, abruptly, a black circle . . .

It takes some time to understand visually its relationship with the peaceful scarlet background. To some extent, the shape of the black rupture goes along with the square at the top left in its geometrical form. Compared to the amorphous and natural-looking mass and its surroundings, the circle and the square look static and rather artificial in their defining outlines. It seems as though the entire movement of the amorphous mass is halted and fixed onto the picture plane by these geometrical figures.

As we have seen in the series *Work*, a hole (holes) has appeared in Park's works consistently. In comparison to the previous holes seen in *Work*, which were empty and rarely yellow (*Work N*) or red (*Work 18*), the black hole in this work is dense and has many strata inside. In looking closely, we can see many layers inside it and it seems hardly possible to measure its depth. Despite its evident existence and undeniable dominance in the scene, it cannot be seen or read. Ironically, it is too obvious to be seen properly, yet it haunts the spectator, making a strong impression on us.

Figure 10.7 Re-Hyun Park, *Bottom of the Sea*, 1973, print, 43 × 37 cm

In a certain way, the black hole which does not look like a hole any more may represent visually the Kristevan notion of the *chora*. As a utopian figure for the primordial integration of mother and child, as Kaja Silverman hinted at in *The Acoustic Mirror*, the chora is the *place* where we relegate the mother.[22]

> Once again the child's discursive exteriority – its emergence from the maternal enclosure – can be established only by placing the mother herself inside that enclosure, by relegating her to the interior of the chora, or – what is the same thing – by stripping her of all linguistic capabilities.[23]

In the lowest layer of subjectivity, as low as the bottom of the sea, where there is no word, no meaning, not even sound, the mother is to be found in a vague form – so vague that it is difficult even to recognize her.

In *Mask* (Figure 10.8), we can see the mother's face clearly inside the black hole – to be exact, it is the mother's mask. Wearing a female Korean mask, she seems to be absolutely isolated from the outside world where there are all sorts of different faces, which are overlapped, upside-down and distorted almost like a dream. What seems real is only the mother, whose face is smiling slightly and at the same time is full of grief, emerging from the darkness, the darkest layer of subjectivity. As in the *Bottom of the Sea* and *Work* series, a sense of paradox is noticeable here, that is, the complete rupture of what is hardly likely to be penetrated.

The surface of the print looks as hard as ancient rock and the faces on it are like traces and remains of old memories. It seems to me that such a surface and the

Figure 10.8 Re-Hyun Park, *Mask*, 1973, print, 44.5 × 45.2 cm

Figure 10.9 Re-Hyun Park, *Mask* (detail)

black circle could never exist at the same level. The emergence of an unexpected black layer through the rupture of the thick layer of rocky surface is quite shocking. In fact, it would be as unexpected as the encounter of the symbolic and the semiotic. Obviously, the long black trace on the rough surface above the black scene gives a sense of linkage between the two levels as reminiscent of the black, the unknown.

A woman – certainly a Korean woman – is there, in the black area which may be the womb, the chora or the semiotic (Figure 10.9). She is putting a mask on her face, which has long eyes, bony cheeks, a medium-sized nose, and a small mouth – so small that she could hardly speak with it. It is face which reminds us of *the mother-as-genetrix*, which Kristeva consistently equates with the woman. Being relegated to the interior of the chora/womb, the mother is reduced to silence by Kristeva and

us all.[24] It is worthwhile to notice that her muteness is reaffirmed by the mask she puts on. To read what she really feels and thinks is so difficult, that is, almost impossible. Then, where is her real face?

With regard to her face, it is useful to refer to Joan Riviere's article, 'Womanliness as a Masquerade' where she says:

> Womanliness therefore could be assumed and worn as a mask, both to hide the possession of masculinity and to avert the reprisals expected if she was found to possess it The reader may now ask . . . where [do] I draw the line between genuine womanliness and the 'masquerade'? My suggestion is not, however, that there is any such difference; whether radical or superficial, they are the same thing [original emphasis].[25]

Nevertheless, Stephen Heath's question remains insistently, 'What is left behind the mask of womanliness?'[26] As he asks, would it be the intellectual woman, the feminist, the hysteric or a different sexuality?[27] How about female madness or the Korean woman's shaman? Whatever it is, it must be the *unknowness* in femininity that men are afraid of.

To me, a daughter of the mother, it is obviously *anger*, an enormous degree of anger. Through all those agonizing years, how has the mother been so calm, generous and loving all the time? It is impossible. Where is her anger? I cannot visualize her angry face clearly. Taking most of the responsibility in the family and keeping the relationship solid without any hint of a crack in the absence of the father, the mother was not supposed to be angry, which is such an egoistic emotional state. She had to be strong enough not to be angry.

It seems to me that the hole in Park's works is the *semiotic hole* through which feminine anger is being exploded. Yet the anger itself is not to be seen, because she was the mother, the strong-minded Korean mother. After going through all the experiences of the early modern era in Korea, what the mother was concerned with was *the birth*, which represents the solid entity which would never fall apart or break down. It was by means of sublimation rather than explosion that she chose to experience her anger.

CONCLUSION

With the rise of modernization in the early twentieth century in Korea, in another segment of *the linear time* of history, maternity was being constructed (and was very much involved in structuring itself) in the name of 'development' for the sake of the father and the son. It has been believed to be spiritually 'mature' enough not to explode its own desire and emotionally 'patient' not to assert itself, its identity, in front of men, who have been engaged in the great task of social reconstruction on the plane of history and politics. Despite all her contributions to it, the mother has remained quiet, which was one of 'big girls'' great virtues. In order to become 'wise mother and good wife',[28] she should not lose her temper.

Through the works which were produced by such mothers in those days, we can catch a glimpse of what is not supposed to be seen or spoken – mother's anger and mother's desire. However, surprisingly, it must be realized that it is not her anger and desire but rather the daughter's which has been projected onto her. In this respect, the images of Park and Na are a 'secure' place where the mother and her daughter can encounter each other not much interrupted by the father's law. It may be possible that in this place the lost attachment of the girl to her mother is to be recovered and represented at another symbolic level whose boundary is wider than the phallic.

Here is the point at which we need to introduce the ideas of Bracha Lichtenberg Ettinger. Proposing to separate the equation between symbol and Phallus, she asserts as follows,

> Symbol is wider than Phallus, and we have to introduce non-phallic symbolic spheres alongside the phallic sphere. I call one such sphere the Matrix. The Matrix conceptualizes not-one-ness, prenatal experiences of I and not-I(s) in co-existence without assimilation and without rejection.[29]

In terms of the Matrixial mode, the daughter does not have to detach herself from the mother in order to accede to the order of signs which is only defined by the phallus. She would rather make contact with the maternal in order to give symbolic meaning to her prenatal experience. What is significant in the feminist reading of works by women artists is, I suppose, to seek 'the possibility for passages of traces of feminine otherness into an-other symbolic dimension'.[30] 'The connivance of the girl with her mother'[31] is not necessary any more. Expressing her profound reservations about the fate of a young girl in having to be separated from her mother suggested in Freudian psycho-analysis, Kristeva asks a question, 'Why and in the name of what dubious symbolic benefit would she want to make this detachment so as to conform to a symbolic system which remains foreign to her?'[32]

There must be some ways in which the daughter can remain as a daughter herself in order to re-establish the contact with her mother even when not becoming a mother herself. In order to reconcile motherhood with paternal history, what we need most of all is the connection between the mother's generation and that of the daughter as emphasized in recent feminist theory. Maternal time needs to be cherished by the young throughout her life. Otherwise, it seems to be impossible to construct our own time, which is neither subsumed under the name of the lineal time of father's history nor denigrated as 'cyclical time' or 'monumental time'.[33]

The meanings Korean women artists produced through their works were quite different from how they would be represented. And Griselda Pollock is certainly right when she points out: 'Such interventions as have been made could be dismissed, ignored, redefined and eventually obliterated because the power to determine what is "high", "great" or "historically significant" art remained in the hands of male-dominated institutions'.[34]

Articulated in visual language, what the mothers exploded in their art – their anger – has not been read properly, at least in Korea. None the less, there are still traces and memories in which we can encounter them and read, through the social positioning of their way of articulation, ultimately their anger and desire.

This project was launched as one of such readings in order to meet the mother, tracing back through the lineal time of paternal history – the history which stepped into modernization and industrialization. In the course of the rapid development of Korean society as a whole, the mother was projected as the figure to whom everyone could bring the hurts experienced to this process: a struggle for survival in a harsh and profoundly phallocentric world. As a healer and comforter, she supported the father and the son at the expense of the daughter and herself. After all, somebody in the family had to be sacrificed at the crucial moment in history.

The 'great' Korean mother, who has often been praised for her sacrifice especially, remained lonely inasmuch as she could not explore her subjectivity in order not to break 'myth of the mother'. Among a lot of myths around woman, it is obvious that this myth was quite functional for Korean society in the modern era. And at the same time, it is the reason why so many mothers faded away from the stage of modern history, not much being signified at the symbolic level. None the less, the works by women artists as an archive of the mother and traces of her, indicate the possibility of her appearing and speaking in her own voice in that historical moment.

It is noteworthy that the mother who became visible and was heard in Park's work is not to be defined in a single collective category as 'Korean mother'. Through the multiplicity of each person's identifications and the relativity of her symbolic in Kristevan terms,[35] we may have to take into account not only 'the specificity of the female' in terms of collectivity but 'that of each individual woman' in terms of singularity.[36]

In this project, through the work of Re-Hyun Park, the experience of the feminine in Korean society in the middle of the twentieth century, has been read especially in relation to a Korean concept of maternity. As a singular woman artist who represents the collective figure of the Korean

mother, Park could somehow suggest a way to make some space for the femininity which was not held up by its social definition. In that space, Park could show a possibility of representing what she wanted to speak of by going through the feminine experiences in the mother's language without borrowing the father's.

Notes

1 Chris Weedon, *Feminist Practice and Poststructuralist Theory*, Blackwell, Oxford and Cambridge, Mass., 1978, p. 70.

2 Edwin Ardener, 'Belief and the Problem of Women', in Shirley Ardener (ed.), *Perceiving Women*, London, Malaby Press, 1975, p. 21; cited in Hae-Joang Cho, *Women and Men in Korea*, Seoul, Mun-Hak-gua-Ji-Sung-Sa, 1988, p. 341.

3 Edwin Ardener, op. cit., pp. xiv–xv and J. Okely, 'Gypsy Women: Models in Conflict', in Shirely Ardener (ed.), *Perceiving Women*; cited in Cho, op. cit., pp. 341–2.

4 Cho, op. cit., pp. 343–4.

5 Mitsuye Yamada, 'Invisibility Is an Unnatural Disaster', in C. Morraga and G. Anzaldua (eds), *This Bridge Called My Back: Writings by Radical Women of Colour*, Watertown, Mass., Persephone Press, 1981, pp. 36–7.

6 Chandra Mohanty, 'Under Western Eyes: Feminist Scholarship and Colonial Discourse', *Feminist Review*, no. 30, Autumn 1988, p. 80.

7 Cho, op. cit., p. 91.

8 Ibid., p. 92.

9 Louis Althusser, 'Ideology and the Ideological State Apparatuses', in Ben Brewster (trans.), *Lenin and Philosophy and Other Essays*, London, New Left Books, 1977 (2nd edition), pp. 149–73.

10 Cho, op. cit., p. 92.

11 Ibid., p. 93.

12 Griselda Pollock, *Vision and Difference*, London and New York, Routledge, 1988, p. 81.

13 Ibid., p. 66.

14 N. Tanner, 'Matrifocality in Indonesia and Africa and among Black Americans', in M. Rosaldo and L. Lampfere (eds), *Woman, Culture and Society*, Stanford University Press, Stanford, 1974, pp. 131–2; cited in Cho, *Women and Men*, p. 103.

15 Hae-Joang Cho, 'Social Change and Family-Centred Ideology in Korea', *Korean Cultural Anthropology*, no. 17, December 1985, p. 83.

16 In other words, traditional painting does not necessarily mean 'an old style' and the western genre does not refer to avant-garde. They merely coexist in different categories.

17 Ku-Leul Lee, 'Western Painting in the Period of Introduction', in Byung-Jae Chang *et al.* (eds), *Korean Modern Art Collection*, Seoul, Han-Kug-Il-Bo-Sa, 1977, p. 93.

18 Irit Rogoff, 'Tiny Anguishes: Reflections on Nagging, Scholastic Embarrassment, and Feminist Art History', *Differences*, no. 3, vol. 4, Fall 1992, p. 64.

19 Kwang-Su O, 'The Lineage of the Naturalism', in Byung-Jae Chang *et al.* (eds), *Korean Modern Art Collection*, p. 86.

20 It is necessary to remind the reader of the fact that Hae-Suk Na graduated from the institution about thirty years earlier and three other women painters who were contemporaries of Park, including Kyung-Ja Chun, were educated there.

21 Throughout the Japanese colonial period *Hyub-Jeon* was suppressed by the government and *Seon-Jeon* became the only exhibition to show art works to the public in Korea.

22 Kaja Silverman, *The Acoustic Mirror*, Bloomington and Indianapolis, Indiana University Press, 1988, pp. 102–3.

23 Ibid., p. 105.

24 Ibid., pp. 112–13.

25 Joan Riviere, 'Womanliness as a Masquerade', in Victor Burgin, James Donald and Cora Kaplan (eds), *Formations of Fantasy*, New York, Methuen & Co. Ltd, 1986, p. 38.

26 Stephen Heath, 'Joan Riviere and the Masquerade', in ibid., p. 55.

27 Ibid.

28 The ideology of 'wise mother and good wife' has been representative in suggesting the ideal type of Korean woman up to the present day. Originally, it comes from a Japanese one, 'good wife and wise mother', which was a slogan made by the revolutionary government in 1868, in order to support the male-centred family alongside the development of capitalism in the modern era. Later on, it has developed into the image of 'professional wife' in Japan. In Korea, on the other hand, due to the tradition in which blood lineage is cherished and the mother's role is regarded as quite important, the order of the phrase has been reversed as 'wise mother and good wife'. What was emphasized was not the relationship of couple but the mother–child (son) relationship.

(Hae-Joang Cho, op. cit., pp. 100–2)

29 Bracha Lichtenberg Ettinger, 'Matrix and Metamorphosis', *Difference*, p. 178.

30 Ibid., p. 195.
31 Julia Kristeva, 'Women's Time' in Toril Moi (ed.), *The Kristeva Reader*, Oxford and Cambridge, Mass., Blackwell, 1986, p. 204.
32 Ibid.
33 Ibid., p. 187.
34 Rozsika Parker and Griselda Pollock, *Old Mistresses*, London, Pandora Press, pp. 135–6.
35 Kristeva, 'Women's Time', p. 210.
36 Ibid., pp. 196, 210.

Bibliography

Cho, Hae-Joang. (1985) 'Social Change and Family-Centred Ideology in Korea'. *Korean Cultural Anthropology* 17.
—— (1988) *Women and Men in Korea*. Seoul, Mun-Hak gua Ji-Sung-Sa.
Heath, Stephen. (1986) 'Joan Riviere and the Masquerade'. in V. Burgin, J. Donald and C. Kaplan (eds) *Formations of Fantasy*. London and New York, Methuen, pp. 45–61.
Kim, Ki-Chang. (ed.) (1985, 2nd edition) *Woo Hyang Park Re-Hyun*. Seoul, Kang-Me-Mun-Wha-Sa.
—— (1993, 2nd edition) *My Love and Art*. Seoul, Jung-Woo-Sa.
Kristeva, Julia. (1986) 'Women's Time' in Toril Moi (ed.) *The Kristeva Reader*. Oxford (UK) and Cambridge (USA), Blackwell, pp. 187–213.
Lee, Ku-Leul. (1977) 'Western Painting in the Period of Introduction' in Byung-Jae Chang *et al.* (eds) *Korean Modern Art Collection*. Seoul, Han-Kug-II-Bo-Sa, pp. 82–108.
Lichtenberg Ettinger, Bracha. (1992) 'Matrix and Metamorphosis'. *Differences* 4 (3): pp. 176–208.
Mohanty, Chandra. (1988) 'Under Western Eyes: Feminist Scholarship and Colonial Discourse'. *Feminist Review* 30: pp. 61–88.
O, Kwang-Su. (1977) 'The Lineage of the Naturalism' in Byung-Jae Chang *et al.* (eds) *Korean Modern Art Collection*, vol. 7. Seoul, Han-Kug-II-Bo-Sa, pp. 82–106.
Park, Re-Hyun. (1978) *The Echo of Love and Light*. Seoul, Kang-Me-Mun-Wha-Sa.
Park, Yong-Sook. 'The Expansion of Consciousness and the Experiment of Materials' in Byung-Jae Chang *et al.* (eds) *Korean Modern Art Collection*, vol. 8. Seoul, Han-Kug-II-Bo-Sa, pp. 82–114.
Parker, Rozsika and Pollock, Griselda. (1981) *Old Mistresses: Women, Art and Ideology*. London, Pandora Press.
Pollock, Griselda. (1988) *Vision and Difference*. London and New York, Routledge.
Riviere, Joan. (1986) 'Womanliness as a Masquerade' in Victor Burgin, James Donald and Cora Kaplan (eds) *Formations of Fantasy*. London and New York, Methuen, pp. 35–44.
Rogoff, Irit. (1992) 'Tiny Anguishes: Reflections on Nagging, Scholastic Embarrassment, and Feminist Art History'. *Differences* 4 (3): pp. 38–65.
Seitz, C. William. (1983) *Abstract Expressionist Painting in America*. Cambridge, Mass., and London, Harvard University Press.
Silverman, Kaja. (1988) *The Acoustic Mirror*. Bloomington and Indianapolis, Indiana University Press.
Weedon, Chris. (1978) *Feminist Practice and Poststructuralist Theory*. Oxford (UK) and Cambridge, Mass., Blackwell.
Yamada, Mitsuye. (1981) 'Invisibility Is an Unnatural Disaster' in C. Morraga and G. Anzaldua (eds) *This Bridge Called My Back: Writings by Radical Women of Colour*. Watertown, Mass., Persephone Press, pp. 35–40.

PART VI

The land

Chapter Eleven

Cecilia Vicuña's *Ouvrage:*[1]

knot a not, notes as knots

Catherine de Zegher[2]

Criss-crossing the Antivero river, a single white thread joins rocks and stones under and over the clear water. In this remote place, high up in the Chilean Andes, Cecilia Vicuña – an artist and a poet – is tracing the fragrance of the *ñipa* leaves and tying with cord one verdant side of the river to the other. Flexible, straight and light, the line that she draws is a visible act. When suddenly two boys come up the river, jumping from stone to stone, they watch her carefully dropping lines inside the water. Without saying a word they slowly approach closer and closer in the prints of her hands. While Vicuña is securing the yarn as into a warp – the loom of the Antivero: the river is the warp, the crossing threads are the weft – their curiosity turns into interest. Sitting on a rock they observe

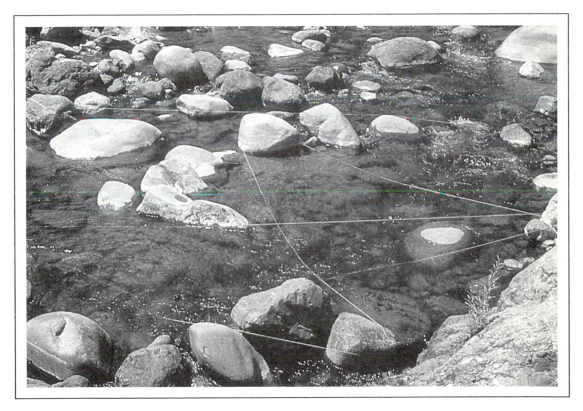

Figure 11.1 Cecilia Vicuña, *Antivero*, San Fernando, Chile, 1981

her gestures/signs and finally ask her what it is. When she returns them the question, the boys reply that they do not know, but that they would like very much to get the string. With a laugh Vicuña grants their request and immediately they start to untie all the rocks and plants, gradually dissolving the spatialized drawing or geometric pattern of woven lines into the current.

A DRAWN GAME

To the boys the line is a valuable length of cord used with or without a rod for catching fish. To Vicuña the line – as a single row of words in a poem – is a trail of communication, and the gift is the completion of the circle, where the process of forming in the present by disappearance is taken up again in the flow of events. Perhaps to some the line is a contour of an overtly romantic and idealistic story about 'nomad space', because it blurs the borderline between the 'real' and the 'imaginary', between art and life – the object consumed in the act; because it circumscribes and 'protects' the mountain water as a source of life before contamination; because it alludes to joy, play and ramble; because it refers to the whole meaning in the action – even more, to the perpetual motion of 'doing' and 'undoing' in weaving as in language; and because it recovers in a distant past our sensory memory of a children's game at school: 'cat's cradle'.

Played by two or more persons, cat's cradle is a widespread game of making geometrical string figures, looped over the fingers and stretched between the two hands, while the figures progress as the string is passed from one person to another. As if speaking and listening to each other with the fingers in alternate moves of restriction and freedom, cat's cradle consists of not only taking over the string, but also recasting the pattern without losing the thread. Moreover, hundreds of individual patterns can be generated from the same loop of string. Drawing patterns of construction/dissolution, cat's cradle is a play of beginnings, an interplay between the new and the customary without which a beginning cannot take place. Similarly, in Vicuña's work *Antivero* (1981) (Figure 11.1), the two rocky banks of the river could be considered as two hands, where the intertwined thread seems to function as the cradle and the communication, as the 'nest' and the 'text'. Etymologically, 'nest' derives from 'net',[3] an open-meshed fabric of cord, hair, or twine used for protecting, confining, or carrying. A meshwork relates to a framework of interwoven flexible sticks and twigs used to make walls, fences, and roofs in which to rear the young. To give birth and to protect the lineage, women needed to weave nests into wattle and daub shelters.

A POINT BETWEEN LINES

Although it is no longer possible to recapture details of prehistoric women's lives, it seems that weaving has always been associated with caring: child care and food preparation. In *Note on the Division of Labor by Sex*, Judith Brown states that, whether or not the community *relies* upon women as the chief providers of a given type of labour depends upon 'the compatibility of this pursuit with the demands of child care'.[4] This is particularly the case for the crafts of spinning, weaving and sewing: 'repetitive, easy to pick up at any point, reasonably child-safe, and easily done at home'.[5] Being perishable, the textiles themselves at best provide only fragmentary evidence about women's lives, but materials and metaphors of weaving do inform, since they permeate both: childbearing and food.

Weaving (resulting in cloth) and parturition[6] (resulting in babies) both display women's generative capability. Tzutujil Maya use anatomical terms for loom parts (i.e. head, bottom, ribs, heart, umbilical cord), indicating that weaving is equivalent to giving birth. Midwives in Santiago Atitlàn bind a pregnant woman's belly with the long hair ribbons that Atiteco women wind around their heads. These mimetically regulate the uterus's snake-like coils to correctly position the baby for delivery. In Chenalho, fine *huipiles*[7] are thrown into the nearby lake when women dream that the Virgin Mary needs this nourishment.[8]

According to Vicuña caring and weaving fuse in naming: to care and carry, to bear children, to bear a name.[9]

Pointing out the relation between textile, architecture and text, Vicuña observes that language is inherited from the dead and yet again and again it is 'recovered' – meaning to regain control, to repossess, to create again or to conceal again – by the living. So words are simultaneously old and new. Their universe is 'version' – in the sense of transformation – and version indicates passage, direction, action, movement. Still in a recent thread piece *La bodega negra* (Barn Yarn) (1994) (Figure 11.2), which was made in an old barn in the region of her childhood near San Fernando (Chile), it is clear that the 'directional' remains an important issue in Vicuña's work. When the artist catches the intense sunrays inside the dilapidated barn piercing the roofholes and producing starlike points on the stone walls, earthen floor, ploughshare, harrow, sacks, crops and fodder, once again dispersal and inversion take place. Dazzled when entering the barn, the viewer experiences the exterior brightness of the day turning into the interior obscurity of the night. As blind spots the constellations are cast down to earth. On her arm Vicuña is seizing a (circular) point, another one, and another, and one more: the Southern Cross. She has fastened across the space, from stones in the wall to stones on the floor, threads that, as extensions of her body, momentarily hold the suspending light. In the desire to map, this microcosmos provides protection and offers 'abstracted points of identification with the human body'.[10] As Henri Michaux writes in *Beginnings*: 'Hands off in the distance, still farther off, as far away as possible, stiff outspread fingers, at the self's outer limits, fingers Surface without mass, a simple thread encompassing a void-being, a bodiless body.' Later in the evening, inversely, when the sun is setting and the angle of light is changing,

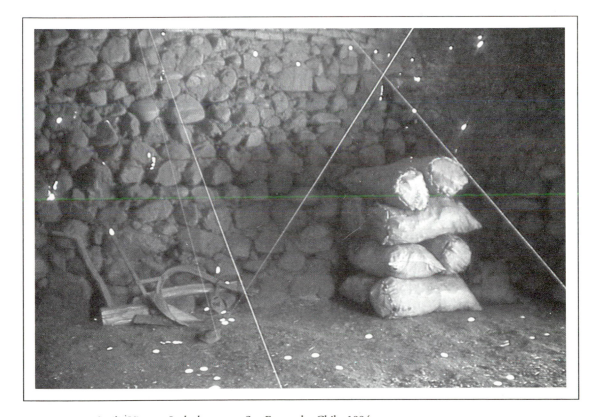

Figure 11.2 Cecilia Vicuña, *La bodega negra*, San Fernando, Chile, 1994

the stars in the barn disappear in the twilight to reappear in the night sky. 'Space is now time cease-lessly metamorphosed through action.' (Lygia Clark).

Besides the use of roofholes by the French Revolutionary architect Etienne-Louis Boullée in his domed Cenotaph dedicated to Newton, another more recent example comes to mind in the *Sun Tunnels* of Nancy Holt. During the early 1970s Nancy Holt concentrated on urban or landscape spaces as seen through holes in tunnels, pipes and other devices that made the viewer consider both outside and inside, perceptual and physiological sensations.[11] The conduits were, however, perfo-rated on purpose and oriented in a very specific direction by the artist. If Land Art claims to be concerned with nature as the incontestable provider of ideas and with light as the constitutive ele-ment in art and architecture, the work of Vicuña (like the work of Roberto Evangelista) introduces a different way of marking, one that addresses nature and (agri)culture in a dialogic way. *La bodega negra* is responding to a sign, it is not imposing a mark. Being a 'non-site' piece, it is not about appearance, but about disappearance.

ODDS AND ENDS

Since January 1966, when Cecilia Vicuña made her first outdoor piece *Con-con* on the beach in Chile at the junction of two waters, the Aconcagua River and the Pacific Ocean, she examined this conception of transience and named her work: '*precario*'. 'Precarious' is what is obtained by prayer. Uncertain, exposed to hazards, insecure. From the Latin *precarius*, from *precis*, prayer.[12] Prayer understood not as a request, but as a response, is a dialogue or a speech that addresses what is (phys-ical) 'there' as well as what is 'not there', the place as well as the 'no-place', the site as well as the 'non-site'; the dialogue as a form of transition from what is to what could be. 'Sacrifice' is an act-made-sacred and transcendent by the awareness that this act is not only physical, but retains another dimension, and thus has a double meaning, is ambiguous. As Vicuña quotes from the Vedic text: 'the first sacrifice is "seeing", because the act of seeing is a response.' The root of the word 'respond' is to dedicate again, to receive something and to donate it back.

Born of contemplation and made of refuse, Vicuña's earth works are an answer to the land and the sun, to the lost feathers and accumulated objects. Many times she has combed the beach with a stick into lines, circles and spirals. Gathering flotsam and jetsam, she recognizes the inherent value of discarded materials which are lying down, and stands them up. Her desire to order things is a kind of response to their language: garbage/language, in the sense that garbage has a signify-ing potential and impulse that gives new tension to the signifier. But whatever order she has created,[13] the wind scatters it and long waves rolling upon the sand – also called beachcombers – erase her work *Con-con* at high tide. Thus, since the mid-1960s Vicuña has been producing *precarios*, which consist of small multicoloured assemblages of found materials such as fragments of driftwood, feathers, stones, lumps of shredded plastic, herbs, thin sticks, electric wire, shells, bones and thread. What is remarkable is that each piece is composed in such a way that every material holds another in balance. And, although not featuring any symmetry or similarity, the whole structure is put together, stands up an correlates in a fragile state of suspended equilibrium (e.g. *Balancin*, 1981; *Pesa*, 1984; *Espiral de Jezik*, 1990; *Poncho*, 1992). Vicuña says about her '*basuritas*':

> We are made of throwaways and we will be thrown away, say the objects. Twice precarious they come from prayer and predict their own destruction. Precarious in history they will leave no trace. The history of art written in the North includes nothing of the South. Thus they speak in prayer, precariously.

Read in comparison with the Land Art of Nancy Holt or Richard Long, Cecilia Vicuña's earth works differ not only in their relationship to the environment and the body, but also in their dif-fusion of knowledge. In contradistinction to Vicuña's perception, these artists have staged a landscape

for the viewer to colonize in order to aggrandize the self and to summon awe for the sublime Other, which may in fact work as a justification for obliterating it.[14]

> In Richard Long's work the body is absent, though implied there is in fact a disembodied consciousness, a romantic primitivist fantasy of virgin nature projected no matter where in the world by an observing eye enjoying a sovereign isolation: residues of the colonial mind-set.[15]

Again, in the case of Vicuña, the earth work is not about appearance, but about disappearance. And in Chile the *desaparecidos* (the disappeared ones) of the Junta during the 1970s have a body.[16] For this reason Vicuña drew, on her first return from exile to Chile, the work *Tunquen* (1981) on the sand with colours of pigment featuring the encounter of sun and bone, life and death.[17]

BY NAME

From 1966 to 1972 Cecilia Vicuña often practised her work in the streets of Santiago de Chile, where she created various unannounced performances and events. In 1971 she had her first solo exhibition at the National Museum of Fine Arts in Santiago with the work *Otoño* (Autumn) and filled the main room with autumn leaves three feet deep. In 1972 she travelled with a fellowship for postgraduate study at the Slade School of Fine Arts in London, where she had an exhibition at the ICA (1973). When the miliary coup happened in 1973 and President Allende died, Vicuña decided not to return to her country and remained in exile in Great Britain. Increasingly she became a political activist and founded – together with Guy Brett, David Medalla and John Dugger – an organization Artists for Democracy to oppose the military dictatorship in Chile. The ideas were linked to her first revolutionary group action in 1967: the formation of Tribu No (the No Tribe) issuing manifestos and staging public interventions. Following Vicuña's artistic practice and particularly its relationship to political protest, it seems that the investigation of language and the politics of definition are always at stake, because for her 'naming' is the most political act of all. *Arte Precario* is a nomination given by Cecilia Vicuña as an independent voice within the Southern hemisphere challenging her colonized position. Her art *is* Andean, it is not about Andean art. It belongs to this urban mestizo culture and not to the western purist version of it incorporating 'the little lama'. Her work concerns '*la batalla de los significados*' (the battle of signifieds).

Confronted with a sense of loss and isolation Cecilia Vicuña left London in 1975 to return to South America. She went to Bogota, where for several months she continued to make banners for stage sets of revolutionary theatre companies (i.e. Teatro la Candelaria). While travelling she lectured around Colombia about the 'Chilean Struggle for Liberation', made a film at a bus stop near a *fabrica de santitos*, and for a living read successfully her own 'erotic' poetry. Stunning at that time was Vicuña's performance of a spilled glass of milk: *Vaso de leche* (Glass of Milk) (1979) (Figure 11.3), commemorating the child-victims of toxic milk and confronting the viewers with its witness. When it was estimated that every year 1,920 children in Bogota died from drinking contaminated milk produced in Colombia, and the government neither prosecuted the distributors nor took any action to stop the 'milk crime', Vicuña decided to announce and to perform, in front of a government building, the spilling of a glass of milk under a blue sky. She attached a short cord around the glass of milk, pulled it over, and thus 'the poem was written on the pavement'. About this performance Leon Golub once said that it was the most efficacious political work. Inversely proportional to its small size and precarious content, it had indeed the most powerful and complex impact.

NOTES AS SNOT

Much like the precarious objects, the handling of small objects consisting of branches and cords or the making of string figures seemed in different cultures a way for people to depict the natural

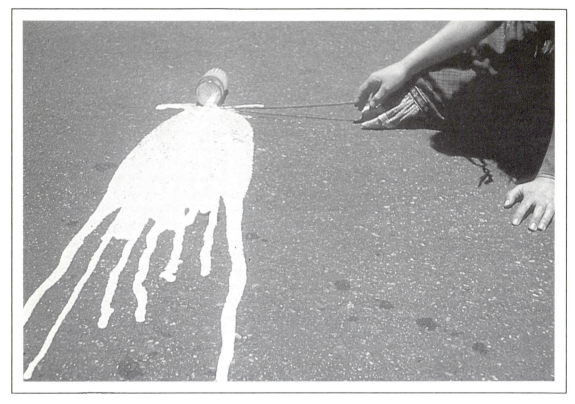

Figure 11.3 Cecilia Vicuña, *Vaso de leche*, performance, Bogota, 1979

environment, the material culture (tools, food, clothing sources, food gathering and other daily activities), interpersonal relationships, legends.[18] Confronted with chaotic movement, the human requirement for subsistence and understanding led to the fundamental research of well-defined points outside the self, but within a system. Key elements in Vicuña's work are: *star* and *stone*, *warp* and *word*, which she defines as points of exact observation (i.e. a tall stone in a vast area indicates a fixed place to observe the earth and the sky; a constellation indicates a reference in the universe; etc.) constructed within models outside the self such as: constellation, weaving and language. Moreover, although these 'structured sets'/models are permanent and account for various aspects of empirical social reality, they possess in their fixity (i.e. the celestial course, the weaving grid, the alphabet) an inner movement, and thus are again more relevant to the altering viewer/reader. A warp is many threads, a word is many sounds, many ideas.[19] Simultaneously constitutive and alien, these structures are vehicles as much to define the self – and thus means of empowerment – as to de-identify the self, because the strangeness or otherness of the self occurs as soon as it is constructed out of the self, i.e., as soon as it is symbolized.

Any act of symbolization, being a loss and a formation of the self and its reality, should therefore remain a coming-into-language, a continuous process of defining, open to shifts in its mapping. Star, warp, word: each of these points conceives inner movement and ambiguity, and should be used only as a reference for movement within the unlimited. Motion avoids the petrifying effect implicit in the fixed gaze that belongs to an observer thought to be more powerful. Everything in Vicuña's work is about connecting, weaving, studying the relations of lines to points, and what they refer to. However, once these references are fixed, certain thoughts are established as unalter-

able truths. 'Thus immovability within movement is created and along with it the Illusion of Order and Time.' Cecilia Vicuña writes in May 1973:

> In thinking of the form for which I am looking I can't help but find other forms for things outside my paintings, for any search must associate and connect with the search for a social way. If not, it is a castrated search, an apolitical occupation good for nothing, or good to help maintain the present structures which have been established for the benefit of the few and the destruction of the rest. But now these structures must be established taking into consideration facts other than profit or power. It will be possible to simplify these facts to these three categories: the way in and out of air, of food, of semen in the body.[20]

In this sense Vicuña proclaims 'laws' as necessary, but movable and directional, written considering the benefit of what goes in and out of the body: breath, snot, urine, excrement, babies.

WORD AND THREAD

Vicuña's working field consists of the exploration of the symbolic function in weaving and language, stressing the fundamental place of textiles in the Andean system of knowledge. Affirming a basic congruence among the realms of writing, agriculture, and weaving, the opening lines of the Popol Vuh (the Quiché Maya's ancient sacred text) have two possible translations: 'This is the beginning of the Ancient Word, here in this place called Quiché. Here we shall inscribe, we shall implant the Ancient Word'; or 'Here we shall design, we shall brocade the Ancient Word'.[21] The most valued and respected products in Andean culture are textiles,[22] which construct, carry or are meaning and identification. Technically a woven fabric is constituted by two kinds of elements with different functions: the fixed vertical threads (warp) and the mobile horizontal threads (weft or woof), intersecting perpendicularly and passing above and beneath the fixed. Stake and thread, warp and woof have been analysed in basketry and weaving as a particular figure of 'supple solids'.[23] Determined by the loom (the frame of the warp), the textile can be infinite in length but not in width, where it is closed by a back and forth motion. It took a long time before warp-patterned weaving, the characteristic weaving structure of all remaining Andean weaving today, was recognized as valuable and fundamental to studies of gender, social identity, economic network and modernization. As a strong indicator of cultural patterns – what the Maya of Mexico and Guatemala call *costumbre* – textiles have communicative, but also poetic, economic, ritual and political power. Weaving is meaning in multiple ways.

Compared to the privilege given to painting, sculpture and architecture, very often textile arts have been ignored. But then, following the Bauhaus, the distinction and interrelationship of design and art were greatly elaborated in the work of Anni Albers. She overcame 'two fallacious premises: that designing and making art are conflicting occupations; and that work in the fiber medium is categorically craft and not art'.[24] Exploring the randomness of a discarded string in *Knot II* (1947), Albers said that 'although it is small, each thread seems charged with uninterrupted energy: the underlying units twine and intertwine with nonstop vitality, as if to say that they exist singly but also part of something greater'.[25] Working with material 'is a listening for the dictation of the material and a taking in of the laws of harmony. It is for this reason that we can find certitude in the belief that we are taking part in an eternal order.' Taking these materials further than anyone else at that time, as Mary Jane Jacobs argues, Albers also revived long-forgotten methods, particularly those used in Peruvian textiles, which she studied and collected. These ancient craftspersons employed almost all known hand methods and their work constitutes perhaps the richest body of textile art by any culture in the world. Albers praised the Peruvians' adventurous use of threads, and commented on their 'surprising and ingenious ways varying in inventiveness from piece to piece'.[26]

Using thread and cloth as her main medium, Cecilia Vicuña not only proposes weaving as a form of participation issuing from popular culture, but has always perceived and understood it as an

alternative discourse and a dynamic model of resistance, as do most indigenous Latin American women. Janet Catherine Berlo points out 'that all of the cultural cross-currents and overlaps in textile art of Latin America are not, however, simply a "making do". They are not merely a passive, defensive response to five centuries of colonialism.' In 'Beyond Bricolage' she argues that 'the improvisations and appropriations in women's textiles are deliberate and sometimes culturally subversive'. Despite their world fame as tourist items, their fabrics are signs of renewal, of new forms and topical setting, coming directly from the people. Although both women and textiles are crucial to the study of postcolonial representation, western biases have until recently viewed women's textiles as sub-'primitive' art.

MISTRESSES OF THE NEEDLE [27]

As 'cloth makes manifest deeply held cultural values that may otherwise be imperceptible – in fact, it may be women's very crucial job to translate these ephemeral values into material objects –'[28] it seems that, even in an excluding patriarchal culture, spaces of intervention exist, where suppressed voices not only articulate their experiences and self-defined positions, but where they also express their participation in culture as active agents of transformation. The techniques of weaving allow a mobility of doing and undoing within the accumulative medium of textiles (adding brocade, embroidery, trim and appliqué) increasing the meaning, power, value and visual display. Women in Latin America transform alien objects, influences, materials and ideas in purposeful collages as they adopt multivocal aesthetics into indigenous culture. From this point of view textiles can be read as active texts that play out the on-going intercultural dialogue of self-determination and cultural hegemony, as well as the dialogue of exchange between conservatism and innovation, continuity and transmutation.[29] In the material realm women confront otherness – be it due to remoteness in time (colonialism) or to remoteness in space ('first world') – in a vision of indigenous culture that balances both and that, simultaneously, demonstrates its durability through the strength and vitality of their fabric. 'This is a subversive act for it co-opts the hegemonic tradition that views the third world as a dumping ground for its products.[30]

When we consider the work of Cecilia Vicuña it becomes clearer how actively she participates in the definition of culture and the social fabric of language by disrupting the grammar imposed by figures of authority and by recovering the texture of communication. Her strategies of endeavoured improvisation, thoughtful linguistics, and accumulation allow Vicuña to diffuse a multi-levelled/referential body of meanings and to display in numerous spheres of action. During the 1960s, when she was daily taking the bus in the capital of Santiago, she decided to wear every day another woven invention as a multicoloured glove over her hand. For weeks she manufactured different types of sometimes funny gloves in many colours and forms. As an operator of signs, she wanted these handfuls of threads to function like a surprise, new – 'like art' – each time that she took the bus and raised her hand to reach out for the handgrip. Her use of the body as a material for 'performance art' inscribed itself in the city and its human movements. For both the artist and the 'person in society', a liberating force was implicated in the awakening of each gesture. Turning the familiar material (a glove) and daily gesture (reaching for the handgrip) into a question mark, she shattered the quiescent habits of the passengers and reintensified the desire and capacity to reformulate models of signification.

Vicuña's bus performance, *El guante* ('the glove') (Figure 11.4) was prompted by the necessity to restructure language of creativity, so that the artwork could remain a force for opposing authority (be it military or multi-national) and its concepts of meaning. And it was created as a tool to retain independence and to nourish resistance. On the one hand her action seems to be related to the earlier dissatisfaction of rebellious young poets, writers and painters in South America – such as Violeta Parra,[31] Jose Luis Borges, Xul Solar and the manifesto-issuing *vanguardistas* – with the

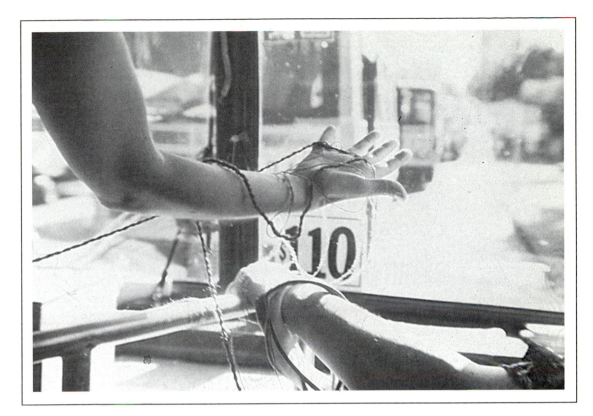

Figure 11.4 Cecilia Vicuña, *El guante* (Bus/Glove performance), Santiago de Chile, 1964–7

prevailing norm of Spanish literary language as a system of repressive and deadening constraints. For them

> a model of a perpetually reinvented language, constantly shifting to accommodate new concepts and information, was close at hand – again, in the streets of Buenos Aires, where Argentines daily enriched the staid speech of Castille with Italianisms, fragments of German and English, and their own surprising coinages.[32]

On the other hand Vicuña's bus performance seems to retrace an ancient Mapuche practice in Chile, where an old myth tells that the Mapuche women learned how to weave from observing spiders at work and from contemplating their cobweb of fine threads used as a nest or as a trap. Therefore, when a baby girl is born, mothers walk out to catch a spider and let it walk on the baby's hand. For the movements of the spider will stick to her hands, and the spider will teach her.

EL MIRAR CRUZADO[33]

More recently, in 1994, two outdoor works in Chile reframe Vicuña's concerns of transgressing the individual and the collective, the private and the public, the local and the global, the 'smooth' and the 'striated', the 'nomad space' and the 'sedentary space'.[34] First, there is *Hilo en el cerro* (Thread in the Mountain) at Cerro Santa Lucia in the public park, the trysting place of lovers and others in the centre of Santiago, where she wove with a bowl of red yarn spun in the house of a Mapuche woman. Was she using the thread in order to find her way out of the labyrinthine garden, or in order to enweb the little mountain? Does the red string indicate the solution of a

Figure 11.5 Cecilia Vicuña, *12 Hilos en un corral*, San Fernando, Chile, 1994

problem or does it entail a question? Second, there is *12 Hilos en un corral* (12 Threads in a Corral) (Figure 11.5), which was made in the corral of a farm in the mountains near San Fernando. The corral is a trapezoidal space created by stone walls (*una pirka*) for the mestizo purpose of domesticating horses. Inside the irregular corral Vicuña's woven striation is suspended in mid-air at the height of all the stone walls. Emphasizing the spatial 'imperfection', it is an open weaving, an open work for the viewer to enter, to slide in the head and to look upon. Essential in both weavings is the crossing of threads, the crossing of straightened lines, the intercrossing of opposed forces, the intertexture. Vicuña's art exists at the *crux*, where fertility sprouts, and change or transformation happens through the encounter. However, it is remarkable that, if the former weaving consists of her usual unrolled woollen lines revealing an optional trajectory around trees and flowers, local linkages between parts, multiple orientation or constant change in direction, the latter weaving represents a most regular grid structure.

In principle a fabric has a certain number of characteristics that define it as a striated space. However, it seems that this conventional thinking about weaving should be suspended and regarded within some distinctive processes. For example, felt is a supple solid product that proceeds altogether differently, as 'an anti-fabric', and since it implies no separation of threads, no intertwining, only an entanglement of fibres obtained by fulling, it constitutes a smooth space.[35] Like paper, felt is using a matrix without entering it. But according to Deleuze and Guattari striated space is not simply opposed to or differing from smooth space. Although there is a distinction between the two, in fact they exist only in a mixture and in passages from one to another. In this sense, and contrary to one's expectation about the striated in a fabric, most of Vicuña's

weavings seem to belong to smooth space, where variation and development of form are contin-
uous and unlimited, where the lines go in all directions, where 'the stop follows from the trajectory'.

> Smooth space is directional rather than dimensional or metric. Smooth space is filled by events or haecceities, far
> more than by formed and perceived things. It is a space of affects, more than one of properties. It is *haptic* rather
> than optical perception. . . .It is an intensive rather than extensive space, one of distances, not of measures and prop-
> erties.[37]

Vicuña's sites (sand beaches, sea and river, streets . . .) and works – whether in Chile, Bogotá or
New York – are 'local spaces of pure connection'. Her linkages, signals, orientations change accord-
ing to temporary vegetation, occupation, and precipitation. The abstract line that she draws is 'a
line of flight without beginning or end, a line of variable direction that describes no contour and
delimits no form'.[38]

Yet it appears that Vicuña's two recent outdoor weavings, *Hilo en el cerro* and *12 Hilos en un cor-
ral*, enact at once respectively smooth space and striated space, and almost literally the crossings,
passages between both spaces, as though one emanated from the other, 'but not without a corre-
lation between the two, a recapitulation of one in the other, a furtherance of one through the
other'.[39] Her unexpected use of the woven grid in the corral piece visualizes the striation of space
as a way to subordinate and to measure it within anxiety in the face of all that passes, flows or
varies. As the grid since the Renaissance has been applied on a vertical plane to master the three-
dimensional space in painting, so the grid applied on a horizontal plane in Vicuña's open weaving
brings to mind an archaeological method for mapping ancient sites in an instrumental and clear
way. Additionally, it is important to mention that there are, among the Quechua of Chinchero
(Peru), profound conceptual and linguistic links between the processes of working the loom and
working the earth, both providing life's fundamentals – clothing and food. Here the word *pampa*
refers both to the agricultural plain and to the large single-colour sections of handwoven textiles.
Khata is a furrowed field ready for planting as well as the textile warp configuration ready for pat-
tern formation.[40] Since Vicuña's materialization of the grid in this work seems to be projected
without vantage point, it perhaps, more importantly, figures and embalms the connection in weav-
ing that protects. In this sense two examples of protective clothing can be recalled: the plain weaving
of Penelope's fabric which – because of its possibilities of doing and undoing – kept not only
Penelope but also Odysseus alive; the plain weaving of the poncho, which is made like a blanket
with a central slit for the head. Since its structure is part of 'an eternal order' as Anni Albers tells
us, the open (corral) weaving 'protects' the entering viewer/reader and the land against the multi-
national grip of North American corporate agro-industry – which eliminates the 'inferior' native
corn to replace it by their own 'rich' corn, treated so as not to run to seed, so that the Chilean farm-
ers become completely dependent on those corporations for production.[41]

Moreover, taking up the grid's geometricized flatness, its ambivalent relation to matter and to
spirit, and its 'capacity to serve as a paradigm or model for the antidevelopment, the antinarrative,
the antihistorical' – as described by Rosalind Krauss[42] – Vicuña extends it in her work to the trans-
ference of modernity onto Andean culture, and vice versa. Apparently, in Vicuña's spatialized
weaving not only the plain surface of the grid is under consideration but also the subversion of the
line. A binary discourse on the grid (nature vs. artifice, sign vs. phenomenon, etc.) is questioned,
while the relation of the line to points is extended according to what Deleuze and Guattari for-
mulate as the smooth and the striated to be 'distinguished first of all by an inverse relation between
the point and the line (in the case of the striated, the line is between two points, while in the
smooth, the point is between two lines)'. Textiles are spatial constructions realized by setting out
from supple and fixed elements. The spatial feature of weaving occurs on several levels and in revolv-
ing movements, that are outside a defined surface, but at the same time create surface. Still, there
is a lack of fit between the experience of space and the discourse of space, between the hand and

the weaving, between the gesture and the work. The artisan entered into a dialogue with her/his work, while labour, increasingly automatized and mechanized, had lost every expressiveness in its relation (Lygia Clark). Rediscovering one's own gestures filled with new meaning, and reconsidering two values that constantly serve change – the variable and the constant, the mobile and the fixed, the supple and the solid going on simultaneously – are at stake in Vicuña's weaving. The artist's enduring transpositions on many levels are the only constant in her work. It is with enormous perspicacity that she disorganizes and redefines the forms of meaning transmitted to her from her Andean culture and from dominant western cultures, in order to overturn the distinctions between the vernacular and the modern and to shift the international models of language. Her use of multiple fluctuating referents and of ambiguity applies to her visual art as well as her poetry.

KNOTS IN WOOL AS NOTES

Simultaneously approaching and distancing herself from so-called international movements or institutions, such as Body Art, Land Art and Arte Povera, she chose a flexible though firm position, which remained unassimilable to different cultural programmes. Already her first spatial work *El khipu que no recuerda nada* (The Quipu Which Remembers Nothing) (1965) was a line carrying those convergences, where the aesthetic of silence has been embraced in an attempt to initiate a critique of the self-reflexive model and its enforced hermeticism by challenging and refusing the quietistic conditions of modernism from within.[43] By that time, during the 1960s, in one of the anthologies about twentieth-century European modernist thought and art[44] that were translated and published in Buenos Aires to find their way to Chile, she noticed a photograph of Kurt Schwitters' *Merzbau* (1923–36) in Hanover. And at that time Vicuña outlined in her own bedroom an empty thread and entitled the work significantly: *El khipu que no recuerda nada*. Consisting of cords with knots in wool, the *quipu* (Figure 11.6) is an Inca instrument which permitted the registering of events, circumstances and numerals. Ancient documents tell us that these registering artefacts continued to be used during the first period of the *conquista*, to be replaced later by written systems. The largest and most complex *quipu* found within the extensive region of Tawantinsuyu is on display in the Museo Chileno de Arte Precolombino at Santiago.[45]

The entire *quipu* carries meaning: the length, the form, the colour, the number of knots, and simultaneously it carries within it all possibilities of modification. The most one could say on a substantial level is that, in contradistinction to other writing systems, it provides the author with the opportunity of infinite inscription since the 'inscribed' is never fixed. The act of tying and untying, ins and outs as in weaving, offers multitudinous possibilities or beginnings, flexibility and mobility. In this sense Vicuña's *Khipu que no recuerda nada* synthezises an attitude towards life, language, memory and history in a postcolonial country, where the process of transformation had generated the foundation for a new socialist collective culture. On the verge of being willing to lose any trace of representation, Cecilia Vicuña oscillates between, on the one hand, the constructivist strategies of transparency of procedures, self-referentiality of signifying devices and reflexive spatial organization, and on the other hand the strategies of differentiation of subjective experience and of historical reflection. Taking into account the experience of colonialism (and even more of the actual neo-colonial dependence) with its legacies of oppression and destruction, from which her identity emerged, she holds on to the name: *quipu*. Taking account of the desire from a new generation to be 'absolutely modern', Vicuña wanted to articulate a beginning and to position herself at this beginning, but within the pre-Columbian and colonial history. She perceives 'beginning' as Edward W. Said describes it: 'Beginning is making or producing difference; but difference which is the result of combining the already-familiar with the fertile novelty of human work in language.'

Figure 11.6 *Quipu*, knot *(quecha)*, ancient accounting system of knotted cords used in the Andes to record and transmit information, it reached its highest expression during the Inca period 1330–1533 CE. 'The knots form a symbolic representation . . . an abstraction . . . of an exceptionally sophisticated type . . . a base positional system of 10, that is evidence that the Incas knew the key concepts involved in arithmetic'.
(M. Ascher and R. Ascher, *Codes of the Quipu*, Ann Arbor: University of Michigan Press 1981)

KNOT IN A HANDKERCHIEF

Perhaps, at first, the connection seems incongruous; however, it is in the context of Chilean colonial history that I wish to analyse and emphasize the relationship of the work of Cecilia Vicuña to the work of Kurt Schwitters. There is an affinity worth exploring, since both artists' *œuvres* agree on several issues: non-representational multi-media constructions, a 'non-objective' art, emphasis on connection and interaction – the 'directional' rather than the 'dimensional' – the use of refuse, the strategies of naming (*precario* and *Merz*), and also the experimentation with other forms of art, e.g. with poetry. By letting the elements of poetry such as letters, syllables, words, sentences interact, they create meaning.[46] Most striking, however, is the similarity in the construction procedure between the *Merzbau* conceived in Schwitters' house, and Vicuña's *quipu* which was realized in her bedroom without any knowledge of the former's installation process. As the result of particular interest in the combination of various materials and in the interaction of things, and thus also of the components of his own works, Schwitters started by tying strings in his studio from one object, picture or work to another to emphasize or materialize this interaction. Eventually they became wires, then were replaced with wooden structures which, in turn, were joined with plaster of Paris.

The structure grew and grew and would fill several rooms resembling a huge abstract grotto.[47] Schwitters had called his principle of artistic creation with any material *MERZ*.[48]

However, besides the aesthetic considerations and the formal analogies between Schwitters' and Vicuña's work, it is of interest to compare the analogues between both the process of naming and the use of waste materials in a specific socio-economic environment. Therefore, the political and social setting from which both *œuvres* emerged should be put in historical perspective. And this analysis provides us with parallels of periodical suppression in Schwitters' time in Germany before and during the Second World War and Vicuña's time in Chile during the dictatorship. This is particularly instructive, since it seems that the German connection[49] has also worked in both ways – in a very progressive way (e.g. at the universities) and in a very repressive way (on a military and political level) – an increasingly important role in the colonial and postcolonial history of Chile.[50] The consideration of these attested historical facts reminds us of the Chilean context from the 1960s onwards in which Vicuña acted, while it throws extensive light on her attention (later on serious study of) to Dadaism, particularly to Kurt Schwitters, in her visual art practices, and her interest in the German Romantic poets, such as Novalis, in relation to her poetry.[51] She also noticed affinities between pre-Columbian and German Romantic poetry in the way in which memory and lament were exalted. The German avant-garde art of the late nineteenth and early twentieth centuries had dissolved identities and shattered the communicative, representative aspect of language in favour of a dynamic conception of art. These artists gave rise to a theory of the subject in process, a subject equally constituted by symbolic and semiotic elements. Considering them as rebels in a restraining German society,

Figure 11.7 Cecilia Vicuña, *Cruz nunca*, 1986, 29 × 6 × 5 cm

Cecilia Vicuña embraced their modernist vanguard aesthetic and poetry as a liberating force contributing in one move from within to both, and on the one hand, the newly defined process of social production of culture propagated by the Unidad Popular of the Marxist President Salvador Allende, and on the other the resistance against German colonization and its ramifications in an emerging totalitarian regime.

DESIRE OF THE HAND

If this presumed equation were not based on aesthetic and socio-political recurrences and convergences in time, but instead on a linear idea implicating the notion of filiation and belatedness, then it could be once again considered as another neo-colonial attempt to create predecessors for South American art in Europe. Still, at the same time it is imperative to read Vicuña's work, which fuses the knowledge of a colonial Chilean and local Andean culture with the quest for a global avant-garde, with regard again to the propositions of her contemporaries in South America. Her determination to break away from the universalist claims of geometric abstraction, though without leaving a non-figurative, geometrical vocabulary or the general social concerns of constructivism, and her desire to take on complex human reality and to remain receptive to her immediate environment parallels the same earlier attitude of the Neo-concrete group in Brazil.[52] They affirmed the values of modernity and eschewed 'regionalist realism'; but they attacked in the *Manifesto Neoconcreto*[53] (1959) the positivism and mechanistic reductionism of the European philosophy (of Max Bill and the Hochschule für Gestaltung Ulm), which was designed for an advanced capitalist/industrial society, and they restated the problem of subjectivity in a specific Brazilian context.

'Significantly, Lygia Clark's and Hélio Oiticica's work gradually lost the technological sheen associated with constructivism and moved (in very different ways), towards the use of common and relatively valueless materials which were 'at hand' in the everyday environment of Rio.'[54] Notwithstanding the isolation of all these artists and the lack of communication at that time between most of the countries in South America, it appears that, in 1966, at the moment when Vicuña in Chile was naming her works *Arte Precario*, Clark in Brazil was proposing '*precariousness* as a new idea of existence against all static crystallization within duration; and the very time of the act as a field of experience'.[55] At the same time, in the 1960s and 1970s, these South American artists positioned themselves in relation to the international claims of the *Arte Povera*, resolutely stressing their own naming and its intrinsic differences. In a letter to Clark (15/10/68) Oiticica states:

> For European and North American expression, this is the great difference: the so-called Italian *Arte Povera* is done with the most advanced means: it is the sublimation of poverty, but in an anecdotal, visual way, deliberately poor but actually quite rich: it is the assimilation of the remains of an oppressive civilization and their transformation into consumption, the capitalization of the idea of poverty. To us, it does not seem that the economy of elements is directly connected with the idea of structure, with the non-technique as discipline, with the freedom of creation as the super-economy, in which the rudimentary element in itself liberates open structures.[56]

According to Guy Brett, their

> material-linguistic objects like Oiticica's *Bolides* (*bolide* = fireball in Portuguese), his *Parangolés* (capes), *Penetrables*, *Nests* etc., and Clark's individual and collective 'propositions' using plastic, sacking, stones, air, string, sand, water etc., are not 'representations' but cells, nucleuses, or energy-centres. The object itself is secondary, appropriated, incomplete, existing only to initiate dialogue, and to indicate 'environmental and social wholes' (Oiticica). Literally, in many cases, they cannot exist without human support.[57]

Apparently Vicuña responded in her way, in her country, to the same cultural necessity and was drawn to the same tendencies of 'expanding beyond the concept of the art object, beyond the gallery and the museum, into the environment, mixing media, and inviting the participation of the public'.[58] Striking here are the concurrences not only in the use of 'precarious' materials (netting, strings, shells) or of textiles (Oiticica's *Parangolés*, Vicuña's *Ponchos*), but also in the notions of space/time, of beginning, of bodily action (perception, touch, manipulation, voice, smell; the 'eye-body'), of dialogue, and even of another basic human creation: architecture. If for Clark a 'living biological architecture' was created by people's gestures, and if Oiticica's sensory and social nucleuses, like his *Nests*, cabins and *Penetrables* poetically suggest new ways of constructing and inhabiting the environment – 'as a metaphor of communication' – then Vicuña's *Weavings* show points of interface within the semiotic/linguistic research of 'nest' and 'text'.

Lo nunca projectado[59]

However, most intelligible in all these works is the action of time and of 'spatialization'. What they mean by spatialization of the work is 'the fact that it is *always in the present, always in the process of beginning over*, of beginning the impulse that gave birth to it over again – whose origin and evolution it contains simultaneously' (Neo-concretist Manifesto). In this sense the repetitive texture of criss-crossing straight lines, and eventually the grid, in Vicuña's woven works are formally closer to the accumulatative system of joining wire cables in the kinetic *Reticulárea (ambientación)* (1968–76) and the *Dibujos sin papel* (Drawings without Paper) by the Venezuelan artist Gego, than to the arbitrary cluster of thread in *La bruja* (The Broom) by Cildo Meireles (Brazil) at the Biennal of São Paulo (1981),[60] or the earlier installation work by Marcel Duchamp at the exhibition First Papers of Surrealism (1942) in New York. The use of thread in these latter installation works is rather dealing with the problems of cultural institutionalization and reception to 'openly denounce the validity of the retrospective exhibition and criticize the quasi-religious veneration of the acculturation'.[61] At first sight Meireles' work appears as a gratuitous gesture enhancing chaotic dispersal, dust and dirt (at least the criticism was heavily negative), but then one discovers that it is organized by this small domestic cleaning tool, giving meaning to something abject and senseless at the beginning. Is sweeping a space not the best way to know it? It is not about making measurements in the head with the hands?

Basting the space with large loose stitches, Vicuña recently constructed *Hilumbres/allqa* at the Béguinage of St Elizabeth Kortrijk.[62] To realize a double 'weaving in space' she uses industrial black and white cotton, that is spun in Flanders' factories out of raw materials imported from the 'third world' (Turkey, Egypt, Peru ...). 'I speak to the moment in which the visible becomes invisible and vice versa,' said Vicuña, 'to the moment when the cognition, the definition, has not yet been formed. Moving through the room people should discover the limits and traps of their own perception, the wandering attention.' The title of her work can be referred to as *Hilumbres*, a word made by Vicuña, is composed of two words *hilo/lumbre* (thread/light) meaning 'the thread catching light' or 'the thread of light'; *allqa* is an Aymara word and a textile term, that refers to a sharp contrast in the play of light and shadow; in weaving it applies to the connection or the encounter of those things that can never be together: black and white. In Andean weaving this union of oppositions generates a degradation – or as Vicuña formulates it: 'a soft stair-way', which argues for a model of subjectivity not rooted in binary thought: self/other, love/hate, aggression/identification, rejection/incorporation. Similarly, it should be noted that in Andean and Mayan textiles the joins between two woven panels are often the focus of articulation and elaboration. 'The seam itself is not rendered unobtrusive as it is in our apparel. Instead it is emphasized by silk or rayon stitching of bold colour and emphatic form. This is called the *randa*.'[63] Dealing with the past and the Other in various ways, the crossing of borderlines and seams of cultural articulation are often highlighted in this work.

The words of Lygia Clark about her *Trailing* (1964) express a similar thought about a continuum, a 'matrixial' space: 'If I use a Möbius strip for this experiment, it's because it breaks with our spatial habits: right/left, front/back, etc. It forces us to experience a limitless time and a continuous space.'[64] The exploration of another possibility of seeing, that is not the phallic gaze, is at stake in Vicuña's work and in this sense it connects with the issues in the paintings of Bracha Lichtenberg Ettinger, who developed the psychoanalytical theory of 'Matrix and Metramorphosis'.[65] Griselda Pollock, who has systematically and profoundly analysed the painting of Lichtenberg Ettinger, explains that modalities based on the rejection/assimilation paradigm apply to how paintings are viewed as much as how societies treat immigrants.

> What is not us, strange and unknown, be that woman for man, the other for the white European, the painting for the viewer is positioned under this phallic logic as either one of the two terms: to be assimilated and if that is not possible to be cast off as completely other.[66]

Lichtenberg Ettinger argues for 'a shift of the phallic' by introducing the 'matrix'. For

> if we allow ourselves to introduce into culture another symbolic signifier to stand beside the phallus (signifier of difference and division, absence and loss and orchestrating these either/or models), could we not be on the way to allowing the invisible feminine bodily specificity to enter and realign aspects of our consciousnesses and unconsciousnesses? This will surely extend as do all these metaphors of sexual difference to other others – issues of race, immigration, diaspora, genocide are tangled at the moment around the lack of means to signify other possible relations between different subjects – *I* and *non-I*. The matrix as symbol is about that encounter between difference which tries neither to master, nor assimilate, nor reject, nor alienate. It is a symbol of the coexistence in one space of two bodies, two subjectivities whose encounter at this moment is not an either/or.[67]

POETRY IN SPACE

If Vicuña's *ouvrage* challenges questions of recent art such as the status of the object, the relation of the artist and the viewer/reader, the bodily action, the relation space/time, the environment, the inner and outer, the connection of the visual to the other senses – at once moving readers away from their habit of compartmentalizing artistic production into separate media – it also evokes a polemical attitude towards modernity investigating a universal development of art without negating local forms of expression. In the knowledge that eventual elaboration of popular elements shows links with 'bricolage' and that in 'bricolage' the continual reconstruction from the same materials takes place, in the sense that it is always earlier ends which are called upon to play the part of means,[68] she reconsiders the changes of the signified into the signifying and vice versa. Vicuña dwells im-possibility. Like Violeta Parra and Xul Solar, she demands a laying open of the mechanism that produces meaning: the formation of a language. Her ideal is a form of discourse characterized by plurality, the open interplay of elements and the possibility of infinite recombinations.[69] However, it is Vicuña's conclusion that '(visual) language speaks of its own process: to name something which can not be named'.

Notes

1 *Ouvrage* (French) is: a work of literature (a writing), a work of architecture, of handcraft, of weaving, of embroidery or a work of art.
2 I am grateful to Griselda Pollock for giving me the opportunity of publishing in her book this shortened version of an essay which was written for the retrospective catalogue of Cecilia Vicuña (to be published by the Kanaal Art Foundation at Kortrijk with support of the Andy Warhol Foundation for the Visual Arts). Working with and about Cecilia Vicuña is a privilege and a pleasure, and I therefore thank her. For their continuous support and for critically reading this essay my warm thanks go to Benjamin H.D. Buchloh, and also to Jean Fisher, Sally Stein and Paul De Vylder. Last but not least I am very thankful to my family who allowed me – but luckily not always – to disappear behind my desk.
3 Cecilia Vicuña, 'Metafísica del textil', in *Revista Tramemos II*, Buenos Aires, 1989.
4 Elizabeth Wayland Barber, *Women's Work: The First 20,000 Years. Women, Cloth, and Society in Early Times*, W.W. Norton, New York and London, 1994, pp. 29–33.
5 Ibid.
6 Cecilia Vicuña creates the new verb '*palabrir*', which means 'to open words', noting that *abrir* (to open) originally meant *parir*: to give birth.
7 *Huipil* is a rectangular or square shirt, sewn on the sides, with a circular opening for the head, made of cotton or wool, and usually embroidered. Worn in Mesoamerica since pre-Columbian times, it is still used in the South of Mexico and Guatemala, where indigenous women continue to weave *huipiles* both for their own use and for trade.
8 Janet Catherine Berlo, 'Beyond Bricolage: Women and Aesthetic Strategies in Latin American Textiles', in *Textile Traditions of Mesoamerica and the Andes: An Anthology*, ed. Margot Blum Schevill, New York, 1991, pp. 437–67.
9 Cecilia Vicuña, *Unravelling Words and the Weaving of Water*, Graywolf Press, Minnesota, 1992.
10 Lucy Lippard, *Overlay*, Pantheon Books, New York, 1983, p. 106.
11 Ibid.
12 Cecilia Vicuña, *Precario/Precarious*, Tanam Press, New York, 1983.
13 Cecilia Vicuña quotes that 'art' and 'order' both derive from the same root *ar*, 'to fit together'. The word *armus* (upper arm) comes from what the arms did. In this sense the Latin *ars* (art) was 'skill', and the Latin *ordo* (order) from *ordiri* (to begin to weave) was 'a row of threads in a loom'.

14 Jean Fischer, *1:1 Lynn Silverman*, in cat. Angel Row Gallery, Camerawork and the University of Derby, 1993.

15 Guy Brett, about Roberto Evangelista: 'Immersion' in cat. *America. Bride of the Sun. 500 Years Latin America and the Low Countries*, Royal Museum of Fine Arts, Antwerp, 1992, pp. 245–6.

16 The *desaparecidos*, or the 'disappeared ones', was the name that the people of the Southern Cone (Chile, Uruguay and Argentina) gave to men and women who were led away by the secret police from their homes or in the streets during the dictatorships of the 1970s, because they were never seen again, and the military police denied having taken them in the first place. Only after years of struggle, human rights organizations were able to demonstrate that the people who had been 'disappeared' by the thousands, not only did exist, but had been effectively tortured to death and/or murdered by the military regimes of the three countries. Only some of the collective or individual burials have been found; sometimes their bodies were exploded by dynamite, sometimes bathed in lime and then covered by soil to render them unrecognizable.

17 Vicuña, *Precario/Precarious*.

18 Julia Averkieva and Mark A. Sherman 'Kwakiutl String Figures', in *Anthropological Papers of the American Museum of Natural History*, vol. 71, New York, 1992, pp. 137–50.

19 Cecilia Vicuña, *Palabrir*, forthcoming by Editorial Sudamericana, Chile.

20 Cecilia Vicuña, *Saborami*, Beau Geste Press, England - Latin America, 1973.

21 Barbara and Dennis Tedlock, 'Text and Textile: Language and Technology in the Arts of the Quiché Maya', *Journal of Anthropological Research* 41(2), 1985, pp. 121–46.

22 César Paternosto speaks of 'Major Art'; William Conklin of 'Textile Age'.

23 André Leroi-Gourhan, *L'homme et la matière*, Albin Michel, p. 244.

24 Mary Jane Jacobs, 'Anni Albers: A Modern Weaver as Artist', in *The Woven and Graphic Art of Anni Albers*, Smithsonian Institution Press, Washington, D.C., 1985, p. 65.

25 Anni Albers, *The Woven and Graphic Art of Anni Albers*, Smithsonian Institution Press, Washington, D.C., 1985, p. 22 (and pl. 1).

26 Jacobs, 'Anni Albers', pp. 71–2.

27 Ruth Bunzel, *Chichicastenango: A Guatemalan Village*, University of Washington Press, Seattle, 1952, p. 308.

28 Berlo, 'Beyond Bricolage'.

29 Ibid.

30 Ibid.

31 The art, poetry and music of Violeta Parra have been of great influence on Vicuña's propositions. Violeta Parra (1917–67) was a Chilean peasant woman, whose research in weaving, oral poetry and music of Chile, as well as her own work, were the foundations of the movement called La Nueva Cancion Chilena. With its political and contemporary bent, retaining at the same time the ancient mestizo rhythms of traditional music, it was influential all over South America.

32 Naomi Lindstrom, 'Live Language against Dead: Literary Rebels of Buenos Aires', *Review: Latin American Literature and Arts*, no. 31, New York (Jan–April 1982).

33 *El mirar cruzado* means: looking at something from (two) different points of view, mixing the sources; in Cecilia Vicuña's unpublished manuscript 'Fragmentos de poeticas'.

34 Gilles Deleuze and Félix Guattari, *A Thousand Plateaus: Capitalism and Schizophrenia*, trans. Brian Massumi, University of Minnesota Press, Minneapolis and London, 1987, pp. 474–500.

35 Ibid. p. 475.

36 Ibid., p. 429: "Haptic" is a better word than "tactile" since it does not establish an opposition between two sense organs but rather invites the assumption that the eye itself may fulfill this nonoptical function.

37 Ibid. p. 493.

38 Ibid. p. 499.

39 Ibid.

40 Berlo, 'Beyond Bricolage' pp. 446–7.

41 In fact this situation is part of an ongoing destruction process of native agriculture from colonial times. At first not only most of the wild wheat was devastated by the *conquistadores* to be replaced by imported western wheat, which the Indian population had to buy, but also a great number of alpacas and llamas were killed so that these herds had to be replaced by sheep and cows sold at very high prices. See also Cecilia Vicuña, 'The Invention of Poverty', in cat. *America. Bride of the Sun*, Royal Museum of Fine Arts, Antwerp, 1992, pp. 414–15.

42 Rosalind E. Krauss, *The Originality of the Avant-Garde and Other Modernist Myths*, MIT Press, Cambridge, Mass., 1986, pp. 8–22.

43 Benjamin H.D. Buchloh, 'Refuse and Refuge', in cat. *Gabriel Orozco*, Kanaal Art Foundation, Kortrijk, 1993.

44 Examples are: Jean Cassou's *Panorama de las artes contemporaneas* and J.E. Cirlot's *El arte otro*; and also, translated by Aldo Pellegrini: *Antologia de la poesia surrealista*, Buenos Aires, 1961.

45 *A Noble Andean Art*, cat. Museo Chileno de Arte Precolombino, Santiago de Chile, pp. 72–3, no. 0780: *Khipu*, Camelid fibres, Inca, 1470–1532 AD; main cord length: 168 cm.

According to the museum's catalogue this *quipu* was excavated from an Inca cemetery in Mollepampa, a location in the valley of the Lluta River, near what is now the city of Arica. Seven white cords without knots, joined to the main cord by a red bow, divide six sets of ten groups of cords each. Towards the end of the instrument, ten white knotless cords can be seen, with the exception of one which has only one knot. The *quipu* ends in eleven sets of cords. These sets of cords, each one with knots, are formed by a main cord from which other secondary ones derive, which sometimes give origin to others of a third category. The location of these sets and that of the cords and knots within, the way of twisting each cord and the colours used, are part of a symbolism which has still not been completely deciphered. Until now we know only that the pattern of knots used the decimal system accordingly to their position on the cord. It seems that the colours encoded non-numerological information.

46 Kurt Schwitters said: 'I let nonsense interact with sense. I prefer nonsense, but that is a purely personal matter. I feel sorry for nonsense, since, so far, it has rarely been formed artistically. Therefore I love nonsense' (see Ernst Schwitters, *Kurt Schwitters – Father of Merz – My Father*, p. 141).

47 *Merz = Kurt Schwitters*, Karnizawa, The Museum of Modern Art, Seibu Takanawa, Tokyo, October–November, p.83; Ernst Schwitters, *Kurt Schwitters*, p. 142.

48 Werner Schmalenback, *Kurt Schwitters*, Cologne, 1967, p. 93. *Merz* is the second syllable of *Kommerz* (commerce). The name originated from the *'Merzbild'*, a picture in which the work *'Merz'* could be read in between abstract forms.

> When I first exhibited these pasted and nailed pictures with the *Sturm* in Berlin, I searched for a collective noun for this new kind of picture, because I could not define them with the older conceptions, like Expressionism, Futurism or whatever. So I gave all my pictures the name *'Merz*-pictures' after the most characteristic of them and thus made them like a species. Later on I expanded this name *'Merz'* to include my poetry (I had written poetry since 1917), and finally all my relevant activities.

49 Some remains of the German language still pop up daily in Chilean Spanish. The most remarkable example is the word *'ya'*, which means 'already now' in Spanish, 'yes' in German, and 'yes, already' or 'yes, instantly' as a contraction of both meanings in Chilean Spanish.

50 During the nineteenth and twentieth centuries several presidents eventually wielded a concrete policy of 'germanization' and facilitated the German immigration to the South of Chile so-called 'in order to bring prosperity to a forsaken land and to improve the Indian race'. Thus they were encouraging the 'populating' of the provinces south of the Araucania (Valdivia, Osorno, Llanquihue) by taking the land from the Mapuche. During the Second World War a German fascist presence in the South of Chile was evident through the existence of support groups for the Nazis (two National Socialist Parties) and after the war this presence was enforced by the arrival of exiled and former Nazis, from whom it is known by now that they participated in the dictatorship of General Pinochet.

51 The grandfather of Vicuña, who was the writer and civil rights activist and lawyer, Carlos Vicuña Fuentes (Dean of the University of Chile and Deputate to the Chilean Parliament), had received in his home a group of refugees from the Spanish Civil War. Among the refugees were the playwright José Ricardo Morales and the editors Arturo Soria and Carmelo Soria, who was later murdered by the secret police of Pinochet. These men and their families became part of Cecilia Vicuña's family and education. It should be remembered here that the Nazis were also instrumental in the rise of Franco and the defeat of the Spanish Republic. Carlos Vicuña Fuentes was made an 'honorary Jew' by the Jewish community in Santiago as a result of his anti-fascist activities.

52 Members of the Neo-concrete group were: Lygia Clark, Hélio Oiticica, Lygia Pape, Amilcar de Castro, Franz Weissman, Reynaldo Jardim, Theon Spanudis, the poet Ferreira Gullar and the art critic Mario Pedrosa.

53 Reproduced in Ronaldo Brito, *Neoconcretismo, vertice e ruptura*, Funarte, Rio de Janeiro, 1985, pp. 12–13; reprinted in French translation in *Robho*, no. 4, and in English translation in *October*, 69, Summer 1994, pp. 91–5.

54 Guy Brett, 'Lygia Clark. The Borderline between Art and Life', *Third Text*, I, Autumn 1987, pp. 65–94.

55 Lygia Clark, 'Nostalgia of the Body', *October*, 69, Summer 1994, p. 106.

56 Isso é a grande diferença para a expressão européia e americana do norte: a tal *povera arte* italiana é feita com os meios mais avançados: é a sublimação da pobreza, mas de modo anedótico, visual, propositalmente pobre mas na verdade bem rica: é a assimilação dos restos de uma civilização opressiva e sua transformação em consuma, a capitalização da idéia de pobreza. Para nós, não parece que a economia de elementos está diretamente ligada à idéia de estrutura, à não-técnica como disciplina, à liberdade de criação como a supra-economia, onde o elemento rudimentar já libera estruturas abertas.
> (Lygia Clark e Hélio Oiticica, Funarte, Sala especial do 9. Salão Nacional de Artes Plásticas, Rio de Janeiro, 1986–7)

57 Ibid. p. 75.

58 Ibid.

59 *Lo nunca projectado* is the title of an album of poems by Alfredo Silva Estrada and illustrations by Gego (1964).

60 *La bruja* consisted of 2,500 km of white cotton thread unrolled in a fortuitous way through every single space all over the three floors of the Biennal building to end up at a broom placed in a little store-room near the toilets.

61 For the installation work by Marcel Duchamp see: Benjamin H.D. Buchloh, 'The Museum Fictions of Marcel Broodthaers', in *Museums by Artists*, ed. A.A. Bronson and Peggy Gale, Art Metropole, Toronto, 1983. 'Vintage cobweb? Indeed not!' Duchamp was reported to have said.

62 Exhibition of Cecilia Vicuña in the series, 'Inside the Visible. Begin the Béguine' organized by the Kanaal Art Foundation as Cultural Ambassador of Flanders (1 October–11 December 1994).

63 Berlo, 'Beyond Bricolage', p. 453.

64 Lygia Clark, 'Nostalgia'.

65 Bracha Lichtenberg Ettinger, 'Matrix and Metamorphosis', in *Differences: A Journal of Feminist Cultural Studies*, vol. 4, no. 3, Indiana University Press; 'The Becoming Threshold of Matrixial Borderlines', in *Travellers' Tales*, Routledge, London, 1994; 'The almost-missed encounters as eroticized aerials of the Psyche', in *Third Text*, vol. 28/9, 1994.

66 Griselda Pollock, 'Oeuvres autistes' in *Versus 3*, 1994, pp. 14–18.

67 Ibid.

68 Claude Lévi-Strauss, *The Savage Mind*, University of Chicago Press, 1966, p.21.

69 Naomi Lindstrom 'Xul Solar: Star-Spangler of Languages', in *Review 25/26, Latin American Literature and Arts*, p. 121.

Chapter Twelve

'Resting' in history:
translating the art of Jin-me Yoon

Brenda Lafleur

Jacques Cartier, landing on the shores of Canada in 1534 was greeted by Iroquois Indians. When he asked them 'Where am I?' the answer was 'Ka-na-ta', which was translated to mean 'rest in my home'.

This story of history, taught to schoolchildren in Canada when I was growing up, never acknowledges the possibility of mistranslation – that the Iroquois' use of the word 'rest' may have meant a kind of 'sit down, we'll fix you a bite to eat, and then be on your way'. Unfortunately for the Iroquois, Cartier's translation of the word 'rest' focused on a kind of 'unload your boats, take over our land, and why don't you invite all of your friends to settle here as well'. *The Oxford English Dictionary* defines the word 'rest' as including both the idea of 'pausing' as well as that of 'ceasing from movement'. Yet it is the latter that has determined the official 'History' of Canada.

This tale of translation introduces my main argument – that the forging of a Canadian national identity was based on a privileging of Cartier's idea of 'rest' as a 'fixing on the land'. The land and its attendant notion of progress being a conquering and settling of the land was an important ideological vehicle in this project. It is an idea which requires, like all hierarchical binaries, the violent exclusion of the second term, in this case the non-fixed, the non-unified, the unstable. According to Jacques Derrida: 'In a classical philosophical opposition we are not dealing with the peaceful coexistence of a vis-à-vis but rather with a violent hierarchy. One of the two terms governs the other ... or has the upper hand'.[1] That the non-white, non-western-European immigrant of Canada is imbricated on the side of the non-fixed is an example of what Gayatri Chakravorty Spivak characterizes as the quintessential gesture of hegemony – the epistemic violence that effaces the colonial subject and requires that subject to occupy the space of the imperialist's self-consolidating 'Other'.

I want to interrogate the binary of fixed/unfixed within a specific period in the canon of Canadian art history, the inter-war years, a period in which the project of Canadian nationalism was intense and in which a group of artists known as the Group of Seven played a key role. Their work will be read in light of the art practice of a contemporary Canadian artist, Jin-me Yoon. I will argue that Yoon uses the tools of deconstruction to demonstrate the instability of this 'reality' of 'Canada' and how this nationalist project concealed its own material and historical construction.

One of the most pervasive myths about Canada is that it is a country which embraces its *lack* of fixity. We describe ourselves as multi-cultural, as a 'mosaic' of equally valued cultures. In the words of Margaret Atwood, the immigrant faces a situation in which 'there is no new "Canadian" identity ready for him to step into: he is confronted only by a nebulosity, a blank; no ready-made ideology is provided for him'.[2] Canadians have been described as living in 'Notland, where being Canadian means not being someone else – not English not American, not Asian, not European'.[3] 'It is easier', noted Vincent Massey, 'to say what Canada is not than what it is'.[4] But, as Derrida and Jacques Lacan note, to define oneself by what one is not *is* how subjectivity is formed.

Figures 12.1 Jin-me Yoon,
Souvenirs of the Self, 1991,
installation at Edmonton Art Gallery.

Collection of Walter Philips Gallery,
the Banff Centre for the Arts,
Banff, Alberta, Canada

And if, as Louis Althusser asserts, the power of ideology comes from its seeming absence, it is this invisibility of the construction of a Canadian national identity which has allowed it to colonize the norms of race, class and gender.

Thus a particular ideological and political hegemony was produced and reproduced throughout the history of the country by various economic, social and political discourses. For example, the desire to build a nation that would preserve and reflect the social and political system of the United Kingdom translated into an ideology that settlement on the land was the right of only those immigrants of western European origin.[5] The way these discursive forces historically and socially controlled and imaged the land secured the means to establish a very specific Canadian identity. This was particularly evident in the inter-war years, when discriminatory practice was at its height. It was during this period that the art practice of the Group of Seven was forged, fostered and used as a symbol for Canadian nationalism.

Various political and cultural institutions supported the Group and saw a way to tie their own nationalist economic and political agendas to the Group's work. The National Gallery of Canada wanted to wrench control away from the hands of the conservative Royal Canadian Academy in order to establish itself as *the* national art institution. By purchasing the Group's work, touring their exhibitions across Canada, supporting lecture tours, and publishing their catalogues, the Gallery found and fostered the perfect vehicle to do so.

The Canadian government was seeking to establish its own power apart from that of Britain and change its status from a feminine 'colony' to a masculine 'nation'. The association of the land and the paintings of the Group of Seven with a masculine ruggedness served to establish 'difference' from Britain and counter the British colonialist rhetoric of cultural and national superiority, without compromising the desire for white western European immigration. The appeal to the mythology of the northern landscape, and its attendant qualities of the courage, tenacity and strength of the Canadian settler in the Group's work, established a binary between Canada and England. The New World is set against the Old World in gender-related terms: the rough landscape versus the softer, mistier landscape. Britain itself was not opposed to the use of nationalist fervour to expand settlement in western Canada, as its domestic economic growth had stagnated and it was seeking new markets to expand into.

The art practice of the Group of Seven was used by these institutions as a vehicle to impose a vision of the country on the country. It was also supported by the Group's own moves to assert themselves as discoverers of the 'real' Canadian landscape and to tie their 'empty landscape tradition' to the male 'bush-whacking' artist who would 'capture' that landscape in his art. They presented themselves as explorers, untainted by imported artistic styles and conventions and representing the *new* national spirit. Unspoiled nature had to be seen to be conquerable and this was achieved in their work by the assertion of artistic mastery by the male artist.[6]

The Group attempted to construct 'Canada' using a binary of fixed/non-fixed and the linking of the fixed with the settled, the conquered land and the white male settler; while the unfixed became synonymous with the unsettled, unconquered land and the non-settler, whether female or non-white, non-western-European male. Using the tools of deconstruction, the work of Jin-me Yoon disrupts the nationalist narrative offered by the Group of Seven and displaces its assumption of fixity. 'Canada', as a set of discourses presenting and inscribing reality, is interrupted by Yoon's installation of *Souvenirs of the Self.*

The installation includes large colour photomurals of herself positioned within various western Canadian landscapes, one of which is reproduced here (Figure 12.1). In it she is positioned on a rock ledge in front of a lake in the Rocky Mountains of Alberta. On another wall of the gallery hangs Lawren Harris' *Athabasca Valley, Jasper Park* (1924) (Figure 12.2). The Harris work was borrowed from the Edmonton Art Gallery's permanent exhibition on the canon of Canadian art. Beneath the Harris painting Yoon has inscribed sentences in Japanese, Chinese and Korean.

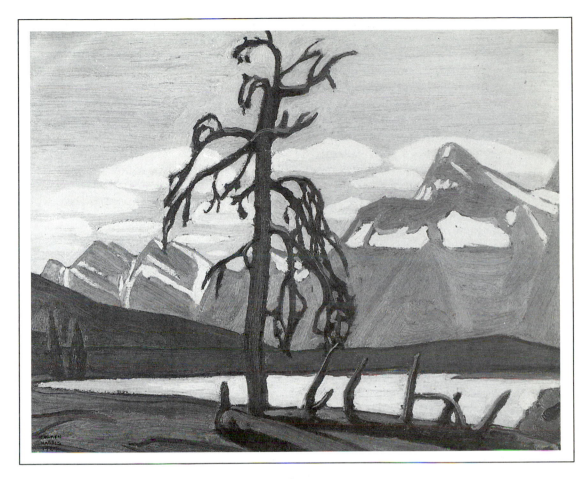

Figures 12.2 Lawren Harris, *Athabasca Valley, Jasper Park*, 1924.
Edmonton Art Gallery collection, Gift of the Ernest Poole Foundation, 1975, Canada

The practice of deconstruction is dependent on a method of reading which no longer assumes that the 'text' has a single essential centre upon which meaning ought to converge, or even upon which the interpretations of different critics ought to converge. As a proponent of deconstruction, Jacques Derrida conceives of meaning in a way that does not involve a movement from marks on the page to mental contents and images. His answer to the problem of the elusive signified, the problem that there is no decisive mental content or image when we attempt to look at the meaning of a word in our minds, is to assert that the signified does not exist. Rather, it is merely an illusion that has been invented in order to avoid confronting the consequences of a materialist conception of language. Derrida's theory of language involves an unstoppable movement from signifier to signifier rather than from signifier to signified.

> The meaning of meaning . . . is infinite implication, the indefinite referral of signifier to signifier . . . its force is a certain pure and infinite equivocality which gives signified meaning no respite, no rest, but engages it in its own economy so that it always signifies again and differs.7

A deconstructivist reading of *Athabasca Valley, Jasper Park* using Derrida's words would note that, despite the intention of Lawren Harris to 'rest' the signifier (painting) within a signified 'national-

ism', the meaning of the work is never fixed. The spatial signifiers within the painting exist only in terms of an equally spatial movement running through these signifiers – 'in effect, signifying is nothing more or less than signifiers *in motion*'.[8] This is not to deny the power of representation to construct national identity, but only to signal that the readings of these works, and indeed the works themselves, have never been 'settled'. It is not possible to state *the* meaning of the work, nor is it possible to fall back on the position of multiple meanings. Meaning remains unfulfilled – constantly pointing away to another signifier, which in turn points away to another signifier and so on. Yoon's work does not undermine the fixity of *Athabasca Valley, Jasper Park* in order to posit another fixity as truth or reality, but instead simply signals undecidability and constant deferral of meaning.

Part of the project of deconstruction, according to Spivak, involves the overturning of the implicit hierarchy established in the binary to 'discover the violence'.[9] In this case, it is to show how the unfixed is already a part of the fixed. Yet simply to reverse the opposition of fixed/unfixed, Canadian/Asian, male/female falls into a number of traps – the constitution of the second part is still determined according to the terms of the original opposition and remains caught within the very binary that is being disputed. Thus, a deconstructive move must displace as well as reverse the opposition in order to provide a position for critical intervention.

This is done, as Derrida sets it out, but inscribing one's own practice at the place of 'indecidables'. These indecidables mark the oppositions and relate different oppositions to one another. They seem to raise the possibility of turning in either direction yet do not assume the position of either side. In effect, they bear the character of neither-nor/either-or. I want to suggest that Yoon inscribes her work at the point of indecidables and that we can note the deconstructive indicators and their inscription. Deconstructive indicators have been described as linking one side to another, serving as the hinge between – bringing together and at the same time separating off the two.[10] Examples of deconstructive indicators can be traces, borders, margins, blanks and edges.

Souvenirs of the Self can be read as a text in which deconstruction operates. As such it is possible to assess the markings that act as deconstructive indicators of the metaphysical thinking informing the work of the Group of Seven. These indicators act to disrupt the binary of fixed/non-fixed and a host of binaries which 'rest' upon this opposition – northern/southern, male/female, Canadian/non-Canadian, settler/migrant, Self/Other, unity/diversity, home/not-home.

The Scandinavian sweater that Yoon wears in the photograph acts as a deconstructive indicator. It marks the border between her body and the northern landscape. It signifies the 'northernness' of the Group of Seven paintings yet is worn by a woman of South Korean heritage. She literally juxtaposes the 'northernness' of the sweater with the western blue jeans and their attendant notions of pioneer cowboys and pioneer spirit, and then places them on a body of constructed 'Otherness'.

The idea that Canada's unique character derives from its heritage of northern races is a recurrent theme in Canadian history. That this character was linked to the masculine side of the binary is clear. 'Northern' was tied to strength, hardness, self-reliance and masculinity while 'southern' was equated with degeneration, deterioration and effeminacy. What is also clear is that these 'northern' characteristics were believed to be prerequisites for settlement and fixity on the land. In 1948 Vincent Massey stated that 'the vast majority [of Canada's population] springs either from the British Isles or Northern France, a good many, too, from Scandinavia and Germany, and it is in northwestern Europe that one finds the elements of human *stability* highly developed.'[11]

The ideology of northern distinctiveness became central to the production of works by the Group of Seven, who became collectively known for their images of the 'North'. They were determined to express the essence of Canada through its landscape and to focus on its 'northernness'.

For Lawren Harris, this ideology was compounded by the theosophist view that a spiritual, cultural and aesthetic renaissance would come from the 'North'. By the 1920s, Harris had begun to embrace these formulations of art and nationalism in his paintings and writings. The 'North' would

bc instilled into the work's outlook by, according to Harris, 'the bodily effect of the very coolness and clarity of its air, the feel of soil and rocks . . . from its clear skies, great waters, endless little lakes, streams and forests, from snows and horizons of swift silver'.[12] These features can be noted in *Athabasca Valley, Jasper Park* – a frozen silver lake, rugged snow-capped mountains, clear icy blue skies, clouds that have the mass and denseness of snow. The whole surface of the painting is smoothly finished as though enclosed in ice.

Athabasca Valley, Jasper Park is made into a signifier of an unspoiled, untouched place, a missing unity. Harris believed that he could transcend social reality in his art by reducing forms to transcendental ones. In many of his paintings, Harris strips the subject matter of a sense of its locale and its material texture in order to reveal its 'underlying truth' and attain 'pure, universal form'. Harris produces 'Canada' as a 'painting', that is, as a signifier which implies the signified as a unified and organic entity capable of being desired. *Athabasca Valley, Jasper Park* works as a fetish object – one which continues to reproduce itself as the object of desire through the production of particular mythologies of stability, unity and wholeness.

The lone pine acts as a signifier of the missing unity. The image of the single tree became associated with the works of the Group of Seven, particularly through Tom Thompson's *The Jack Pine* (1916–17) and *The West Wind* (1917). The symbolic isolation of the lonely, heroic, weather-beaten tree in the Group's paintings came to be accepted as a self-evident and non-contradictory symbol of Canadian nationalism.

In *Souvenirs of the Self*, Jin-me Yoon's insertion of her body into the photograph in place of the tree acts as a deconstructive indicator. That the figure of a South Korean woman should stand in place of a 'universal' form introduces slippage into that originary attempt to fix the meaning of the word 'universal' within a discourse of 'northernness'. Her controlled pose mimics that of the tree and recalls the fixity that the tree is meant to signify in the Harris painting. Yet at the same time the figure is Canadian/non-Canadian, Asian/non-Asian and is therefore an indecidable. By replacing the lone pine of the Harris work by the figure of an Asian woman, Yoon makes visible the power of the nationalist project to construct and foster 'Otherness'.

The lake in the photograph inserts another indecidable into the northern/southern binarism. It disrupts the appeal to unity and stability in the Harris work. It is not the solid, frozen and fixed lake of the Harris painting but is not fluid water either. Is it on its way to freezing over or is it melting? The melting/freezing lake is representative of a marking point where conventional historiography attempts to conceal its own failure.

Yoon places herself on a spot where capitalism and imperialism used the labour of Chinese workers in the mines to build the most dangerous expanses of the railroad through the western mountains in order to construct a 'Canada' and then made that labour invisible within national symbols.[13] The Group's paintings fail to confront the issue of the brutal violence that was used by the white population to wrest control of the land. *Athabasca Valley, Jasper Park* is framed in a way that elides any evidence of the aboriginal peoples who had been 'settled' in the area for centuries and emphasizes a vision of the area as an empty untamed wilderness.

In this way, the spatial structure of the Harris painting concurs with the dictionary definition of the word 'space' as 'a blank portion or area' or 'an unoccupied area'. Yet 'spaces', 'blanks' and 'unoccupied areas' *do* create meaning. Power relations are always implicated in spatial practices; they are significant vehicles for the coding and reproduction of social relations. As Pierre Macheray notes:

> What is more important in a work is what it does not say. This is not the same as the careless notation 'what it refuses to say', although that would in itself be interesting: a method might be built on it, with the task of *measuring silences*, whether acknowledged or unacknowledged. But rather this, what the work *cannot* say is important, because there the elaboration of the utterance is carried out, in a sort of journey to silence.[14]

Spivak responds to this by stating: 'Although the notion "what it refuses to say" might be careless for a literary work, something like a collective ideological *refusal* can be diagnosed for the codifying legal practice of imperialism.'[15] *Athabasca Valley, Jasper Park* can then be read as a painting of 'silences'. Yoon's intervention 'measures the silences' of the seeming emptiness of the Harris work. The gaps in *Souvenirs of the Self* make explicit what is implicit in the painting of the Group of Seven – a hegemonic discourse of racism, capitalism and patriarchy.

Yoon's position on the edge or gap points to this aporia – this blind spot where understanding and knowledge are blocked. Spivak writes that 'between patriarchy and imperialism, subject-constitution and object-formation, the figure of the woman disappears.[16] Yet Yoon does not place herself within the frame to retrieve the 'Asian woman' as a singular monolithic subject or to offer a counter-history by making her the subject of her own history, but rather to look at the points of location and inscription of the subject-positions which were conferred and to note the subject-effects of such constructions. Yoon traces the problems inherent in fixing such a signifier as an object of knowledge.

The flatness with which the image of *Athabasca Valley, Jasper Park* is rendered attempts to represent a system where there are no internal gaps into which meaning can disappear and no surrounding void in which meaning can disperse. Even the fact that the subject matter is a western Canadian landscape refers to the triumph of nationalism – the linking of all parts of the country into an unbroken chain by the railroad. The Harris painting can be likened to a structuralist system in which meaning will 'rest' upon its difference from other images. It is significant that the dictionary definition of the word 'rest' includes the notion of 'leaning up against . . . resting upon' – a notion that the structuralist system of meaning depends upon. For structuralist writers such as Saussure words are not settled, fixed or stable by themselves but stand still and stable by leaning up against other words. Saussure's system remains in balance as long as words push against each other at exactly the same time – there are no internal gaps to give words room for falling and no surrounding void to give words room for dispersing.[17]

Derrida dispenses with Saussure's concept of a total simultaneous system. In a Derridean system, words do not push against one another at the same time, they push successively in a kind of causal chain, creating gaps and 'toppling one another over like lines of falling dominoes'.[18] These gaps and voids are highlighted in *Souvenirs of the Self* and point to the dispersal and ultimate denial or disappearance of fixed meaning. The opposition between such binaries as fixed and unfixed, Canadian and non-Canadian, northern and non-northern are unbalanced in a way that Derrida has described as '*without ever* constituting a third term, without ever leaving room for a solution in the form of speculative dialectics'.[19] The figure in the photograph of *Souvenirs of the Self* is positioned on a built rock ledge that is ground/not-ground – overhanging the lake but not a part of it. The gap between the ground and the lake is a place of deferral and displacement – it is the place of Heidegger's *Unheimlichkeit*, 'not-at-homeness'.

Yoon's hieratic pose in the tightly controlled and framed photograph mimics the 'lone pine' tradition and yet inserts a Derridean unstoppable movement of signifiers. This trope of constant movement and deferral assists in the project of de-essentializing author, text and reader. By juxtaposing *Athabasca Valley, Jasper Park* with the photograph she asserts the forced mobility of Asian immigrant workers into the painting and ruins the representative narrative of fixed national identity forged in the Harris work. The landscape in the Harris work then becomes a signifier which enters into a Derridean movement from signifier to signifier, in much the same way that the Asian migrants who worked on that land were barred from settlement and forced to continually move.

The untranslated Japanese, Chinese and Korean words on the wall near the Harris painting in *Souvenirs of the Self* also point to the silences and gaps of understanding. The usual role of text as a form of communication is inverted. The text instead stands as a marker of non-communication

– of the gap between the east and west, the white settler and the non-white migrant worker. While the sentences are fixed in space on the wall they represent the unknowability, the deferral of meaning. The words act as a hinge between the Harris painting and the photograph, becoming metonymic indicators of the erased Other, of cultural difference.

The sentences also act as indecidables in their deconstruction of the notion of 'home'. The project of nationalism was based on making a 'home' on the land; of asserting public settlements onto private unpopulated terrain. Yet 'home' falls on the 'fixed' side of the binary and thus the notion of turning the land into a 'home' was allowed only to a racially specific group of immigrants. Jacques Cartier's response to the Iroquois statement 'rest in my home' was to colonize the notion of home for white settlers. The Group of Seven's statement accompanying their first exhibition in 1920 – 'The great purpose of landscape art is to make us at home in our own country'[20] – was similarly racial- and gender-specific in terms of who landscape art was to make a home for. In *Souvenirs of the Self*, the writing on the wall beneath the Harris painting disrupt the conflation of 'home' with the white immigrant. The translated words read 'We are also keepers of the land' and 'This land is also our home'.

The use of photography in *Souvenirs of the Self* disrupts the modernist privileging of painting over photography. The art of the Group of Seven can be located within the modernist claims for personal expression and universal understanding based on the 'gesture'. Because landscape was the chosen subject on which the Group imbricated national identity, it was necessary for them to differentiate their work from that produced by photographers, whose landscape images had been so important in the nationalist project of the late nineteenth and early twentieth century. Peter Wollen points out that one of the responses to advances in photographic techniques was for painting to embrace a Kantian perspective and emphasize the subjective and the intuitive.[21] The Group emphasized artistic expression and the ability of their work to signify the 'essence' of Canada rather than simply 'record' the Canadian landscape.

Modernist ideas of individual artistic creativity and the concept of the artist as a free, autonomous, creative individual is inverted by Yoon. She poses in the landscape, a present-day tourist area, and has a friend take the picture for her. By not taking the photograph herself, she subverts the myth of the modernist artist that the Group of Seven espoused. The work has no illusions of capturing an 'essence' – the figure is obviously posed rather than 'caught' in action.

The denigration of photography by the Group of Seven as either simple recordings of the land or tourism snaps is inverted in *Souvenirs of the Self*. The photographs evoke the sort of 'holiday snaps' that fill personal photo albums. They were also reproduced by Yoon and sold as a series of postcards in the Edmonton Art Gallery shop. Yet, in the gallery, the large scale of the photographs (245.5 x 183 cm) confronts the smaller size of *Athabasca Valley, Jasper Park* (26.7 x 35.2 cm). The mass-produced 'postcard' is here given prominence, inverting the original hierarchy.

By playing on the discourse of tourism photography, Yoon makes explicit what was implicit in the Group of Seven works – that despite their pretence of producing transcendental symbols of Canada, their paintings were commodities. They were used by the government and railroad companies to foster tourism and settlement in the western lands that they owned. The Group constructed a 'Canada' that then entered into the capitalist system of consumption and exchange.

Yoon's work is deconstructive in that received history is tampered with – not to invite us to see from the perspective of the Other, but simply to mark the points at which this received history becomes unfixed. The attempt by Harris to 'fix' history in the painting is ultimately undermined by inserting it within a matrix of associations in *Souvenirs of the Self*. The photograph by Yoon, which to a certain extent mimics the landscape shown in the Harris painting, raises a number of questions: Who can claim a national identity? Who can occupy space? Whose history is being represented and canonized in the Harris work?

Thus the apparent closure which the simple binary of fixed/unfixed effects in the Harris work becomes unstuck in the Yoon work. It becomes unstuck at the point where the violent hierarchy that has historically been at the centre of Canada's definition of itself as a 'multicultural' country is noted. Yet my adoption of a deconstructive approach to 'translate' the work of Lawren Harris and Jin-me Yoon is itself subject to the pitfalls of translation that this article began with. It may even have, depending on the reader's perception of my particular translation, enacted its own form of violence. For example, it is difficult for me to reconcile my use of post-structuralist discourses which undermine the idea of a unitary Subject, when today, in Canadian law courts, the legitimacy of land right claims by Aboriginal peoples is turning on just such ahistorical conceptions of culture and essentialist notions of identity. I must ask myself whether my deconstructive reading allows these groups no room for agency. As a feminist critic I am caught in the uneasy position that Spivak describes: 'The radical critic in the West is either caught in a deliberate choice of subalternity, granting to the oppressed either that very expressive subjectivity which s/he criticizes, or instead a total unrepresentability.'[22]

Yet it is precisely this commitment to feminism and to my role as a feminist art historian which forces me to examine the moves that are made for me and also by me in order to create meaning, with the processes and structures which facilitate the power of discursive knowledge. While it is a use of 'history', I do not share the empiricist's confidence in the knowability of a 'real' history outside or even including these texts and contexts or the desire to describe things 'as they really were'. Rather, I wish to explore how a particular narrative of reality was established as the normative one. I use a problematized 'history' to contest the more dispersed implications of the system of which I necessarily form a part; to interrupt this meta-narrative of referential truth and reality. I share with Spivak the desire to preserve the discontinuities between discourses and to exploit their ambivalence, to position myself in an equally ambivalent relation to these discourses.

It is as a feminist critic that I approach the canon of Canadian art history to challenge the central categories and assumptions of this work by Lawren Harris and the way that its particular nationalist paradigm constructs, intersects and complicates gender, class and racial subjectivities, my own included. I want to unfix the frame, so to speak, in order to reveal the gaps in which political intervention can occur, so that meaning does not 'rest' in History, but rather will pause, in the sense that the Iroquois may have meant it, on a provisionally framed meaning and then move on.

Notes

1 Jacques Derrida, *Positions*, trans. Alan Bass (Chicago: University of Chicago Press, 1981), 43.
2 Margaret Atwood, *Survival* (Toronto: House of Anansi, 1972), 150.
3 Tony Wilden, *The Imaginary Canadian* (Vancouver: Pulp Press, 1980), 2.
4 Vincent Massey, *On Being Canadian* (Toronto: J.M. Dent, 1948), 27.
5 Canadian immigration laws stressed the importance of settlement – that the immigrant must be able to adapt to the Canadian landscape in order to settle. The non-western-European immigrant was believed to be inherently incapable of adapting and therefore incapable of settlement.
6 Natalie Luckyj, *Visions and Victories: 10 Canadian Women Artists 1914–1945* (London, Ontario: London Regional Art Gallery, 1983).
7 Jacques Derrida, *Writing and Difference*, trans. Alan Bass (Chicago: University of Chicago Press, 1978), 25.
8 Richard Harland, *Superstructuralism: The Philosophy of Structuralism and Post-Structuralism* (London: Routledge, 1987), 135.
9 Gayatri Chakravorty Spivak, 'Criticism, Feminism, and The Institution', in *The Post-Colonial Critic: Interviews, Strategies, Dialogues*, ed. Sarah Harasym (New York: Routledge, 1990), 8.
10 Hugh Silverman, 'Writing (on Deconstruction) at the Edge of Metaphysics', *Research in Phenomenology*, vol. 13 (1984): 109.
11 Vincent Massey, *On Being Canadian* (Toronto, 1948), 29–30 (italics mine).
12 Lawren Harris, 'Revelation of Art in Canada: A History', *The Canadian Theosophist* (1926), 86.

13 Near to the site that is depicted in *Athabasca Valley, Jasper Park* was the coal-mining town of Bankhead where Chinese workers were segregated to live apart from the town while those of British background held managerial positions and lived in the town.

14 Pierre Macheray, *A Theory of Literary Production*, trans. Geoffrey Wall (London: Routledge, 1978), 87.

15 Gayatri Chakravorty Spivak, 'Can the Subaltern Speak?' in *Marxism and the Interpretation of Culture*, ed. Cary Nelson and Lawrence Grossberg (London: Macmillan, 1988), 286.

16 Ibid., 306.

17 Harland, *Superstructuralism*, 136.

18 Ibid, 137.

19 Jacques Derrida, *Positions*, trans. Alan Bass (Chicago: University of Chicago Press, 1981), 43.

20 Quoted in Terence Heath, 'A Sense of Place', in *Visions: Contemporary Art in Canada* (Toronto: Douglas & McIntyre, 1983), 46.

21 Peter Wollen, 'Photography and Aesthetics', *Screen* 19, no. 4 (Winter 1978–9).

22 Gayatri Chakravorty Spivak, 'Subaltern Studies: Deconstructing Historiography', in *In Other Worlds: Essays in Cultural Politics* (New York: Methuen, 1987), 209.

Embodied geographies:

subjectivity and materiality in the work of Ana Mendieta

Anne Raine

INTRODUCTION

In her work of the 1970s, the Cuban-American artist Ana Mendieta enacted a series of private rituals which she called 'a dialogue between the landscape and the female body'.[1] Working at outdoor sites in Mexico and Iowa City, she used materials such as earth, sand, stones, water, gunpowder, fire, plants, flowers, trees, blood, human hair, and her own body, tracing and retracing her silhouette on the landscape, mapping its outlines onto and into the earth: attending, discerning, digging, moulding, carving, burning, exploding, plucking, scattering, arranging, and occupying space along the visible and tactile boundaries between the body and the land. Mendieta wrote of this work:

> Through my earth/body sculptures I become one with the earth. . . . I become an extension of nature and nature becomes an extension of my body. This obsessive act of reasserting my ties with the earth is really the reactivation of primeval beliefs . . . [in] an omnipresent female force, the after-image of being encompassed within the womb.[2]

What remains of this intimate practice is a series of photographs and films, optical indexes of concrete meditations; their power draws on other registers of sensory and psychic experience than those organized around vision. Viewed as a series of memory-traces, the inscriptions of the female body through which Mendieta traced her urgent and tentative itinerary are both repetitively familiar and strangely disquieting.

Lucy Lippard has written that visiting ancient stone circles and other prehistoric aesthetic-symbolic sites prompted her 'to perceive places as spatial metaphors for temporal distance', and to consider how this dialectic between space and time might relate to 'the crucial connections between individual desires (to make something, to hold something) and the social values that determine what we make and why'.[3] Lippard's question draws together landscape and history, the psychic and the social into two axes across which I want to read Ana Mendieta's *Silueta* series (Silhouette series) and *Serie árbol de la vida* (Tree of Life series).[4] Using Freud's notion of the uncanny and Bracha Lichtenberg Ettinger's theory of matrixial subjectivity, I want to attend to Mendieta's images and their 'dark, incantatory power',[5] and to read her negotiation of the traditional association between woman and nature for the insights it might provide into something like a politics of space for the 1990s.

In the late twentieth century, we are dealing on a global scale with the personal, social, political and environmental aftermath of colonial imperialism and the industrial revolution. The feminist Christian theologian Sallie McFague argues that these crises demand an ethical and conceptual paradigm that takes seriously the concepts of embodiment, space and place; in her view, 'Geography,

often considered a trivial subject compared to the more splendid history (the feats of the forefathers) may well be *the* subject of the twenty-first century'.[6] I am not arguing against the strategic possibilities of what Donna Haraway calls cyborg politics,[7] and I agree with Haraway that we technological sceptics may need to rethink our notions of the body and space in order to deal effectively with the postmodern world of new biotechnologies, microelectronics, telecommunications and cyberspace, and transnational capital. I am arguing, though, that in such times and spaces it seems all the more urgent, personally and politically, to find ways of being, literally, grounded. Ana Mendieta's work speaks to this desire and this political imperative.

Early in the twentieth century, D.H. Lawrence wrote a fascinating essay[8] in which he argues that the English tradition of landscape painting is rooted in anxiety about the body, and represents an escape from physicality into 'optical systems' and 'mental concepts'. Dismissing painted landscapes as 'background with the real subject left out' (139), he champions Cézanne's still life paintings as 'the first real sign that man has made for several thousands of years that he is willing to admit that matter *actually* exists' (145–6). In Lawrence's view, Cézanne wanted not to question the possibility of representation in art but rather to make art *more* 'true to life' than what Lawrence calls 'the optical vision, a sort of flashy coloured photography of the eye' (138). Lawrence defines Cézanne's project as an attempt 'to touch the world of substance once more with the intuitive touch . . . to displace our present mode of mental-visual consciousness . . . and substitute a mode of consciousness that was predominantly intuitive, the awareness of touch' (156). In Cézanne, he writes,

> modern French art made its first tiny step back to real substance, to objective substance, if we may call it so. Van Gogh's earth was still subjective earth, himself projected into the earth, but Cézanne's apples are a real attempt to let the apple exist in its own separate entity, without transfusing it with personal emotion. Cézanne's great effort was, as it were, to shove the apple away from him, and let it live of itself.
>
> (145)

Truth, for Lawrence, lies in the 'appleyness' of bodies and things, in materiality as irreducible otherness to the meanings imposed by eye and mind. 'The only bit of a woman which nowadays escapes being ready-made and ready-known cliché is the appley part of her', and the artist's model should strive to 'be primarily an apple', to 'sit still and just be physically there, and be truly non-moral', to 'leave out all your thoughts, all your feelings, all your mind and all your personality, which we know all about and find boring beyond endurance' (156–7). Lawrence continues, 'The eye sees only fronts, and the mind, on the whole, is satisfied with fronts. But intuition needs all-aroundness, and instinct needs insideness' (157). These passages raise intriguing questions, both about how a painting practice could be considered 'non-optical' and so '*more* true to life', and also about precisely how the desire for 'appleyness', or 'intuitive reality', is related to the gendering of embodied artists, models and viewers.

Lawrence says of Cézanne:

> It was part of his desire: to make the human form, the *life* form, come to rest. Not static – on the contrary. Mobile but come to rest. And at the same time he set the unmoving material world into motion. Walls twitch and slide, chairs bend or rear up a little, cloths curl like burning paper.'
>
> (158)

I am wondering what desire exactly Lawrence is talking about; and I want to read this passage as being *about landscape* – landscape understood as a way of imagining the relationship between human subjects and the physical environment. In his reading of Cézanne, Lawrence invokes a conception of landscape which gestures towards the strange combination of stillness and unsettledness in Ana Mendieta's earth/body sculptures half a century later, and in which the non-human material world is neither mere 'background' nor a 'subjective earth' infused with the artist's personal

emotions. This is not only a question of painting or other avant-garde practices, but also a psychic as well as a social, political and ecological question. It can be separated neither from issues of gender and the formation of subjectivity, nor from concrete political struggles: as Oriana Baddeley and Valerie Fraser argue in their study of contemporary Latin American art, 'Landscapes, whether or not they are populated, are about land and land use, space, frontiers, boundaries, territories.'[9]

Lucy Lippard and others have located Mendieta's practice in relation to other feminist artists of the 1970s who reclaimed goddess imagery and a celebratory identification with nature. The Cuban art historian Gerardo Mosquera, focusing on Mendieta's Cuban roots, has read in her work both 'a harmonious coexistence of Man and his landscape' and 'a return to one's origins'.[10] More recently, Mendieta's work has been discussed within debates about diasporan identity and cultural politics. In a 1989 article, Luis Camnitzer attributes her success in the 1970s to a misreading of her work as 'a programmatic expression of feminism enhanced by a U.S. perception of mysterious exoticism', rather than as 'much more simply and modestly, a self-portrait'.[11] It seems to me that all of these readings turn on the crucial question of the relationship between human subjects, individually and collectively, and something I have been calling *whatever else there is*: the maternal body, the imaginary self, social and cultural Others, landscape and 'nature', the Real. Ana Mendieta distilled into deceptively simple images a number of complex and urgent questions of aesthetic-symbolic production,[12] subjectivity, gender, the body, cultural identity, and what we now call 'the environment'. I want to think of her work as inscribing not female or 'natural' essences, but a gendered physicality, memory, desire and representation, across a concrete material terrain always already marked by politics and history. In my view, Mendieta's work does represent an engagement with self-portraiture, but one that is not at all simple, and is crucially involved in what I am thinking of as a diffuse and multi-levelled problematic of figure and ground.

LANDSCAPE

In *The Culture of Nature*, Alexander Wilson defines landscape as not only an art genre, but a complex discourse socially produced through multiple practices and productions, from abstract attitudes and values to concrete buildings and spaces.

> The way we produce our material culture – our parks and roads and movies – is derived from and in turn shapes our relationships with the physical environment. I call all of this activity *landscape*. . . . In the broadest sense of the term, landscape is a way of seeing the world and imagining our relationship to nature. It is something we think, do, and make as a social collective.[13]

The dominant discourses of landscape in late twentieth-century North America have a history which can be traced as far back as the shift from ancient earth-centred goddess cults to patriarchal religions, but is also closely related to the development of 'natural science' in sixteenth- and seventeenth-century Europe. As Carolyn Merchant argues in *The Death of Nature*,[14] the revolution in European science coincided with a paradigm shift in which 'nature' ceased to be regarded as a nurturing mother and living organism, and became instead an orderly system of inert particles moved by external rather than internal forces. This change from 'organismic' to mechanistic constructions of nature both enabled and was demanded by changing agricultural, industrial and commercial practices, which required a different conception of the relationship between human goals and values and the material world. Unlike the personification of the earth as mother, which provided some moral restraint against wholesale plundering of nature's resources,[15] the mechanistic model constructs nature as an object of knowledge, mastery and improvement by human reason and technology, and so facilitates resource extraction, industrial development, and social and ecological disruption on an unprecedented scale. 'Landscape' as a fine-art genre increased in importance

and popularity during the increasing hegemony of scientific discourses and industrial capital; within the dominant paradigm, physics and ethics were worlds apart, and by the late nineteenth century, the concerns of 'landscape' could be theorized as neither moral nor political, but optical effects of light, shade and colour – or in D.H. Lawrence's polemical phrase, 'delicious nowhereness'.[16]

Mechanistic discourses of landscape produced not only landscape painting as art-for-art's sake, but also the bleak topographies of the twentieth century: drained wetlands and deforested hillsides; fertile farmlands made arid by industrial agriculture; sterile suburbs and squalid ghettos and shanty towns; poisoned air, lakes and rivers; and their damaging and often lethal effects on the bodies of plants, animals and people, especially working-class people and those in the Third World. At the same time, modernist landscape discourses have produced other topographies: national park systems, scenic highways and signposted roadside 'viewpoints'; summer cottages, outdoor recreation organizations and facilities for picnicking, hiking and camping; anti-modernist communities from the Hutterites and Amish to the 'back to the land' counter-culture; and conservationist projects from bird sanctuaries to blockaded logging roads. These alternative approaches to landscape often draw on what Merchant calls the organismic model, the view of nature as living body, which remains an underlying tension in the dominant mechanistic paradigm and has resurfaced at such historical moments as the Romantic reaction to the Enlightenment, American transcendentalism, Marx's early writings, and twentieth-century theories of holism and process philosophy. However, the notion of 'unspoiled' nature as living, life-giving and intrinsically worthy of preservation emerged from a society whose self-construction depends on excluding 'nature' from its frontiers. The resurgence of the organismic view of nature in the late nineteenth and early twentieth century is closely connected with accelerated resource exploitation and industrial development, an increasingly urban population and a tourist industry based on the automobile; as Wilson notes, the management of Canadian and American national park systems has always been inextricable from that of logging, mining and commercial development. While providing an oppositional alternative to the mechanistic world-view, the organismic 'nature' of nature tourism and conservationist politics has also been complementary to the dominant culture founded on technological mastery of the material world.

In this critical yet complementary relationship with urban industrial society, the conservationist view of nature that dominates contemporary environmental movements is rooted in the western pastoral tradition, which Merchant describes as 'an escape backward into the motherly benevolence of the past'.[17] Originating in the writings of Virgil and other classical authors, pastoralism is based on nostalgia for bucolic landscapes uncorrupted by urbanization, and re-emerged in the Renaissance personification of Nature as a benevolent mother or virginal bride. In pastoral imagery, nature is constructed as a living female body rather than an inert system of particles; however, both nature and woman are essentially passive and subordinate, their primary function to provide material and spiritual nourishment for men weary of urban life. Because of this slippage from nature as 'active teacher and parent' to nature as 'mindless, submissive body',[18] the pastoral mode is compatible with human domination over nature (and male domination over women) at the same time as it constructs nature, like women, as a pristine sanctuary that compensates men for the alienation of modern industrial society.

With the discovery of the Americas, distant lands replaced distant times as the idealized space of pastoral imagination. Explorers and colonizers described the 'new world' in pastoral terms, indicating that the pastoral mode is complicit not only with technological domination of nature, but also with imperialist domination of newly discovered lands and peoples. For the male, white, urban subject, the Americas and their native inhabitants represent an Edenic state of simplicity, purity and harmony with nature, and are consigned to an idealized past in the narrative of human progress, a nostalgic mirror in which European culture can gaze at its own imagined infancy; or they are

removed from history altogether to become part of the landscape, the scenic backdrop across which 'history' (the acts of white European men) is staged. Like 'nature', indigenous peoples represent a timeless space where, as Wilson writes of Disney nature films, 'the cycle of the seasons – "always enthralling, never changing" – sits in for real historical change.'[19] Within this discourse of landscape, wildlife and native cultures are consigned to reserve lands, oases of 'nature' in a desert of modern culture. History is banished from the pastoral scene; yet underlying and pressing on the borders of that dehistoricized territory are other, non-pastoral landscapes – the city, 'progress', imperial civilization. As Sidonie Smith observes, 'If the surface of pastoral promotes timeless spatiality, the subtext introduces historical specificity, the very history that undermines the pastoral vision, the very history from which the subject of pastoral would escape.'[20]

It is within these complex histories and geographies that I want to locate Ana Mendieta's work, along with that of other American artists who abandoned the art gallery for outdoor sites during the late 1960s and 1970s. John Beardsley has described the land art movement as a return to landscape, which after its apotheosis in Impressionism had been a neglected genre for much of the twentieth century.[21] Landscape, however, was now site rather than subject, for works conceived not as discrete objects but as fully engaged elements of their environments. Like the 'dematerialization of the object' in conceptual and performance art, earthworks were a way of resisting the gallery system and the commodification of the art object; they also asserted a specifically American avant-garde sculptural practice in resistance to Minimalism's European roots in Rodin and Brancusi. In 1969, Michael Heizer stated that 'Art had to be radical. It had to become American.' If traditional and Minimal sculpture were both based on the 'intrusive, opaque object' which 'has little exterior reference' and 'is rigid and blocks space', the goal of this new American practice would be 'an incorporative work' which is 'aerated, part of the material of its place, and refers beyond itself'.[22]

Lucy Lippard has argued that forms resembling prehistoric architecture, barrows and standing stones re-emerged in the land art of the late 1960s 'in part as a reaction against the cool technology of most Minimal sculpture', but also partly 'as a *response* to Minimalism's formal affinities with the simplicity and clarity of ancient monuments'.[23] Similarly, the literal return to landscape in art was both a critique of the Minimalist object and an extension of Minimalism's attempt 'to exclude all symbolic, metaphorical or referential aspects' to create 'a concrete actuality, perceived within the "real time" of the immediate present'.[24] Ana Mendieta was not alone in feeling that 'my paintings were not real enough for what I wanted the images to convey';[25] the trend away from painting and sculpture towards outdoor sites and natural materials reflected a desire not only to 'dematerialize' the rigid, commodified art object, but also to 're-materialize' landscape, somehow to escape the mediations of modern culture and make art which, rather than mimicking the 'concrete actuality' of nature, *encountered* it in ways that were more direct, palpable, 'real'. However, Heizer's insistence that 'It's about art, not about landscape'[26] indicates that although the earthwork might refer beyond itself to the materials and forms of its surroundings, it often remained embedded in the formalist discourse of high modernism, in which art as such, 'incorporative' or not, remains as self-referential as ever.

What is repressed in Heizer's construction of the earthworks movement is that its critique of the sterile isolation of the art object in the gallery space coincided historically with other movements away from the alienated, commodified spaces of modernity. Widespread disillusionment with consumerism, industrial capitalism, technological optimism, and ethnocentric notions of 'civilization' and 'progress' resulted in such events as the 1960s' boom in nature tourism, the increase in environmental activism, the 'back to the land' movement, the popular romance with Native American culture, and feminism's reclamation of formerly devalued 'feminine' activities and attributes, including goddess spirituality and women's traditional identification with the cycles of nature. Heizer

and some of his contemporaries may have resisted the connections between earthworks and these other interventions into social discourses of landscape, but others welcomed such connections as an opportunity for critical engagement with broader issues than those of avant-garde aesthetics.

Such artists made earthworks which incorporated not only site-specific materials and forms, but also social, symbolic, or ritual content; the encounter with the 'concrete actuality' of the outdoor site could then enact a reintegration, not only of art and nature, but also of nature and the social. In different ways, this desire underlies the synthesis of land art and body art in the work of Charles Simonds and Ana Mendieta, as well as the projects of Robert Smithson, Robert Morris and others who reworked abandoned industrial sites into aesthetically satisfying public environments. This impulse also informs the practices of feminist artists such as Margaret Hicks and Mary Beth Edelson, who strove to make earthworks more intimate, less abstract and monumental, through rituals that reaffirmed the work and its site as a locus of social and spiritual values.[27] For many, the 'return to landscape' was linked with a revaluation of traditionally feminine values and practices, and also with a growing interest in anthropology, ancient goddess religions and the aesthetic-symbolic production of Native American and prehistoric societies: both the 'feminine' and the 'primitive' seemed to offer alternative, more fulfilling ways of constructing 'nature' and 'culture' than those offered by mainstream American society. Many shared Ana Mendieta's view that animistic and/or matriarchal cultures possessed 'an inner knowledge, a closeness to natural resources . . . which gives a reality to the images they have created'[28] and which could provide both formal and philosophical inspiration for modern attempts to reformulate 'landscape', to imagine and give concrete form to different kinds of relationships between the human and the physical world.

FIGURES

The various alternative approaches to landscape in the 1960s and 1970s, including many land art practices, can been seen as attempts to 'humanize' the landscape, to affirm its living presence and intrinsic value rather than regarding it as a distant, neutral, passive object of observation and use. As I have argued, the organismic view of nature was compelling in the 1970s: radical feminist texts such as Susan Griffin's *Woman and Nature* (1978) and Mary Daly's *Gyn/Ecology* (1979), as well as J.E. Lovelock's *Gaia: A New Look at Life on Earth* (1979) which popularized the controversial 'Gaia hypothesis' of the earth as a living organism,[29] were among many texts and practices which, like Ana Mendieta's *Silueta* and *Árbol de la vida* series, invoked the body as a mediating metaphor between human subjects and societies and the material environment. As Donna Haraway has observed,

> most American socialists and feminists see deepened dualisms of mind and body, animal and machine, idealism and materialism in the social practices, symbolic formulations, and physical artifacts associated with 'high technology' and scientific culture. From *One-Dimensional Man* (Marcuse, 1964) to *The Death of Nature* (Merchant, 1980), the analytic resources developed by progressives have insisted on the necessary domination of technics and recalled us to an imagined organic body to integrate our resistance.[30]

Yet, as Haraway argues, the organismic model has its limitations as a strategy for intervention into dominant discourses of landscape. The oppositional view of society and the earth as organic body has been an affectively powerful and enabling resource for both feminist and environmental movements, but has also 'perhaps restricted too much what we allow as a friendly body and political language'[31] and tended to discourage the adoption of other strategies which might more effectively resist the global spread of economic and ecological domination. For example, anthropomorphic language has sometimes undermined the scientific and political credibility of the environmental movement: as science historian Joel Hagen observes, Lovelock's 'Gaia hypothesis' was not taken seriously in the scientific community partly because, despite its appeal to the pop-

ular imagination, 'naming his hypothesis after a Greek goddess was perhaps a poor strategy for catching the attention of professional biologists'.[32]

Scientific debates have identified other problems with organismic conceptual frameworks beyond their tendency to be marginalized and disempowered within the dominant mechanistic paradigm. Some ecologists argue that describing populations and ecosystems in terms of living bodies, anthropomorphic or not, tends to impose arbitrary boundaries and notions of harmonious balance and teleological function onto material phenomena which might be structured by radically different mechanisms, such as indeterminism, instability and constant change.[33] Discourses of landscape that use the metaphor of the body to establish harmony between nature and the social also tend to assume that the body in question is a human one, and to project human characteristics, values, narratives and desires onto the non-human world. As Sallie McFague argues, the humanist vision embodied in Leonardo da Vinci's drawing of a male figure whose limbs map the four corners of the cosmos can be deeply troubling as a model for the body politic and the cosmic order.

> [T]he body forming the basis for the model was *one* body and it was the *ideal* human body . . . a perfectly proportioned young, physically fit, white, human male body . . . [T]he organic model is a unitary notion that subordinates the members of the body as parts to the whole; it is concerned principally with human and especially male forms of community and organization; and . . . if there is only one body with one head, there can be only one point of view.[34]

In contrast to the view of nature as a landscape made friendly through identification with a nurturing female body, this particular organismic model constructs the cosmic order as an ideal male body identified not so much with landscape or the material world as with history: that is, with the universalized subject of western history and its discourses of anthropocentric, patriarchal, imperialist domination. Despite the emphasis on embodiment and interdependence of parts, rational human (western, male) consciousness is privileged as the literal and figurative head, paradoxically both part of and sovereign over the body of the material world. Like nature imaged as female body, this model offers a sense of harmony and intimacy with the non-human which is lacking in the mechanistic view of the physical world as inert object of observation and use. However, imaging the cosmos as an ideal human body also renders invisible the multiplicity and diversity of life on earth, and supports the privileging of human bodies, conceptual structures, ambitions and desires over the needs of other life forms. In its complacent self-centredness, this model represents what Lawrence calls ' the tyranny of mind, the white, worn-out arrogance of the spirit, the mental consciousness, the enclosed ego in its sky-blue heaven self-painted'. Within this claustrophobic world, the non-human can be experienced only as 'self projected into the earth'; there is no 'outside' to human consciousness, and it is impossible to 'get out of the sky-blue prison into real air'.[35]

Like Lawrence's reading of Cézanne, the social and aesthetic 'return to landscape' in the 1960s and 1970s can be read as both a critique of mechanistic landscape discourses, and an attempt to reach beyond the apparently omnipresent subject of western history. One strategy towards these dual goals was to embrace that which is marginalized within the classic organic model's 'self-painted' universe: the 'feminine', ancient and non-western cultures, materiality, the non-human world. The construction of nature as female body, drawing more on prehistoric cultures than on the western pastoral tradition, was one such oppositional strategy, offering radically different ways of organizing the body politic and its relations with the non-human environment. However, the desire to 'get in touch' with a lost unity between humanity and nature through the metaphor of the earth as female body bears a suspicious resemblance to the pastoral journey, in its fantasy of escaping the mediation of culture to return to an original unalienated state, and its complicity with a set of aligned binaries (male/female, modern/primitive, mechanistic/organic, culture/nature) whose terms are fixed by the dominant spaces of the metropolis. The construction of nature as female body also remains a projection of human forms and desires onto the non-human world; landscape is still 'self

projected into the earth', although the 'self' in question has changed. It remains possible to read a project like Ana Mendieta's 'dialogue between the earth and the female body' as John Perreault does, in terms that echo the anthropocentric humanist vision of man as the measure of all things: 'Her version of body art aspired to the universal: she used the measurements of her five-foot form to measure the world'.[36]

The impulse to give human form to the landscape derives, paradoxically, from the desire in Lawrence's reading of Cézanne: the desire for an 'outside' to human subjectivity as defined in dominant western discourses of selfhood – but crucially, an 'outside' which is more than a system of inert particles. This might also be described, in Wilson's words, as a desire to encounter the non-human environment as 'an agent of historical processes as well as the field of human action', not merely as object or empty background but, in a sense, as subject.[37] But what kind of subject? The anthropomorphizing of the earth as mother is entangled in what Robert Smithson has called 'the ecological oedipal complex',[38] in which a female 'nature' becomes both the pastoral landscape of desire and the repudiated object of domination for the universalized male subject of history, while the female subject can articulate her difference only through identification with that ambivalent figure/landscape, 'nature'. However, the earthworks movement offered a possible alternative to this impasse in practices like that of Carl Andre,[39] which attempted an explicitly non-anthropocentric perspective from which the material world might be apprehended as a kind of 'subject', but one autonomous of and *other than* the human.

Like Michael Heizer's more monumental projects, Andre's influential strategy of 'tak[ing] his sculpture back to "ground level" – to the floor, or the earth – rejecting the pedestal and felling the traditionally anthropomorphic stance of heroic vertical sculpture'[40] critiqued the isolated, fetishized Minimalist object. At the same time, Andre's practice continued Minimalism's critique of the fetishization of individual (human, and usually masculine) subjectivity in the Abstract Expressionist painterly gesture. In lieu of both the subjective gesture and the self-contained object with its anthropomorphic residues, Andre proposed 'sculpture as place', which he defined as 'an area within an environment altered in such a way as to make the rest of the environment more conspicuous'.[41] This attempt to evacuate the human as an organizing principle for art production recalls Lawrence's argument that materiality as vital otherness to human subjectivity – what Minimalism calls 'concrete actuality' and Lawrence calls 'appleyness', the 'real air' beyond the 'sky-blue prison' of the ego – can be apprehended only by 'deliberately painting *out* the so-called humanness, the personality, the "likeness", the physical cliché'.[42] What is central in 'sculpture as place' is no human or anthropomorphic form, but precisely that non-human otherness which the work's intervention invites viewers to apprehend.

Ana Mendieta's practice in the 1970s appears far removed from Andre's solution to the problem of anthropocentrism in discourses of art and landscape. Although based on encounter with a chosen site or 'place', Mendieta's *Silueta* and *Árbol de la vida* works are insistently anthropomorphic (Figures 13.1–13.5); they have been called 'overly narcissistic and reductive'[43] for their repeated tracing of the artist's own form onto the land, a literal enactment of the anthropocentric 'self projected into the earth' that Lawrence critiques in Van Gogh. Underlying Mendieta's self-inscriptions are both a desire to 'become one' with a maternal earth, and 'a personal will to continue being "other"' to dominant white society (including American feminism, which she denounced as 'basically a white middle class movement').[44] That is, she used the meeting of female body and land as a deliberately oppositional position of identification with modern industrial America's excluded Others, invoking an animistic view of nature as 'omnipresent female force' and drawing on concepts and motifs from ancient and non-western cultural traditions, particularly Santería, a Cuban syncretic religion based on African Yoruba and popular Catholic beliefs and practices.[45]

As I have argued, such strategies of resistance are implicated in complex ways with pastoralism and anthropocentrism as well as restrictive gender binaries. They are also open to a particular claustrophobic reading in which Mendieta is identified with her own images as a romanticized figure of exotic otherness: defined by her personal trauma of exile and by some 'innate' affinity with the 'natural' and 'primitive' because of her female gender and Cuban origins, she and her work are relegated to a timeless realm removed from contemporary aesthetic, social and political debates. Yet Mendieta was also an artist trained in the United States in the 1960s, whose deployment of landscape, Santería and goddess imagery participated in the social and cultural discourses I have discussed, and was linked not only to a personal longing for the culture of her childhood[46] and a desire to 're-materialize' the landscape through 'the reactivation of primeval beliefs', but also to her support for the Non-Aligned Nations in resistance to First World political and economic domination.[47]

The view of Mendieta as an apolitical, ahistorical 'primitive' is supported by the fact that in contrast to Andre's ideal of art that points to the specificity of its surroundings, Mendieta's works often appear oddly unlocatable in space or time. Unlike Andre's outdoor installations, the encounters Mendieta staged between work and site are now accessible only as photographic images; their sites, although carefully chosen and identified in the titles, are not encountered directly by viewers, and the images themselves focus on the boundaries of the human form and contain few distinguishing marks of place. This apparent 'placelessness' also contrasts with strategies in contemporary Latin American painting, where the land is so infused with bitter tensions – from European conquest to the clearing of the rainforest for cash crops – that artists cannot approach landscapes in terms of timeless aesthetic values, but rather insistently identify them as both particular places and sites of particular historical and political struggles.[48] Contemporary Latin American landscape painters resist the dominant narrative of western history, and its dehistoricizing of landscape as

Figure 13.1 Ana Mendieta, *Untitled*, 1977, from *Serie árbol de la vida* (Tree of Life series), colour photograph, 20 × 13¼". Earth-body work with tree and mud executed at Old Man's Creek, Iowa City, Iowa

its pastoral Other, by insisting on the specificity of place while refusing to let the continuing realities of political, economic and cultural colonization be consigned to the past. Yet, as Irit Rogoff has argued, Mendieta's work too can be read as resisting hegemonic history through a strategic deployment of the geographic: a spatial rather than temporal itinerary which 'def[ies] cultural time as a progressive sequence' but does not thereby 'impose some other non-specific notion of timelessness'.[49]

Such a reading must attend to the particular conception of geography underlying the *Silueta* and *Árbol de la vida* series, a conception quite other than either the dehistoricized landscape of pastoral, the 're-historicized' landscapes of contemporary Latin American painting, or any landscape surveyed through Lawrence's 'optical vision'. Mendieta's intervention into dominant discourses of landscape posits a relationship to the non-human based on the indexical rather than the symbolic; it attempts, as Lawrence writes of Cézanne, 'to displace our present mode of mental-visual consciousness . . . and substitute a mode of consciousness that [is] predominantly intuitive, the awareness of touch'. As Rogoff argues, Mendieta employs 'matter versus contour as the essence of a personalized geography';[50] her works do not depict landscapes recognizable to the eye, but invoke a landscape encountered as 'appleyness', that material otherness beyond the 'self-painted' human world, that non-humanness to which Andre's 'sculpture as place' attempts to gesture. At the same time, however, her practice resists the notion that a non-anthropocentric approach to landscape requires an evacuation of the human from notions of site or place. In the *Silueta* and *Árbol de la vida* series she attempts, like Cézanne, 'to set the unmoving material world into motion' not by banishing the human form, but by making it 'come to rest'. Within this

Figure 13.2 Ana Mendieta, *Untitled*, 1976, from *Silueta* series (Silhouette series). Earth-body work with stones executed in Mexico (Oaxaca?)

tactile geography, her insistence on the anthropomorphic represents not so much an imposition of the human on the landscape, as a refusal to evacuate questions of cultural identity and gender – questions both of individual subjectivity and of social and political relations – from her reconfiguration of the relationship between the human and the material world.

Figure 13.3 Ana Mendieta, *Untitled*, 1977, from *Serie árbol de la vida* (Tree of Life series), colour photograph, 13¼ × 20". Earth-body work with cloth executed in Oaxaca, Mexico

BODY AND REPRESENTATION

Ana Mendieta's practice posits a relationship to landscape which is insistently an embodied one. The body is the site of negotiation between materiality, psychic drives, and social and cultural inscriptions, and is therefore central to a practice in which the encounter with the non-human and the exploration of human psychic and social existence can occupy the same space, and indeed are posited as inseparable. As Elisabeth Bronfen has written,

> The real body is positioned before or beyond semiosis. As that which is replaced by signs and images, it can serve as the medium through which language hooks back into the world, through which it returns to the referential. But because the body marks a site of real insertion into the world, it also serves to establish social laws and allows culture to materialize ideas. The word turning flesh can serve to establish and authenticate a political, theoretical or aesthetic discourse.[51]

The body functions for human subjects as the boundary between the symbolic order and the real, and at the same time, in Sidonie Smith's words, as

> the margin joining/separating one subject from the other, one sex from the other, one race from another, the sane from the mad, the whole from the unhealthy . . . whereby the culturally dominant and the culturally marginalized are assigned their 'proper' places in the body politic.[52]

It is Mendieta's attention to both of these aspects of embodiment which underlies her insistence on the anthropomorphic; her invocation of the body alludes both to the relationship between subjectivity and materiality, and to the ways in which, as I have argued, the trope of the human body is used to support and to resist discourses of patriarchal, imperialist and ecological domination. In Mendieta's practice, all of these issues come together in the encounter between landscape and self-

Figure 13.4 Ana Mendieta, *Untitled*, 1976, from *Serie árbol de la vida* (Tree of Life series), colour photograph, 13¼ × 20". Earth-body work with flowers, dead tree trunk on sand, executed in Oaxaca, Mexico

portraiture, an encounter in which gender is acknowledged as a crucial category. The question is how to read this 'dialogue between the landscape and the female body' in terms which are both psychic and political, and which do not reinscribe either pastoral binaries or anthropocentric configurations in their attention to the gendering of both domination and desire.

Many of Mendieta's images appear to document ordinary sights that anyone might pass by during an afternoon walk, an impression reinforced by the apparent transparency and literalness of the photographic medium. Yet this unthinking familiarity is continually disrupted by the sometimes obvious, sometimes barely perceptible presence of a human-like form, which becomes increasingly insistent when the works are viewed as a series. The *Silueta* and *Árbol de la vida* images provoke a double *déjà vu*: because of the ordinariness of the scenes, and because of the continual recurrence of the silhouette, whose roughly anthropomorphic shape evokes a sense of something utterly familiar yet made strange by its repetition across a variety of materials and sites. If these are landscapes, the eye does not traverse their expanses, but rather is drawn to rest on the outlined human form with a satisfying sense of self-recognition, as though on the viewer's own image in a mirror. However, the stillness thus produced seems in its very intensity to be always on the verge of tipping over into restlessness. The images do not provide a safe resting place for narcissistic self-contemplation, since, despite its stubborn recurrence, the anthropomorphic form is also utterly tentative, its boundaries vague and subject to immanent dissolution: at any moment, the flowers will scatter or decompose, the mud or sand will wash away, the flames will burn out, the figure will come to life and spirit itself out of the frame – or a second glance will reveal what appeared to be a human form as a momentary trick of light and shadow, a self-projection onto a chance formation of earth or wood. Narcissistic

identification is also unsettled by the fact that although the silhouettes are linked to the feminine through references to goddess iconography and through Mendieta's bodily presence in the ritual of making, they often do not bear the visible signs of anatomical sex that uphold stable categories of sexual difference within the symbolic order. Both sensuous and schematic, the anthropomorphic outlines simultaneously insist on the presence of the body and mark its almost palpable absence, like the chalk drawings used by police to mark the position of an absent corpse.[53]

In their ambivalent interplay between establishment/unsettling of boundaries and presence/absence of the body, Mendieta's images can be read as self-portraits which function as uncanny doubles, as theorized by Freud and elaborated by Elisabeth Bronfen in her book *Over Her Dead Body: Death, Femininity and the Aesthetic*. Freud defines the uncanny as a particular category of aesthetic or life experience which produces anxiety by 'lead[ing] back to what is known of old and long familiar';[54] summarizing Freud's discussion, Bronfen writes that the sources of uncanny experiences lie 'in the compulsion to repeat, to re-present, double, supplement; in the establishment or re-establishment of similarity; and in a return to the familiar that has been repressed'. Bronfen describes instances of the uncanny as 'situation[s] of undecidability, where fixed frames or margins are set in motion', where 'the question whether something is animate (alive) or inanimate (dead), whether something is real or imagined, unique, original or a repetition, a copy, cannot be decided' (113). The 'double', a figure somehow identical to or interchangeable with the self, is one of the most unsettling instances of the uncanny, since it implies a doubling, dividing or exchanging that results in undecidability or blurred boundaries between self and other. Bronfen extends Freud's definition of the double to include the ambivalent distinction between a material, animate body and its inanimate

Figure 13.5 Ana Mendieta, *Untitled*, 1979, from *Silueta* series (Silhouette series), photograph, 20 × 13¼". Mud silhouette executed at Sharon Centre, Iowa

representation: portraits, 'similar to but also different from the body they resemble', can function as uncanny doubles, 'hover[ing] between an absence/presence of their object of reference' (111).

Freud argues that the double produces uncanny anxiety because it 'harks back' to 'a time when the ego had not yet marked itself off sharply from the external world and from other people', to ideas and psychic states which were once familiar but have become alien through processes of repression during the formation of the adult self:

[T]he 'double was originally an insurance against the destruction of the ego . . . and probably the 'immortal' soul was the first 'double' of the body. . . . Such ideas, however, have sprung from the soil of unbounded self-love, from the primary narcissism which dominates the mind of the child and of primitive man. But when this stage has been surmounted, the 'double' reverses its aspect. From having been an assurance of immortality, it becomes the uncanny harbinger of death.[55]

The urge to 'double' the self – through the notion of an immortal soul or the production of self-representations – represents an attempt to protect the self against the material decomposition of the real body by ensuring its survival within the imaginary and symbolic registers. Yet the double also memorializes the mortality and lack in the self which produces the drive to supplement the self through doubling; and by definition, the double involves a split or gap between double and self which undermines any attempt to construct the self as whole and intact by means of a reassuring mirror image. Such attempts to ensure self-stability are also ambivalent in that the more perfectly the double resembles the self, the more difficult it is to decide which is which: the self's apparent wholeness and fullness are both reinforced by the mirroring double and at the same time undermined by the difficulty of distinguishing self from image.

The perfectly 'lifelike' portrait thus produces uncanny anxiety through the confusion it provokes between the symbolic and the real. As Bronfen writes,

Even though the creation of the portrait can be seen as an effort to privilege a symbolic form of semiosis that clearly distinguishes signifier from signified (because it always contains the artist's signature and a self-referential moment), its perfect execution denies the self-referential dimension and evokes a scandalous return to the literal; reintroduces an uncertainty about the distinction between a body and its image.

(115)

This uncertainty leads to a desire to restore stability of meaning by deciding the disturbing question posed by the uncanniness of the image, re-establishing safe boundaries between body and image, self and other. This is often done through what Bronfen calls 'a move to the figural, a posture of scrutiny and judgement of the portrait, which binds the mobility of meaning to a fixed signified': that is, the portrait's disturbing undecidability is enclosed within a narrative about the artistic skill that produced such a lifelike representation, thus re-establishing the portrait as a symbolic production ontologically distinct from the intact fullness of the material body to which it refers (115–16).

In contrast to the uncanny likeness of the portraits Bronfen discusses, the uncanny anxiety provoked by Ana Mendieta's *Silueta* and *Árbol de la vida* images does not derive from a perfect resemblance between portrait and model, since except where Mendieta's body is literally present in the photograph, the silhouettes are neither marked with individual identity nor visually similar to their model except in scale (and even this is not clear from the photographs alone, which are much smaller than life size). The threatening semantic instability in Mendieta's self-portraits derives from a 'scandalous return to the literal' of another sort: the insistently literal presence of the stones, flowers, mud, water, sticks, and other materials that constitute the silhouette. The photographic images of these objects and substances refer indexically and iconically to their material referents in the physical landscape, even as they are used to construct a symbolic image signifying a human presence. This persistent reference to the elements of the landscape as 'themselves' prevents the perfect resemblance that would create an undecidability between signified (material human body) and signifier (portrait). Instead, uncanny anxiety is produced through the undecidability between two possible objects of reference: the signified of the anthropomorphic form might be either the human body for which it acts as a double, or the landscape out of which – *in* which – it is made. The threat to the self remains one of substitution or undecidability, but what is potentially substituted for/indistinguishable from the self is precisely *not* a mirroring double, but rather the implacable material presence of the non-human.

Mendieta's uncanny silhouettes, like Bronfen's uncanny portraits, provoke a desire for a recuperating narrative that can restore stability of meaning. In this case, however, the narrative usually invoked draws on Mendieta's description of her work as 'a direct result of my having been torn from my homeland (Cuba) during my adolescence',[56] and constructs her self portraits as products not of artistic skill but of inner compulsion. In a much-quoted statement, Mendieta universalizes the personal loss produced by her family's response to particular historical events, identifying her own specific exile with alienation from both 'nature' and the maternal body:

> I am overwhelmed by the feeling of having been cast from the womb (nature). My art is the way I re-establish the bonds that unite me to the universe. It is a return to the maternal source. Through my earth/body sculptures I become one with the earth.[57]

This account binds the uncanny mobility of meaning in the silhouette images to a fixed signified, the ritual of healing through restorative union with a female nature; it allows the spatial or geographical sequence of the *Silueta* and *Árbol de la vida* series to be read also as a temporal one, a progressive history leading to spiritual fulfilment. This optimistic narrative offers a reassuring position of identification for viewers, thereby deciding the disturbing question of reference in favour of a human rather than a non-human signified for the silhouette. At the same time, the narrative attempts to hold *both* possible signifieds, human body and landscape, through asserting a utopian unity between them.

I want to compare this ambivalent gesture with Bronfen's reading of another narrative of survival, the Swiss painter Ferdinand Hodler's portraits of his dying mistress Valentine Godé-Darel. This series of portraits documents the visual effects of Godé-Darel's slow, painful death by cancer, followed by images of her corpse and then by a landscape supposedly drawn on the day of her death. Read as a temporal sequence, the images point to a moment of uncanny undecidability between human and non-human in the space between the last portrait of the corpse and the landscape image that follows it; yet, as Bronfen argues, this construction also supports the self-stability of the male viewer by 'reassuringly suggest[ing] that there is ultimately no distinction to be drawn between death, the corpse, woman, landscapes'[49]. Godé-Dorel's individual, embodied and violent experience of death is repressed and replaced as signified of the series by a double narrative in which a universalized human body (though not coincidentally female) dissolves peacefully into landscape, while a universalized human (male) subject heroically transforms into art his own disruptive and threatening experience of her death. As in Mendieta's account of her silhouettes as encounters with the earth as 'omnipresent female force', the uncanny anxiety provoked by the visual slippage between animate and inanimate is both articulated and repressed through a merging of landscape and the female body into a figure/scene of pleasure and desire, which signifies the survival of the artist (and by extension the viewer) in the face of traumatic loss.

There is, however, a crucial difference between the two narratives. In the narrative surrounding Hodler's images, self-stability is asserted through a gender binary that codes survival as masculine and invites viewers to identify with the artist as a removed, though intimate and privileged, observer of the feminine spectacle of dissolution into landscape. In Mendieta's account of her *Silueta* series, survival and psychic healing occur precisely *through* active participation in a pleasurable union with a female earth; and since few of the silhouettes are unambiguously gendered, the position of survivor is not determined by rigid categories of sexual difference. Female subjects are a privileged audience for this work, but viewers of either sex are invited to identify with, rather than to survey, the figure/scene with which the artist herself identifies during the process of making. The uncanny effects of both Hodler's and Mendieta's series can be read as traces of earlier, now repressed psychic states in which the boundaries of the self were still being formed; however, the slippage from body to landscape in the two series does not refer to the same moment in the development of subjec-

tivity. In the Hodler images and their surrounding narrative, the displacement of the threat of dissolution onto the female body is structured in part by the traumatic recognition of sexual difference during the Oedipal phase.[58] In contrast, Mendieta's uncanny self portraits invoke a state in which the infant proto-subject has not yet assumed a gender identification, and the threatening apprehension of difference takes the more general, non-gendered form of the recognition of absence as different from presence: specifically, absence and presence as figured by the maternal body from which the infant begins to recognize itself as a distinct subject.

Freud's interpretation of the 'fort–da game' in *Beyond the Pleasure Principle* provides a model for understanding representation and self-representation as related to the threatening absence of the maternal body. In the repetitive game Freud describes, an 18-month-old child makes a toy reel on a string disappear by throwing it over the edge of his cot, while saying 'o-o-o-o', which Freud interprets as the German word *fort* ('gone'). Sometimes the child then draws the reel back on its string until it becomes visible, accompanied by a joyful '*da*' ('there'). Freud argues that through this game, the child copes with the mother's periodic absence by replacing the absent maternal body with a symbolic object whose disappearance and return it can control. Through this symbolic repetition the child assumes the position of active master of the situation rather than passive victim of loss, and compensates itself for the trauma of the mother's real or potential absence by staging in representation her reassuring return. However, the game must perpetually be repeated, since the pleasure of the return to presence is never complete: what returns in representation is always a substitute, and the very act of representation, while speaking desire for the absent maternal body, also negates that body by replacing it with a symbol or mental image. This ambivalent doubling/negation of the maternal body culminates in another version of the fort–da game, where the child watches its own image in a mirror and says 'Baby o-o-o-o' as it crouches down to make the image disappear. As Bronfen argues, in this game

> the child doubles the disappearance of the mother, gliding from her to his own effacement. Where the 'complete' game initially included the return ('da') which always confirmed the absent body, this shift from reel (internal image of the mother) to self-image transfers the moment of reassuring return from the mother to the self'.
>
> (27)

In this substitution between maternal image and self-image in ambivalent play between image/body and absence/presence, the maternal body is a prototype for all uncanny doubles: it both affirms self-stability by 'doubling' the self, and at the same time disrupts any sense of stability and points to the possibility of the absence of the self. During primary narcissism, or what Lacan calls the mirror stage, the infant proto-subject begins to structure it chaos of sensations and drives through the satisfying recognition of its own image, both in literal mirrors and in the mirroring figure of the maternal body. This pleasurable self-image provides boundaries between self and other within which the subject can experience itself as stable and whole; but this security is undermined by the troubling awareness that the image is always other than the self and potentially indistinguishable from or substitutable for the self. In response to this threat of absence and lack, the maternal body becomes a figure for an imagined pre-subjective stage of presence without possibility of absence, in which no boundaries separated self from mother/other.[59] In its role as imaginary mirror, however, the maternal body, like any image, must already be other than the self, signifying the fragmentation of that imagined earlier unity. Paradoxically, therefore, the maternal body also signifies the trauma of loss, the severing of unity which continually disrupts any sense of wholeness or self-sufficiency. The shift from 'o-o-o-o' to 'Baby o-o-o-o' involves a relationship between the maternal body, representation and self-representation which is much more complex than the absence/presence dialectic of the first fort–da game: an object of anxiety as well as pleasure and

desire, the maternal body represents not only a mirror image or uncanny double of the self, but also the ground out of which the subject differentiates itself as a coherent self-image, and from which the subject is thereby irrevocably severed.

In Ana Mendieta's *Silueta* and *Árbol de la vida* series, union with the earth is equated with a 'return to the maternal source': landscape, in the form of various chosen sites, serves as a trope or substitute not only for the homeland of Mendieta's particular exile, but also for the maternal body in its dual role as both 'figure' and 'ground' for the process of imaginary self-formation. Through an intimate working process of lying on the ground and literally tracing the boundaries of her own body onto the earth, Mendieta re-stages the establishment of a reassuring narcissistic self-image in the imaginary mirror of the maternal body; at the same time, the satisfying fullness of tactile encounter with the earth invokes the fantasy of absolute plenitude in unity with the maternal body. The invitation to viewers to identify with the resulting figure/scene turns not only on the delight of self-recognition in the anthropomorphic figure, but also on the sensory pleasures to which the images of sand, wood and water indexically refer: the imagined experience of nestling in the curve of the silhouette, feeling the textures of the landscape along the surface of the skin. This combination of narcissistic and tactile pleasures is what made Mendieta's work so compelling to many feminists in the 1970s, offering powerful affective resources for an oppositional politics rooted in celebration of earth-centred female spirituality. However, what is repressed in this reassuring formulation and 'returned' by the uncanniness of the images is not only the impossibility of absolute union with the earth/mother, but also the threatening aspect of that union, which signifies both plenitude and the subject's dissolution into undifferentiation. Despite the utopian claims of the surrounding narratives, the relationship between Mendieta's self-inscriptions and the landscape as maternal body is contradictory and ambivalent. In their tactile references and the uncanny undecidability they stage between human and non-human, the silhouettes point to another crucial aspect of imaginary self-formation: they suggest that subjectivity is constituted not only through images of the self and the maternal body, but also in relation to what Bronfen calls 'the unencompassable body of "matter-materiality-maternity", which indexically figures death'(111).

Like any fort–da game, the obsessive repetition of Mendieta's silhouettes both resists and points to absence and death, because the material/maternal presence they invoke is always a substitute for the imagined state of originary plenitude, and is always already lost before it can be repeated in representation. Encountered in the gallery, the photographic images further repeat the separation from the maternal body, since they refer to the fullness of a tactile encounter which remains always absent from its visual representation. Yet, as Bronfen argues, notions of loss and mortality are invoked not only by the mother's absence, but also by her *presence*, because the maternal body indexically figures the position previous to life and so prefigures the absence of the self in death. As I suggested, the tentative boundaries of Mendieta's silhouettes unsettle narcissistic identification by implying a temporal sequence in which the anthropomorphic form, like the feminine corpse in Hodler's series, will eventually dissolve into its material surroundings. In Mendieta's work, this dissolution can be read as utopian fusion of self and landscape/maternal body, but it also points to the maternal body's repressed signified, the terrifyingly unimaginable dissolution of the self in death. At stake in representation as fort–da game is both the ambivalent substitution of images and signifiers for the absent mother and the potentially absent self, and also the impossible signified of the self's inevitable disappearance in the real, material dissolution of the body.

The uncanny effect of the *Silueta* and *Árbol de la vida* images is, however, only partly due to the implied temporal sequence of self-dissolution/mortality; the slippage between animate and inanimate in these images is constructed not only temporally, but spatially. As I have argued, the insistently literal reference to the materials that constitute the silhouettes creates an uncanny undecidability between two possible signifieds, human and non-human, for the anthropomorphic form.

This undecidability is experienced not only as a semantic problem, but also as a conflict between the invitation to identify with the pleasurable merging of self and earth and the physical impossibility of such a union. Although viewers can imagine occupying the space of the silhouettes hollowed from sand or mud, the images built of flowers or stones frustrate such a fantasy, filling the space of the human form with insistently non-human materiality, which can be experienced as surface but not as interiority. Mendieta's inscription of the anthropomorphic form literally *in* the landscape produces anxiety as well as pleasure, since it both suggests a palpable intimacy between body and earth, and insists on the unimaginable situation of human body and non-human landscape literally occupying the same space.

This paradox points to the impossible and necessary relationship between subjectivity and soma. It suggests that the threat to the self represented by the maternal body (and its substitute, landscape) is not only mortality and the material dissolution of the body, but also the very constitution of the real body *in* materiality. For the subject constituted in the imaginary and the symbolic, the real body grounds all psychic drives and representations, yet remains inaccessible, since the real is precisely that which image and language are not, the unknowable material referent to which signifiers are arbitrarily linked. Impossible to picture or articulate, materiality, like death, threatens all stability by pointing to the collapse of representation in the unrepresentable, the inadequacy of language and images as means of apprehension, mastery and self-construction. In its complex configuration of representation, self-representation, the maternal body, landscape, mortality and materiality, Ana Mendieta's practice stages what Bronfen describes as 'the ambivalent and indeterminant shift between real body and image/symbol, as well as between real body of the mother and maternal body as figure for one's own soma' (34–5). The ambivalent object of both negation and desire is not only the maternal body, but the limit and ground of representation and selfhood: that more global, implacable yet unencompassable otherness of materiality/mortality which cannot be known except through representations, yet which always exceeds and resists representation.

EMBODIED GEOGRAPHIES

Elisabeth Bronfen argues that repressed anxiety about this 'unencompassable body of matter-materiality-maternity' underlies the displacement of loss and lack onto the feminine body, and therefore supports gendered structures of domination:

> What is put under erasure by the gendered concept of castration is the other, so often non-read theme of death, forbidden maybe because far less conducive to efforts of stable self-fashioning than notions of sexual difference. To see the phallus as secondary to the scar of the navel means acknowledging that notions of domination and inferiority based on gender difference are also secondary to a more global and non-individuated disempowerment before death.
>
> (35)

The navel is the index of death in that it points both to the subject's irrevocable separation from the maternal body of plenitude, and to the maternal body as figure for the subject's inevitable dissolution in material death. However, through its connection to the maternal body as both imaginary figure and concrete presence, the navel also points to the inseparability of subject and soma, to the implacable yet unknowable presence of materiality which both grounds and disrupts all imaginary and symbolic stability. Rather than claiming utopian identification between woman and landscape in opposition to phallic technocratic civilization, Ana Mendieta's *Silueta* and *Árbol de la vida* series can be read as an aesthetic-symbolic practice organized under the sign of the navel: both non-gendered and related to feminine bodily specificity through its link with the maternal body, this practice displaces the binary structures of the phallic symbolic order and patriarchal social relations by attending to the ambivalent relationship of separation and inseparability, negation and desire between human subjects and materiality/mortality.

The relationship traced in Mendieta's practice is suggested not so much in her claim that 'through my earth/body sculptures I become one with the earth' as in the slightly amended 'I become an extension of nature and nature becomes an extension of my body'. The second statement suggests a relationship based less on fusion, or even identification, than on proximity: the image of a human body is inscribed in a maternal landscape conceived not as undifferentiated unity with or mirroring double of the self, but as unknownness encountered through touch along the boundaries of the body. The human body in this configuration is both an imaginary construct through which the self is reinvented in the act of inscription,[60] and a mediating surface through which the self encounters that which is other than the self – including the otherness of its own soma. In their invocation of tactile encounter with the unencompassable unknown, Mendieta's uncanny self-portraits invoke a moment in the development of subjectivity other than the primary narcissism theorized by Freud: they suggest a relationship with landscape, and its analogue the maternal body, that recalls the psychanalytic model proposed by Bracha Lichtenberg Ettinger, in which subjectivization begins and is partly structured by intra-uterine experience.

In Lichtenberg Ettinger's model, the symbolic order is organized not only around the phallus, but also around the matrix, a symbolic term linked to invisible female bodily specificity. The phallus remains the sign for aspects of subjectivity 'involving *oneness*, totality, and sameness, and oedipal, symbolic castration'; however, Lichtenberg Ettinger introduces the matrix as a sign for aspects of subjectivity previously unsymbolized within the symbolic order, 'involving multiplicity, plurality, partiality, difference, strangeness, relations to the unknown other, *prenatal* passages to the symbolic, with processes of change of I and non-I emerging in co-existence, and of change in their borderlines, limits and thresholds within them'.[61] Within Lacan's exclusively phallic paradigm, the prenatal state represents total fusion with the maternal body and therefore 'both a paradise and a state of annihilation'.[62] Alongside this, Lichtenberg Ettinger proposes a matrixial paradigm in which the co-emerging subjectivity of mother and infant proto-subject is understood not as originally fused and then separated, but as originally differentiated, through the organization of experience in the infant–mother unit 'in terms of sensory surfaces, movement, time-intervals, rhythm and tangibility'.[63] Within the infant–mother unit, subjectivity co-emerges through shared encounter along intimate, shifting boundaries between the known I and unknown non-I(s). There is differentiation, but that which is differentiated is neither background nor a mirror for the developing subject, but an unknownness whose presence is registered at the level of unconscious desire as nonvisual, non-symbolic traces of tactile experience.

Lichtenberg Ettinger argues that such traces of prenatal experience persist in the unconscious throughout the subject's life, forming a matrixial stratum of subjectivity which coexists and interacts with the imaginary and symbolic strata. In so far as subjectivity has matrixial aspects, that which is other than the self is not necessarily perceived as threatening, and can be encountered and acknowledged without either assimilation or rejection:

> The Matrix deals with the possibility of recognizing the other in his/her otherness, difference, and unknownness. . . . The Matrix is a composition of I and non-I(s), of self and not-selves while they are unknown or anonymous. Some selves identify one another as non-I without aspiring to assimilate in order to become one, without abolishing differences and making the other a *same* in order to accept him/her, and without creating a phallic rejection so that only one of them can occupy the physical/mental space.[64]

Such encounters are accompanied by 'matrixial affect': neither pleasure nor displeasure, nor an oscillation between the two, but a distinct pleasure/displeasure affective response shared through 'evocations of silent alertness, amazement and wonder, curiosity, empathy, compassion, awe, and uncanniness'.[65] This model offers another way of reading the uncanny undecidability between self and other, body and landscape, human and non-human in the *Silueta* and *Árbol de la vida* series. As well as an oscillation between presence/absence and pleasure/anxiety, Mendieta's images invoke

a hauntingly undefinable response that might be considered matrixial; they stage an intimate, anonymous coexistence in the same space of the known I (apprehended through recognition of or identification with the human form) and non-I(s) which might become known in part as soma, m/other, landscape, but which also remain unrecognized, unidentified, their unfathomable presence gestured towards by the invocation of boundaries continually renegotiated through non-verbal, non-visual, tactile encounter.

In its acknowledgement of 'the other in its otherness, difference, and unknownness' and its emphasis on the tactile, Ana Mendieta's practice privileges matrixial aspects of subjectivity and posits the emodied subject as a site of simultaneous inscriptions of the unviewable, out-of-the-signified real as well as of history and acculturation. However, these matrixial traces cannot be separated from the imaginary and symbolic registers through which they must be conveyed in order to participate in cultural production. As Charles Merewether writes in an article on Latin American artists in diaspora, 'The issue is how to understand the social formation of the body – the realm of the senses, of memory and the unconscious, as well as vision and visuality – as social facts.'[66] Mendieta's oppositional practice is not only the private ritual of the artist's encounter with the earth, but also its documentation and exhibition in photographic form; and within the private and encounter, the real body and landscape are always already inscribed with personal, social and historical meanings, and experienced through imaginary and conceptual bodies and landscapes produced by various psychic events and social discourses. Mendieta's self-inscriptions enact an encounter between the human subject and its limit and ground in mortality and materiality, experienced simultaneously as the physical landscape, the imaginary maternal body and unknown not-I(s); yet this encounter is always also an intervention into the interrelated social discourses of patriarchal, imperialist and ecological domination, a resistance to the dominant narrative of western history and its universalized subject whose relation to its Others (woman, non-western cultures, landscape) is structured by the phallic either/or of assimilation or rejection. In their undecidability, whether experienced as uncanny anxiety or as matrixial affect, Mendieta's *Silueta* and *Árbol de la vida* series insist on the necessity of acknowledging the limits of selfhood (individual and universalized) in the unrepresentable unknownness of materiality/mortality: both individual death, and the implacable resistance of the biosphere to human attempts to reconstruct it according to our own designs and in our own inflated self-image. The relationship between human and non-human in these images is infused simultaneously with pleasure, anxiety, desire, and an intimate anonymity; it points both to the utter impossibility of knowing the non-human except through representations, and to the utter necessity of adapting our discourses and practices to attend to that other, unencompassable territory.

Notes

This chapter owes much to the support and inspiration of my fellow students in the MA Feminism and the Visual Arts programme at the University of Leeds, 1993/4. Special thanks to Andrea Wakefield and Karen MacKinnon, and to Alison Rowley, whose insights haunt these pages.

1 Ana Mendieta, unpublished statement, 1981; quoted in Petra Barreras del Rio and John Perreault, *Ana Mendieta: A Retrospective* (exh. cat.) (New York: The New Museum of Contemporary Art, 1987), p.10.

2 Ibid.

3 Lucy R. Lippard, *Overlay: Contemporary Art and the Art of Prehistory* (New York: Pantheon Books, 1983), p.4.

4 The two series, produced concurrently, have different formal and conceptual emphases, but are similar enough in form and strategy to be treated as one body of work for the purposes of this chapter.

5 The phrase is from a review by Ellen Lubell in *Art in America* vol. 71 no. 6 (Summer 1983), p. 161.

6 Sallie McFague, *The Body of God: An Ecological Theology* (London: SCM Press Ltd, 1993), p. 101.

7 See Donna Haraway, *Simians, Cyborgs and Women: The Reinvention of Nature* (London: Free Association Books, 1991).

8 D.H. Lawrence, 'Introduction to These Paintings (Puritanism and the Arts)', *Lawrence on Hardy and Painting* (London: Heinemann Educational Books Ltd, 1973; first published in *The Paintings of D.H. Lawrence*, London, 1929). To avoid an excessive number of footnotes, page references to this text will appear in the body of the chapter.

9 Oriana Baddeley and Valerie Fraser, *Drawing the Line: Art and Cultural Identity in Contemporary Latin America* (London and New York: Verso, 1989), p. 11.

10 Gerardo Mosquera, catalogue essay in Ana Mendieta, *Rupestrian Sculptures/Esculturas Rupestres* (exh. cat.) (New York: AIR Gallery, 1981).

11 Luis Camnitzer, 'Ana Mendieta', *Third Text* no. 7 (Summer 1989), p. 48.

12 Gerardo Mosquera suggests 'aesthetic-symbolic production' as an alternative to the term 'Art', which is historically and culturally specific to post-Enlightenment western culture and fails to acknowledge the culturally specific social meanings and functions of past and non-western cultural practices. See Mosquera, 'The History of Art and Cultures' (seminar paper presented at the Centre for Curatorial Studies, Bard College, New York, 15 April 1994).

13 Alexander Wilson, *The Culture of Nature: North American Landscape from Disney to the Exxon Valdez* (Cambridge, Mass. and Oxford, UK: Blackwell Publishers, 1992), p.14.

14 Carolyn Merchant, *The Death of Nature: Women, Ecology, and the Scientific Revolution* (New York: Harper & Row, 1980). This is a detailed analysis of various competing models of nature in relation to gender and to social and environmental history; for reasons of space I have had to oversimplify this complex and contradictory field.

15 Ibid., pp. 29–41.

16 Lawrence, 'Introduction to These Paintings', p. 142.

17 Merchant, *The Death of Nature*, p. 6.

18 Ibid., p. 190.

19 Wilson, *The Culture of Nature*, p. 154.

20 Sidonie Smith, *Subjectivity, Identity and the Body: Women's Autobiographical Practices in the Twentieth Century* (Bloomington and Indianapolis: Indiana University Press, 1993), p. 171.

21 John Beardsley, *Earthworks and Beyond: Contemporary Art in the Landscape* (New York: Abbeville Press, 1984), p. 7. It should be noted that the notion of a more or less universal twentieth-century devaluation of landscape art comes from a particular perspective based in New York high modernism; in Canada, for instance, landscape was the dominant vocabulary of modernist painting in the first half of the twentieth century.

22 Michael Heizer, quoted in Beardsley, *Earthworks and Beyond*, p.13.

23 Lucy R. Lippard, 'Quite Contrary: Body, Nature, Ritual in Women's Art', *Chrysalis*, vol. 2 (1977), pp. 39–40.

24 Lippard, *Overlay*, p. 78.

25 Mendieta, bilingual wall text for exhibition *circa* 1981, quoted in Barreras del Rio and Perreault, *Ana Mendieta*, p. 28.

26 Heizer, quoted in Beardsley, *Earthworks and Beyond*, p. 19.

27 Lippard, 'Quite Contrary', p. 40.

28 Ana Mendieta, gallery sheet for *Silueta Series 1977*, an exhibition at Corroboree, Gallery of New Concepts, Iowa City; quoted in Mary Jane Jacob, *Ana Mendieta: The 'Silueta' Series, 1973–1980* (exh. cat.) (New York: Galerie Lelong, 1991), p. 8.

29 See Joel B. Hagen, *An Entangled Bank: The Origins of Ecosystem Ecology* (New Brunswick, N.J.: Rutgers University Press, 1992), pp. 191–2 for a summary of the scientific status of the 'Gaia hypothesis', understood more rigorously as proposing not that the earth is literally an organism, but that the biosphere is controlled by living organisms which regulate the conditions essential for life through the complex feedback mechanisms of earth's ecosystems.

30 Haraway, *Simians, Cyborgs and Women*, p. 154.

31 Ibid., p. 174.

32 Hagen, *An Entangled Bank*, p. 191.

33 See Hagen for a history of late nineteenth- and twentieth-century ecology and its debates over the use of organismic and technological language in scientific discourses.

34 McFague, *The Body of God*, p. 36.

35 Lawrence, 'Introduction to These Paintings', p. 146.

36 John Perreault, 'Earth and Fire: Mendieta's Body of Work' in Barreras del Rio and Perreault, *Ana Mendieta*, p. 13.

37 Wilson, *The Culture of Nature*, p. 14.

38 Robert Smithson, quoted in Lippard, *Overlay*, p. 57.

39 It would be irresponsible not to note that Carl Andre and Ana Mendieta married in January 1985, and that Mendieta died tragically later that year by falling out of the window of their 34th-storey apartment in circumstances that are still unclear. Luis Camnitzer notes in his article on Mendieta that Andre was acquitted of murder in 1988 because his guilt had not been proven 'beyond a reasonable doubt'.

40 Lippard, *Overlay*, p. 30.

41 Carl Andre, quoted in ibid. p. 141.

42 Lawrence, 'Introduction to These Paintings', p. 157.

43 Donald Kuspit, 'Ana Mendieta' (review), *Artforum*, vol. 26, no. 6, p. 144.

44 Ana Mendieta, 'Introduction', *Dialectics of Isolation: An Exhibition of Third World Women Artists of the United States* (exh. cat.) (New York: AIR Gallery, 1980).

45 See Jacob, *Ana Mendieta*, for the most detailed discussion to date of Mendieta's use of Santería.

46 It should be noted that Mendieta did not grow up practising Santería, but encountered it through the stories of African-Cuban servants in her parents' household, and later through the writings of Lydia Cabrera and the Santería practices of Cuban communities in New York and Miami. Her deployment of it is thus more a deliberate, strategic identification than an expression of pre-existing identity. See Jacob, *Ana Mendieta*, p. 4.

47 In the exhibition catalogue *Ana Mendieta: A Retrospective*, Marcia Tucker notes that Mendieta 'was outspoken and aggressive about her political views, but at the same time she felt that art's importance lay in the spiritual sphere'. She quotes Mendieta as stating that 'Art is a material part of culture but its greatest value is its spiritual role, and that influences society, because it's the greatest contribution to the intellectual and moral development of humanity that can be made.' See Barreras del Rio and Perreault, *Ana Mendieta*, p. 6. See also Mendieta's introduction to the exhibition catalogue *Dialectics of Isolation*.

48 See Baddeley and Fraser, *Drawing the Line*, chapter 1, 'Mapping Landscapes'.

49 See Irit Rogoff, 'The Discourse of Exile: Geographies and Representations of Identity', *Journal of Philosophy and the Visual Arts*, July 1989, pp. 72–3.

50 Ibid., p. 72.

51 Elisabeth Bronfen, *Over Her Dead Body: Death, Femininity and the Aesthetic* (Manchester: Manchester University Press, 1992), p. 52. To avoid an excessive number of footnotes, further references to this text will appear in the body of the chapter.

52 Smith, *Subjectivity, Identity and the Body*, p. 10.

53 This point is made by Camnitzer, 'Ana Mendieta', p. 50.

54 Sigmund Freud, 'The "Uncanny"' (Standard Edition, vol. XVII), p. 220.

55 Ibid., pp. 235–6.

56 Mendieta, unpublished statement, 1981; quoted in Barreras del Rio and Perreault, p. 10. The 13-year-old Ana Mendieta and her sister were among a number of children sent in the early 1960s from newly Communist Cuba to Catholic orphanages in the United States; their mother joined them three years later. Mendieta revisited Cuba in 1980, and in 1981 she 'took the *Silueta* series back to its source' by making her 'Rupestrian Sculptures' at Jaruco, Cuba.

57 Ibid.

58 Space does not permit me to support this argument fully, but see Bronfen, *Over Her Dead Body*, pp. 121–4, for a summary of the workings of sexual difference and fetishism in images of women/Woman.

59 See Kaja Silverman, *The Acoustic Mirror: The Female Voice in Psychoanalysis and Cinema* (Bloomington and Indianapolis: Indiana University Press, 1988) for a useful discussion of the maternal body as imaginary mirror and object of retrospective fantasy.

60 I am indebted here to Charles Merewether's reading of Mendieta's project: he argues that 'Mendieta shifted the location of meaning and identity from the fixity of an image or place (the body represented, or the land) to the actual processes of inscription'. See Merewether, 'Displacement and the Reinvention of Identity' in Waldo Rasmussen (ed.), *Latin American Artists of the Twentieth Century* (exh. cat.) (New York: The Museum of Modern Art, 1993), p. 146.

61 Bracha Lichtenberg Ettinger, 'Matrix and Metramorphosis', *Differences*, vol. 4, no. 3 (Fall 1992), pp. 178–9.

62 Lichtenberg Ettinger, 'Metramorphic Borderlinks and Matrixial Borderspace' (seminar paper presented at the University of Leeds, 15 March 1994), p. 13.

63 Ibid., p. 14.

64 Lichtenberg Ettinger, 'Matrix and Metramorphosis', p. 200.

65 Lichtenberg Ettinger, 'Metramorphic Borderlinks and Matrixial Borderspace', p. 11.

66 Merewether, 'Displacement and the Reinvention of Identity', p. 155.

PART VII

History

Comfort women

women of conformity: the work of Shimada Yoshiko

Hagiwara Hiroko

JAPAN AND ASIA

Shimada Yoshiko's print-etching was published on the cover of the 1994 September/October issue of *Asian Art News*, a publication in English from Hong Kong (Figure 14.1). The image can be identified as the late Japanese emperor Hirohito, though his face is burnt out, not to be represented, and the hollow face is marked with a big cross. Shimada uses an old photograph of Hirohito in military uniform, which was treated as a sacred icon in wartime Japan. The whole piece is tainted with rusty red, which is reminiscent of blood.

The magazine is widely distributed in Southeast Asia but rarely in Japan. I must stress a dramatic contrast: what happened in Hong Kong would never happen in Japan. No art magazine in Japan will use an artwork including the emperor's image to illustrate the cover for fear of ultranationalist attack. Censorship to avoid the use of the emperor's image has been internalized by artists. Few artists dare to use the image. This specific piece by Shimada is visually too controversial to be reproduced on a cover. In contrast, in Hong Kong and other Asian countries which were once ruled by Japan, Shimada's

Figure 14.1 Shimada Yoshiko, *A Picture to be Burnt*, 1993, etching, 60 × 45 cm

image can be properly shares and appreciated as an explicit representation of the artist's negation of the iconic divinity of the emperor.[1]

The contrasting attitude of Japan and Asia towards the emperor's image is suggestive. 'Japan and Asia', which is a common expression in Japan, might seem odd but reflects the region's contrasting experiences of colonialist wars since the closing decades of the last century. Shimada Yoshiko, an artist born in 1959, is critically conscious of the Japanese connotation of the word 'Asia', which indicates Asian countries other than Japan, yet she knows she cannot easily equate the different experiences of the colonized and the colonizer in wartime and the South and the North in the post-war period.

In her prints, installations and performances Shimada deals with issues of Japanese war crimes in Asia, for which even ordinary Japanese women were responsible, and with Asian women's experiences, which made a remarkable contrast with those of Japanese women. To focus on differences between 'Japan and Asia' is the artist's far-sighted strategy to position Japan in Asia.

IMAGES OF JAPANESE WOMEN

Shimada's etchings are quite minimalist. She uses old newspaper photos and postcards published in the 1930s and 1940s without adding complex arrangements. She simply quotes old materials to mount on prints and makes them recite real, hidden or new meanings that were unseen at the time of their production.

The series of prints, *Past Imperfect* (1993), manifests her critical view of Japan's modern history, with an emphasis on the image of women and their experiences. *Three Women* (Figure 14.2) is a reproduction of an old touristic postcard. The images of three Japanese women wearing kimonos and the traditional hairdo playfully take the pose of 'hear no evil, see no evil, speak no evil'. The postcard was produced as a lighthearted souvenir. But with the passage of time, which has provided a change of social context, the pose of the women can be now seen as symbolic of restrictions once imposed on women.

The image of a geisha girl has been repeated again and again in the western media to reproduce the stereotype of Japanese women, the women from the Far East who are devoted, submissive, exotic and desirable. The stereotyped image is ahistorical, but the geishas in Shimada's print, *Fujiyama, Geisha* are historical women. They are photographed sitting before the rising-sun flag and the swastica flag. The photo the artist quotes would have been taken around 1940 when Japan formed an alliance with the Nazis.

The ideological functions of established images of women pervading the media are also revealed in many other pieces by the artist. Hara Setsuko, a Japanese film star, best known as the gentle widow in Ozu's *Tokyo Story*, appears in a still of *Die Tochter des Samurai* the artist quotes.[2] This propaganda film was jointly produced by Germany and Japan in the 1940s. Another photo, which is juxtaposed with it, is a snapshot of Hara and Goebbels. It is not widely known that Hara featured in many government propaganda films during the war. The artist's concern here is to betray people's fantasized image of Hara, the icon of post-war democratic Japan.

The next piece, *Before and After*, also uses a pair of images of Hara and effectively reveals the fact that the iconic image was a made-up one (Figure 14.3). The picture of Hara on the left, which is taken from a still of a wartime film, is of a devoted working mother who would whip up war sentiment. The one on the right is a photo taken after the war. She is smiling, with her hair permed, which was condemned as anti-nationalist luxury in wartime, and, blazoned above her, the slogan of democratization. The image of one woman was used to encourage the pro-war nationalist attitude and the anti-war democratic posture. The image of women was something to be manipulated and consistently regarded as being essential for social control.

Figure 14.2 Shimada Yoshiko, *Three Women*, 1993, etching, 15 × 22.5 cm

Figure 14.3 Shimada Yoshiko, *Hara Setsuko, Before and After*, 1993, etching, 30 × 45 cm

WOMEN'S WILLING SUPPORT OF WAR

Shimada's constant concern is that Japanese women's willing and aggressive participation in the colonialist war should be made visible. She is also anxious to shed light on the cult of motherhood, thanks to which women could be positive about their femininity and, at the same time, could be negative about other ways of living.

A series of prints, *White Aprons*, visually reveals women's virtue in wartime (Figure 14.4). The *kappogi*, the white apron to be worn over a kimono, was adopted as a uniform of the National Defense Women's Organization, the aim of which was to aid and comfort Japanese soldiers and their families. The organization was founded in 1932 and its major activity was to send off soldiers and serve them tea at the port and the station. Thanks to an overalls-type white apron, any woman could participate in the activity without bothering about what to wear. But the most significant function of the apron was to make any member into the mother of any soldier.

The old photos Shimada uses are all startling. The photos in *White Aprons, Triptych* could have been taken in the 1930s and early 1940s. A housewife is cooking in the kitchen, members of the women's organization are sending off soldiers, and women with pistols are learning to shoot. A picture of domesticity is juxtaposed with pictures of Japanese women behaving aggressively. They are all in white aprons. Since the white apron was a symbol of motherly care, and the chastity and asexuality of a housewife, it functioned as a useful tool to encourage ordinary housewives to go out of the home and participate in a social activity. Until then, ordinary housewives had not been expected to be active in public. Before Japanese women gained the suffrage in 1945, they had no legal standing, no chance to get higher education and no way to be independent individuals who could move freely in a social sphere. Being a mother and housewife was the only acceptable social status for women. As long as they were wearing a white apron women were allowed to be openly active.

The photo of aproned women holding pistols is repeated in the centrepiece of *Shooting Lesson* (Figure 14.5). They could be colonists in Manchukuo, which was founded in 1932 in the guise of an independent state and was virtually controlled by the Guandong Army, Japan's field army in Manchuria. Wives of colonists are learning to shoot under the guidance of soldiers. Japanese colonists, many of whom were migrants from impoverished farming villages in Japan, took over local people's land to cultivate. Since they were often attacked by anti-Japanese guerrillas, they formed a self-defence civilian force. Even women learned to shoot in order to defend their land and family from 'rebellious natives' or 'local barbarians'. Aprons, which could not have been practically needed for shooting lessons, were needed as a sign to cover up a gap between femininity and armed action.

At each corner of the print, there is a portrait of a Korean comfort woman, who was forced to serve front-line Japanese soldiers sexually. The piece shows the contrasting situations of the women. The four military comfort women at the corners are victimized and swayed by events beyond their control, while the four aproned women in the centrepiece are learning to be aggressors. The visual images here are all quotes but Shimada's arrangement is successful in showing the different experiences of women. No, 'different experiences of women' is euphemistic. Rather, I should say that the differences that women experienced were not simply a matter of possible variants over which each woman exercised some choice. Rather, these differences reflect the hierarchically differentiated social positions of women in the mutual and conflicting determinations of gender, class and nationality.

Japanese women's willing participation in war is also the topic of the piece *Balloon Bombs*. At the end of the Second World War balloon bombs were designed to carry bombs effectively to the US west coast. The balloons were made of tough paper and potato paste. Highschool girls in

Figure 14.4 Shimada Yoshiko, *White Aprons, Triptych*, 1993, etching, 45 × 73 cm

Figure 14.5 Shimada Yoshiko, *Shooting Lesson II*, 1993, etching, 45 × 60 cm

Kokura, on Kyushu island, laboured over twelve hours a day to produce them. Over 9,000 balloons were said to have left Japan. About 1,000 reached the United States and Mexico. Only one bomb that was carried to Oregon did damage. The balloon bomb seems to have been a laughable, puerile trick which was not a serious armament. But it effectively worked to induce young women to be eager war-supporters. A red balloon in Shimada's print is swollen to a considerable size and below the balloon, girl workers in kimonos are smiling radiantly.

Figure 14.6 Shimada Yoshiko, *Mother and Child*, 1993, etching, 60 × 40 cm

The cult of motherhood has both encouraged and suppressed the Japanese women's movement. In wartime the cultist craze of motherhood enabled women to be aggressors. But motherhood was the only channel for women's skills. *Mother and Child* (Figure 14.6) is made of layered images of several pairs of mothers and children. The empress embraces a baby, the present emperor Akihito. Mothers are proudly holding baby boys that have won a baby contest. Women were actually encouraged to reproduce boys, who would be soldiers. At the bottom of the piece a famous photo of air-raided Osaka is quoted to show the burnt bodies of a mother and a child. And beneath all those images a sacred icon of the Holy Mother and Baby Jesus is vaguely seen. From ordinary women to the empress, from a bombed victim to the Madonna, women were praised as mothers, not as individuals. Women were encouraged to be the National Mother, who would support the family and the state. The cult of motherhood was part of the nationalist ideology, which would sustain that illusory unity, the steadfast and foremost family-state, Japan.

After seeing successful examples of the artist's minimalist scheme, it would be easy to read the connotations of small pieces of simple reproduction of photos of a chrysanthemum flower and cherry blossoms. The flowers can now be seen as heavily charged with nationalist ideology. The chrysanthemum can be read as the imperial family's crest. Cherry blossoms appear to be a sign standing for the Japanese, who believe themselves to bloom and fall fast and gracefully for the nation, or for the emperor. Because Shimada has added sombre

texture to the original photos, the flowers are dubiously dull in hue to show the artist's confrontation with these nationalist symbols. She would exhibit these pieces in the final section of a show, so that the audience would have learned the artist's visual discourse when they reached these concluding statements. The audience would be horrified to be made aware that even flowers cannot escape from metaphorical enclosure within this family-state, Japan.

MILITARY COMFORT WOMEN

The issue of military comfort women is repeatedly taken up by the artist in the series *Past Imperfect.* In the etching *A House of Comfort* (Figure 14.7), Shimada places a photo of a mansion-cum-military brothel in the top zone of the print and a snapshot of Asian prostitutes at the bottom. In the centre an undressed figure is standing. The title is sarcastic. What comfort was provided there and to whom?

The issue Shimada is concerned with is what produced that system of rape, why Japanese people have supported it, and what stance Japanese women should take. I must emphasize that there are very few artists in Japan who take up the issue of military comfort women. The issue itself had long been publicly silenced until 1991, when one ex-comfort woman from Korea came out and revealed the Japanese armed forces' involvement in the construction and administration of military brothels.

The military brothels were a widespread official establishment which started shortly after the open war against China, when the troops were dispatched in large numbers to China. The first military brothel was set up by the Japanese army in Shanghai in 1932. The subsequent commandant of the Japanese field army in China, Okamura Yasuji, who was then still adjutant to the general army staff, later proudly recalled being the initiator of the military brothel system.

Figure 14.7 Shimada Yoshiko, *A House of Comfort,* 1993, etching, 60 × 45 cm

The system started for the sexual gratification of soldiers and the lowering of the venereal disease rate, that might have been higher if the soldiers went on freely raping local women.

The Japanese navy set up a brothel for its sailors in Shanghai in the same year. The 14th brigade, which operated in Manchuria, opened its own brothel in 1933. After the Japanese atrociously conquered Nanking, then the Chinese capital, in 1937, hundreds of soldiers were convicted by a military court of rape, or rape and murder. It has been estimated that 200,000 people were killed and 20,000 women raped. The fear that army officers of high rank felt about the reputation of the Imperial Japanese Army gave impetus to construction of military brothels. The atrocities provoked anti-Japanese sentiments among the local people and endangered the Japanese occupation of the area. The problem was to be solved by setting up military brothels.

Places of sexual gratification were said to have an immediate and far-reaching effect on the soldiers' mentality. It was reported that, thanks to construction of military brothels, war morale was raised, army discipline was improved, and crime and sexual disease were effectively prevented. The military brothel was not an accidental product of wartime madness but a well-thought-out plan that was deliberately put into practice in order to execute the colonialist war.

By the end of the war military brothels were found wherever the Japanese troops advanced. Even the rough report of an official investigation made by the Japanese government since 1992 confirms the existence of military brothels in China, the Phillippines, Malaysia, Singapore, Indonesia, and on some southern islands in Japan. Other documents collected with great effort by private researchers confirm their existence also in Burma, Taiwan, New Guinea, Indochina, and on some Micronesian islands. It is not easy to estimate the number of women who were forced into prostitution. Estimates vary from 100,000 to 200,000. Though women from all regions that the Japanese armed forces went to were victimized, the greatest number of military comfort women were from Korea.

The reason why Korean women were seen as suitable for military comfort women was that Korea was a Japanese colony. Most of the Japanese women who were recruited for military brothels were already working as prostitutes and many were reported to be infected with sexual diseases. Apart from infection, the military authorities had another fear about recruiting Japanese women for their brothels. The soldiers would have lost their fighting spirit and put up resistance if their sisters and daughters had been made into military prostitutes, or if Japanese comfort women had been reminiscent of their sisters and daughters at home. In order to protect the soldiers from infection and to spur them on to fight, women from the colony were regarded as suitable for service in military brothels. Korea had been a Japanese colony since it was annexed to Japan in 1910. The Japanese thought that the country, its resources and its population could be freely exploited. The Japanese troops could forcibly recruit Korean women under favourable conditions. Though Japan was a member of the international treaty for the fight against the trade in female children, an appended clause removed Korea, Taiwan and Manchuria from the ban. It was formulated to permit the recruitment of women, even minors, from these regions.

In the very beginning, the collection of women on the orders of the army was carried out by fully licensed middlemen. In Korea they travelled from house to house, sometimes accompanied by the village chief or police officers so as to avoid resistance from the women's parents. The middlemen who travelled through Korea collected young women over twelve or thirteen with the false promise that they would work for wounded soldiers in overseas hospitals.

As the deceptive practices of the middlemen began to attract local people's attention, the recruitment of women was soon put under the direct control of the armed forces. In 1938 an adjutant of the war ministry sent the following order to the commanders of the units stationed in China:

> The recruiting [of women for military brothels] should be controlled by the respective units. The contractors charged with recruitment must be selected with care. The recruitment should be carried out in close contact with the military and civil police. These matters should be dealt with carefully so as not to harm the army's reputation.[3]

The Japanese government claimed until recently that army participation in the recruitment of women could not be proved. Some documents bearing concrete evidence have now been found. But the eye-witness accounts of kidnapped women and of ex-military personnel, who themselves took part in the womanhunt, had already revealed that the army issued orders for the acquisition of women and was involved in their transport.

'Sexual slavery' is still a lame expression for its official policy and for the plight of forced comfort women from Korea. It was a colonialist system of rape, which was organized and executed according to a deliberate plan made out by the official body.[4]

COMFORT WOMEN AND WOMEN OF CONFORMITY

Shimada's intention is not to expose and exhibit the dreadful daily life of Korean comfort women in military brothels. She knows she must be circumspect in dealing with the issue so as not to encourage the Japanese audience's pitying gaze on the victimized. In the artist's book, *Comfort Women, Women of Conformity* (1994) (Figure 14.8) which consists of photographic images and texts, she clearly contrasts and problematizes opposing experiences of Korean comfort women and Japanese mothers, and the imperialist hierarchy between them, which produced the opposition.[5]

This twenty-page book is entirely made of quotes, and the insightful compilation and composition convey the artist's stance. Each spread consists of contrasting photos and texts, Japanese women's on the right-hand page and Korean women's on the left.

On the right-hand page of a spread the artist cites two eugenicist comments from the late 1930s and the early 1940s made by contemporary Japanese women intellectuals. Takeuchi Shigeyo, who was a doctor and a member of the National Spirit Mobilization Committee, says as follows.

> Lately highly educated people tend to get married at an older age. This must be changed. People with good qualities should get married at an early age and produce many strong, intelligent children. Those who do not have such good qualities should do the reverse. Those with severely inferior qualities should be sterilized and leave no offspring. . . . The Japanese are the supreme race. We should not allow lesser quality weeds to spread in our soil. We must advocate eugenics along with other studies so that the people of Japan will improve their intellect, have better offspring and contribute to the prosperity of our nation.

The other quote is from the essay, 'Marriage, Family and Children', by Hiratsuka Raicho, who was a well-known pioneering feminist: 'For the protection of our racial superiority and motherhood, we urge the necessity of prohibition against marriage of the inferior (those who are mentally ill, retarded, alcoholic and infected with an epidemic).'

Lee Gyong Song, a Korean woman on the opposite page, was born in 1917 and summoned at the age of twelve by the village chief. The photo and text are quoted from the book, which is a collection of ex-comfort women's recent portraits and accounts edited by Itoh Takashi, a male photo-journalist.[6] Lee was taken to a munition factory in South Korea and forced to work in the comfort house attached to it for four years until she took flight. Her words read as follows: 'I got pregnant when I was sixteen. The lieutenant said, "We don't need a Korean baby who won't be loyal to the Emperor". He stabbed my stomach and killed the foetus.' Lee's portrait, which is reproduced on the page, was taken after she came out a few years ago to demand an apology and compensation from the Japanese government. Shimada puts a four-sided white patch over the mouth of the portrait. The mouth of the old woman in her seventies is covered with a patch, on which her words are printed. Her old face with the mouth covered reminds us of her long years of silence, while Japanese women on the opposite page are elatedly loquacious.

Another spread is made of opposing accounts about venereal disease. Again Hiratsuka Raicho's words are cited, from the essay, 'War and Childbirth', published in 1939. She is fearful of the spread

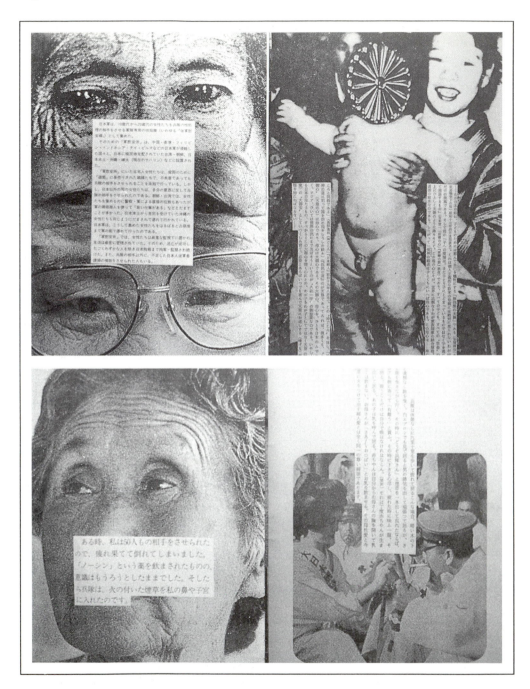

Figure 14.8 a and b Shimada Yoshiko, *Comfort Women, Women of Conformity*, 1994, artist's book, 30 ×
21 cm

of VD among Japanese women after the soldiers' return from the front. She never questions why soldiers are infected but just claims preventive measures against VD for 'motherhood of soldiers' wives, and maidens of the same class who are to be their future wives'. Shimada illustrates the page with a photo of Japanese schoolgirls, maidens, in wartime, who are practising the Imperial Subject's Gymnastic Exercise, the exercise dedicated to the emperor.

On the opposite page the Korean woman Lee Kwi Bun, who was kidnapped in the street at the age of fourteen and shipped to a military brothel in Taiwan, says:

> Most women (in the brothel) had VD. It hurt when soldiers were rough. But if we refused, they beat us up. I saw a soldier shoot a woman in the vagina and just leave the body behind. When a woman got syphilis, she could not expect medication or food. Some died with swollen wombs. If one died, a new woman was supplied.

The pages of Korean women's accounts all confront the ones of Japanese women. Kim Dae Il was forcibly taken to work in a hospital in Japan. There she got raped by a doctor, who then sold her to a military brothel in Shanghai. She was transferred to various front lines in China. At the end of the war she saw many women massacred. She was one of three who survived from the same comfort house. Kim, now in her late seventies, bitterly speaks of the past after silence over a half century: ' When I had to serve fifty soldiers a day, I fainted from exhaustion. They gave me medicine but I felt still dizzy. Then a soldier put a lighted cigarette into my nostrils and vagina to wake me up.'

A Japanese woman in a photo on the opposite page is lighting a soldier's cigarette. The woman is in a white apron with a sash marked 'National Defense Women's Organization'. The text is an army officer's praises for the motherly love of Japanese women, who would kindly light a cigarette for a soldier.

> There is nothing like a cigarette after a long march. Now all you have to do is to smoke because it has been already lit by a caring woman in a white apron. She willingly lights a cigarette for a soldier. She is like a mother, who willingly opens the breast to feed a crying baby. Motherly love is exactly the same as the womanly love that offers a lighted cigarette to a tired soldier.

The artist's composition of the two accounts about a lighted cigarette is suggestive. After contrasting the anger of the former comfort women from Korea and the eugenicist ideology of imperial motherhood as stated by Japanese women in wartime, Shimada cites, at the end of the book, the post-war comments by ordinary Japanese women: 'It was wartime. Nothing could have been done'; 'It is the fault of war'; 'We suffered, too. Everybody did. It was war'. Nothing was wrong but war. No one was responsible but war. In those words Shimada sees the same imperialist mentality continue. They wouldn't face the fact that they actively supported and produced the plight of women from the colonized Asia. According to the artist's statement, the whole comfort women issue will never be our problem but someone else's if we do not accept Japanese women's complicity in colonialist war.

IMPERIAL MOTHERHOOD, MATERNAL IMPERIALISM

The performance piece with the same title as the artist's book puts more stress on the issue of imperial motherhood as a harmful ideology. The artist, now dressed as a sacred Japanese mother, stands in a white apron, holding a divine baby boy, whose face is a round mirror. The artist has a mask on her face, which implies lack of the mother's individuality and her lack of responsibility. The texts she narrates are the ones quoted in the Japanese pages of the book mentioned above. The portraits and voiceless accounts of the former comfort women are projected on the wall behind the artist one after another. The silenced anger of old Korean women, who were sexually abused and rendered infertile, is quietly shown. It is all the more clear that the praise of motherhood that the

artist now narrates was applicable only to Japanese women. At the very end of the performance there is a newly added fictional text, which is not in the book. The Japanese mother acted by Shimada decisively speaks out.

> I myself lost my son in the war. He died for the nation and his spirit was enshrined in the National Yasukuni Shrine by His Highness. My son is God of the Yasukuni Shrine. My son never did anything unjust. My son couldn't and wouldn't. It is not my son who committed atrocities. For my son is God. For my son is God.

The mother thrusts out the baby doll to the audience. In dark space the mirror of the baby's face glaringly reflects the slide-projector's light. The audiences faces must be reflected in the mirror of the god-like son, but they cannot stare at the mirror because of the glare. Then the mother suddenly stabs and kills the baby. Blood splashes around. On the wall now the portrait of Hirohito is being projected.

Performance art in general has a strong tendency to be like a ritual. An artist often plays a deified role and dominates the space and audience as someone holding a sacred, unearthly or special power. But this piece is clearly attacking such ritualization. The role the artist plays here, National Mother or Imperial Mother, is not to be deified but to be pulled down from the sanctified pedestal. The audience is not allowed to be passive art-lover/worshipper but to share the questions with the artist: what produced the system of rape, why it has not been problematized until recently and how Japanese women supported it. Shimada's attempt here is to politicize art and audience in order to turn a critical gaze on the ideology of imperial motherhood with the audience.

Her work as a whole is full of political sensibility. I must stress that her work has originated from her own conceptualizing and visualizing scheme. She is not copying or illustrating an idea that pre-dates her art. She is not supporting someone who raises questions about imperial motherhood; she herself is raising the questions.

In the core of the military comfort women issue Shimada sees Japanese imperialism. She finds it maternal. Actually fanatic imperialists use expressions such as 'motherly imperialism' and 'motherly emperor'. In wartime people often called themselves 'the Emperor's baby'. This maternal disguise obstructs people's view of patriarchal power. Japanese imperialism has been supported by a set of patriarchal, ethnocentric and elitist ideologies, which are all exclusionist. It separates public, central and active men from domestic, marginal and passive women, the sacred mother from the filthy prostitute, subjects of pure and homogenous Japanese descent from other Asians. Shimada points out in her unpublished essay 'Military Comfort Women and the Japanese Paradigm of Sex', that real mothers under the protection of maternal imperialism exercised patriarchal power over their sons on behalf of the emperor. The national mother was irresponsible because of a lack of that individuality that would allow her to be responsible. She was blindly protective towards blood relations. This loyalty was easily extended then to the Japanese nation: indicated when Shimada repeats the words 'my son' when holding up the child as if it were a national god at the ending of the performance. It was the imperial mother/maternal imperialism who killed her son, never taking ultimate responsibility for the action. Those ideologies, which underlay the actual institutions, needed and produced the military brothel system.

But the English word 'imperialism' is perhaps too vague to anatomize a specific set of ideologies focused on in Shimada's work. The phrase 'the Emperor System', as she calls it in Japanese, would be more explanatory. For it is not just an ideology or the politics of expansionism, national supremacism or hegemonic domination, which can be seen in the USA or France, but of a monarchy embodied in a divine persona, the emperor. Shimada deals with the issue of the Emperor System not as a past system but as one functioning in contemporary Japanese society. Why does the Japanese public react coldly towards the former military comfort women, who came out and revealed the political reality of that system after a long silence? Shimada thinks the systemic lack

of responsibility continues to provide people with a sense of unity as a nation in harmony in a family-state, Japan, while excluding Asian others.

Hiratsuka Raicho, whom Shimada quotes in her book, was a founding editor of *Seito* (Blue Stockings). Doctor Takeuchi was once a suffragette. Other women intellectuals such as Ichikawa Fusae and Kora Tomi, who also appear in the book, were all well-known feminists who were active against women's oppression in the 1910s and 1920s. Shimada's quotes, however, are eugenicist and pro-war statements that they made in the 1930s and 1940s. The artist's view is that their reactionary statements were explicable not as wartime conversion or compromise, but as a consistent imperialist position, which was defined by great patriarchal power and limited to the women of the nation. Shimada's concern with the issue of women as assailants is generated from the fear that we might be still assailants even if we consistently keep on feminist action. Her work is generating feminist debate beyond the sphere in which an artist, even a woman artist, has hitherto been expected to be in.

Notes

1 As for the piece, *A Picture to be Burnt*, see the detailed review by Nancy Shalala published in *Asian Art News*, Hong Kong, September/October 1994.
2 The film was released as *New Land* in Japan.
3 *Asahi Shinbun*, Tokyo, 15 July 1992.
4 The historical introduction in this section mainly depends on the documents published in *Jugun Ianhu Shiryoshu* (Collected documents concerning military prostitution) by Yoshimi Yoshiaki, Tokyo, Otsuki, 1992.
5 This is a hand-made book produced in small numbers as a private edition.
6 Itoh Takashi, *Yaburareta Chinmoku: Asia no Jugun Ianhu-tachi* (Breaking through Silence: Asian Military Comfort Women), Nagoya, Fubaisha, 1993.

Chapter Fifteen

Gleaning in history or coming after/behind the reapers:

the feminine, the stranger and the matrix in the work and theory of Bracha Lichtenberg Ettinger

Griselda Pollock

LET ME TELL YOU A TALE FOR OUR TIMES

There was once a woman. She was also a mother. She had two sons. But she and her family lived at the time of a dreadful famine and they had to leave their own land in search of food and a better life. They travelled around a land-locked sea to the land of the mountains they used to watch swathed in purple and pink by the setting sun. They settled in this foreign land. The woman's sons grew up and married women of the country. But soon disaster struck. The father sickened and died. Still the woman had her sons and her daughters-in-law. Then there was another tragedy which took from her both sons. The woman was left bereaved, isolated and stricken. When she eventually returned to her home town where the famine had lifted, she told her friends to call her no longer by her name, which meant 'pleasantness'. They were to call her 'bitterness'.

This woman, Naomi, from the biblical Book of Ruth, can be borrowed as an image of the Survivor. She was the one who came back bearing the permanent burden of inconsolable loss. I want to drag Naomi and the narrative in which she is the central character from its remote times and mythical status, to serve as a tale for the late twentieth century. The chariot of such time travel is feminism – and in particular a conjunction between feminism, femininity, and the questions of strangeness, alterity and survival. The art work about which I shall be writing is the product of a specific historical conjuncture: the atrocity known in Europe as the Holocaust and, in certain Jewish traditions, as Ha-Shoah, the destruction, meets a new turn in feminist interventions in psychoanalysis to track an unexpected covenant between the Jewish experience of modernity and the predicament – as well as the promise – of the feminine.

Let me go back then to Naomi.

'Do not call me Naomi [pleasantness],' she replied. 'Call me Mara [bitterness] for *Shaddai* has made my lot very bitter. I went away full, and the Lord has brought me back empty. How can you call me Naomi, when the Lord has dealt harshly with me, when *Shaddai* has brought misfortune upon me?'

Book of Ruth, 1: 20–21

In her paper 'Matrix, a Shift beyond the Phallus', Bracha Lichtenberg Ettinger considers the several names for the God of the Hebrew Bible. One is *El Rahamim*. Translated usually as 'God full of mercy', this is a figurative reading of signifiers whose literal meaning is wombs. In Latin, womb is matrix. Bracha Lichtenberg Ettinger thus suggests, shockingly, that the text is actually giving us

a God full of wombs; a God who 'matrixes' us – is merciful through an image that is highly gendered. The matrix is for Bracha Lichtenberg Ettinger not a place or an entity, like Plato's chora. It is a symbol, a signifier that transports into meaning and consciousness another set of relations through which to imagine, fantasize and think subjectivity.[1]

> Matrix is an unconscious space of simultaneous emergence and fading of the *I* and the unknown *non-I* which is neither fused nor rejected. Matrix is based on feminine/prenatal inter-relations and exhibits a shared borderspace in which what I call *differentiation-in-co-emergence* and *distance-in-proximity* are continuously rehoned and reorganised by metramorphosis . . . created by and further creating *relations-without-relating* on the borderspaces of presence and absence, subject and object, me and the stranger. In the unconscious mind, the matrixial borderline dimension, involved in the process of creating feminine desire and meaning, both co-exists and alternates with the phallic dimension.[2]

Another ancient name for this God is *El Shaddai*, as used here by Naomi. The nomination is used frequently in Genesis and sometimes in Exodus, always in relation to the covenant between God and the patriarchs, or between God and the people of Israel/Jacob. The usual translation is 'omnipotent' or 'almighty'. The literal meaning of *shaddai* is 'my breasts', 'my nipples'. The artist concludes:

> In traditional Biblical interpretation based on the original Hebrew, matrixial, maternal and feminine connotations of God's name are usually ignored, although we do still have access to them through the signifiers themselves. In the translation, however, they totally disappear. The abolition of the wombs and the breasts from God's names, constitutes, in my view, not only the elimination of conventional feminine imagery from God's Image, but also a non-inclusion, or foreclusion, of a symbolic dimension of alliance or covenant, a dimension I have called 'matrixial', which I qualify as 'feminine'. Thus certain basic notions of the Jewish tradition (on which psychoanalysis relies heavily) are not necessarily paternal, but is systematically diverted through interpretations and translations that serve the Phallus.[3]

In yet another paper, the artist Bracha Lichtenberg Ettinger has explored the matrixial dimension of the most famous name for God. Usually translated as 'I am that I am', the Hebrew is grammatically cast in the imperfect, which means rather 'I will be what I will become', introducing a sense of subjectivity as that which is continuously co-emerging in a dimension of the several – the covenant, rather than in the image of the self-sufficient, completed One. Bracha Lichtenberg Ettinger is attentive to intimations of the feminine already present in the signifiers of these texts, not in order to argue that God is really a Goddess, but to suggest the feminine dimension – the metaphorics in the feminine – that participates in this conceptualization of alterity and covenantal subjectivity. The shock of finding it there already is directed at both the nature of the repression and erasure of such important acknowledgements of the feminine and the difficulty in accommodating it to a symbolic order that is so thoroughly shaped by its opposite, the phallic paradigm of the One. The artist is proposing a theory based on the symbol of the Matrix to allow this feminine dimension of subjectivity a means of transport into a shifted, realigned symbolic. The Matrix signifies a realignment of the process of the stranger – the non- I – and the subject – the I – through the prism of a feminine symbol.

In the biblical text of Ruth, Naomi is abandoned, therefore, by the matrixial, maternal element of what is called God – echoing, of course, her fate as a woman deprived of the children she bore in her own womb and suckled at her own breasts, *shaddai*. Naomi – a legend for the Jewish survivor – is thus also a figure of the derelict feminine in patriarchal culture.

We are not here arguing theology. Rather, taking a cue from both psychoanalysis and deconstruction, we are reading in the founding texts of western culture the legends and mythologies by which subjectivity is symbolically represented and in turn in relation to which it is constituted. We are then finding more than we expected: a matrixial narrative nestling in a phallic legend. Feminism has been waging a war on the myths, legends, texts and canons of what it names patriarchal culture. Using post-structuralist theory, such a culture is also defined as phallocentric, a culture not only ruled by

the Name of the Father, but one semantically organized around the privileged signifier, the Phallus, in whose sovereign and single image being and meaning are said to be exclusively constituted by a series of oppositions: self/Other, presence/absence, love/hate. incorporation/rejection. Various feminist theorizations have emerged over the last twenty-five years of renewed and dedicated feminist intellectual and political activity. They have each named a part of the problem, and offered a partial analysis of the nature of the repression, dereliction, foreclosure of the feminine in both phallocentric culture and phallocentric theories. However critically they engage with the culture of the Father, they tend, however, to be caught in the very binary relation that fundamentally underpins that culture. Inversion or regression, valuing the mother, the pre-Oedipal, the archaic, all these projects are haunted by their relativity to the dominant phallic terms. From this stems an unease about any reference to the mother's body, her womb or her breasts, navels, placentas and so forth amongst feminist intellectuals – both captured by necessary aspects of phallic organization of subjectivity and language and rightly afraid of the psychotic tendencies that might be released if we simply allowed ourselves to indulge in fantasies around mother right, the all-powerful maternal imago and body, the abjection of which is claimed to be the necessary price of non-psychotic subjectivity.

Through an artistic practice dealing with heavily freighted materials that bear the wounds and scars of Europe's horrendous tragedy carved upon her own familial text, Bracha Lichtenberg Ettinger, a trained and practising psychoanalyst as well as a painter, began to intimate another dimension of this feminist project to see through the phallic system and to see through to something which is not phallic but co-resides with it, at times an alternative, at times a supplement, always a relief, sub- rather than pre-Symbolic. She names this stratum of subjectivization – i.e. this level at which subjectivity is forged and we become subjects – matrixial. Like the names of God, it has to do with breasts and wombs, with mercy, loving-kindness and something mighty. It is linked to 'the feminine' but not by biological or anatomical derivation. The matrix is the subjectivities associated with invisible feminine sexual specificity raised to the level of a symbol – that is, it is a filter for archaic sensations and the most archaic forms of meaning, pictograms, that relate to a moment when the earliest processes of subjectivization occur between several, at least two, part subjectivities. The Phallus is an organizing symbol of the subject in terms of the One versus the Other – aggression, separation, castration, assimilation; the Matrix is a symbol aligning the subject in relation to coex- isting, co-emerging but unknown part-subjects that come before the castration paradigm and perpetually accompany it. The predicament of 'Woman' in the culture of the Phallus is that she is unspecificable in her sexual and psychic specificity because she is cast by the castration model as the Other/Woman/Thing – excessive to and not all that the Phallus allows us to imagine and think (fantasy and ideas being the characteristic forms of meaning of Imaginary and Symbolic registers according to Lacanian theory). This is also the predicament of any Other – the Jewish people to Western Christianity, the African or the Oriental in colonial culture. In racist, postcolonial and sexist societies of late twentieth-century imperial capitalism, so many of us have a common stake in finding a way to symbolize non-phallic relations between several irreducibly different part-subjects.

To see this, matrixial, possibility – as something that can be discerned already there in texts, signifiers, legends, paintings, ourselves – let me go back to Naomi, and to the one person who formed an alliance with her, the stranger, the Moabite Ruth.

AFTER THE REAPERS, 1985–93[4]

If Naomi is the survivor – the one who came back from the Holocaust, from the trauma of devastating loss, loss of husband, sons, the hope of family, identity, faith, trust in the future, all that – then Ruth is the figure of the 'feminine' covenant of renewal, of a future in the 'feminine'. Ruth is the one who comes 'behind/after the reapers'.

In Hebrew, temporal order and spatial order, after *(acharei)* behind *([me]achor),* follow *(acharei),* before *(liphnei),* in front of *([me] liphneir),* before – anterior *(lephanim) are all established by* other *[acher] and by* inside *(pnim). – By inside linked to* face *(panim).*
–Go seek beyond/after the desert.[5]

<div align="right">(M.H-L 1987: 23)[6]</div>

After the Reapers is the title used by Bracha Lichtenberg Ettinger of a series of paintings dating from 1985 (Figure 15.1). The title might evoke a landscape painting, leaning like Poussin's famous *Summer* for his series of paintings of the seasons, on the ancient biblical narratives that endow nature with cultural significance. Poussin placed Ruth and Boaz in his ripe wheatfields to create an image of restoration, redemption and reconciliation, displacing the medieval image of the grimmer reaper, Death. Bracha Lichtenberg Ettinger's paintings allow no final decision between these two. There is light in her painting, but not the golden warmth of a classical picture of a Southern landscape. Harsh and almost blinding, the whiteness of the landscape seems almost irradiated, and turned into a desert.

White space. The 'minus'(-) of all that is more than one, Matrix, blind earth.
<div align="right">(M.H–L 1985: 10)</div>

The whiteness is also like a silence that becomes quite deafening when you hear what it mutely shrieks. The sense of distress moves the hand-held brush across the canvas to trace what are neither shapes nor precisely images – though some tremble on the edge of emerging into one – pathways and trajectories that are both abstract, gestural and loaded.

The line, as mourning the unknowable, mourning consciousness of the unseen.
<div align="right">(M.H-L 1987: 15)</div>

A line can produce a wound with no cure.
<div align="right">(M.H-L 1987: 27)</div>

Figure 15.1 Bracha Lichtenberg Ettinger, *Behind the Reapers*, from the series *After/Behind the Reapers & Means of Transport – Family Album*, 1985, acrylic, oil pastel and pastel on canvas, 148 × 154 cm. Calais, Musées des Beaux Arts et de la Dentelle

These shapes – a skull form, an omega, a trailing, painted line will form a recurring, abstract alphabet that will bridge the space between the otherness of the image and the paper and the artist through a calligraphic touch.

Exhibited with the series *After the Reapers* was another, *Means of Transport – Family Album* (1985). The former destroyed the latter.

In Europe train stations are cemeteries. In Israel trains are ill-frequented. And yet . . . November. White and cold sky, I hate you.

<div align="right">(M.H-L 1986: 21)</div>

Although figures are hard to discern, we can make out some within these paintings. But they are back views and we are thus placed 'behind/after' the reapers. The thought that cannot be banished from such a dislocation of the imageries associated benignly with the theme of harvest is the cruel horror of those who were not harvesting the summer of the twentieth century, but were themselves cut down, brutally and callously harvested for their labour, their gold, their hair, their treasures, their lives. We now come 'after the reapers' and must live with that knowledge of what happened. Pressing onto the scene of European painting, with its idealizing landscape and heroic body, its celebrations of beneficent nature and redemption, its medieval Christianity and its classicizing ideals, are the terrible traces of our Jewish death held painfully before us in the documentary images that bear witness to the destruction. In the fertile countryside of Poland, they built the death camps, and now grass grows obscenely green around the buildings that delivered naked death and turned humanity to ashes. There can be no more landscape painting now.

This work is a work of transition in another sense. What it tries to encompass is history, in the sense of the formative, tragic historic events whose shadow is its legacy. Traditionally history was the subject of painting. History painting was the privileged site and highest point of intellectual ambition in the western tradition. Its vocabulary was the human body. History painting told stories that constituted the West's cultural identity, fashioning them according to competing ideological interests and projecting them onto the screen of representation in a confident act of anthropomorphic imagery. The body, idealized and perfected, became the expressive and symbolic core of art education, visual representation and cultural identification.

Theodor Adorno's chilling remark that there can be no lyric poetry after Auschwitz can be extended precisely to that combination of the body – often nude – and narrative which was History Painting and which serviced the West's Imaginary through idealizing representation and relentless

Figure 15.2 Installation shot of *Borderline Conditions and Pathological Narcissism* at Le Nouveau Musée, Villauban, 1992

specularity. What can the body signify after Auschwitz? After its terrible sufferings made known to us through a thousand chilling documentary photographs? Its coherence as a signifier was cremated there. The body can now only be painfully naked – and the problem is the inversion of expression and narration. Bracha Lichtenberg Ettinger's work, after 1985, abandoning as impossible figurative painting, none the less retains a reference to the body while acknowledging an end to its function as the idealized specular image for the ego. The morphology of the body is residually present in the form her work of 1989–93 took. Framed perspex units hung on walls in trios and groups cannot but evoke a body, echoing the spectator's own as s/he stands before their transparent yet reflective surfaces, that also form ghostly shapes, undecidable testimony at once to absence and survival, delimiting the space of the other which must have a corporeal dimension without ever being able to achieve, unproblematically, embodiment (Figure 15.2). These are bodies on that borderline that European modernity burned onto our consciousness.

Narrative dies here too for the telling mark of the Holocaust survivor is a silence. Words and stories cannot comprehend what might need to be said – or need to be not-said. In David Grossman's novel, *See Under Love* (1986), set in Israel in the 1950s, 'over there' is a brief verbal emblem whose meanings more literally elude its signifiers in ways that even Derrida could not imagine. A more than geographical allusion to the unnameable Europe, Poland, Auschwitz, marks a past that continues to contaminate the present and must therefore be quarantined in euphemism, imprisoned in as few words as possible for fear 'the beast' will once again escape. Thus the problem for the generation of survivors' children lies in working with silence, with the unsaid, with the constant pressure of dreaded knowledge that is, however, always overpoweringly there.

My parents are proud of their silence. It was their way of sparing others and their children from suffering. But in this silence all was transmitted except the narrative. In silence nothing can be changed in the narrative which hides itself.

(*M.H-L 1991: 85*)

In what cultural forms can this be worked through?

In the film based on the autobiography of another child of the Holocaust generation, Gila Almagor, *The Summer of Avia* (Eli Cohen), a mother, a survivor, released from mental hospital visits her daughter at her residential school to find her hair infected with head lice.[7] Taking her home, she proceeds to cut off her child's hair with a terrible ferocity, and to shave her head, while the child, uncomprehending, cries out in confusion to her mother. With equally distressing gentleness after such wordless violence, the mother raises the child's head from the bowl of disinfectant and the audience witnesses the recreation of a ghastly image, the shaven head of the camp inmate.

Two of my mother's sisters had returned from over there. The youngest of them used to say to me all the time: 'I have no memory of it except this one: my head had been shaved and when I passed in front of the windows of the barracks I couldn't recognise myself. I didn't know, out of all those women, which one was me. That's my only memory.'

(*M.H-L 1989: 60*)

A generation of Israeli artists emerged in the 1980s who could not but confront their own deeply historicized subjectivity in which this history is inscribed with the same letters, sounds and inchoate memories as constitute the texture and tissue of their being. They are the evidence of what is called transgenerational memory. This is the phenomenon of a passing of trauma to a generation who did not live it but continues in its shadow so that they themselves have to perform the mourning and working through that their parents cannot because of the inconsolable nature of their pain and grief. In films like The *Summer of Avia* or in David Grossman's *See Under Love,* and in this body of paintings by Bracha Lichtenberg Ettinger, the specific experiences of the children of sur-

Figure 15.3 Bracha Lichtenberg Ettinger, (a) *The Eyes of the Matrix* 1990–1, triptych, photocopy, indian ink on paper, 122 × 35 cm (each)

vivors of Ha-Shoah is at last given a form in which it can be partially represented and acknowledged.

In her book *Memorial Candles: Children of the Holocaust*, the psychotherapist Dina Wardi suggests a particular pattern of family management of trauma and dysfunction. A certain child in families of survivors becomes the 'memorial candle' for the losses their families have sustained, taking on, through intergenerational transmission, a complex of roles and emotional burdens, fantasies and anxieties from histories they never lived in person.[8]

All children imbibe their culture's body habits, language systems, memories and values through unspoken exchanges with parents as well as in the usual routes of transmission in stories and formal instruction. What is different and specific here is both what is being passed on – because it is unbearable, obscene, humiliating and overwhelmingly concerned with inconsolable loss – and how it is transmitted – that is, at what psychic level and by what psychic systems. The artists, film-makers and writers who deal with and must take on the most intimate and horrific of historical legacies do not merely exhibit it in representation but transform that cultural process into another form of working through this trauma. This term, 'working through', precise with psychoanalytical and therapeutic meaning, refashions our understanding of the possibilities of artistic practice as a form of

Figure 15.4 *Nichsapha [Languish]-Lapsus*, no. 1–3, 1991, photocopy, indian ink on paper, 135 × 35 cm (each)

'history painting' *after history* and *after painting* which must explore at the limits, the borderlines and thresholds of a subjectivity which Bracha Lichtenberg Ettinger argues is always 'enlarged, shared, *several*' – '*I(s)* and *non-I(s)* come before the One' (symbolized by the Phallus); it is a parallel, a '*beside*' stratum of subjectivization. The unique dilemma of the children of survivors lends its texture to this sense of being constantly with, shaped by and shaping, unknown others who may come towards you from an anonymous image, whose name and even looks you may bear, who are strange and yet can neither be assimilated nor abandoned.

The cinematic imagery of *The Summer of Avia*, retelling an episode from one Israeli childhood,[9] creates an emblem for the transmission of memory which Dina Wardi's work shows often to be infinitely more subtle and perplexing. In the film, the daughter receives her mother's trauma, transmitted almost raw, unmediated in the wordless emotional violence that re-enacts what the mother herself carries as her own experience of dehumanization. But none of it is conscious, and, in a sense, the film with its combination of narrative and iconic representation (with its inevitable leaning towards a realist aesthetic that cinema inherited from western history painting) cannot fully articulate the process of the unconscious or the matrixial dimension of this intergenerational sharing. The film repeats the history by trying to give what is passed between survivor and child an iconic

form. Dina Wardi's work with the children of survivors patiently follows the complex trails and paths of the ways in which a new generation who never directly experienced these traumas have become, none the less, its keepers, living, in their heads and dreams and relationships, other people's lives and other people's deaths verbally conjoined with them by shared names. Gleaners and the gleaned.

Certain psychoanalytical perspectives and processes may be the only way to understand and 'work through' a phenomenon that, because the history it memorializes was so horrifically deviant, has itself to be grasped as rupturing the temporal finiteness the word history typically conveys. This happened but it is not in the past. We therefore live in a moment that is both 'after history', and is yet a continuous 'beside'[10] history which may correspond to what Freud uncovered in his archaeology of the split subject. The human subject is not the end product of a narrative development called maturation; rather the subject is a discontinuous layering and sedimenting of always active elements that filter through from archaic moments and strata via the unconscious to be a continuous consciousness of 'beside', to use the artist's vocabulary, rather than of 'under'. Psychic time is not linear and the unconscious is the mechanism by which we live before and after as beside.

But here is where art may be, as the artist describes it, *symbologenic*. It may be able to generate not an image of the trauma but a symbol that allows the foreclosed the relief of signification, a pathway into language. In psychoanalysis, it is argued that archaic elements or foreclosed memories may precipitate the subject into psychosis if they are expelled from representation.[11] They need a signifier – a symbol – to rescue them from foreclosure and drag them across the borderline and to save the subject from becoming what is called analytically a 'borderline case'.[12]

The problem is that, in the aftermath of the Holocaust, there has been a conspiracy between the silenced and the repressed and 'in silence nothing can be changed in the narrative that hides itself'. There is, however, another dimension here, a feminine one: which brings us to Ruth, or rather the couplet Ruth and Naomi, the specificity of the 'feminine as more than one' that needs a symbol to emerge from foreclosure within a phallic regime and thus to begin to rework the tropes of exile, death and reconnection in ways which offer a specifically feminine dimension to the debates about mourning the Holocaust.[13] In distinction from film and even literary narrative, a certain kind of move in 'painting' against the specular and iconic may provide the way for such a radically reconceived femininity to become the necessary witness and Other of meanings hitherto (re)pressed to or even pushed beyond the limits of visibility and cognition.

Bracha Lichtenberg Ettinger's painting *after painting* displays a series of formal characteristics (Figure 15.3). Fragmentary pieces of cut paper carry incomplete photocopies of found images – stadia photographed from above, German aerial surveys of Palestine during the First World War, an engraving of a woman from a treatise on madness dated 1874, diagrams of buttocks used to contrast superior and inferior races, drawings from Freud's case studies (Figure 15.4), diagrams and notes from Lacan's seminars, marching boots, an image of a broken doll, a photograph of the artist's parents walking together down a street in Lodz, a fragment of an anonymous photograph of naked women and children at an unknown lager. Interrupting the process of mechanical reproduction before the image is once again fixed, the artist traces in paint and in ink the deposits of the photocopic dust that lie like a semi-transparent veil across the paper, itself sometimes tenderly or painfully violet. She touches the place where the image is about to be or was, marking the limit of visual representation that remains trapped in material as a stain, a trace that promises but can not deliver the comfort of meaning by coming across the threshold into imaginary embodiment. These intricately worked readymade remade-unmade things create, and then negate the promise of presence, to stress the fantasy investment and projection of the viewer into an image which, at best, functions momentarily as an evocation, not an objectification, of an unknown other, whose persistence is registered, but not captured in the false binaries of fetishism, itself premised on the phallic binary of presence/absence.

WOMAN-OTHER THING 1990–3

In series of works of 1990–3, one a grouping titled *Woman-Other-Thing* (Figures 15.5–7)and another a reprise of the theme *Behind/After the Reapers*, one particular image becomes the support – the *means of transport* – for a prolonged engagement with a matrixial reworking of loss, mourning and memory. It shows a group of women, some with a child in their arms, naked, in a camp, probably on their way to their deaths.

As a child I was a witness to witnesses.
When I paint or when I listen I am that too.

Accomplish the mysterious gestures of painting in all that space up to now negatively feminized: loss, void, crumbling, languish-*desire, weakening. Disparition which is elsewhere apparition.*

Multiple registers of the matrix start up their besidedness. A limit-recognition of the matrix resides in the lines with a beauty-pain, an image which does not want to turn toward me. This woman has more to look at than the watchers of painting . . . but what she looks at is inhuman.

(*M.H-L 1992: 84–5*)

'Behind' the image lies the Book of Ruth through which the alterity – of the feminine and/as the unknown other – finds a subtle, vulnerable, resistant, inviting, fading, emerging, unknowable support. Ruth is a figure of identification for the artist.

The Book of Ruth contains two narratives. One imaginatively traces a loving covenant between two women, across the generations and between not only cultures or strangers but between enemies, leading from images of total loss and barrenness through to a future that ensures a line of continuity through the elective relations between two women and their child. This is ultimately displaced by a patrilineal narrative which never quite reconciles its purposes in establishing the genealogy of King David because of the irruption of the alien, the stranger, indeed the enemy, a Moabite, a woman, into its intimate lineages of masculine begetting. What holds these narratives together is the covenant between Naomi and Ruth that marks another possibility of the relations

Figure 15.5 Bracha Lichtenberg Ettinger, *Woman-Other-Thing no. 6*, 1990–2, ensemble of two elements, indian ink, pencil, pastel and photocopy on paper, plexiglass, 41 × 84 cm

of self and stranger that is at once radically other than patriarchal systems and yet, as this story emblematizes, their necessary condition. What is important about the story is that these several registers coexist, that of Naomi and Ruth supplementing the genealogy of the Father–Son. One might go further and point to the different logics which structure the two dimensions of the Book of Ruth. One is the law of exchange and kinship systems, in particular, that of Levirate marriage which positions Naomi and Ruth as objects of exchange, of property, relicts, and they, like the fields of Elimelech, are (or have become) barren. Both land and women must be fertilized and then reaped by the harvesters after redemption by Elimelech's kinsman, Boaz. This is a phallic logic premised on a play of outside/inside, barren/fertile, exiled/incorporated. Against the phallic law which sustains the paternal genealogy we might glimpse, and still struggle theoretically with, another logic, another modality of co-emergence and relations of/in difference which also includes the child that is produced as its token. This logic is not phallic. This modality might be an instance of what Bracha Lichtenberg Ettinger calls matrixial.

Ruth voluntarily takes on her mother-in-law's beliefs, culture, homeland. She is not a convert in the sense that the Latin word imposes, for she has not simply changed her ideas or been changed – *conversa* is passive. She makes a journey to become a part of her mother-in-law's people because she loves her and shares her grief. She crosses a frontier. The Greek word is *proselyte*, which means immigrant. In our age of diaspora and postcolonial migrations this term resonates much more profoundly with our multiple experiences of displacement and attempted matrixial *'alliance-in-difference'*.[14]

Ruth says to her mother-in-law: 'Entreat me not to leave thee, or to return from following after thee; *for whither thou goest, I will go' (Ruth I:16)*

(*M.H-L 1991: 90*)

To 'follow after' is both to 'go behind' and also to 'be a future'. Ruth makes a series of promises of affiliation to her mother-in-law. She will go, she will stay, she will take on Naomi's people, she will take on Naomi's God. She also affirms that where Naomi will be buried, she too will be buried. She is committed to the future, which includes a death that is imagined as a confirmation of their covenant in the present.[15] The Book of Ruth is unique in the text of which it forms a part, for it narrates a covenant between two human subjects, and these subjects are women. Ruth's decision involves taking on something of Naomi – represented by the patrilineal narrative of the written text by her being perceived within Jewish Law and the community in Bethlehem as the relict property of Naomi's husband Elimelech. In a feminist Midrash, we might read Ruth's decision to stay with Naomi as more than loyalty. The two women share a grief, which passes between them just like the son, whom they both lost – one as mother, the other as wife, and they share the son whom Ruth will bear, and who will in effect be 'born to Naomi', as the women of Bethlehem declare (Ruth 4: 17). Naomi nurses her/Ruth's child. She is restored to motherhood – the fullness of her breasts – by the procreativity of an other, Ruth, and through vicarious access to intersubjectivity occasioned by recollection of the matrixial encounter with an other, the child. This image of Naomi breastfeeding – matrixed – reveals a 'feminine' dimension of this text.

The imagery of famine on the plane of history and geography, and grief and emptiness on the level of the subject, suggests that the themes of fertile/barren land and fertile/barren women are crucially interrelated and may represent the remaining traces of a matrifocalized consciousness. The mother/daughter imagery associated with seasons of plenty and of barrenness appear in many cultures, Demeter and Persephone being a late but widely known instance. Th story of Ruth and Naomi is, however, crucially different from the Greek remnant of Neolithic goddess worship, which assimilates woman to the earth and to nature through the image of the Mother and Daughter dyad ultimately broken by patriarchal law. The Book of Ruth is culturally and theoretically significant

precisely because the bonds it deals with are neither between woman and earth nor are they familial. They are in the realm of the subject, of strangers, and they are covenantal, that is two subjects are party to the mutual transformation of their co-emergence that leads neither to assimilation of the one to the other nor to rejection.

After the Reapers
Wounds and shattering and pride in the inverse-exile. And that strange behind after' *that resonates on the root other (a.ch.r). Other multiplied who is this woman in inverse exile to the man she is going to love. Dimension of the future in all its splendour. Women are the active seeds of behind-other to come. They create the initiation ceremony that signals the journey. In other initiation ceremonies (Moses, Abraham) it is a man and a God that sign the deal.*

(M.H-L 1990: 78)

How can we explain the transitivities of this text – from what source do the traces of this other, matrixial narrative derive? How do we reconcile the voice given to the stranger to declare her choice and in doing so become the instrument of restoration and a future? What is the meaning of the Naomi/Ruth couplet – an 'I and a non-I that co-emerge' from loss? How can we retrieve the 'woman to woman covenant' as an image of the matrixial 'covenant of the several'[16] which is the emblem of a specifically feminine continuity and of the role of the feminine in the making of history because it is the very condition of a future?

After the Reapers, acharei, *Orpa and Ruth*
Orpa in Hebrew signifies the nape of the neck, the back as obstinence. And also shadow, cloud, wave. Again and always, Ruth comes from behind or after (the reapers, her mother-in-law); acharei – acharai: beyond/behind/after someone, behind/after me. But also the others of an other and my others. More: beyond, *and* because. *The question of an* inverse exile *is raised.*
Ruth's exile is the inverse of mine but it's also an inverse exile. She leaves a space of No (non-site) to seek truth, meaning, lover, God, a promised land with an open future; origin is revealed as linked to the future.
Is what hurts in front of her or behind her? Before or after?

(M.H-L 1990: 74)

The artist lives in Europe having gone back to the Europe from which her parents escaped. Our moment of history does not allow this artist or any of us a choice about dealing with

Europe and the desert of Judea. Israeli–European archaeology. The earth and all that filth underneath; underneath – Europe must be looked at. During every journey I see the green everywhere; and I see the filth underneath. Nature, and all that it has swallowed. The plain desert; blessed drought, or drought wounded.

(M.H-L 1987: 29)

Before or beyond? Time and Place. Approached through the prism of Hebrew, painting is a process of gripping the two in a momentary embrace that makes us journey behind and after while we have an encounter in space that takes much time to sense it.

In the first paintings of After the Reapers, *I watch a man who doesn't know that I am watching him. Now it's a woman seen from behind who is looking off somewhere. In the passage from one painting to the next, the subject traverses several curves of the spiral. Circular forms link up.*

(M.H-L 1990: 74–7)

The artist is working in 1990 – the date of that passage – on a series of pieces that will be titled *Woman-Other-Thing* (Figure 15.6),[17] as well as, once again, *After/Behind the Reapers.* Both are

possessed by an image and a process of working with it which reveals what I call *'after painting'* in the *'after history'*. The use of a found photograph links this project with the Duchampian tradition of the readymade which then re-entered postmodern art practice in the 1980s through concepts of appropriation and depropriation.[18] Used mostly for cultural commentary on the meaning systems authored by western culture, appropriative strategies that emerged in the early 1980s, seemingly mimicked the commodified production of images and signs through which our identities are socially manufactured. In the more radical practice of depropriation, a term used by Mary Kelly of work in an exhibition of 1984 called 'Beyond the Purloined Image', a critical or political distance could be gained by artistic refabrication of cultural materials which drew on the legacies of conceptual art and Brechtian theory. But Bracha Lichtenberg Ettinger's use of the 'readymade' – the culturally or, in this case, the historically given image that is also the threshold of her own interpenetrated, shared subjectivity – launches us into a radically different sphere by learning from and going beyond the work of a conceptually informed feminist art moment of the 1970s to 1980s via psychoanalysis to the unconscious and fantasy via the touch of painting which has not been the site of feminist intervention to the extent that other mechanical media used in conceptual modalities have been.[19]

Using the ultimate anti-auratic machine, the photocopier, the artist interrupts the very processes of photomechanical reproduction at the point where she can then intervene with the marks, the touch (as opposed to the gesture) that come from the practice of painting. The icon of commodity culture, and the signature artistic gesture that has traditionally been reified as the authentically self-affirming opposite of the commodity, collide to explode the claims of both. This encounter creates a fragile terrain, where meaning might emerge in an encounter at the borderline of visibility and the threshold where the oppositions of original and given, self and other, founder in an experience of joint subjectivization. For nothing is here to be expressed. Unlike the film discussed above, the working process precisely prevents a collapse onto a fixed image (which is a phallic effect). Unlike the novel, which can only work metaphorically, this project keeps to the margins and thresholds where another process of meaning is glimpsed: what the artist calls *metramorphosis*.

Figure 15.6 Bracha Lichtenberg Ettinger, *Woman-Other-Thing no. 7*, detail

> Metramorphosis is the process of change in borderlines and thresholds between being and absence, memory and oblivion, I and Non-I, a process of transgression and fading away. The metramorphic consciousness has no center, cannot hold

a fixed gaze – or, if it has a center, constantly slides to the borderline, to the margins. Its gaze escapes the margins and returns to the margins. Through this process the limits, borderlines and thresholds conceived are continually transgressed or dissolved, thus allowing the creation of new ones.[20]

A great deal of feminist theorization and artistic practice has identified the gaze as a key issue.[21] In necessarily deconstructing the politics of vision by defining the gaze within a phallic regime of sexual difference, feminists have equally been trapped within a scopic regime that can only imagine the gaze in terms of mastery and sadism, or as, in psychoanalytical terms, a phallic *objet a*, the lost object defined by castration, i.e. separation, rejection, hate.[22] Bracha Lichtenberg Ettinger's working method begins to make possible a glimpse of another kind of vanishing point – another kind of gaze, matrixial, beyond appearance – that is not locked into this logic of subject/object, presence/absence, see/seer, same (self)/different (other).[23] The works make possible recognition of another means by which meaning may be produced which does not rely on alternation or opposition, on spectator versus seen object, or on gaze versus seen spectator, the binary opposites which structuralism as the final theorization of a phallic logic in discourse argues are the only bases of meaning.

> The matrixial gaze emerges by a simultaneous reversal of with-in and with-out (and does not represent the eternal inside), by a transgression of borderlinks manifested in the contact with-in/-out an artwork by a transcendence of the subject–object interval which is not a fusion, since it is based on a-priori shareability in difference.
>
> In the matrixial aesthetic experience, relations without relating transform the unknown Other into a still unknown partial-subject within an encounter. The subject's relations with the Other do not turn it into a known object, swallowed or fused, rejected or abjected. The non-I as subject changes me while the I changes it; all the participants are receiving and investing libido with-in and with-out the joint process of change itself – the metramorphosis, with-in and with-out their common borderspace.[24]

Metramorphosis gives us access to a route for the feminine to filter into the Symbolic, into meaning. This feminine is not specular and can only be murdered by being trapped in a phallic gaze.

In the history of painting her image tells too much and her symbol too little.

(*M.H-L 1990: 73*)

Woman-Other-Thing
*Painting is not the image; painting is not the visual. Nor the visible. Not even gaze. The biblical prohibition against the image displays its force by profaning (*lehalel*) the word, by distancing the Name. Anguish and repression are like the fear of the image, the dispersion of the feminine. Debris of images. Debris and ruins of the image in revolt against the symbol. They desecrate it. . . .*

*A nomad-word can create (*leholel*) and dance (*leholel*) in the real.*

Woman as hallucination. Like an object-thing? as matrixial subject.
I and non-I dispersed; I and non-I assembled; painting or matrix.

(*M.H-L 1990: 72–3*)

Up to this point I have wanted to keep close to the encounter with the work – not as a thing in an exhibition, the work of art, the object, other, to be assimilated or rejected, that being the characteristic of criticism. Rather I have wanted to see how the poetic and pictorial images of transport, journeys, exiles, deserts, reapers can be thickened to yield an intricate pattern of meanings that could also be said in other ways when replanted in another field: psychoanalytical theory. It would have been equally possible to approach this artist's work through that prism of theory. The danger would be that the length to which it would be necessary to go to explain how profound a contribution the artist/analyst is making to psychoanalysis would screen off the fact that painting is a

critical site for these discoveries. But *Woman-Other-Thing* brings *the encounter* into momentary attention (Figure 15.7).

The title, *Woman-Other-Thing*, addresses the field of specifically Lacanian theory, for the artist has worked closely with late and unpublished texts, where Jacques Lacan, like Freud before him, found himself forced to confront the structuring issue of psychoanalysis: femininity, and to admit that he had inadequately understood things from what he called 'the ladies' side'. [25] In the Lacanian schema Woman (his term for the representation of the feminine) occupies several positions: Thing, hole in the Real, *objet a*. These all refer to what is excessive to the Symbolic, the realm of graspable signification, that is, what is unavailable to its signifiers is pushed beyond meaning. In a number of notorious and misunderstood pronouncements, Lacan grappled with the predicament of the feminine in such a phallic system. Thus Bracha Lichtenberg Ettinger writes:

> She [Woman] is Other ('The Other, in my language can only by the Other Sex'. Lacan, *Encore* 1972–3, p.40 translation by the artist) but since by the Other we understand 'treasure of signifiers', she is also a hole in the Other, and therefore, 'The Woman doesn't exist and doesn't signify anything' (ibid., p. 69). Furthermore, when she is put in any of these positions [Thing, Other and *objet a*], they cannot reach one another, and she, as subject, cannot reach them *since the woman is repressed for women as well as for men* [my emphasis]. Is woman, asks Lacan, the Other, the place of desire which, intact, impassable, slips under words, or rather the Thing (*la Chose, das Ding*), the place of *jouissance*? Woman is, to borrow an expression of Deleuze, this white, this lack in the signifying chain with the resultant 'wandering objects' in the chain of the signified. The elusive woman is this wandering object. Since the Other is precisely a land clean of the 'intolerable immanence' of *jouissance*, these two positions cannot meet. [26]

Figure 15.7 Bracha Lichtenberg Ettinger, *Woman-Other-Thing no. 9*, 1990–3, varnish and photocopy on paper mounted on canvas, 26.4 × 25.5 cm

This passage explains elements of the Lacanian system in terms which draw upon the artist's own work as I have tried to trace it: wandering objects, migrant women, white landscapes. The parallels remind us of the metaphorics that are involved in all discussions of the psyche and subjectivity. The trio of 'Woman, Other, Thing' is a poetic attempt to give shape to that which is, by definition, so difficult for us to grasp about ourselves. Whichever way it is said, it is the conjunctions that matter, that which places the feminine as both 'more than' and 'less than' what a system of meaning based exclusively on a phallic logic allows to filter through to a symbolic field it imperially rules to the exclusion of all other symbols that might form a signifying alliance – covenant – with as yet unknown, strange and unsignified elements of our subjectivities. In phallic logic, Woman can only be identified with the Other – the unknown beyond the limits, with the *objet a* – the representative of all that is lost when we enter the signifying chain and take on our sexes and language, and with the Thing – if there is no signifier, no symbol for another set of relations, 'another passageway' for archaic sensorial body experiences and affects. In this legend of the subject that Lacan constantly struggled to articulate, Bracha Lichtenberg Ettinger, the artist as analyst and theoretician, glimpses the possibilities for a 'shift' in the paradigm. For, while the *objet a* is excluded, it none the less determines the subject. While it cannot be a specular object (hence all representation of Woman, when we make an image of it, becomes inevitably phallic), it can achieve a 'borderline visibility'. 'And from the point of view of the visual, the *objet a* is a non-specular object situated at the borderspace in relation to the subject's mirror images, created by the Other.'[27] Bracha Lichtenberg Ettinger is exploring the affect of aesthetic forms and pleasures from the psychic point of view. Suggesting that these 'fragmented archaic non-symbolised derivations of the body' manifested as *objet a* can be intuited 'behind the image', she also argues, in agreement with Lacan, that even if the image is itself 'a horrible apparition' there may always be there a 'reflection of beauty': 'The *objet a* is thus incarnated in art even if its image is that of horror or death.'[28]

This argument returns us to the question of the limits of representation posed by Saul Friedlander in relation to Ha-Shoah:[29] what are the psychic mechanisms by which engagement with images that 'as representation' are fearful and painful to behold can none the less generate some comfort, some mercy? It is not at the level of aestheticizing the horror through art. But rather, a certain kind of painting where the optical dissolves into pulsational touch and imaginary tactility becomes a means to allow a glimpsed almost-visibility of that other – not as object of specular representation and phallic mastery – that promises access to archaic zones hitherto unacknowledged by a phallic Symbolic. In so far as these excluded elements are associated with Woman, the feminine has likewise been kept out, at the cost of psychosis unless art seeks out their possibilities and provides through specific formal devices and relations of viewing ways to allow new pathways:

> In Lacan's description, sublimation keeps the woman in a rapport of love at the price of her constitution at the level of the Thing. But in a matrixial system, the passageway back and forth between exterior and interior, and between Thing and Other, is open and subjectivity situated at the borderlines is not a prisoner of either. The feminine, like painting, can be both subject, Other, and Thing or both subject and Other in constant relation to the Thing (via *objet a*).[30]

Thus painting, in the realm of sublimation and Beauty, can be the place of the possibility of new understanding of subjective processes as well as being in its practice a passage to the unblocking of those pathways that will shift the phallic paradigm, to allow foreclosed elements of the feminine other relations to our subjectivities. This will entail specific operations at the level of the formal procedures as well as a different kind of response and commentary at the level of its effects when we discern through the act of painting a *'matrixial affect'* shared between viewers, the artist and what the painting allows us to encounter in 'silent awareness, amazement and wonder, curiosity, empathy, compassion, awe, uncanniness'.[31]

AUTIST WORKS 1993–5

Woman-Other-Thing, After/Behind the Reapers and finally *Autistwork* (Figure 15.8) are series where history meets autobiography as the screen for the inscriptions in the feminine that are allowed metramorphically to filter into view and into affect. Their 'readymade' is a tiny document of Ha-Shoah. The image was perhaps already behind the reapers, screened by them. The image presents us with a woman who does not look back, who does not return the gaze, a gesture that we long for to affirm us in what is always an imaginary misrecognition of our subjecthood based on the relays of seeing and being seen seeing. She is not looking at us. She is looking elsewhere. The artist, and after her the viewer, looks at her and experiences an intense longing for connection, an overwhelming sense of her fragility and vulnerability, and yet her disgrace, which makes ambivalent our anxious care and constant guilt if we could not, did not save her. Disowning the gaze (which must be identified with the Nazi photographer and fascism's bureaucratic drive to record its own perversity as mere orderliness) in order to see into the scene/seen, the artist's many workings of this image (Figure 15.9) make us aware of the many dimensions of its terrible freight. By disturbing the photocopying processes and working over the unstable deposit of powdered ink with a colour-loaded brush or pen, she makes the image come always and ever from 'over there', that time and space of Jewish memory and painful oblivion. By patiently painting the place where the grains of ink were deposited on their journey towards the image and thus towards the traces of the people once photographed and inadvertently memorialized, the artist touches that time and space which she, like Ruth, must always come after, gleaning its haunting residues.

Figure 15.8 Bracha Lichtenberg Ettinger, *Autistwork no. 1*, 1993, oil and photocopy on canvas, 32.5 × 28 cm

Each black grain has its freedom, and its freedom is also mine. I am lost before each black grain – Black sorrow – this loss is in me and in painting.
(*M.H-L 1989:* 57)

White, black and violet are already almost too much. White, I tell myself could tell all about black and more. Violet cuts through them like a wound, or like a scar, depending on the moment.
Sometimes I am in the India ink; sometimes I look from afar or from the machine and non-I stays in the ink.

(*M.H-L 1987:* 37–8)

The painter touches the time and space whose terrible meaning resides in the spaces between the marks, in the grains themselves. For here painting displaces its capture by the phallic notion of the gaze, with its specularity and use of the visible in the play of mastery. Bracha Lichtenberg Ettinger's autistic painting works with touch as a matrixial *objet a* – which is the filter from the archaic processes of intra-uterine existence where an inside and an outside were experienced uncannily as a shared borderspace between sensate beings unknowable to each other and yet as close as any two discrete beings can possibly be. This work is precisely feminist, matrixial painting '*after painting*' – i.e. beyond the phallic dimension, because of that relation to a non-image, and the use of the painted touch to evoke an *extimate borderline*. [32]

Documents – I don't seek them out. They come to me; they become real bodies to me. They penetrate my privacy as if they'd always been there.

(*M.H-L 1987*: 23)

The truth value attributed to the document is infused with doubt and the idea of a precise thing collapses. Multiple possibilities open up. Elements that have fled the definite past come out the back way.

(*M.H-L 1987*: 22)

In a language that keeps us close to the modernist discoveries of the semiotic potential of painting's elements, line and colour, these entries from the artist's *carnets* invest the making of this art with a ritual dimension in the continuing struggle around memorialization and working through to a future – the behind that is also beyond, the after that is also behind, and the besidedness.

The image used in the *Woman-Other-Thing* and *Autist Work* series is a detail of an anonymous photo taken in the camps. A lot of women and children look – who knows where, for where was there to look for help? The artist knew this photo as a child. She later found it also hanging

Figure 15.9 Bracha Lichtenberg Ettinger, *Autistwork no. 7*, 1993–4, oil and photocopy on paper mounted on canvas, 28 × 22 cm

in a museum for *Ha-Shoah*, and she found it reproduced in a film. It belongs therefore in an archive which shows that across its anonymity many people have projected their own fantasies, found their own non-I(s). The artist imagined this to be an image of a lost member of her own family, whose absence inhabited her own existence. The photo, perhaps with that power to freeze and stay time that belongs uniquely to photography, holds us forever to the moment

before her fate. But there is something else in that photographic detail's specific imagery: the lost look, the face that is turned away; the other that will never look at me and yet enthralls a looking.

I want her to look at me! That Woman, her back turned to me. This image haunts me. It's my aunt, I say, no, my aunt's the other one, with the baby. The baby! It could be mine. What are they looking at? What do they see? I want them to turn to me. Once, just once, I want to see their faces. The hidden face and the veiled face are two moments calling to each other; moments of catastrophe.

(M.H-L 1990: 67)

Please look at me once. You are my dead aunt or you are my living aunt or you are someone I don't know. Lost, you do not stop raising questions in me. In painting, face to face, face to non-face. A moment before leaving again. Mother-I, my aunt could have been by daughter.
Through the symbolic dimension of the Matrix, woman/daughter/mother co-emerge and co-exist until woven together.

(M.H-L 1990: 68)

One other image that functions as the recurring support and lure for the artist is a fragment of a photograph of two people walking down a street. A man and a woman, dressed in late 1930s style, confident, they stride towards the camera from a world of Polish Jewry that was so brutally destroyed leaving a caesura that survival required some to live – somehow already dead – beyond. They approach us but the gulf between us and them is that space of pain that the artist describes around the missed gaze.

Erasing-tracing – isolating-drowning – housing and destroying; and we live the erasure-trace. I and non-I in emergence look at each other but do not see each other. See each other but without the gaze. In pain.

(M.H-L 1990: 78)[33]

It is here art-making precipitates us – other gleaners – into a confrontation with death and loss. We all scrutinize images of our parents at some point to see them in history, as Barthes called it, before we were.[34] He did this when his mother had died. He writes how he found one photograph of his mother as a 5-year-old child. He used the image for a prolonged contemplation of the intimate connections between photography and death which revealed itself to be the core of his book on photography *Camera Lucida (La Chambre claire)*. Barthes would not publish the image. He writes: 'for you it would nothing but an indifferent picture, one of the thousand manifestations of the "ordinary".'[35] By this gesture, he effectively fetishized the photograph – made it both a memorial to his loss and a veiling disavowal of it, by substituting his words for our access to that moment of his encounter with an intimate, forever unattainable (m)other. He preserved his exclusive possession of the image of his mother and, therefore, possession of his mother, and he makes this withholding the basis of his text – she remains silent, iconic, he becomes discursive, the author, allowing no encounter, no transformation. No future. The section in his book reads like a suicide note.' From now on I would do no more than await my total, undialectical death.'[36] For Barthes, there appeared to be no way to imagine coming 'after the reapers'.

Images mean nothing in general. They are mostly indifferent until someone attends to them and invests them with some vividness in the field of fantasy and desire. Strategies of representation in the visual arts, from painting to photography and film, have been institutionalized to lure our gaze and suture our desire to that to which the culture wishes to fix us. Feminist interventions in the visual of arts have therefore, of necessity, had to negotiate the question of the gaze, desire, suture, spectatorship. For a period during the 1970s, this produced a 'negative aesthetics' amongst

certain feminists in the cultural field, a radical distanciation from any aspect of the spectacle and visual pleasure, a distrust of the visual image, of the iconicity especially of women. The necessary work of ground clearing has been done and those artists associated most strongly with such moves, such as Mary Kelly and Laura Mulvey, have themselves reclaimed the territories of desire in the field of vision. Bracha Lichtenberg Ettinger's place in this feminist genealogy arrives via the conjugation of feminist interventions in the politics of representation and sexual difference with modernity's genocidal horror. For she argues theoretically, that one level of the image is that which is beyond appearance. *Objet a* refers to non-symbolized fragments of the body and traces of the archaic maternal body rather than fantasies of lost limbs or missing organs. Lichtenberg Ettinger defines it as:

> that aspect or element which is severed from the subject and cannot become a visible object on the level of specular imaginary recognition. *Objet a* is the invisible *par excellence*, it is a remnant of the signified which cannot appear in representation.'[37]

She furthermore suggests, however, that in art *object a* may achieve a borderline visibility. The *beyond the visible* in the Phallus is, at the same time, she argues, an *outer-in-side the visible*. Because of the connections between Woman in phallocentric culture and *objet a*, Woman and Other, Woman and Thing, this 'beyond appearance' may be theorized as connected to the feminine, and this borderline visibility that an excess in art achieves may be a means to access it and theorize it – not just for women, but as a means to realign all subjects in relation to elements of the unconscious that have not been allowed to filter into the Symbolic, which yet insist through what Freud called the experience of the 'uncanny'.[38] This practice defines yet another relation to the image in addition to Barthes' 'possessive exclusion' or feminism's distrustful 'negation'.

In the studio, there occurs the daily, repeated coexistence with the images that are of others, and are Other, and yet, because of the unique psychic formations associated with transgenerational transmission, they are also intimate elements in the subject, non-I(s) that are part of the process of the emergence of the I. The insight into a matrixial stratum, and into the question of how art works on us, emerges in the same moment that the foreclosure of the feminine is interrupted. Images that are about death, horror and loss, concretely the legacy of our century, substantively the texture of this artist's subjectivity, open up a covenantal matrixial space for 'Ruth', for a principle that is not Boaz, the redeemer, the reaper, but for the feminine Other, the strange uncanniness of the feminine that offers us a way of thinking beyond a modernity that made the Holocaust possible. It is neither too much nor too mystical to put the issue thus starkly: we all need access to the matrixial feminine.

The violence of the foreclosure of the feminine (the lack of a means of signifying the feminine dimension, and especially the invisible feminine specificity with its promise of plurality and coexistence) can be associated with the violence of Christian western culture towards the Jews as strangers, as one of Europe's intimate structuring Others. Both Woman and Jew foil modernity's dreams of order by representing ambivalence – that which can neither be mastered nor assimilated to a phallic logic of the same, but which, in that logic, can only then be rejected as impossibly, threateningly other, different.[39]

In the post-Holocaust era Europe is once again breeding its fascisms and racisms, targeted now on other Others. In such a phallic structure, any group can find itself victimized as the other that must be destroyed or repressed. There can only be a future through alliance, through covenant, through what the artist calls a coexistence in difference. But the philosophical and political legacies of modernity do not provide either a social or, as importantly, a psychic model for such unfamiliar proximities. It is in the not surprising but, for some, unlikely spaces of feminist artistic practice in

all its difference from crude notions – art *versus* society, theory *versus* practice – that we find, in the case of Bracha Lichtenberg Ettinger, a means to recognize, already there and also awaiting further symbolization, an understanding of subjectivity that could provide such a non-phallic and non-fascist model for relations between subjectivities. Neither in its relation to feminism nor to the issues of racism and postcolonial practice, does the matrix offer cosy plurality or compromised coexistence. The matrix is one of the most challenging new theorizations to emerge, not unallied to the ethical philosophies of Emmanuel Levinas, the anti-Oedipal psychoanalysis of Deleuze and Guattari, in their sense that the very forms of our current thinking imprison us in models of subjectivity that sustain and prolong the forms of social horror which threaten our survival and have already compromised our humanity. The theoretical elaboration of the theory lies in specialized debates within psychoanalysis but it can be glimpsed and sensed otherwise in the practice and experience of painting 'after painting *after* history' which is the project of Bracha Lichtenberg Ettinger.

Figure 15.10 Bracha Lichtenberg Ettinger, *Autistwork no. 9*, 1993–4, oil and photocopy on paper mounted on canvas, 28.4 × 25.5 cm

CONCLUSION: PAIN AND SOLACE / NAOMI AND RUTH

Bracha Lichtenberg Ettinger's recent work has taken her once again to canvas and to oil paints: an even closer focus on the veiled and hidden head of the woman, and even greater proximity in the touches of paint that build up, red, violet, over the black traces of the fading image-trace that is drawn and erased (Figure 15.10). They are hung on the wall, before a bench, where the viewer is literally placed in physical proximity and yet kept at a distance by the web of paint marks. Titled *Autist Works*, we are being prompted to imagine a loss of any sense of social interaction and subjective mutuality. Yet the vibrancy of the colour is powerfully affective in the stillness of the repeated retracing of the masses of dark and light that were the photograph's means of record. Specularity and its associated voyeurism are banished by another attraction of the gaze to the palpability of coloured touch. There is the now more substantial reference to the body – the canvases hung at head height that then bring the viewer's body to the piece. There is no reciprocal gaze, no play of mastery, object, subject. There is pain. But also that strange, uncanny solace that until now had no name where this painting invites to the very borderlines of visibility, however mournful the image it bears like a wound, that something beyond appearance which allows escape from the phallic castration and loss to a feminine, matrixial dimension of the several.

Before hearing and seeing there is active and passive touching. The grains of the skin, all around, touch. Grains from before the gaze. Magic moment of touch. The gaze, saturated from too much seeing, suddenly sees no more and touches. It joins with the grain of the skin; it falls in love.
– Give it sensitised form.

(*M.H-L 1991:* 91–2)

Notes

1 See Bracha Lichtenberg Ettinger, 'Matrix and Metramorphosis', *Differences*, 1992, vol. 4 no. 3.

2 Bracha Lichtenberg Ettinger, 'Metramorphic Borderlines and Matrixial Borderspace' in *Rethinking Borders* ed. John Welchman, London and New York, Macmillan 1996.

3 Bracha Lichtenberg Ettinger, *Matrix: A Shift beyond the Phallus*, Paris, BLE Atelier, limited edition 1993, 3; can be consulted at the Tate Gallery Library, London, and the Israel Museum, Jerusalem and the Bibliothèque Nationale in Paris. The introductory chapter was published in *Women's Art* (UK) no. 56, 1994. Given as a lecture at The Point of Theory conference, University of Amsterdam, 1993.

4 *Derrière les moissoneurs* (1985) was a series exhibited at the Musée des Beaux Arts, Calais, in 1988, reproduced in the catalogue *Bracha Ettinger*. For further illustrations of this series see *Matière et mémoire: Ettinger, Fontenau, Mackendrée*, Isy-Brachot, Paris, 1985.

5 See the artist's important analysis of the role of 'behind the desert' in the biblical narrative of the encounter between Moses and God, and the giving of the covenant to the Jewish people at Sinai. 'The Becoming Threshold of Matrixial Borderlines', in *Travellers' Tales, Narratives of Home and Displacement* ed. George Robertson *et al.*, London, Routledge, 1994.

6 Bracha Lichtenberg Ettinger, *Matrix. Halal(a)-Lapsus Notes on Painting* (Carnets 1985–92) trans. Joseph Simas and the artist, Oxford, Museum of Modern Art, 1993. Subsequent citations will be recorded as *M.H-L*, followed by year and page.

7 The film of Gila Almagor's second volume of autobiography, *The Dominen Tree*, has just been released and as I write I read in *The Jerusalem Report* (27 July 1995) more information on her actual family history which suggests that her mother was not in fact in Europe during the war. In the film *Summer of Avia*, her mother claims she was a partisan in Poland before she was captured.

8 In the introduction to the book of that title, however, she writes to connect individuals' specific situations with the larger community.

> Indeed, which member of the Jewish nation is not a child of survivors in potential? It therefore seems to me that the problems raised in this book touch the essence of the Jewish nation in the post-Holocaust generation. The central topic of this book is none other than the intergenerational transmission of the traumas caused by exile and extermination, which have unfortunately been only too frequent throughout the generations and have not ceased even in our own generation. It is thus possible that my descriptions and explanations may be able to elucidate to some extent problems belonging to large groups of people throughout the generations in different countries.

Dina Wardi, *Memorial Candles: Children of the Holocaust*, London, Routledge, 1992, p. 5; Hebrew edition *Nos'ei Hahotam*, Maxwell-Macmillan-Keter, 1990. See Yael S. Feldman, 'Whose Story Is It, Anyway?' in Saul Friedlander, (ed.), *Probing the Limits of Representation: Nazism and the 'Final Solution'*, Cambridge, Mass., and London, Harvard University Press, 1990, who also discusses this generation of writers and relates their experiences to Dina Wardi's book.

9 On which I have written in 'Œuvres autistes', *Versus* no. 3, 1994.

10 All along *Matrix. Halal(a) – Lapsus*, the artist is tracing 'places of beside'.

11 Foreclosure/*foreclusion* is a term introduced by Jacques Lacan to denote a specific mechanism associated with psychosis in which a fundamental signifier (in his terms: the Name of the Father) is ejected from the subject's symbolic universe. The foreclosed signifier is not integrated into the unconscious but it can return – from the Real – through hallucination. See: Bracha Lichtenberg Ettinger, 'Matrix and Metramorphosis'.

12 The term designates psychopathological conditions that lie on the borderline between neurosis and psychosis, the latter being conditions in which the subject lacks or is unconnected to the necessary signifiers. See the *Borderline Conditions and Pathological Narcissism* exhibition at Institut d'Art Contemporain – Le Nouveau Musée, Villauban, 1992. Text by Rosi Huhn. The exhibition title refers to the book of that title by Otto Kernberg, New York, Jason Aronson, 1985.

13 I want to stress here, as the artist does, that the appeal to the feminine does not produce a separatist or partisan conception of the feminine. The feminine is foreclosed to women and excluded by men; its potential is obviously important for women who may have a privileged relation to it, but it is also a critical dimension for masculine subjects and thus in the realignment of our understanding of sexual difference and sexual specificity our culture would gain from an enlargement offered by the feminine aspect.

14 Bracha Lichtenberg Ettinger, 'Matrix: A Shift In-side the Symbolic'.

15 See Emmanuel Levinas in conversation with Bracha Lichtenberg Ettinger, *Time Is the Breath of the Spirit*, MOMA, Oxford, 1993.

16 On the matrixial covenant or alliance, ibid.

17 Dating to 1990–2 there are seven pieces titled *Woman-Other-Thing*, and a further three are added to the series by 1993.

18 See Griselda Pollock, 'Screening the Seventies: Sexuality and Representation' in *Vision and Difference*, London, Routledge, 1988.

19 In an interview in *Art Press*, no. 176, January 1993 (by Anne Dagbert), the artist replied to the question about appropriation (in this instance of the book's title *Borderline Conditions and Pathological Narcissism*) and the use of the readymade, by saying:

> I pervert the idea of the readymade because I do not make use of objects but of documents and photographs. I kept the English title because 'Borderline' signifies both a geographical frontier and a psychoanalytical 'cas-limite'. I wanted to indicate a crossing point between analytic and plastic investigations, frontier zones where my painting is inscribed.
>
> (p. 84.)

20 Bracha Lichtenberg Ettinger, 'Matrix and Metramorphosis', p. 201.

21 These derive from Laura Mulvey's key formulation about cinema spectatorship, 'Visual Pleasure and the Narrative Cinema', *Screen*, 1975 vol. 16 no. 3.

22 'The gaze is a model of a "pure" *objet a*. When *beyond appearance* we search for a "lacking something", separated, fragmented and lost, this lacking something is not *any* "no-thing". It is a *particular nothing*.' Bracha Lichtenberg Ettinger argues that within Lacanian psychoanalysis, this lacking something is always assimilated to the 'symbolic value of the lacking Phallus'. Her explorations in artistic practice and psychoanalysis lead her to propose, via a reading of Freud's essay 'The Uncanny' another symbolic value and signifier for loss based on fantasies of uterine life: the Matrix. See *The Matrixial Gaze*, University of Leeds, Feminist Arts and Histories Network, 1995.

23 For the full theoretical explanation of this gaze see *The Matrixial Gaze* cited note 22.

24 Ibid. p. 55.

25 The artist has been the Hebrew translator of Lacan's texts and has had access to many unpublished seminars and papers dating from the last period of Lacan's work.

26 Bracha Lichtenberg Ettinger, 'Woman-Other-Thing: A Matrixial Touch' in *Bracha Lichtenberg Ettinger: Matrix-Borderlines*, Oxford, Museum of Modern Art,1993, pp. 15–16. A full-length analytical account of these issues is provided by Bracha Lichtenberg Ettinger in *The Matrixial Gaze*.

27 Bracha Lichtenberg Ettinger, 'Woman-Other-Thing: A Matrixial Touch', p. 17.

28 These short quotations are all from ibid., p. 17.

29 Friedlander, *Probing the Limits*.

30 Ibid., p. 18.

31 Bracha Lichtenberg Ettinger, 'Matrix: A Shift In-side the Symbolic'.

32 The term 'extimate' is used by Lacan to define those phenomena that traverse the inside–outside binary, like a shout which comes from within but is only heard on the outside. Bracha Lichtenberg Ettinger expands the word to evoke that borderline that is the inner limit of the one and the outer edge of the other at one and the same time – the womb in late pregnancy, for instance.

33 Artist's statement for the exhibition *Oeuvres autistes*, Begijnhof Sint-Elizabeth Kortrijk, Belgium, 1994 (Kanaal Art Foundation).

34 Roland Barthes, *Camera Lucida*, London, Fontana, 1982, p. 65.

35 'I cannot reproduce the Winter Garden Photograph. For you, it would be nothing but an indifferent picture . . . at most it would interest your *studium*; period, clothes, photogeny; but in it, for you, no wound' ibid., p. 73).

36 Ibid., p. 72.

37 Bracha Lichtenberg Ettinger, 'Woman-Other-Thing: A Matrixial Touch', p. 17.

38 See Bracha Lichtenberg Ettinger, *The Matrixial Gaze*, for her analysis of Freud's 'The Uncanny' and her attention to his recognition of one source of the uncanny in 'womb fantasies', i.e. fantasies about that intimate relation to the maternal body.

39 And when that logic was allowed to seek out its unthinkably literal end, it meant an attempted destruction whose scars remain carved in our present . See Zygmunt Bauman, *Modernity and Ambivalence*, Cambridge, Polity Press, 1991. Bauman does not see the parallel between the Jewish predicament and that of women. I make the connection.

Name index

(Page numbers in *italic* denote illustrations)

Subject index